From The Women's Press Ltd
124 Shoreditch High Street, London E1

The authors of *Women Artists* are well known in feminist and art circles for their unique collection of more than 5000 slides of the work of women artists. The collection is housed at Sonoma State College, California, but Karen Petersen and J. J. Wilson show it all over the United States to illustrate their lectures, out of which work this book came. The academic background of both women is in literature. Karen Petersen studied German literature at the University of California, Berkeley, and J. J. Wilson took her Ph.D at the same university in Comparative Literature. Their interest in art history came out of their feminism and their very practical realisation of the shrieking absence of available material on women artists. Their work is refreshingly free from academic bias, while satisfying serious standards of scholarship; thoroughly accessible and awesomely wide-ranging. 'The only places we have not found women artists are where we have not yet looked.'

The chapter on women artists in China has been contributed by Lorri Hagman. The book was designed by Patricia Girvin Dunbar.

KAREN PETERSEN & J. J. WILSON

WOMEN ARTISTS

Recognition and Reappraisal
from the Early Middle Ages to the Twentieth Century

The Women's Press

First published in Great Britain by
The Women's Press Limited by arrangement with
Harper & Row, Publishers, Inc, in 1978

Reprinted in 1979, 1985

The Women's Press Limited
A member of the Namara Group
124 Shoreditch High Street, London E1

Printed and bound in Great Britain by
Hazell Watson & Viney Ltd,
Aylesbury, Bucks

Dux femina facti

The Aeneid, Book I

To struggle for strength. It sounds so dramatic. One does as best one can, and then one goes to bed. And that's how suddenly one day, it becomes evident that one has achieved something.

Paula Modersohn-Becker

Acknowledgment

Our thanks to the friends who helped bring this book to completion, some by bringing us books we needed, some by taking the baby away to play with, some by typing piles of manuscript, some, bless 'em, by staying away . . .

We were helped too by the moon's crescent at dawn, the summer afternoon wind, the quiet, glowing twilights.

We were helped, most of all, by one another.

Contents

WOMEN ARTISTS

In Our Own Image

In myths about the invention of art, the first artist is sometimes named as Kora, the daughter of the potter Dibutade, a young maiden who was moved to sketch the shadow outline of her lover on the wall before he went off to war . . . This myth—and many others about women artists—our book wishes to reconsider.

When people first look at the miniature illustrated here, they assume it portrays a courtly lady putting on makeup. (Fig. I, 1) Closer scrutiny shows her brush to be pointing the other way, outward, and indeed it is a fanciful reconstruction of Marcia, a Roman artist, in the process of doing her self-portrait. However, there may well be some connection between self-portraiture and painting one's face. Certainly the mirror is an important tool for women, though a double-edged one, as Patricia Meyer Spacks warns: "reflections *always* contain danger: at one extreme, of narcissism; at the other, of self-knowledge."[1] (Note that in the myth of Narcissus, it is a young man who falls in love with his own reflection, for it would not be considered aberrant behavior for a young woman to gaze thus often at herself.) However, when the brush points outward, as it does with Marcia, then we can assume that the Narcissus spell is broken, and that at least there will be a self-portrait

to record the mirror's introspection. Art may well have been invented by women for the purpose of sketching their *own* shadow-selves rather than those of their lovers. Self-portrait as self-identity: like diaries, one of the few ways women have to leave their side of the story. Looking at art by women has been for us like looking in a mirror.

This familiar scene by Mary Cassatt portrays a naked little girl being shown her reflection by her much-draped mother. (Fig. I, 2) Soon she will have left that early unself-consciousness behind, as she assumes the identity required by society and checked anxiously in mirrors or other women's eyes. It is a charming and terrifying portrayal of the socialization process. There is, however, yet another mirror behind, reflecting all of this for posterity, and that is the mirror of art. While women artists have no monopoly on the mirror in art, they do often reflect a different view.

Mirrors recur tellingly throughout Cassatt's work as we see in this painting of a girl arranging her hair. (Fig. I, 3) The origin of this particular work is instructive. Edgar Degas, her very close friend, had challenged her regarding the possible content of art—saying, in effect, that one cannot make a beautiful painting out of an ugly subject. Cassatt took up the challenge and painted her rather awkward, adolescent (and lower-class) maid looking into the mirror as questioningly and

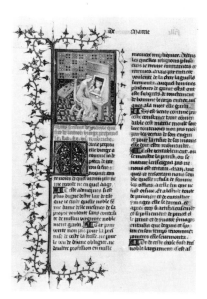

Fig. I, 1 Marcia, depicted painting a self-portrait. 1402.

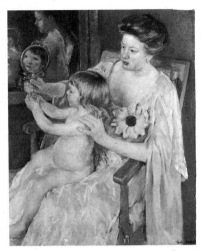

Fig. I, 2 MARY CASSATT. *Mother and Child*. 1905.

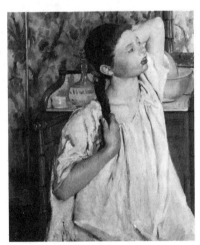

Fig. I, 3 MARY CASSATT. *Girl Arranging her Hair*. 1886.

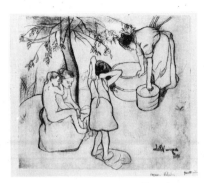

Fig. I, 4 SUZANNE VALADON. *Dressing Two Children in the Garden*. 1910.

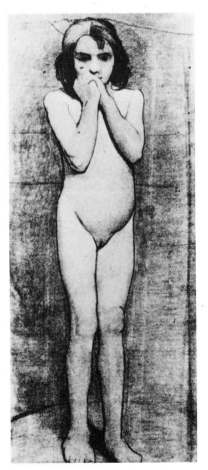

Fig. I, 5 PAULA MODERSOHN-BECKER. *Nude Study*.

insecurely as we all do. Degas acknowledged that he had learned something from this painting (he even bought it), and we learn from it, too. The impact on women's self-image of centuries of idealized representations by male artists has been to falsify our own sense of our physical selves. A classic example can be seen in Kenneth Clark's widely used book *The Nude*, where no women appear as artists, only as the subject of art; indicatively the index entry for women reads: "condemnation of, crouching, old nudes of, statues of, as Virgin."[2] Elizabeth Janeway chastises us:

> Because women have let the false images stand as our representatives, we have falsified ourselves, diminished ourselves, chosen to divide ourselves and exist in a hopeless, endless stasis, unable either to act truly or to be ourselves in freedom and enjoyment. What can we do? We must change our image instead of merely withdrawing inside it and denying that it represents the self.[3]

We agree, and thus for the purposes of this study have chosen to rediscover the images women themselves create rather than to analyze those created of them by others.

For example, Paula Modersohn-Becker had difficulty finding models (as women artists often do) and asked the young girls and old women of her village to come in and model for her. The knock-kneed child pictured here gives us back a reflection of a time in women's lives rarely pictured by male artists: the moment of withdrawal, of self-consciousness that comes with the onset of puberty. (Figs. I, 5–7)

The profile of a peasant girl, hair pulled back straight over a too-high forehead, mirrors out the homeliness in all our faces that society

asks us to hide, to remake, at the least to forget. Modersohn-Becker, through the attention she lavishes on this unlikely subject, returns this aspect of ourselves to us, and to art.

Germaine Richier's standing nude figure, *The Hurricane,* is significantly different from the body types usually found in such sculpture. (Fig. I, 8) Of an indeterminate age rather than eternally nubile, she has an interesting face; she seems to know who she is and where she is going; she accepts that her center of gravity is herself. This single, free-standing form is a frequent and important image in women's art, but so is the phenomenon of looking to another for self-reflection.

Is it mirroring or some deeper psychic process that causes so many double images in women's art? (Figs. I, 9–13) Usually the figures are of the same sex—sisters, perhaps, as in Cassatt's famous painting where the fan seems to separate one Alice from the other Alice in the looking glass. Isabel Bishop's two working girls talking together during the noon hour are wonderfully part of one another and take strength from that reinforced identity. Sher-Gil's use of the two colors in her models derives from her own double parentage: her father a European, her mother from India. It also reflects a frequent dream women have of joyous embrace between the dark sister and the fair sister. *The Two Fridas* depicts another double parentage (Frida Kahlo's mother was a native of Mexico and her father a German Jew), but the artist adds to it her feeling of being split in two when her husband, Diego Rivera, left her. The couple in Remedios Varo's watery painting are the mirror image of

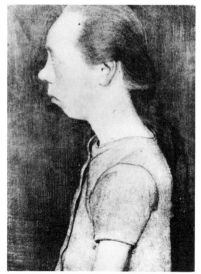

Fig. I, 6 PAULA MODERSOHN-BECKER. *Worpswede Peasant Girl.*

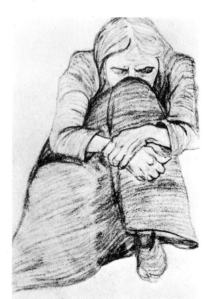

Fig. I, 7 PAULA MODERSOHN-BECKER. *Study.*

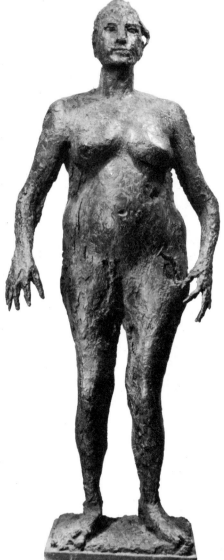

Fig. I, 8 GERMAINE RICHIER. *The Hurricane.* 1948/49.

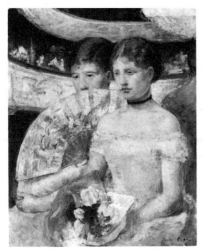

Fig. I, 10 ISABEL BISHOP. *Noon Hour.* 1936.

Fig. I, 11 AMRITA SHER-GIL. *Two Girls.* 1939.

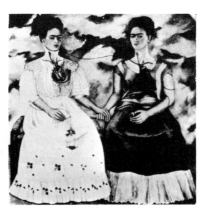

Fig. I, 12 FRIDA KAHLO. *The Two Fridas.*

one another and, as a result, are oblivious to the danger around them.

The fear that women describe of looking into the mirror one day and seeing nothing is an allegory of non-identity, which also reveals fear of desertion, of dependence upon an insufficiently integrated self. (Figs. I, 14–17) In Ernestine Mills's remarkable enamel, the mirror has engulfed the maiden, pulled down by a monster strangely akin to her. Beautiful but frightening, as the woman does not even struggle. So many dreams of drowning, sometimes in a sea of fire, are expressed in this Leonor Fini painting called *The Useless Toilette*. It is worse than useless if, with the false modesty and passivity of a Virginia or an Ophelia, we let the weight of our skirts pull us down.[4] Many women's stories end right there, and poets have for centuries sung approvingly of the young maidens who drowned themselves. When these anonymous, inert bodies are raised out of local rivers, they become the female equivalent of the Unknown Soldier, dead for love and honor. Even Mary Wollstonecraft tried to act out this powerful archetype in despair over the stormy course of love. Her biographer tells us the stark details:

The heavy rain that had begun by the time she reached her destination suggested to her the idea of soaking her clothing so that she would sink more rapidly. For half an hour she walked up and down . . . At last she threw herself from the bridge into the black river.

She did not sink immediately; afterward she remembered trying to hasten the process by pressing her wet clothing closer to her body, before she lost consciousness. She also remembered the frightful pain when the water invaded her lungs, as a suf-

ficient reason for never attempting such an ending again.[5]

Dorothea Greenbaum's *Drowned Maiden* is a classic rendering of this passive defeat, whereas Lenore Thomas Straus's *sumiye* sketch shows yet another way to see drowning—as a necessary descent. This figure lets go willingly, confident that her strength and natural ebullience will allow her to return, richer for this journey to the depths of the self. In just these few works, then, you see some of the themes, nightmares, resolutions, puns, cautionary tales that emerge when you look at the images women themselves create of their lives. Or as Sonia Sekula wrote: "Don't forget that I, am a, woman, a belly, a sword, a, nipple, a, sex, a, dream, cross, and a Sunday, and, a mirror.[6]

REVIEW

The mirroring of art is a frequent theme in art and social histories, but because women's works are rarely considered in them, as any quick survey of the standard texts will confirm, it has been, more often than not, a distorting mirror. Lise Vogel, in an anguished inventory, describes the manifold needs:

Where are the reproductions and slides of the work of women artists? Why can't one find syllabi and bibliographies covering issues of women, art, and feminism? What is the meaning of the almost complete lack of feminist studio and art history courses in the schools? Why are there so few feminist art historians and critics? . . . What should a feminist artist, critic, or art historian do?[7]

This book, intended as a general historical overview of women artists working in the Western tradition, will try to fill some of these gaps. Our

Fig. 1, 13 REMEDIOS VARO. *Lovers.*

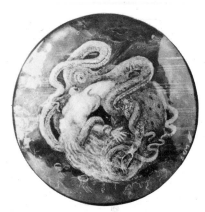

Fig. 1, 14 ERNESTINE MILLS. *Mermaid Overwhelmed by Octopus.* c. 1910. Enamel tondo, 7 in. diam.

aim is to accumulate in one place as much information as we have found thus far on the lives of women artists, realizing how much has been lost or distorted. The illustrations must speak for themselves, as we are not able to give them the formal analysis of trained art historians. Nor do we try at this point in our research to compare and connect our artists with the better-known male artists of the same period. This important work will have to be done, but we hope that the biographies, the reproductions, and the bibliography included here will show the rewards of taking a feminist perspective on history.

The searching out of a history that has been almost as systematically obliterated as were the faces and breasts of women in Egyptian murals requires patience, luck, faith, and what Susanne K. Langer calls "a new way of seeing."[8] We need to cultivate that special sort of alert attention that Simone Weil advises, where "above all our thought should be empty, waiting, not seeking anything, but ready to receive in its naked truth the object that is to penetrate."[9] The only places we have not found women artists are where we have not yet looked.

However, the art reference books are not compiled with women in mind, and even teachers of goodwill find themselves at a loss to tell their students where to go for guidance. Again and again we have seen students, originally enthusiastic about doing their work on a woman artist, become discouraged and fall back on more conventional and feasible projects—another study of Rembrandt or something rather daring on Oldenburg—because their teachers, librarians, and fellow students give them more support in these well-trodden ar-

eas. We are especially proud, therefore, to include as part of this book some very daring and difficult research done by our student and friend Lorri Hagman on the history of women artists in China. (See Appendix.) There are significant analogies between the suppression of women artists in that history and our own, and she has made many fascinating discoveries. These women dared to challenge the Confucian saying that "Only the untalented woman is virtuous."

Our book seeks to stimulate general reconsideration of assumptions in art history. People can no longer afford to ignore the historical and present achievements of over half the population, achievements now being painstakingly reconstructed through the labors of feminist scholars in all the academic disciplines: art, music, literature, history, science, and philosophy.[10] Already much is lost to us.

For the artists themselves, this denial of their full history has had appalling consequences. Tillie Olsen, in her essay "Silences," warns us of the terrible toll that being ignored can take on creativity.[11] People are not just silent; they are silenced. And the art world is not free of such ignorance. Kenneth Clark recently "answered" a question about women artists by a sweeping statement that well, after all, there had been no women composers either, and he supposed they just lacked the architectonic sense for making music, as they lacked it for building. . . . As Ursula LeGuin warned in a recent interview, if you stay in the mainstream, you're likely to end up in a backwater.[12]

The danger of having a fixed, or unexamined, art history perspective is that it all too frequently predisposes us to look only at certain

Fig. I, 15 LEONOR FINI. *The Useless Toilette.*

kinds of art, to see only certain superstars, chosen by biased criteria:

The art world has traditionally ignored the issues of sex, class, and race, at most acknowledging them as background or context. Moreover, it originally assumes that a single human norm exists, one that is universal, ahistorical, and without sex, class or race identity, although in fact it is quite clearly male, upper-class, and white.[13]

For example, Judith Chase, curator of Charleston's Old Slave Mart, states in her 1971 book, *Afro-American Art and Craft,* that no Afro-American artists have been included in *any* standard art history.[14] "It is never safe to argue from silence. . . ." as a fine historian warns us, and the new books that focus on third world artists show what we have been missing.[15] Why limit our vision by the astigmatism of others?

POINT OF VIEW

Of course, we have biases of our own and should try to identify them here. We have already said that this is not a book analyzing images *of* women *in* art but a book *of* art *by* women. Unfortunately we cannot even include all that art by women discriminatorily categorized as "minor," though we entirely agree with Elizabeth Janeway that:

Creativity is not really a rare gift . . . it is present not just in the high arts of music and drama and dance and literature and painting and sculpture; it is present in folk art too. The quilts our great-grandmothers made, the knitting patterns they adapted, the embroidery with which they enlivened simple traditional styles of clothing, were all products of creativity. So were folk songs and work songs and country dances, weaving and pottery making, and all the

Fig. I, 16 DOROTHEA GREENBAUM. *The Drowned Girl.* 1950.

Fig. I, 17 LENORE THOMAS STRAUS. Illustration from *The Tender Stone*.

crafts that were in earlier days a necessary part of life.[16]

Wonderful books are being published on these contributions to our past and present arts, as they are on women's filmmaking and photography.[17] In the short compass of this book, we have chosen to concentrate on reconstructing what Judy Chicago calls, "a new kind of art history, one that searched out women's work for women's point of view."[18] Our experience in the burgeoning discipline of Women Studies has taught us the values of looking at traditional scholarship anew. The lives of women in all fields hold particular instruction for us. Here we take an interdisciplinary approach and though specialists may take exception to our interpretations, the absence of formal analysis, our preoccupation with biography, our leaps and bounds, the book is intended for what Virginia Woolf (and Samuel Johnson) calls "the common reader." It should serve as a supplement to any general course on Western art and culture until something better comes along; we hope that it will be used also as a basis for special courses or units on women artists.

Our own academic training has been in comparative literature, and while we both have always been attentive to the visual arts, neither of us identifies as an art historian. Feminism and Women Studies radically changed our research and teaching priorities. In a women's literature class at California State College, Sonoma, in the summer of 1971, Karen chose as a class project to research unknown women artists to parallel the work we were doing with unknown (or ignored) women writers and philosophers. J. J. was particularly interested in Karen's work because the packaged slide collection provided

for Humanities teachers included only 8 works by women out of over 1,300 slides! We wanted the college to photograph works turned up by Karen's research.

She began just by using the names we could remember offhand—and they were lamentably few. Later we were much aided by the *Art News* issue devoted to women artists.[19] The local libraries listed books whose titles promised to answer all our questions: Hans Hildebrandt's *Die Frau als Künstlerin* (1928), Vachon's *La Femme dans l'Art* (1893), Mrs. Ellet's *Women Artists in All Ages and Countries* (1859), Clara Clement's *Women in the Fine Arts* (1904), and Walter Sparrow's *Women Painters of the World* (1905).[20] Our subject, it appeared, was not a new one. However, these books all too often gave the illusion of information without much actual substance. They were dated, sometimes containing pious platitudes about women that set our teeth on edge. It was like reading something in a bad translation, but we were thrown back upon these sources, as no one seemed to have done much since. (Fortunately, now, new books are beginning to appear, and our debt to them will be clear in subsequent chapters.)

These old texts did provide us with more names to work from, so that we could use the *Art Index* and multivolume dictionaries like Thieme-Becker's. Often our research methods were more primitive and ingenious. We discovered that if we looked up the family names of well-known male artists— say, Diego Rivera, Jacopo Robusti Tintoretto, Jean Honoré Fragonard, Pieter Brueghel, Vincent van Gogh, Alexander Calder, Max Ernst, Marcel Duchamp—we often found some account of a wife/lover/sister/mother/daughter who was an artist,

too.[21] Exhaustive books on certain periods, when well done, do include women, though rarely do even expensive books devote their color plates to women's works, choosing instead to reproduce more familiar works by famous male artists. Often our "research" was nothing more than the dogged perusal of indexes of artists' names. We felt well rewarded, however, when we had the luck to find a color reproduction.

As our collection grew, and as we got more and more slides in color, it became a natural step to show classes and community groups what we had found, and their response overwhelmed us. Judy Chicago describes a similar experience in her admirable and heartwarming book, *Through the Flower: My Struggle as a Woman Artist:* "The women in the audience were generally very excited by what they saw and the weekend was filled with identification, laughter, tears, and warmth."[22] The particular combination of women's biography and art seemed to reach a wide variety of people on a deep level. We gave the lecture in Eugene, Oregon, one night to a large and enthusiastic audience and later were invited to the festive opening of a women's art exhibit. Greeting us on the steps of the museum was a young artist, illuminated by the whole focus on women. She asked politely what the name of our book was to be. We asked if *she* had any ideas for an appropriate title. "Call it—US," was her pellucid response. A letter came after we had given the show at Smith College: "Those women you showed weren't fancy; they made painting from blood and bone and terror and, yes, love of beauty." A friend sent us this poem, after a benefit performance for Union W.A.G.E.:

MORE THAN PURE FORM

the woman who teaches
who gives instructions
in the arts

the slides she shows
of other women
who have painted other faces
the stories their stories
she tells as if it were
her story her own work
the sense of their
work in the biography
that she tells

this image she has
of them
her passion in
the telling is the way
you know she is
an artist
she in her own
way forming the passion
of others with
her own[23]

And miraculously we began to meet *other* women involved in researching every imaginable aspect of women's art—cave paintings, matriarchy, cross-cultural studies, female imagery, museum politics, and art education—Sandra Roos, Karla Tovella, Wopo Holup, Kate Feldman, Alice Hauser, Moira Roth, Susan Moulton, Barbara Bell, Pat Tavenner, Joanne Leonard, Eleanor Dickinson, Ruth Iskin, Arlene Raven, and the women from the Feminist Art Program at the California Institute of the Arts. Later on in the East, we were to meet Ann Sutherland Harris, Mary Garrard, and other hard-working women in the Women's Caucus for Art.[24] We subscribed to *The Feminist Art Journal,* which mentioned our research, as did Florence Howe in an issue of *Ms.*[25] Our correspondence increased hundred-fold with people interested in this long-neglected field. POINT, the innovative foundation established to use profits from the *Whole Earth Catalog,* awarded us a wel-

come grant for expansion of the collection. And then . . . in 1974, to our pride and considerable amazement, *Mademoiselle* magazine gave the slide collection an outstanding achievement award; we got to go to New York and show even that town something it had not seen before!

The works of women need exposure; they need sharing with their largest possible audience to develop a special vocabulary of appreciation and the same joy of recognition that men's art has received over the centuries. Molly Willcox, scouting for publishing possibilities from the women's renaissance, sought us out. When she first attended the slide show, she saw, better than we had, its potential for translation into print. Now, with the fullest cooperation from everyone at Harper & Row's Colophon and Audio-visual departments, this book and slide sets are being made available. We hope the beauty of these women's works and the lessons of their lives will help in that "reconstruction of the mind" Adrienne Rich has called for.[26]

We decided to begin around the fifth century A.D., leaving prehistory and classical speculations to those better able to deal with them.[1] Early on in our research we realized that medieval Europe was a rich source of women's art, and indeed the role of nuns as creators and as conservers of culture deserves a study all its own. From St. Melania in the fifth century, praised, Bradley tells us, "for the celerity, exactitude, and beauty of her calligraphic labours," up to and including many present-day nuns, there have always been artists working away in the protective environment of the conventual orders.[2]

It is important to understand that in medieval times joining a convent was one of the few options for respectable women wanting something other than marriage and childbearing:

The right to self-development and social responsibility which the woman of today so persistently asks for, is in many ways analogous to the right which the convent secured to womankind a thousand years ago. The woman of today, who realizes that the home circle as at present constituted affords insufficient scope for her energies, had a precursor in the nun who sought a field of activity in the convent.[3]

Some of the motives for taking the veil are listed by Eileen Power as follows:

1. A career and a vocation for girls
2. A "dumping ground" for political prisoners
3. For illegitimate, deformed, or half-witted girls
4. Nuns forced unwillingly to profess by their relatives
5. A refuge for widows and occasionally for wives[4]

We would add women artists to this list. While there were secular women artists also, convents provided the best working conditions, training, material, and support for the talented and educated women of the times.

And these nuns were not as anonymous as history would have us think! (Figs. II, 2–4) The twelfth-century nun Guda, for example, copied and illuminated a homeliary to which she not only signed her name but included a picture of herself firmly grasping one of the initial letters—to make sure of the attribution, perhaps. Claricia (c. 1200) had a more lighthearted approach, portraying herself swinging on her own exercise letter, providing thereby the tail for the "Q." Her name makes a kind of halo above her head. Maria Ormani is from a later period—the page reproduced here was taken from a breviary completed in 1453—but we include it because the self-portrait and inscription show the same motivation and justifiable pride in the work.

2

The Middle Ages

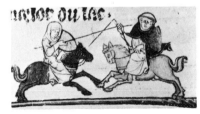

Fig. II, 1 Nun and Monk Tilting. One of the many telling images from the margins of Gothic manuscripts.

Fig. II, 2 Guda, "a sinner, wrote and painted this book." 12th c.

Fig. II, 4 Claricia, exercising on this initial Q. c. 1200.

Fig. II, 3 Maria Ormani, "daughter, wrote this." 1453.

Fig. II, 5 Woman Scribe. Pictured in an anonymous fourteenth-century Book of Hours.

SCRIBENDO ATQUE PINGENDO

In the ninth to the twelfth centuries it was a task imposed on the abbesses to copy and portray sacred symbols, and to paint the margins of books; and to ornament the sacred writings was to inform the mind and raise the soul to God. Painting in calligraphy was a consolation to many a great lady under suffering, and a complement to religious exercises. Such workers did much to preserve art from oblivion, when men gave their time and thoughts and found distraction in the shouts of battle or the disputes of the schools.[5]

Remember that before the invention of the printing press, writing and painting were closely linked, and to be a scribe frequently entailed the imaginative illumination as well as careful transcription of the text. (Fig. II, 5) Radegonde at Poitiers in the sixth century and Sister Giovanna Petroni at Siena in the fourteenth century directed convents founded with the specific intent of training women copyists and illuminators. The eighth-century saints Harlinde and Relinde became teachers also, and their story was chronicled in a ninth-century biography as their learning and artistic productivity were so highly regarded. This early biographer tells us that these two sisters "showed a serious disposition from an early age" and were educated in a convent at Valenciennes, where they acquired instruction, "in what nowadays is deemed wonderful, in writing and in painting (scribendo atque pingendo), a task laborious even to men."[6] Upon returning home from convent school, Relinde and Harlinde founded a settlement at Maaseyck, which many young women joined, following the example of their teachers who "abhorred idleness and were devoted to work." Aside

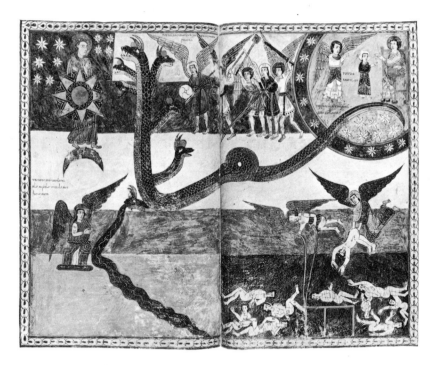

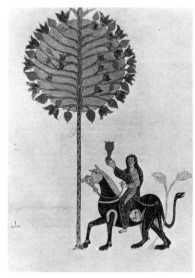

Fig. II, 6 ENDE. *The Battle of the Dragon with the Child of the Woman*, from the richly illuminated *Beatus Apocalypse*. c. 975.

from their administrative duties, the two sisters completed many wall hangings ornately embroidered with gold and jewels, as well as transcribing and illuminating books of psalms and evangeliaries. Fragments of these works remain to this day in the church at Maaseyck, as testimony of their labors.

Adahlhard, St. Giselle, St. Rathrude, and numerous other nuns became famous as illuminators, and the name of one of them, Diemud, became a byword for productivity. Working assiduously in the cloister of Wessobrun from 1057 to 1130, Diemud produced some forty-five manuscripts "of rare beauty, distinguished by highly ornate initial letters and by small writing which is most elegant." Her astonishingly prolific pen caused her biographer to pay her the sincere, if backhanded compliment, that her work "exceeded what could be done by several men."[7]

A Spanish Romanesque manuscript, the Beatus Apocalypse of Gerona, though lettered by a priest, was illustrated in part and signed by *Ende pintrix et dei aiutrix* (Ende, woman painter and servant of God). She may or may not have been a nun, but what is important to remember is that she was surely not the *only* Spanish woman painter around 975 A.D., though she happens to be one of the few who recorded her own name for us.[8]

The subject of the manuscript—the end of the world, a favorite topic of the tenth century as it is in ours—certainly stimulated the painter's imagination. Colorful dragons, demons, angels, animals, and saints fill the pages of her work, "unsurpassed by any other in the tenth century."[9] A sense of theological and aesthetic balance is conveyed in her strongly centered

Fig. II, 7 ENDE. *The Great Whore*, see *Revelations*, xvii.

Fig. II, 8 ENDE. *The Pantocrator.*

Fig. II, 9 ENDE. *The Realms.*

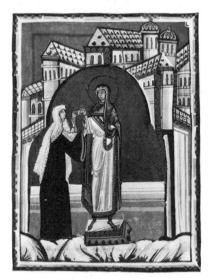

Fig. II, 10 The Abbess Hitda offering her *Gospel Book* to the cloister's patron, St. Walburga. c. 1020.

Fig. II, 11 Christ and his Disciples in the Storm on the Sea of Galilee, from the Hitda *Gospel Book.*

compositions, and the wide bands of color in some of the backgrounds order the complexity of the vision. (Figs. II, 6–9)

The women's names that are generally recorded from this period are those of the powerful abbesses like Aelflaed, Abbess of Whitby; Aethelthrith, Abbess of Ely; Christina of Mergate; Eustadiola of Bourges; Hitda of Meschede; Agnes of Quedlinburg; Ada, sister of Charlemagne; and Uta, Abbess of Regensburg. Sometimes they were the actual artists, sometimes the patrons of the works of art to which their names are connected. (Figs. II, 10, 11, 12) These women exerted an important influence on the church as a whole (as Joan Morris describes in her book entitled *The Lady Was a Bishop*), and they were active administrators and educators as well.[10]

St. Hildegard of Bingen (1098–1179) was one of the most remarkable of these abbesses. Known primarily as a mystic, she was also involved in natural science and medicine, the political and religious debate of her time, music, and language reform. (She invented a secret language of 920 words, and the title of her book of visions, *Scivias,* may well be one of them.) In 1136 she was appointed abbess and promptly moved her community to a new location, Rupertsberg near Bingen on the Rhine, where it flourished.

It was not until her forty-third year that the full impact of her inner visions was revealed:

I had been conscious from earliest girlhood of a power of insight, and visions of hidden and wonderful things, ever since the age of five years, then and ever since. But I did not mention it save to a few religious persons who followed the like observances with myself; I kept it hidden by silence until God in His grace

willed to have it made manifest. . . . It was in my forty-third year, when I was trembling in fearful anticipation of a celestial vision, that I beheld a great brightness through which a voice from heaven addressed me: "O fragile child of earth, ash of ashes, dust of dust, express and write that which thou seest and hearest. Thou art timid, timid in speech, artless in explaining, unlearned in writing, but express and write not according to art but according to natural ability, not under the guidance of human composition but under the guidance of that which thou seest and hearest in God's heaven above. . . ."[11]

Indeed the *Scivias* is dominated by visions of light—stars, moon, sun, and flaming spheres—all struggling against and ultimately overwhelming a powerful darkness filled with demons, dragons, and monsters. The original iconography and the sense of moral tension conveyed in these miniatures are interesting to compare with Ende's work.

Hildegard's writings had considerable impact on the world around her. Bernard of Clairvaux became her staunch advocate and urged the pope that "he should not suffer so obvious a light to be obscured by silence, but should confirm it by authority." Clerical approval of Hildegard's revelations led to the making of a richly illuminated manuscript by the nuns of Hildegard's convent. We have included only four of the thirty-two vivid and intensely symbolic miniatures in the *Scivias;* interestingly, it is the nuns in that same convent today who have printed the facsimile edition for modern readers.[12] (Figs. II, 13, 14, 15, 16)

While Hildegard clearly wrote for the world outside her convent walls, Herrade of Landsberg, the twelfth-century abbess of Hohenburg, was particularly concerned with the edu-

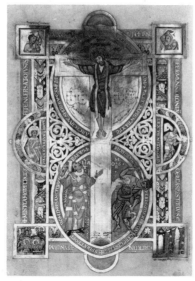

Fig. II, 12 The Crucifixion from the *Gospel Book* of the Abbess Uta. c. 1025. Considered to be one of the most important illuminated manuscripts of this period.

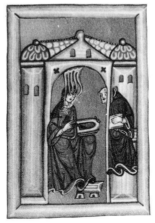

Fig. II, 13 Illustrations from the *Scivias* of St. Hildegard von Bingen, 1165, with her own commentary:

And it happened in the year 1141 of Christ's incarnation, when I was forty-two years and seven months old, that a fiery light of great brilliancy streaming down from heaven entirely flooded my brain, my heart and my breast, like a flame that flickers not but gives glowing warmth, as the sun warms that on which he sheds his rays.

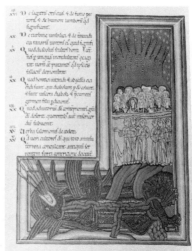

Fig. II, 14 ". . . in their pathway, lay a dragon of huge size and length, of such terrible and threatening aspect as cannot be expressed . . . he had the hands of a man, the feet of a dragon, and below a short, horrible tail. And his neck, hands and feet were bound by a chain and this chain was fixed to the abyss, and held him so fast that he could not move away to suit his wicked will."

Fig. II, 15 "Then I saw a most glorious light and in it a human form of sapphire hue, all aflame with a most gentle glowing fire, and the fire was infused in the glorious light; and both light and fire transfused that human form—all inter-existent as one light, one virtue, and one power."

Fig. II, 16 "Then I saw a huge image, round and shadowy. It was pointed at the top, like an egg. . . . Its outermost layer was of bright fire. Within lay a dark membrane. Suspended in the bright flames was a burning ball of fire, so large that the entire image received its light. Three more lights burned in a row above it. They gave it support through their glow, so that the light would never be extinguished."

Fig. II, 17 HERRADE. *Superbia,* from the *Hortus Deliciarum.*

cation of the nuns under her direction. She undertook, between the years 1160 and 1170, the writing and illuminating of an enormous manuscript designed to educate her nuns in "the history of the world, from the Creation to the Last Days." *Hortus Deliciarum* (*The Garden of Delights*) is without doubt by her hand and contained 636 miniatures, including allegorical figures, illustrations of biblical scenes, apocalyptic visions, gardening hints, and scenes from contemporary life—a kind of almanac and encyclopedia.

This manuscript, treasured in the library of Strasbourg for centuries, was destroyed by fire in the bombardment of the city in 1870. Fortunately, nineteenth-century scholars made meticulous tracings of many figures in the manuscript, and it is these alone—without the silver and gold and brilliant color of the original—that convey to us today the breadth and boldness of Herrade's conception. (Figs. II, 17–19)

One figure in particular has fascinated students of this work: *Superbia* (Pride), seated on horseback, saddled with a lion's skin, and brandishing a spear. She is leading (not shown in this tracing) a whole army of female Vices against a band of similarly armored Virtues in the *Psychomachia* tradition.[13] As so often occurs in such battles of the soul, the vices are rather more interesting than the virtues, and *Superbia* certainly is a compelling figure here, whether she is riding for a fall or not!

As we might suspect from the nature of her book, Herrade herself speaks in many different moods and tones. She could move from the stiffly admonitory, "May forgetfulness not seize you like the ostrich," to the sweetly joyous prose in which she introduces herself and her work:

Herrade, who through the grace of God is abbess of the church on the Hohenburg, here addresses the sweet maidens of Christ. . . . I was thinking of your happiness when like a bee guided by the inspiring God I drew from many flowers of sacred and philosophic writing this book called the *Garden of Delights*; and I have put it together to the praise of Christ and the Church, and to your enjoyment, as though into a sweet honeycomb. Therefore you must diligently seek your salvation in it and strengthen your weary spirit with its sweet honey drops. . . .[14]

In a more paradoxical mode, she enjoins her nuns: "*Spernere mundum, spernere nullum, spernere sese, Spernere sperni se—quatuor haec bona sunt.*" ("Despise the world, despise nothing, despise thyself, despise despising thyself—these are four good things.")[15] Good advice certainly, and Herrade is but one of the strong teachers and models found in these medieval communities of women.

THE ART OF NEEDLEWORK

Embroidery and weaving were highly developed and regarded arts in the Middle Ages and closely allied to painting. Most larger pieces and tapestries were collectively done in workshops, but up until the mid-fourteenth century, there is every evidence of full-scale involvement of secular and religious women in all stages of the work, from the spinning of silk to the art of design.[16] (Fig. II, 20) Sometimes the works are identified by a queen's name, but as with the abbesses, it is difficult to discover whether the queen commissioned the work or actually did it.

Queen Mathilda's name has always been connected with the Bayeux Tapestry, the tradition being that she and her court ladies

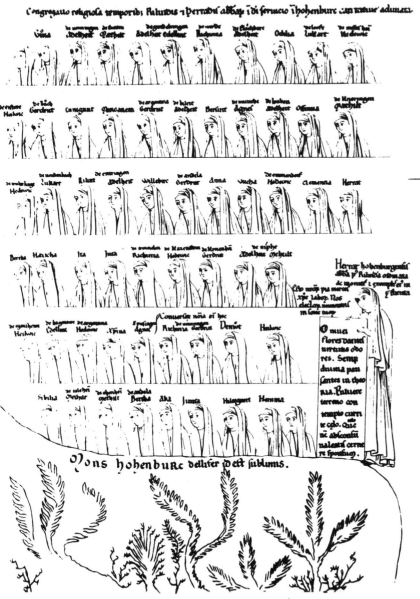

Fig. II, 18 HERRADE. *Women Musicians.*

Fig. II, 19 HERRADE. A kind of class picture of the nuns from her convent, some of whom worked on the manuscript with her.

Fig. II, 20. Woman spinning and weaving, detail from the *Psalter* of Queen Isabella. c. 1308.

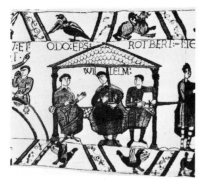

Fig. II, 21 Bayeux Tapestry. *William the Conqueror*, a frame from one of the few early secular embroideries extant.

Fig. II, 22 Bayeux Tapestry. One of the many battle scenes.

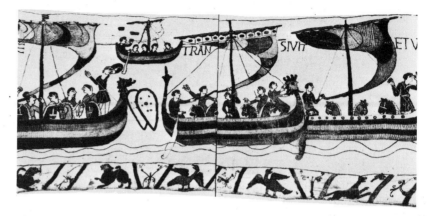

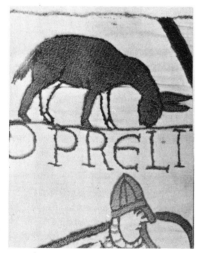

Fig. II, 23 Bayeux Tapestry. Note the attempt at perspective in the legs of this appealing donkey.

Fig. II, 24 *Adam and Eve*, from the margins of the Bayeux Tapestry.

worked on the enormous piece, over 200 feet of embroidered linen, while her husband, William, was off conquering England. Actually the work was executed in England shortly after his campaign, to commemorate (and, incidentally, to whitewash) his activities. (Figs. II, 21, 22, 23)

The authorship has always been the subject of speculation, but while people have usually assumed that the Bayeux designer must have been a man, no one has ever questioned that the incredible task of embroidering all of this huge vision on the toile was executed by the skillful needles of women workers. To whom then goes the credit or blame for the graphically portrayed nudes in the border? (Fig. II, 24) Were these the spontaneous contributions of a group of women bent over their embroidery frames and bent on mischief, or part of the official design? What was the conversation in the workshop that day? There is no telling what kinds of doodles women might make in the margins of male history when given access to tools of expression . . .

The women of England continued to practice and develop the needle

arts through the fourteenth century, and their *opus anglicanum* was highly valued throughout Europe. The earlier works were entirely embroidered in gold on finely woven cloth. Later, beautifully colored silk thread was also used. The subjects, if not the materials, were often the same as in the manuscripts we have seen: biblical scenes within circles, stars, and quatrefoils, enriched with angels, flowering scrolls, birds, and beasts. (Figs. II, 25, 26, 27)

While some of these treasures were executed by the class of professional embroideresses, much was done by nuns also. We hear of Christina of Mergate (c. 1155), a prioress of St. Albans, who "worked three mitres and several pairs of sandals" for Pope Hadrian IV. These pieces were taken to Rome by the abbott of St. Albans, who had affronted Hadrian and wished to propitiate him. The story goes that the pope was so delighted with the artistry of the work that he could not refuse the present.[17]

Apparently not all their gifts were of such high purpose, as the nuns were often chastised for turning their skill to making purses and

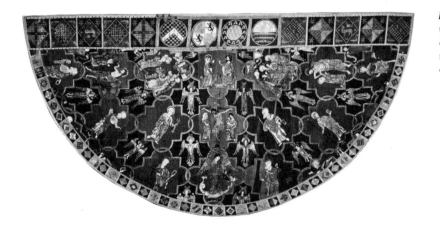

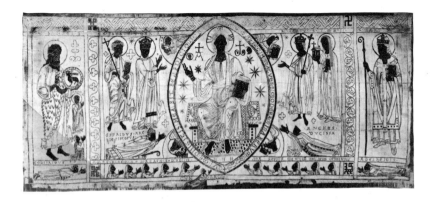

Fig. II, 25 The Syon Cope. c. 1300. When the nuns of Syon were ordered to disband during the reign of Henry VIII, they moved to Lisbon and took their famous cope with them.

Fig. II, 26 Altar frontal from Rupertsberg, near Bingen. c. 1230. St. Hildegard, founder of the convent, is depicted second from the right.

other secular baubles rather than ecclesiastical furnishings, and had to be enjoined not to absent themselves from divine service "on account of being occupied with silk work."[18]

After the middle of the fourteenth century, however, these arts were less and less identified with the convents. As Lina Eckenstein tells us, "Writing, decorating, and bookbinding, as well as weaving and embroidering, were taken up by the secular workers and were practiced by them on a far larger scale. . . . Cheapness and splendour, if possible the combination of the two, were the qualities chiefly aimed at."[19]

And here we see demonstrated a pattern that will be repeated all too often with women's work. An industry is begun by women, usually in situations such as cottages or convents where very little capital investment is required. The product is developed to a high level of attractiveness and a market proven for it. Then male workers gradually begin to replace the women, while so-called protective laws excluding women from all but the most menial aspects of the production are instituted by guild or government.[20] As this development continues, increased capital investment brings about a more advanced technology, which then is used as an excuse for dis-involving the women workers from the now lucrative

Fig. II, 27 The Göss Vestments. c. 1275. According to the inscriptions they were made under the Abbess Kunigunde, whose name appears five times on the vestments.

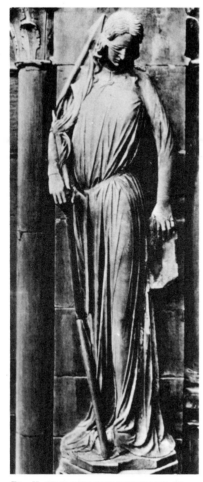

Fig. II, 28 SABINA VON STEINBACH. *The Synagogue,* from the south portal of Strasbourg Cathedral.

Fig. II, 29 SABINA VON STEINBACH. *Ecclesia,* also from the south portal of Strasbourg Cathedral.

trade. Men are brought in and trained to work the new machinery. For example, in the making of tapestry, the fourteenth-century guild rules, like taboos from some early tribe, forbade pregnant or menstruating women (which included just about every woman in those days, after all) from working on the big tapestry looms.

SCULPTURE

Given all these historical and economic determinants, it is astonishing how many women did important art work in the late Middle Ages, often in places where we would least expect them. Scholars of this period are finding in the actual guild records names of women stonecutters, and Sabina von Steinbach must have been one of these. She worked in the early fourteenth century on the south portal of the Strasbourg Cathedral. (Figs. II, 28, 29) When Erwin, the master builder, died (it is later generations that cast her as his daughter), the contract was given to Sabina, despite the overt antagonism of a rival contractor who at night came and sabotaged her work. Never fear! The angels of the Lord came down and repaired the damage before dawn, giving us one of the few examples of divine intervention on the part of the woman artist. . . . Marius Vachon, who recounts this myth with relish, sees in the persistence of Sabina's legendary reputation, the Middle Ages' unconscious desire to pay homage to women artists, so often denied their true place in history.[21]

For those who prefer hard facts to legendary exploits, the artist herself saw to it. Her statue of St. John holds a scroll on which is carved the following message: *"Gratia divinae pietatis adesto Savinae de pe-*

tra dura per quam sum facta figura." ("Thanks be to the holy piety of this woman, Sabina, who from this hard stone gave me form.")[22] Hardly an anonymous work!

Thus we have seen women artists from Ende to Sabina, in a period that supposedly prized anonymity and feared pride, signing their works with obvious pride. Some artists, such as the serious Guda and the high-spirited Claricia, even left us self-portraits as unmistakable evidence of their presence and personality. In the convents, at the courts, and on estates when the men were off at war, women developed the arts of administration, education, philosophy, as well as those we have concentrated on here of brush and needle and chisel. The Middle Ages would appear to have been one of the best times for women's culture since those fabled matriarchies, while ironically, the Renaissance and Reformation, always touted as the beginning of the modern humanist spirit, mark in many of these areas a setback for the status of women.

3

The Fifteenth through Seventeenth Centuries

THE HONOR OF THE RENAISSANCE WOMAN ARTIST

The story of Onorata Rodiani, like that of Sabina von Steinbach, has that special legendary quality, which makes it the truth even if it did not happen. Onorata, however, neither called on nor received divine help. Her own strong sword arm became her salvation.

Working in the early 1400s on a mural for the Tyrant of Cremona, the young painter was interrupted by what historians have called "an importunate nobleman." To save or to redeem her honor, Onorata took out her dagger and stabbed him dead. She then went underground and became captain of a *condottieri* band of professional soldiers. Some versions of the story say that she was recalled to finish the mural and divided her time between painting and fighting, but we have not yet been able to find any traces of her work. Perhaps somebody will one day search it out, but at this time, as Professor Puerari, director of the Cremona Museo Civico, wrote us: "Onorata is only a name." But what a name and what a story! She died defending her birthplace of Castelleone in 1472.

In the Renaissance the art of individual biography was highly developed, and so we often find at least the name and sometimes a telling story about women artists of the time. While we could not resist Ono-rata's drama, our accounts will generally concentrate on representative artists whose works are extant.[1]

THE RENAISSANCE REVISITED

As was suggested at the end of the last chapter, the Renaissance poses something of a problem for feminist scholars. It would seem that such a period of liberalization and individualism could not but be advantageous for women, and yet it is Renaissance Man who remains the primary beneficiary of all the rebirths and reforms. After all, in fifteenth-century Italy there were still women slaves and, as in the rest of Europe, countless witchburnings. All over Europe there was a dramatic increase in prostitution. Even for all the women who were not slaves, witches, or prostitutes, conditions did not noticeably improve. In fact, for those who used to seek refuge in the convents, conditions decidedly worsened, as tirades against the Church built in force. Not all critics of religious orders were as sweetly reasonable as Erasmus, who tried to convince young women that the real test was to exercise piety and enjoy freedom while remaining outside the convent walls.[2] In many convents the nuns were awakened in the dead of the night by an inflamed populace, who looted and pillaged and refused to let them live out their vows in peace. The records are full of desperate letters from abbesses

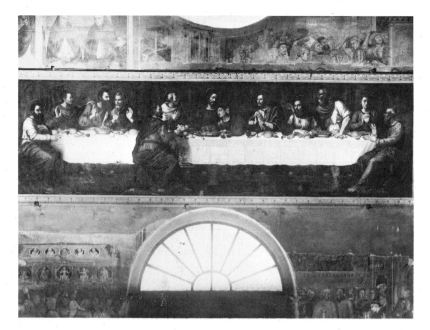

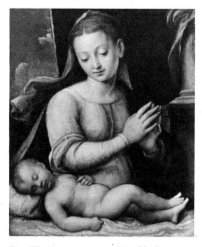

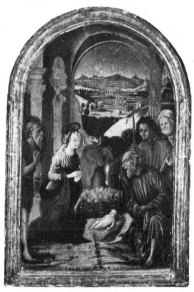

asking various officials "what the result would be if women like themselves, many of whom were over sixty and several over seventy, returned to the world and tried to earn their living, as everyone said they ought to do."[3] A painful period.

In Italy where Catholicism still prevailed, convents continued to shelter and nurture women artists, and certain orders, such as the Ursuline, had a particular tradition of educating women. The artist-nun Caterina Vigri, one of the patron saints of Bologna and also of its art academies, embodies this tradition. Indeed her paintings were invested with power to heal the sick! It should not surprise us to find that nuns are responsible for magnificent frescoes such as this *Last Supper* by Plautilla Nelli, an early sixteenth-century abbess. (Figs. III, 1–4) Of Sister Barbara Ragnoni and Barbara Longhi we know next to nothing, but have these examples of their competent work. Orsola Maddalena Caccia, after her fa-

ther's death in 1625, completed the murals he had been working on for the church in Moncalvo. She also helped to organize a painting studio in her convent, which was run for the mutual profit of the community. Caterina Ginnasi used an inheritance from her uncle, a cardinal, to found a cloister with a seminary for the education of women. She was not content with the traditional emphasis on embroidery and declared that "the needle and distaff were enemies of the brush and pencil."[4]

The Dominican nuns of San Jacomo di Ripoli in Florence utilized an entirely new technology—the printing press. With their confessor acting as business manager and the nuns as compositors and press operators, they issued seventy books between 1476 and 1484, among them Boccaccio's *Decameron,* which they must have enjoyed reading![5]

Generally, however, by the sixteenth century the effects of the Ref-

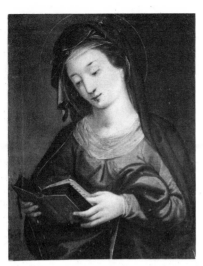

Fig. III, 4 ORSOLA MADDALENA CACCIA. *A Saint Reading.* This artist worked in the convent of Moncalvo creating beautiful devotional images like this one and austere still lifes.

ormation were increasingly felt and the effects of the Counter-Reformation, as enacted by the Council of Trent in mid-century, did not help. Indeed this Council (whose curious ways were interpreted by a woman historian writing in 1874 under the assumed name of L. Meynier) did much to undermine the power of the abbesses. By a variety of political machinations, the convents lost their autonomous status and funding. Strict rules of enclosure were enforced that "had very damaging effects on the general culture of the women's orders."[6]

The secular artists had their problems, too. It is important to remind ourselves that Renaissance artists were not lonely garret geniuses; they were versatile artisans, carefully trained in an approved workshop *(bottega)* in such technical matters as grinding pigments, preparing wood panels, and learning to work with expensive gold leaf. A supervised apprenticeship took years. It was hard even for boys to get taken on as apprentices, and impossible for girls. Such a system had few loopholes, but one was "going into your father's business," and wives as well as daughters often participated thus unofficially. However, the fourteenth-century guilds became increasingly strict about even this in-family participation, going so far as to specify how long a widow would be allowed to run a business before the nearest male relative would have to take over. Guild rules also restricted the kinds of assistance a household maid might give: "They could, for example, poke the fire."[7]

Even moderate historians like Eileen Power make no bones about the economic motivation behind these guild exclusions: "Many craft regulations excluded female labour, some because the work was

considered too heavy, but most for the reason, with which we are familiar, that the competition of women undercut the men."[8] In the thirteenth and fourteenth centuries, Hannelore Sachs tells us, the work in textile industries, for example, was still being done predominantly by women workers, supervised by women overseers, until:

In the sixteenth century all this work was also put into the hands of men. A large number of women had thereby lost their economic independence. Only as hired workers could they now make their living by taking up one or other newly established trades, such as for example the making of pillow lace. It had not been found possible to do without the help of the women's deft fingers for this delicate work.[9]

Spinning, also, was always done by women, as it was the most tedious and low-paid step in the operation; these menial workers were usually found in the anomalous category of single women *(femes soles)* and hence our word "spinster." Generally, if you did not have the protection of your family and/or an early marriage, you did not have much of a chance as a respectable woman in Renaissance society.

Yet to our predominantly male Protestant historians, everything looks fine. Jacob Burckhardt, for example, in the three and a half pages he devotes to women in the Renaissance, reassures us as follows: "There was no question of 'women's rights' or 'emancipation' simply because the thing itself was a matter of course."[10] As we know, women's rights can never be taken as a "matter of course," and the truth is even upper-class women generally did not receive any systematic education. The highly esteemed humanist Pietro Bembo suggested only that "A young girl

ought to learn Latin as this greatly enhances her charm."[11] Erudition was an erotic stimulant and made one a congenial partner, provided women did not take it too seriously. Unless you were exceptionally brilliant *and* fortunate in your father, you really did not get enough education to do you any good or harm.

Sofonisba Anguissola (1535/40–1625)

Amilcare Anguissola, a widower with six daughters and only one son, apparently decided to apply to all his children the humanist ideals of the Renaissance. He was fully committed to the education of his daughters, and obtained for them the best teachers available. It was a remarkable family, as one can imagine, with all six of the daughters developing their talents in painting, music, and literature. Sofonisba, the eldest and longest lived, has achieved the greatest fame.

Vasari visited the Anguissola household in Cremona and described in detail the works of each of the sisters.[12] Europa, Minerva, and Lucia died young, but their works show skill and training. (Fig. III, 5) Elena and Sofonisba both studied with Bernardino Campi. (Fig. III, 6) Anna became famous as a portrait painter, though few of her works are extant. Sofonisba gained recognition early in life from Michelangelo Buonarroti, who encouraged her in her work; a letter thanks Michelangelo for deigning "to praise and judge the paintings done by my daughter Sofonisba."[13] Reflecting the changes in the times as well as her own taste, Sofonisba rarely turned to religious subjects for her art. She preferred to paint the people around her—especially her unusual family and herself—and indeed developed the concept of a group portrait in a domestic setting. (Fig. III, 7)

In 1559 Sofonisba was invited to the court of Philip II of Spain. She remained there for nearly twenty

Fig. III, 5 LUCIA ANGUISSOLA. *Pietro Maria, Doctor of Cremona.*

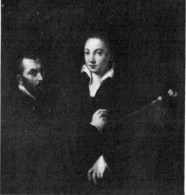

Fig. III, 6 SOFONISBA ANGUISSOLA. *The Painter Campi Painting Sofonisba Anguissola.* A unique form of self-portraiture and a tribute to her teacher.

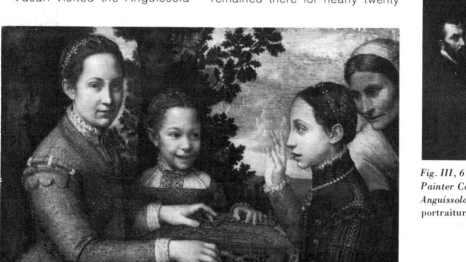

Fig. III, 7 SOFONISBA ANGUISSOLA. *Three of the Artist's Sisters Playing Chess.* 1555. The group portrait composition in a domestic setting was characteristic of her.

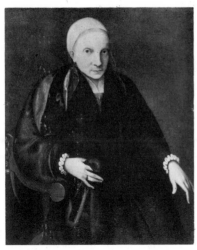

Fig. III, 8 SOFONISBA ANGUISSOLA. *Portrait of an Old Woman.* This portrait may have been one of her last works and some say it is a self-portrait. Is it not curious how much van Dyck's sketch resembles it?

Fig. III, 9 ANTON VAN DYCK. Page from his *Italian Sketch Book.* "Portrait of Signora Sophonisba, a woman artist, drawn from life in Palermo on July 12, 1624 when she was ninety-six years old, still possessed of a good memory, a fresh spirit and a friendly manner."

years, though few of the works she did for the royal family have survived.[14] She seems to have shown little inclination to interrupt her rewarding work with family responsibilities, but when she finally chose to marry in 1580, Philip and Isabella provided her with a rich dowry and an elaborate wedding. She moved to Sicily with her husband, who died shortly thereafter. Returning home to Cremona, she boarded a ship, fell in love with the captain, and married him when they disembarked in Genoa.

The Flemish painter Anton van Dyck describes his visit to Sofonisba in his *Italian Sketchbook* (Figs. III, 8,9):

While I painted her portrait, she gave me advice as to the light, which should not be directed from too high as not to cause too strong a shadow on her wrinkles, and many more good speeches, as well as telling me parts of her life-story, in which one could see that she was a wonderful painter after nature.[15]

Artists with the breadth of achievement of Sofonisba Anguissola make us regret the survey format of this book. Many marvelous works are now being reattributed to her and she awaits the careful attention of scholars in the field.

WOMEN ARTISTS OF BOLOGNA: ROSSI, FONTANA, AND SIRANI

Humanism, even for women, thrived in the progressive city of Bologna, known for its university, which opened its doors to women as early as the thirteenth century. It is not surprising to find women artists developing and working in this stimulating environment. Women emerged as sculptors, painters, and engravers, obtaining the patronage of rich courts and en-

couraging by example and instruction the talents of other women artists.

Properzia Rossi (c. 1490–1530) is one of these successful Bolognese artists and also one of the few women sculptors whose name and work have survived from this period. She began her career as a carver of curios—a curious taste of the time—and spent months of labor carving the crucifixion scene in the minutest detail on a peach stone. One is reminded of critics' praise of women's natural inclination to work small. As Mrs. Ellet notes, however, "Properzia saw the folly of thus belittling her talents" and began to work on portrait busts and bas-relief.[16] This necessarily involved her in competition with male sculptors who resented vying with a woman for commissions. Probably because of her vulnerable and unique position as a woman sculptor, she has been gossiped about by art historians ever since. Most of the controversy surrounds her bas-relief *Joseph and Potiphar's Wife*, which was interpreted at the time as reflecting her unrequited love for a young nobleman. This silly fiction has passed for fact to the extent that the work is sometimes included in collections of self-portraits; the biographical connections did safeguard the attribution of the work to Rossi. Whatever her personal drama, the piece is dramatic, showing the "superficial classicality and intense individualism" that Laura Ragg considers characteristic of her work.[17] (Fig. III, 10)

Lavinia Fontana (1552–1614) lived a long and productive life—productive in many ways (she had eleven pregnancies). The daughter of an artist, she soon excelled him in reputation, becoming one of the official painters to the Papal

Court.[18] She is perhaps best known now for her elegant portraits, but she also did elaborate pageant paintings such as the *Visit of the Queen of Sheba,* illustrated in Tufts's chapter on Fontana. She worked comfortably with both secular and religious subjects, as we see in her beautiful interpretation of Christ and the woman of Samaria.

(Figs. III, 11, 12) In 1611 a medal was struck in her honor, and she must have been an encouraging example of a respectable and respected woman artist, who did credit to her native city of Bologna.

Elisabetta Sirani (1638–1665), on the other hand, has a reputation based largely upon her astonishing precocity and her early and violent

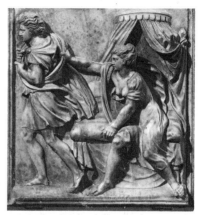

Fig. III, 10 PROPERZIA ROSSI. *Joseph and Potiphar's Wife.* c. 1520.

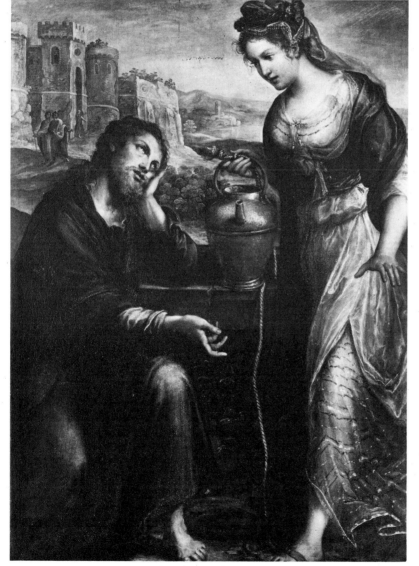

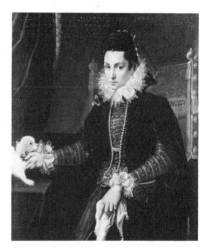

Fig. III, 11 LAVINIA FONTANA. *Portrait of a Noblewoman.* Note the attention lavished on the details of costume reflecting Fontana's appreciation of the woman's status and elegance.

Fig. III, 12 LAVINIA FONTANA. *The Samarian Woman at the Well.* Such fine works by Fontana adorned many churches in her native Bologna and in Rome, where she was commissioned to paint the altarpiece for the Cathedral of St. Paul's Outside the Walls.

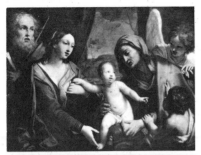

Fig. III, 13 ELISABETTA SIRANI. *The Holy Family with an Angel.*

Fig. III, 14 ELISABETTA SIRANI. *Mary Magdalen.* 1660.

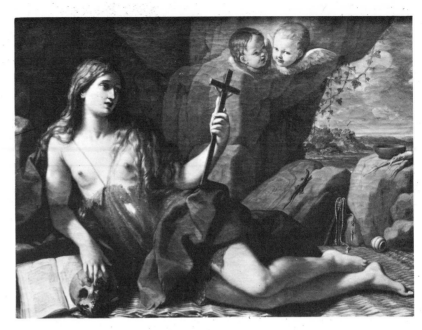

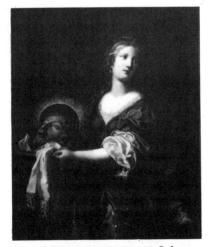

Fig. III, 15 ELISABETTA SIRANI. *Salome.* Of all the biblical subjects, Salome has been the richest in sexual allusions, combining eros, dance, death, and the Oedipal "kill the King" impulses.

death, the Renaissance media being as prone as our own to turn talented young victims into cult figures.[19] Before and after her death, Sirani was heavily promoted by her father and, in fact, her work drew such high prices that her father was accused of pawning off his own work as hers—an interesting reversal.

She was extremely prolific and her painting at times suffers from the haste with which she worked. She drew her subject matter from biblical and classical sources, sometimes including *putti* with piety in a curious mixture; her taste was a bit uncertain. (Figs. III, 13–15) A thoroughly professional artist, Sirani kept detailed written records of each of the more than 150 works she completed before her death at the age of twenty-six. It is important to remember that Sirani was also a teacher, providing a role model for aspiring women artists who found few opportunities to learn from their own sex.

THEIR FATHERS' DAUGHTERS: GENTILESCHI ET AL.

Most women learned their art from —and often for—their fathers, whose reputations, thereby enhanced, have tended to overshadow their daughter's names. Thus among the women artists of the Renaissance we find the names Tintoretto, Uccello, and Gentileschi. Of Antonia Uccello we know next to nothing. Of Marietta Tintoretto we know that she worked on the backgrounds of her father's huge canvases and that she was his first and favorite child. She was much in demand as a portraitist, but her father would not let her go away to paint at other courts and reportedly married her off to a Venetian jeweler to keep her near him. Alas, she died in her early thirties.[20] The attributions of her work are just beginning to be studied.

Artemisia Gentileschi's (1593–1652) history is longer and more

complex than Marietta's, and her paintings, fortunately, are now better documented thanks to recent scholarly studies of her and her father, Orazio.[21] She painted for some forty years, traveling in Italy and England, and had considerable influence on her contemporaries, though her name and fame have since been eclipsed.[22] If mention is made of her, it is usually in connection with the famous rape trial of the infamous Agostino Tassi, a born troublemaker, who was sharing a studio with Orazio. We have not read the record of the hearings, but scholars revel in the melodramatic details: Artemisia, tortured with thumbscrews, purportedly shouted out across the courtroom to Tassi, "and is this then the ring that you promised me?"[23]

Some suggest that her preoccupation with the Judith and Holofernes theme might derive from this early anger. Actually, the Judith story is a favorite of both male and female artists at this time, and women did not step back from this popular, even obsessive, scenario. The Bible story is unambiguous. Judith, a handsome widow, sets out to save her town from the besieging general Holofernes. After adorning herself, she and her maid start through enemy lines, are quickly apprehended and taken to the commanding general's tent. He is impressed by Judith's bearing and invites her to dinner. She drinks him under the table, takes his sword from the wall, and in two blows severs his head from his body. She and her maid put the head in a picnic basket they have foresightedly brought along and pass back through enemy lines. The next day the gruesome trophy is dangled over the town walls to the dismay of Holofernes's soldiery, who flee in fear and trembling. There is great rejoicing, a special celebration in Judith's honor: "and she went before all the people in the dance, leading all the women, while all the men of Israel followed." The Bible also tells us that Judith lived to be 105 years old and that she set her maid free.

It is not surprising to find so many different treatments of Judith by women painters. (Figs. III, 16–19) Gentileschi's versions are virtuoso pieces in which the painter appears far more aware of her present power than of her past pain. It is interesting to compare Gentileschi's dynamic portrayal of the execution itself with the ex post facto treatments by Fede Galizia and Sirani, where the heroine looks away from the dire remains, leaving it to the maid for disposal. In Gentileschi's versions, Judith and the maid are mutual collaborators. She gives her Judith arms equal to the heavy task, and indeed, in all of Gentileschi's female figures their strength of character is molded in their arms and hands.

The connections between eros and violent death intrigued Renaissance and Baroque painters, but due to the Council of Trent's edict against "licentious nudes," the topic had to be veiled in biblical or historical associations. Thus Artemisia painted a Cleopatra, a Lucretia, a Mary Magdalene, as did Sirani. Both knew the work of Guido Reni, whose own paintings of Lucretia and Cleopatra have been described as allegories of the education of the soul to suffer beautifully.[24] Maybe. But holy ecstasy and secular ecstasy begin to look quite alike and a certain sadomasochism can be felt in the martyrs for love, or for love of God.

However, painting was the real passion in Artemisia's life, and indeed she allegorically portrays herself as *La Pittura,* the art of paint-

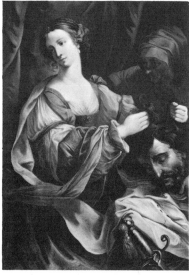

Fig. III, 16 ELISABETTA SIRANI. *Judith with the Head of Holofernes.*

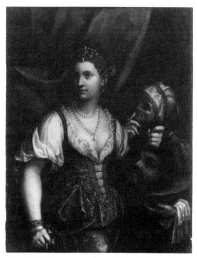

Fig. III, 17 FEDE GALIZIA. *Judith with Head of Holofernes.* 1596.

The Fifteenth through Seventeenth Centuries **29**

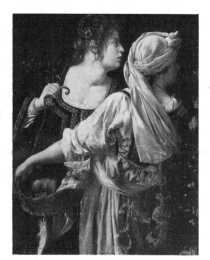

Fig. III, 18 ARTEMISIA GENTILESCHI. *Judith.*

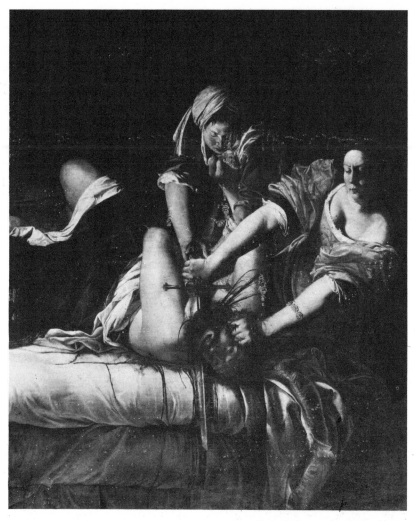

Fig. III, 19 ARTEMISIA GENTILESCHI. *Judith.*

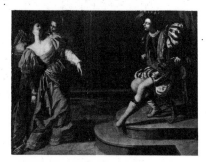

Fig. III, 20 ARTEMISIA GENTILESCHI. *Esther and Ahasuerus.*

ing. (Fig. III, 21) In this energetic self-portrait, Artemisia Gentileschi claims for herself the strength and determination she attributed to her women models. Her confidence in her stature was justified.

SPAIN: DE AYALA AND ROLDÁN

There must be much to be rediscovered about women artists in Spain and Portugal during this prosperous period in their history, when "every city in the south of Spain seemed to be able to boast of a female artist."[25] The little information we do have shows significant parallels with the Italian histories.

There were numerous nuns involved in making art for their convents, such as Teresa del Niño Jesus, who entered the cloister at the age of eight and while there sculpted and painted works about which we have only heard. Diego Velázquez had ladies of high rank as painting students. There were some artists who, like Sofonisba,

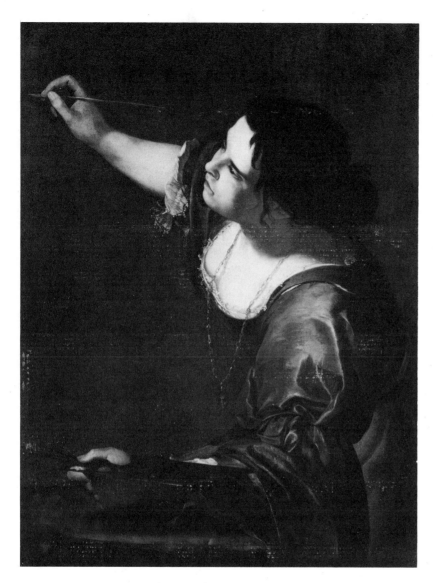

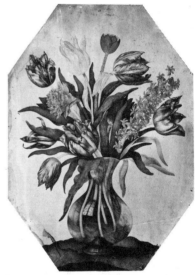

Fig. III, 21 ARTEMISIA GENTILESCHI. *La Pittura*, an allegorical self-portrait.

Fig. III, 22 GIOVANNA GARZONI (1660–1670). *A Vase of Flowers*. Often mislisted as Giovanni, she bequeathed her considerable property to the Academy of St. Luke in Rome, where there is a monument to her.

emerged from humanist families (Maria de Abarca, for example), and others, who, like Sirani, showed great promise and then died young (Donna Velasco, for example, sister of the painter and art historian).[26] Josefa de Ayala (1630–1684) learned her craft from her father and later lived in Portugal doing still lifes, portraits, and religious works like *The Mystical Marriage of St. Catherine.* (Fig. III, 23)

Another treatment of the popular theme of St. Catherine is provided by Luisa Roldán (1656–1704), an official court sculptor to Charles II. (Fig. III, 24) Another "reversal" story is told about her father, her early teacher, who had one of his sculptures rejected and came home all *cabisbajo* (with his head down). Luisa with a few touches in-

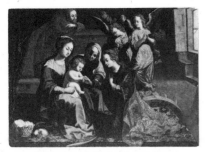

Fig. III, 23 JOSEFA DE AYALA. *The Mystical Marriage of St. Catherine.* 1647. A pious spinster, known for her devotional works and still lifes.

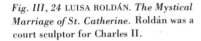

Fig. III, 24 LUISA ROLDÁN. *The Mystical Marriage of St. Catherine.* Roldán was a court sculptor for Charles II.

vested the work with an entirely different feeling, after which it was accepted by the church committee.[27]

She and her older sister María, as well as two brothers, helped in the family workshop that their father, the sculptor Pedro Roldán, established. Another sister, Francisca, was trained as a painter of sculpture.[28]

Later her husband and at least one son helped in her workshop, but it was Luisa who got the commissions, who petitioned to the royal patrons for money and lodgings, as she was "poor and without a house for herself and her children." Beatrice Proske, in the series of articles here cited, gives a wonderful sense of Luisa Roldán's difficult and industrious life and of her large repertory of baroque terracotta and wood works, several of which are housed at the Hispanic Society of America in New York.

An account of the effect of Roldán's work on a contemporary artist emerges in Cindy Nemser's *Art Talk.* Audrey Flack is describing her travels in Europe:

When we arrived in Seville I saw this polychromed, life-sized, wooden statue of the *Macarena*. It's a great work of art; the carving on the face, the patina, the pink cheeks are utterly beautiful. I went around asking who did this statue and when I found out it was done in the seventeenth century, by a woman, Louisa Roldán, you can imagine how I felt.[29]

FRANCE: DE COURT, STELLA, MOILLON, AND CHÉRON

In France there were promising signs of feminist activity. For example, Marie le Jars de Gournay, as well as being the editor of Montaigne's essays, became a spokeswoman for modern feminism. Like Christine de Pisan, she supported

her family by her writing, but unlike her, she did not idealize the role of women. In fact, she enjoins her reader thus:

Happy are you, Reader, if you do not belong to this sex to whom all good is forbidden, since to us liberty is proscribed . . . so that the sole joy and sovereign virtue allowed us is to be ignorant, to play the dullard, and to serve.[30]

Some women escaped this fate. Jaquette de Mombron, widowed sister-in-law of Seigneur de Brantôme, did much of the architectural planning, sculpture, and painting in her family chateau. Suzanne de Court (c. 1600) learned the difficult art of enameling from her father and was successful in her own right. Numerous pieces from "the workshop of Suzanne de Court" are treasured in Renaissance collections. (Fig. III, 25)

The Stella family provide another example of Renaissance enterprise. Coming originally from the Netherlands, they set up shop as engravers in seventeenth-century France. Engravings were the medium in which art students saw the masters, much as we experience them today through photographic reproductions.[31] As was the practice in many of these businesslike workshops, the women of the family were also trained, and Jacques Stella's nieces, Claudine and Antoinette Bouzonnet Stella, did many fine works, one of which, a charmingly domestic scene, is reproduced here. (Fig. III, 26)

Louise Moillon (1615–1675) was from a Protestant painting family, and records have been found of a financial arrangement she made with her stepfather to share alike in the money earned by her still-life painting.[32] They would both have been delighted to know that one of her paintings recently sold for

Fig. III, 25 SUZANNE DE COURT. *The Annunciation.* c. 1600. Enamelwork.

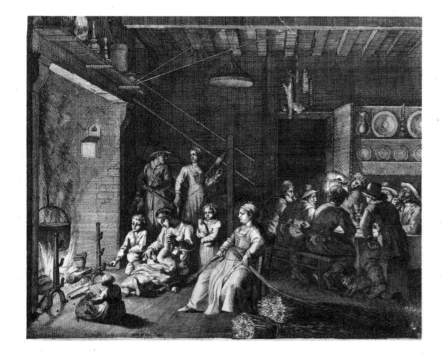

Fig. III, 26 CLAUDINE STELLA. *Pastoral no. 16.* One of the few depictions of diaper changing in art!

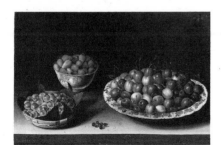

Fig. III, 27 LOUISE MOILLON. *Still Life with Cherries, Strawberries, and Gooseberries.* 1630.

Fig. III, 28 SOPHIE CHÉRON. *Self-portrait.* 1672. She was admitted to the French Academy with this reception piece (now apparently in storage at Versailles).

$120,000! Her fine works (even more exquisite in color, of course) are coming into favor and fashion again. (Fig. III, 27)

In 1648 the first French Académie des Beaux Arts was founded for the express purpose of giving artists a sense of their status as differentiated from craftspeople. The Academy's attitudes toward inclusion of women in its august ranks would make a book of its own (of which more in the next chapter), but we will just mention here that Catherine Duchemin, a flower and fruit painter, who married the sculptor Girardon, was received into the Academy in 1663 as their first female member. Madeleine and Géneviève Boullogne were also members during this period, as was Sophie Chéron, who was sponsored by Charles Le Brun. A poet as well, Chéron was honored under the name of Erato by the Academy in Padua in 1699. An admirable woman by all accounts, she supported her family and educated her brother in England where he had fled due to religious persecution. (Fig. III, 28)

ENGLAND: INGLIS AND TEERLING

In Renaissance England religious, political, and economic pressures had discouraged the development of a national artistic tradition, and no one has much to say during this period about English painting "over which swept the tidal wave of imported styles," as Helen Gardner put it. Women artists from the Netherlands made a substantial contribution to art in Tudor England. The Reformation struggles caused whole families of artists to seek protection in England where Henry VIII welcomed them to his court. Katherine Maynors, Alice Carmillion, and Susanne Horenbout were just some of the portraitists working there.

Most of these women painted miniatures that were highly fashionable and worn as jewelry by lords and ladies of the court. These works can only in rare cases be securely attributed. Levina Teerling (c. 1515–1576), the eldest of the artist Simon Benings's five daughters, traveled to England at the request of Henry VIII, who paid her a higher salary than was given Holbein. She had been trained by her father as a manuscript illuminator and worked jointly with him on *The Hennessey Hours.*

Jane Seagers, a calligrapher, gave what John Bradley describes as a most beautifully written volume to Queen Elizabeth as a gift because, as she explained in her dedication, it was a work written by a virgin on the Virgin and so should be given to a virgin: "It is a thing (as it were) preordeyned of God."[33] Esther Inglis or Anglois (1571–1624) worked for a long time in Edinburgh, illustrating emblem books and other such Renaissance specialities. One of her manuscripts is in the Folger Library in Washington, D.C. She did many curious copies in imitation of printing, which show the trauma printing presses caused those artists trained as copyists. We are glad to have her wonderfully idiosyncratic self-portrait preside over this slim section, however, as most of the other artists of the time worked under the influence of such foreign painters as Hans Holbein, van Dyck, and Sir Peter Lely. (Fig. III, 29)

Mary Beale (1632–1699) was a successful portraitist, in the style of Lely. In fact, in a recent exhibition, "The Excellent Mrs. Mary Beale," the curator cited as a reason for the almost total eclipse of her reputation, "the male chauvinism of catalo-

guers and writers on art, who invariably attributed her best pictures to other male painters, notably Lely."[34] Actually Mary Beale was much in demand to paint the rich, the famous, and the clergy, in 1677 being commissioned to paint eighty-three portraits! (Fig. III, 31) Her commissions were all recorded in small notebooks by her husband; as Walpole says, "when one writes the lives of artists who in general were not very eminent, their pocket-books are as important as any part of their history."[35]

FLEMISH AND DUTCH WOMEN ARTISTS

The artist-family of the Netherlands held advantages and disadvantages for the woman artist. It secured for them respectability and good training, if not always a name and place in history. They did not have to cultivate their eccentricities or, like the women artists of Italy, be either child prodigies or scandals. Rather, they were fellow participants in the highly lucrative family business of painting.

One of the earliest examples of such family work is the elusive van Eycks. We have no actual record that Margaret van Eyck, sister of Jan and Hubert, ever existed, much less that her painting reputation "no doubt went to swell that of her brothers."[36] Indeed, there is little known of her brothers either, but many have sought to debunk the possibility that Margaret could have painted alongside them. W. J. Weale and Maurice Brockwell consider her to be a fanciful invention of earlier art historians and, in 1912, mock the efforts of the "newly founded Suffrage Societies" to restore her to her rightful reputation.[37] Certainly many unattributed early Flemish works were done at least in

Fig. III, 29 ESTHER INGLIS. *Self-portrait* from her *Ecclesiastes.* 1599.

Fig. III, 30 The daughter of Vergecius illustrated a bestiary for her father, the calligrapher, with birds, bears, fishes, all manner of strange creatures, including these houseflies. 16th c.

Fig. III, 31 MARY BEALE. *Thomas Sydenham, physician.* This 17th c. artist earned her family's livelihood painting portraits of dignitaries, while her husband saw to the buying of paints and canvases and also to domestic details.

Fig. III, 32 CLARA PEETERS. *Self-portrait with Still Life.* In this elaborate work, the artist herself in blue bodice and pink skirt is surrounded by all the traditional symbols of a *vanitas* painting—the magnifying glass, transient bubble, dice, jewels, and coins.

Fig. III, 33 CLARA PEETERS. *Still Life with Fruits and Nuts.*

Fig. III, 34 CLARA PEETERS. *Still Life with Fish.* Her fascination with light can be seen in every scale of these fish.

part by women. As in Italy, it was the custom to assign different portions of a painting to various members of the master painter's workshop. Women were active in these labors, though it is rare indeed that their names have survived.

Aside from the sisters and daughters of artists, there are traces in secular records of another group of women artists and artisans such as the following: "Johannes, illuminator et Hilla uxor ejus" or that of Gerardus Mercator, a cosmographer whose wife "had greatly assisted him in his earlier days."[38] The miniaturist Mayken Verhulst, the mother-in-law of Pieter Brueghel the Elder, was the first teacher of her grandson Jan Brueghel. Francesco Guicciardini records her as one of the most famous women painters of her time, though no signed works of hers have survived.[39] Karel van Mander in 1604 records that Anna de Smytere, the wife of the sculptor Jan de Heere and mother of Lucas de Heere,

made a picture of a windmill with every nail on the wings and a miller in it, loaded with a bag, and climbing the mill; below on the knoll of the hill were a horse and wagon and people walking. This entire picture could be covered by half an ear of wheat.[40]

But alas, no trace of her work remains today.

Clara Peeters (b.1594)

Eleanor Tufts describes how "the sparkling richness of four still lifes hanging in the Prado Museum caught my eye and made me wonder who the unfamiliar seventeenth-century painter 'Clara Peeters' might be."[41] Though her impeccable still lifes are now much admired, little is known of the life of this intriguing artist. We do know, however, that Peeters, like the van Eycks, delighted in painting reflecting surfaces, glittering coins, brass vessels, fish scales, and mirrors, and often what they reflected was

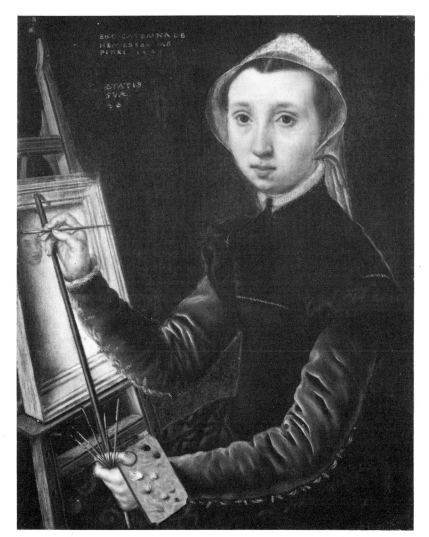

Fig. III, 35 CATHARINA VAN HEMESSEN. *Self-portrait,* "I, Caterina van Hemessen, painted myself in 1548."

Fig. III, 36 CATHARINA VAN HEMESSEN. *Portrait of a Lady,* 1551.

her own enigmatic image. (Figs. III, 32–34) The remarkable self-portrait reproduced here shows the artist surrounded by multiple reflections with true mannerist complexity.

Catharina van Hemessen (1528–c. 1587)

Catharina van Hemessen was highly regarded in her time and traveled with Queen Mary of Hungary to the Spanish court of Philip II. The daughter of Jan Sanders van Hemessen, she assisted him with many of his best known paintings. She did several large religious works, but her sensitive, quiet portraits, all clearly signed and dated, are illustrated here. (Figs. III, 35, 36) Her works give a misleadingly sombre effect in black and white reproduction; in the self-portrait, for example, her black dress is relieved by red velvet sleeves and a pink lace collar and cuffs.

Fig. III, 37 CATHARINE PEETERS. *Sea Battle*, 1657.

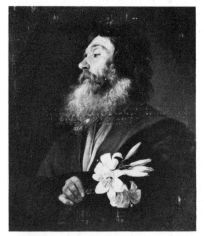

Fig. III, 38 MICHAELINA WAUTIER. *St. Joseph Holding a Lily.*

Fig. III, 39 CATHERINE YKENS. *St. Theresa and Jesus.* 1659.

Judith Leyster (1609–1660)

Thanks to the attention of feminist art historians, in 1927 and now again, the paintings of the important seventeenth-century Dutch artist Judith Leyster are finally coming into their own.[42] Attribution of her work has been confused with her contemporaries Frans Hals and Gerard van Honthorst, as well as with her husband, Jan Molenaer, a painter of low-life scenes. The *Jolly Toper* was long regarded as one of Hals's masterpieces until cleaning of the work revealed Leyster's characteristic monogram. (Figs. III, 40, 41)

Like Hals, she reveled in revels, but she also did interior genre scenes, which have considerable particularity and intimacy. *The Boy and Girl with Cat and Eel* is a lively painting, emerging perhaps from her own experience of motherhood. (Fig. III, 43) Significantly, her productivity sharply declined after her marriage in 1636. We know of only one still life, exquisite, containing a wine decanter, which reflects the artist at her easel. A more accessible self-portrait shows a cheerful mien, enormous ruff, and easel. (Fig. III, 44) Judy Chicago describes her meeting with this painting at the National Gallery of Art in Washington, D.C.: "I was deeply moved. I felt I was seeing an echo of my identity as an artist across the centuries."[43]

Judith Leyster's own identity as an artist could easily have been lost, given the confusion in seventeenth-century Dutch painting attributions; in the excitement over the rediscovery of Hals in the 1860s, there was a tendency to find him everywhere. Actually Leyster's near eclipse is a quite typical example of the misattributions that plague women artists up through the nineteenth century. While often genuine mistakes are made by art dealers and critics, sometimes they are less innocent. Paintings by women and by men as well, particularly in the sixteenth and seventeenth centuries, have been posthumously ascribed to better known (and higher priced) masters. The Baroque portraits by Aleida Wolffsen were ascribed to Nicolaes Maes or Casper Netscher *after removal of the signature*.[44] Wilenski warns:

It is probable that many pictures ascribed to the names most favoured in the international art trade were actually painted by these less successful artists whose signatures have been removed at some time by unscrupulous dealers.[45]

Maria Sibylla Merian (1647–1717)

The unique artist and naturalist Sibylla Merian published her first set of engravings when she was twenty-two. Her studies concentrated on mid-European butterflies and moths and the plants and flowers associated with them. The daughter of Mattheus Merian, owner of a publishing company, she received instruction in painting and engraving while very young. After her marriage to the painter Johann Andreas Graff she moved to Nürnberg, where she pursued her interest in all insects, particularly butterflies and moths.

The marriage was not a happy one, though Merian endured it for twenty years with the consolation of her work and her two daughters, both of whom she taught to paint. After a visit to the celebrated scholar Anna Schurman at her Labadist retreat, she declared herself a widow (somewhat prematurely). In 1699 she sailed off to the tropics

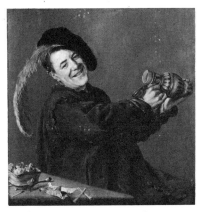

Fig. III, 40 JUDITH LEYSTER, *The Jolly Toper*. 1629. Long attributed to Frans Hals, until her characteristic signature was uncovered.

Fig. III, 41 Judith Leyster's signature— you can trace the *J, L,* and *E,* linked with a star; *Leyster* means "pole star."

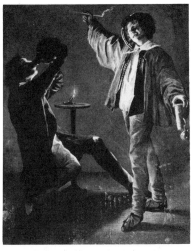

Fig. III, 42 JUDITH LEYSTER. *The Gay Cavaliers.* In this painting Leyster's monogram is on the youth's empty tankard.

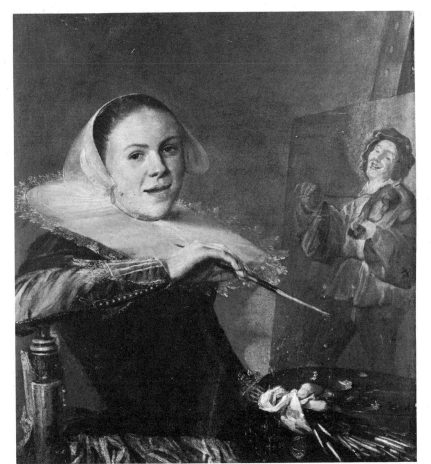

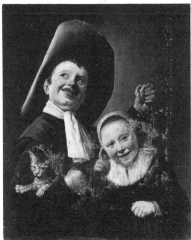

Fig. III, 43 JUDITH LEYSTER. *Boy and Girl with Cat and Eel.*

Fig. III, 44 JUDITH LEYSTER. *Self-portrait.* c. 1635.

Fig. III, 45 SIBYLLA MERIAN. *Banana Plant.*

Fig. III, 46 SIBYLLA MERIAN. *Studies from Nature.*

Fig. III, 47 SIBYLLA MERIAN. **Another of her remarkable studies.**

in quest of yet more colorful butterflies and moths. She spent two years in Surinam, where, with her daughter Dorothea for company and assistance, she worked on a theory of reproduction of butterflies, making careful drawings of each stage in their life cycle. She returned to Amsterdam and published her most famous book, *Metamorphosis Insectorum Surinamensium,* with sixty engravings (which may be found in good botanical libraries even in America).[46]

Her elegant work shows the quality of her mind. Like Leonardo da Vinci, her art was not a matter of outward splendor or of iconographic symbolism but a sign of "the sheer wish to know." "I get myself diligently to consider the source of its life," Leonardo said of his gourd study, and so Merian with her butterflies, banana plants, even pea pods.[47] (Figs. III, 45–47)

Maria van Oosterwyck
(1630–1693)

Flower painting was one of the most lucrative specialities of Dutch genre painting, and huge sums were paid by the nobility as well as the rich burghers for these ''jewels.'' We are not surprised, therefore, to learn that it was a male-dominated field. There were exceptions. Maria van Oosterwyck, for example, won international repute for her flowers, which were bought for large sums by Louis XIV, the Emperor Leopold, William and Mary, and the King of Poland.[48]

The daughter of a Protestant minister, she is said to have been courted by young Willem van Aelst, who proposed to her. After a trial period of observation, facilitated by the fact that his studio was situated near her own, she refused him on the grounds of laziness—he did not stay at his easel long enough each day to meet her exacting standards! In fact, Maria van Oosterwyck chose quite deliberately not to marry so as to be free to devote herself single-mindedly to art.

Always true to her own vision, she deviated markedly from the highly conventional compositions of her teachers, loosening the form and intensifying the light and dark effects in her paintings, which often include large, messy sunflowers. (Fig. III, 48) She further gained a reputation for nonconformity by giving her servants painting lessons, a beneficial experiment as one can see here in the work by her maid, Geertje Pieters. (Fig. III, 49)

Rachel Ruysch (1664–1750)

Rachel Ruysch, who always signed her own name to her famous flower paintings, was the daughter of a professor of anatomy and botany.[49] Her teacher was that same ''lazy'' Willem van Aelst rejected by Maria van Oosterwyck. Unlike the earlier painter, Rachel did marry (a fellow artist, the portrait painter Jurian Pool) and had ten children. She was known to spend several years on a single work and gave them as generous dowries to her daughters. She completed over 100 paintings in her long life, all exquisite, and some inhabited by snakes, lizards, and insects. (Figs. III, 50,51)

Ruysch's unparalleled mastery and invention helped to prove to many skeptics that women could be major artists—for there were still skeptics, of course, despite Anguissola, Gentileschi, Roldán, de Court, Leyster et al. In the eighteenth century, all these problems of the woman artist—such as misattributions, economic and space limitations, and entrance to the academies—will become more explicit and institutionalized and the issues increasingly familiar.

Fig. III, 48 MARIA VAN OOSTERWYCK. *Flowers and Shells.*

Fig. III, 49 GEERTJE PIETERS. *Flowers.* 1675. Contains a sunflower, too, in emulation and tribute to her teacher, Maria van Oosterwyck.

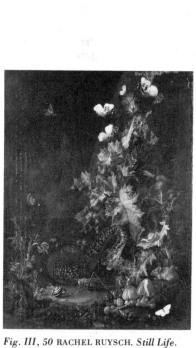

Fig. III, 50 RACHEL RUYSCH. *Still Life.*
Not all was fruits and flowers in Rachel
Ruysch's remarkable compositions!

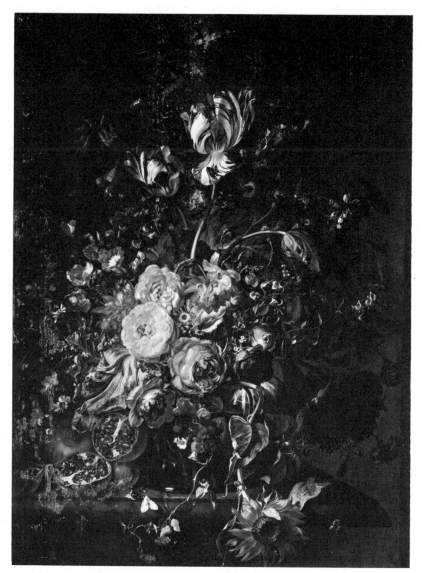

Fig. III, 51 RACHEL RUYSCH. *Fruits and Insects.*

4

The Eighteenth Century

In the eighteenth century every aspect of life became more institutionalized and codified, including the arts. The academies were founded to distinguish artists from artisans and though they provided status and support, they also tied the artist to the state. Membership in an academy, so essential to obtaining commissions, often became a political issue. Furthermore, to enhance the status of the profession and to protect their market, as in professional organizations today, the academies severely limited the number of members and accepted only a token number of women, if any.

Despite the restrictions of this complicated form of credentialing, many women artists rose to prominence, some of them as members in good standing of the academies. Though especially vulnerable to the slander and backbiting all too characteristic of the age, women artists began to be asked to teach young women art students, a significant advance. The ever-increasing secular archives document the esteem, and profits also, won by women artists. All these accomplishments brought about the predictable backlash however, and many of the attitudinal biases against women artists also became institutionalized during this period, art remaining a masculine-affiliated profession.

Indeed, the Age of Enlightenment and of Revolution marked the beginning of that double message so familiar to us now. You women can do anything you want in this brave new world of non-church-dominated equality, but you do not seem to do much.... And then, frustratingly, if a woman artist did paint well, she was complimented by being told she painted "like a man" or she was accused of having a man do the actual work. Either way, women too often did not get the credit. Lady Mary Wortley Montagu, who knew her century well, said: "I am persuaded that if there were a commonwealth of rational horses (as Dr. Swift has supposed), it would be an established maxim among them that a mare could not be taught to pace."[1]

ANGELICA KAUFFMANN (1741–1807)

We have chosen to violate strict chronology here and treat Angelica Kauffmann first in this chapter, as she exemplifies the successful eighteenth-century woman artist of international reputation. She accomplished this feat by her own hard work—she had no royal connections, married no one famous, inherited no fortune. Her pride and confidence in her accomplishments provide a model for us all. She stated in her last will and testament:

As all I possess has been attained by my work and industry, having from earliest childhood devoted myself to the study of painting, so now I can

Fig. IV, 1 ANGELICA KAUFFMANN. *Self-portrait.*

Fig. IV, 2 ANGELICA KAUFFMANN. *Portrait of Johann Joachim Winckelmann. 1764.*

dispose of the fruits of my industry as I will . . .[2]

In art histories much is made of the fact that she, along with Mary Moser (daughter of the first president of the Royal Academy of Arts in England), was made a founder of the Academy. There is, however, rarely mention of the fact that these two women were the last allowed to join until 1922. Ellen Clayton's later analysis should keep us from expecting too much of such institutions:

The Academy has studiously ignored the existence of women artists, leaving them to work in the cold shade of utter neglect. Not even once has a helping hand been extended, not once has the most trifling reward been given for highest merit and industry. Accidents made two women Academicians—the accident of circumstances and the accident of birth.[3]

And indeed, symbolically, in John Zoffany's painting *The Academicians Studying the Naked Model,* Kauffman and Mary Moser are present only in portraits on the wall, as they were forbidden by law and custom to be in the studio with a nude figure, male or female.[4]

Kauffman was always an anomaly, and one of the most persistent myths told of her early life and training was that her father had to dress her as a boy so that she could attend art school. Her life was quite remarkable enough, without the mythmaking. Angelica was born in Switzerland on October 30, 1741, yet another daughter of a painter, Joseph Johann Kauffmann. At age eleven, she painted a portrait of the Bishop of Como, who was her first patron and "professed himself highly satisfied."[5] Her mother died when Angelica was in her early teens, and she and her

father took up the life of itinerant artists, working all over Italy. In Rome, the young Angelica was befriended by the artist Raphael Mengs and his wife and met through them the art historian J. J. Winckelmann, who was important to her aesthetic development, and indeed, to the century's. Winckelmann's deep appreciation of Greek culture, his distaste for Roman imitativeness, and his emphasis upon truth and beauty in form became tenets of belief for his young disciple. Her portrait of him painted at this time shows her respect for his intellect and simplicity. (Figs. IV, 1,2)

While working in Venice, Angelica met a patron in Lady Wentworth, who took her to England, away from her father for the first time. She was twenty-four and "in full enjoyment of her powers both as a woman and an artist."[6] London society welcomed her and enjoyed gossiping about her friendship with Joshua Reynolds. The painter Johann Heinrich Fuseli fell in love with her, but Kauffmann refused him. He later criticized her idealized forms, complaining that "her heroes are all the men to whom she thought she could have submitted, though him, perhaps, she never found."[7]

She found, alas, a villain, not a hero, and the story of her abortive marriage to a confidence man, who posed as the Count de Horn, is not a pretty one. It cost her much in self-esteem as well as in money before she got rid of him, and the whole incident must have seemed a bad dream to her later in contrast to the rest of her respectable and hardworking life. Kauffmann suffered from that special vulnerability of the woman artist, unprotected by family or fortune, or by an accepted role in society; the artist knew that if her personal reputation was blemished, her clientele and commis-

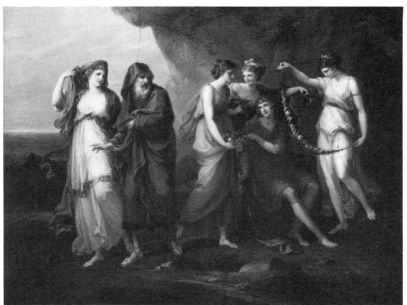

Fig. IV, 3 ANGELICA KAUFFMANN. *Telemachus Crowned by the Nymphs of Calypso.* Large-scale works such as this one were the basis of Kauffmann's fame.

Fig. IV, 4 ANGELICA KAUFFMANN. *Hebe.* Patrons were frequently portrayed in complimentary mythological roles.

sions would fall away. In a gossipy century like this one, such imputations were hard to avoid, and Jean Paul Marat, that complex figure of the Revolution, boasted all over Europe that he had seduced the fair Angelica.[8]

She eventually married a friend of her father's, Antonio Zucchi, a fellow artist. Her father died soon after their marriage, and Zucchi assumed many of his functions, from the shipping of finished canvases to the entertaining of guests in the studio. He certainly respected his wife's art and, Goethe suggests maliciously, especially appreciated the money from her many commissions. They lived in Rome and led busy, sought-after lives. Antonio Canova, Jacques Louis David, John Flaxman, all came to visit, and Goethe and Kauffmann enjoyed a close friendship while he sojourned in Rome. In 1789 when Elisabeth Vigée-Lebrun met her, the renowned French painter described Angelica as "one of the glories of our sex." Privately, however, Vigée-Lebrun remarked in a letter to Hubert Robert that while Angelica Kauffmann was very pleasant and well informed, she "did not electrify me."[9]

Angelica does not exactly electrify us either, but let us take care, as Goethe warned, to "look for what she does, not what she fails to do. How many artists would stand the test if they were judged only by their failings."[10] It has been truly said of her: "She was of the time and the time was made for her."[11] In the decorative arts, her own taste and her century's are reflected in perfect context. Many of her designs were used for Wedgewood and Meissen china, and she received important decorating commissions for the handsome houses so characteristic of this century. Her large historical and allegorical paintings were really her claim to fame, however. (Fig. IV, 3) With Benjamin West, she introduced this mode to England, and these works

Fig. IV, 5 ANGELICA KAUFFMANN. *Drawing of a Woman.*

Fig. IV, 6 MARIA COSWAY. *Self-portrait.*

were welcomed as a return to the grand manner. They were meant to be universal renderings of timeless truths via allegory, attempts to communicate high moral and spiritual values through form. However, as Samuel Johnson admitted even then, "I had rather see the portrait of a dog that I know than all the allegorical painting they can shew me in the world," and it is her exquisite portraits that we can now best appreciate.[12] (Figs. IV, 4,5)

ENGLISH FEMALE ARTISTS

Maria Cosway (1759–1838) was directly influenced and encouraged by Angelica Kauffmann. She spent her youth in Italy and showed talent in both music and art. After her father's financial ruin, she considered joining a convent but was dissuaded by Kauffmann, who sent for her from England and there introduced her to a circle of artists and patrons. She did numerous miniature portraits and was much sought after socially as well. (Fig. IV, 6) She married Richard Cosway, the reigning artist-fop at the time, who was a less than ideal helpmate. After completing two sets of etchings (inspired by William Hogarth), titled *The Progress of Female Dissipation* and *The Progress of Female Virtue,* she established a degree of artistic and personal independence and began that "life of travel" that characterized many upper-class women of the period.

While in Paris, Maria met and became lifelong friends with Thomas Jefferson. The two of them toured about together; he was to tell her of architecture and politics, while she was "to lend him her artist's eyes and help him to better appreciate the paintings, statuary, and music."[13] After the death of her daughter and husband, she returned to

Italy and established the Collegio delle Dame Inglesi, where she lived and taught for the rest of her life. As she wrote to her friend Jefferson, "Who could have imagined I should have taken up this line? It has afforded me satisfaction unfelt before. . . ."[14]

It is undoubtedly significant that Kauffmann and Cosway both received their initial artistic training abroad. In England, an aspiring young woman artist might be told to go feed the rabbits, as Virginia Woolf put it in her novel *The Voyage Out.* Fanny Reynolds, for example, had no encouragement at all from her brother, the famous Sir Joshua Reynolds, who "far from tendering her any advice [he] disliked to see her paint, and ridiculed her miniatures, which, he said, 'made other people laugh and me cry.'"[15] She must have cried a bit herself.

Another response to talent in women, almost equally fatal, was to overpraise and undertrain them and then to call their art dilettante. There are traces of this syndrome in the stories of Anne Damer, Diana Beauclerk, and Catherine Read. They did not achieve or deserve fame, but there is a lesson to be learned from their lives as there is from the success story of Angelica Kauffmann.

Anne Damer (1749–1828), when just a child (another gifted one), was rebuked by David Hume for laughing at the work of an itinerant Italian plaster modeler. He told her she could not do the like and she immediately took to the workshop and began to practice modeling in wax and terracotta. She went on to study with Giuseppe Ceracchi, who was quite charmed by her and asked her to model for his *Muse of Sculpture* (subsequently bought by her father). Modeling took time away from study—being a muse

has always gotten in the way of being an artist.

Her marriage to the wealthy John Damer was an unqualified disaster. After nine years of gambling and drinking, he committed suicide in a tavern in Covent Garden, leaving Anne Damer the time and space to work on the small marble statuary that was to bring her considerable fame in her lifetime. Walpole, her close friend and supporter, extravagantly praised her *Sleeping Dogs* and compared her to Bernini and Praxiteles! He willed to her the use of his remarkable estate, Strawberry Hill. Damer continued sculpting animal pieces for a good many years, and when she died, her mallet, chisel, apron, and the ashes of her favorite dog were placed in her coffin.

Catherine Read (d.1786) and Lady Diana Beauclerk (1734–1808) lived and died less picturesquely, but they too suffered from too early and too easy praise, which may have stunted their artistic development. Beauclerk's saccharine cupids seem absurd to us, but she was at that time strongly encouraged to work in just that sentimental and facile mode. Catherine Read, now almost totally neglected, was in fact a good pastel portraitist, trained by Quentin de La Tour. In a perceptive letter to Catherine Read's brother in 1782, one of her patrons stated:

At the rate she goes on, I am truly hopeful she'll equal at least if not excel the most celebrated of her profession in Great Britain, particularly in "crayons" (pastels) for which she seems to have a great talent. Was it not for the restrictions her sex obliges her to be under, I dare safely say she would shine wonderfully in history painting, too, but as it is impossible for her to attend public academies or even design or draw from nature, she is determined to confine herself to portraits.[16]

ROSALBA CARRIERA (1675–1757)

Rosalba Carriera provided yet another model of the successful woman artist and her influence permeated the era. Catherine Read, for example, was given the accolade "the English Rosalba." Carriera was a native of Venice and began her career by working out designs for the famous *Point de Venise* lace. When the lace market diminished, she took to decorating snuffboxes. Her family, recognizing her talent, sent her to study anatomy and to learn the craft of miniature painting. One of her teachers introduced her to pastels, which were then used mainly to make preliminary sketches for oil paintings. A timely gift of fine "crayons" enabled her to experiment with this new medium and to develop a style of portraiture that suited and indeed helped to create the idealized self-image of the period. Her innovative portraits and allegories in pastel soon captured everyone's attention, and she was deluged with requests. (Fig. IV, 7) One consequence of her popularity —and of her financial need, as she supported her family—was that she was almost too prolific, her portraits becoming at times repetitious and superficial.

Despite her vogue and the fulsome flattery of her patrons, Rosalba Carriera seems to have been singularly shy and retiring in her personal life. She instructed her two younger sisters in art and one of them, Giovanna, was her constant companion and assistant, preparing materials and laying in the background and draperies of her works.

When she did accept an invita-

Fig. IV, 7 ROSALBA CARRIERA. *Spring.*

Fig. IV, 8 ROSALBA CARRIERA. *Self-portrait*. A late and haunting work.

Fig. IV, 9 GIULIA LAMA. *Young Man with a Turban.* While capable of sensitive portraits like this one, Lama was best known for her large-scale religious works.

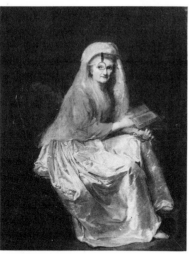

Fig. IV, 10 ANNA DOROTHEA THERBUSCH. *Self-portrait.* 1779. Bold, idiosyncratic, and, we suspect, quite characteristic.

tion to come to Paris, she took her family along. The young king Louis XV sat for her, and having gained so illustrious a client, her success was assured. She was admitted to the French Academy and feted by the reigning artists of Paris. Watteau sketched one of these gatherings, showing Rosalba with her violin.

She kept a slight and curiously untelling journal during this period. In it we get some hint of Rosalba's melancholy, of her occasional "sad days."[17] We do know that her life was darkened by eye trouble and by the death of her beloved sister. Carriera's late and almost haunted self-portrait shows another face of the eighteenth century. (Fig. IV, 8)

We know very little of other women painters in Italy at this time. The independent and creative Marianna Candidi Dionigi, (1756–1826) was accepted into the Academy of St. Luke on the basis of her oil landscapes and wrote a book entitled *The Elementary Rules of Landscape Painting.*[18] She is actually better known, however, for her work in archaeology, the new discipline that had been stimulated by the rediscovery of Herculaneum and Pompeii and that attracted some of the best minds of the eighteenth century.

A prolific painter working from about 1725 to the 1750s, Giulia Lama was praised as being "une femme qui peint mieux que Rosalba pour ce qui regarde les grandes compositions."[19] Her enormous religious works in San Vitale and in the churches of Venice and in the Camaldolese Hermitage in Padua are in the mode of early Tiepolo and her teacher Piazzetta. She, too, did a Judith and Holofernes and some horrifying martyrdom scenes of female saints; the

Uffizi has a self-portrait. Though Lama's work is impressive, it suffers from the languid neo-mannerist line of the last phases of the Baroque, which perhaps explains the lack of attention given her work in recent years. (Fig. IV, 9)

ANNA DOROTHEA THERBUSCH-LISIEWSKA (1721–1782)

The remarkable figure of Anna Dorothea Therbusch commands our attention with the bold and idiosyncratic self-portrait. (Fig. IV, 10) Therbusch apparently developed a strong ego to deal with the excessively masculine world of the Prussian court—and she was criticized as well as respected for the seriousness and professionalism of her work. She and her sisters had studied painting with their father; her husband, too, was an artist. Family responsibilities claimed much of her time and energy and it was not until 1761, when her children were grown, that she was able to accept a major commission to decorate the Hall of Mirrors in Stuttgart for the Duke of Württemberg. Soon after, she traveled to Paris, and the art establishment did not know what to make of this ambitious middle-aged woman. As Denis Diderot ironically observed:

Ce n'est pas le talent qui lui a manqué, pour faire la sensation la plus forte dans ce pays-ci, elle en avait de reste, c'est la jeunesse, c'est la beauté, c'est la modestie, c'est la coquetterie.*[20]

In France where women artists thrived—if, that is, they were beautiful and well-bred—their images as women were at least as important

*It is not talent that she lacks in order to make a big sensation in this country; she has plenty of that. It is youth, it is beauty, it is modesty, it is coquetry.

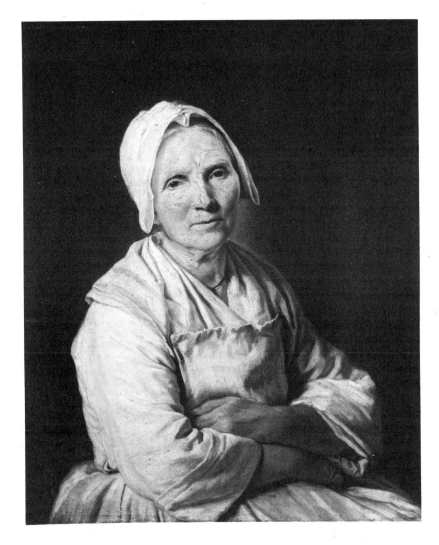

Fig. IV, 11 FRANÇOISE DUPARC (1705–1778). *The Old Woman*. Like Chardin, this fine painter worked in isolation, choosing as her subjects these classic peasant faces.

as their work as artists. They had to cultivate a curious sort of coquetry: they had to be bad enough to be titillating but virtuous enough not to be threatening. That this delicate balance was achieved by so many women at this time is a tribute to their tact and ambition.

ELISABETH VIGÉE-LEBRUN (1755–1842)

And their prototype is Elisabeth Vigée-Lebrun, whose life and work are fortunately well documented. (Fig. IV, 13) Because she wrote her memoirs, we know more about her than about any other woman painter of this period. As we have come to expect, Elisabeth was the daughter of an artist, Louis Vigée, a portraitist in the style of Watteau, and it is no doubt due to his encouragement that she developed her talents. She remembered playing with her father's pastels and drawing on the walls of the convent where she went to school. She began to study

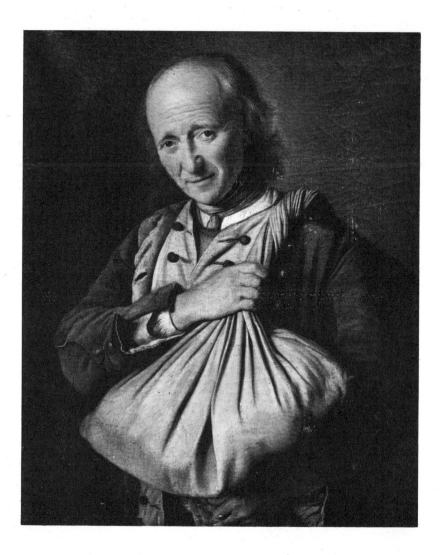

Fig. IV, 12 FRANÇOISE DUPARC. *Man with a Sack*. This lively looking fellow supposedly lived to be 122 years old! There are four paintings by Duparc in the Musee des beaux arts at Marseilles, all we now know of her work.

at the age of eleven under Davesne, along with her childhood friend, Anne Bocquet Filleul. (Anne was later dissuaded by her husband from continuing her work, which Vigée-Lebrun thought a great loss.) Elisabeth's studies were given purpose by the early death of her much beloved father and her melancholy and confusion turned into the resolution to be a serious painter. Her art became the main financial support of her family. Her mother's remarriage did little to alleviate the situation as her stepfather, recognizing the young artist's earning potential, insisted she turn her fees over to him. She soon gave in to her mother's pressure and married M. Lebrun, an art dealer and neighbor of hers:

I was then twenty years old and leading a life free from any anxiety as to my future, for I was earning a good deal of money and felt no desire whatever to get married. But my mother, who thought M. Lebrun to be very rich, unceasingly urged me not to re-

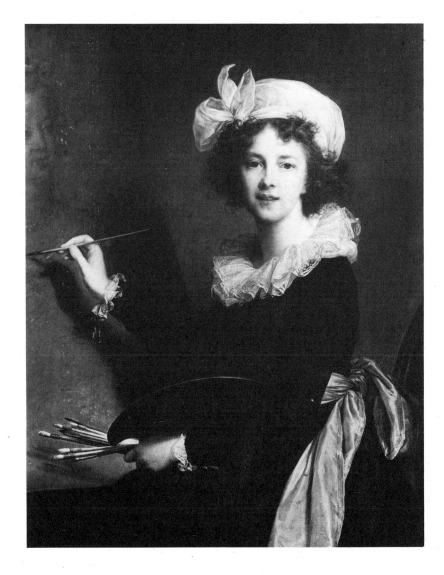

Fig. IV, 13 ELISABETH VIGÉE-LEBRUN.
Self-portrait.

fuse such a profitable match, and at last I consented to the marriage, desiring above all to escape from the torment of living with my stepfather. So small, however, was my enthusiasm to give up my freedom, that on the way to the church I kept saying to myself: "Shall I say yes? Shall I say no?" Alas, I said "yes" and changed my old troubles for new ones.[21]

While M. Lebrun was, by his wife's own accounts, likable enough, he had her stepfather's avarice and the eighteenth century's passion for gambling. His extravagant habits absorbed every spare franc from her portrait commissions. (In what was, perhaps, an excess of responsibility, she continued to send him money from abroad during her years of exile.)

Neither marriage nor maternity inhibited Vigée-Lebrun's work. The artist took her pregnancy lightly.

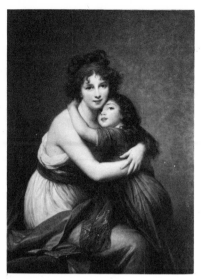

Fig. IV, 14 ELISABETH VIGÉE-LEBRUN. *Mme. Vigée-Lebrun and Her Daughter.* This rendering, along with Morisot's *Cradle* (Fig. V, 62), satisfies popular conceptions of what women's art should be.

Fig. IV, 15 MARIE VICTOIRE LEMOINE. *Mme. Vigée-Lebrun and Her Pupil, Mlle. LeMoine.* Lebrun and her so-called rival Labille-Guiard were both important teachers and models to women art students in prerevolutionary France (*see* Fig. IV, 25).

I failed in foresight owing to my extreme affection for my art, for in spite of my happiness at the idea of becoming a mother, I let the nine months of my labour go by without giving the least thought to the preparation of the things necessary to child-birth. On the day my daughter was born I did not quit my atelier, and continued working at my *Venus Tying the Wings of Love*, in the intervals between the throes. . . .

Mme. de Verdun, my oldest friend, came to see me in the morning. She realized that I would be brought to bed during the day, and as she knew me, she asked me whether I was provided with all that was necessary; to which I replied, with a look of astonishment, that I didn't know at all what was necessary. "That's just like you," she said, "you are a real boy. I warn you that you will be brought to bed this evening."—"No, no!" I exclaimed, "I have a sitting to-morrow. I will not go to bed today." [22]

She did go to bed, and her daughter, Julie, was born that night. One of the several charming pictures she made of herself with her child is here reproduced. (Fig. IV, 14) Looking at it, one does wonder how much time each day Vigée-Lebrun actually spent with her. A perhaps more characteristic scene, painted by her student Marie Victoire Lemoine, shows her in her studio. (Fig. IV, 15)

Vigée-Lebrun's name and art are closely linked with the Queen, and the last and most remarkable of her royal portraits is shown here, Marie Antoinette in a splendid red dress, her children ranged around her. (Fig. IV, 16) It was intended as an historical statement on the vitality and health of the royal family. There are poignant elements in it, as the young dauphin is shown pointing to the empty cradle, a reminder of the youngest child's death, and the young dauphin himself died soon thereafter. Marie Antoinette had the painting stored, as it was too painful for her to look at, and thus it escaped destruction in the Revolution. Already criticized for its size and extravagance, Vigée-Lebrun tells us that when the large canvas was brought into the palace, she heard angry voices muttering, "Voilá la déficite!"

Like so many women artists (especially successful ones) of the eighteenth century, she was the victim of endless speculation about her private life, her court connections, and her merit as an artist. This gossip centered around her much frequented salon. Vigée-Lebrun herself brags that frequently there were so many guests, "the marshals of France had to sit on the floor" and the particularly fat ones had some difficulty getting up again—rather *bohème* for the *Ancien Régime!* She asserts proudly that politics were never discussed there; musical evenings, witty conversations, and elaborate costume parties were arranged to delight her guests, and to fulfill her own picturesque fantasies. (Fig. IV, 17)

She closes one of her letters, which was devoted to rescuing her oft-maligned reputation, with the wise observation:

This is truly a sad letter, fit to turn one with disgust from celebrity, especially if one has the misfortune to be a woman. Somebody said to me one day: "When I look at you and think of your fame, I seem to see rays about your head."—"Ah!" I replied with a sigh, "There may well be a few little serpents among them." And really, has one ever known a great reputation, in whatever matter, that failed to arouse envy? [23]

Vigée-Lebrun was finally admitted to the Academy on May 31, 1783, despite the familiar accusation that

Fig. IV, 16 ELISABETH VIGÉE-LEBRUN. *Marie Antoinette and Her Children.* 1787. "Voila la déficite!"

she had not done her own work.

It is only too true that since I made my appearance in the world I have been a prey to malevolence and stupidity. One tale was that my works were not done by myself; M. Ménageot painted my pictures and even my portraits, although so many people could naturally bear witness to the contrary; this absurd report did not cease till I had been received at the Royal Academy of Painting.[24]

Totally devoted to the royal family, Vigée-Lebrun gave little thought to the rumblings of change around her. Due to her association with the queen, the artist was forced to flee Paris on the eve of the Revolution.[25] She spent the next twelve years in exile in those royal refuges remaining. Wherever she went, she was greeted as a celebrity, made a member of the local Academy, and given dozens of portrait commissions.

Vigée-Lebrun completed 660 portraits in her lifetime—a prodigious feat.[26] (Figs. IV, 18,19) The uni-

Fig. IV, 17 ELISABETH VIGÉE-LEBRUN. *Bacchante.* 1785. Treading the narrow line between allegory and portraiture, this work is a good example of Vigée-Lebrun's inimitable naughty but nice style.

Fig. IV, 18 ELISABETH VIGÉE-LEBRUN. *Madame Molé-Raymond.* This painting of an actress reflects Lebrun's delight in costume and texture.

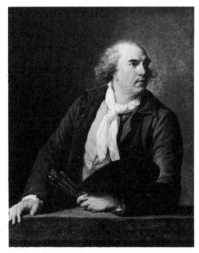

Fig. IV, 19 ELISABETH VIGÉE-LEBRUN. *Hubert Robert.* The respect Lebrun felt for her friend and fellow artist, Robert, is evident in this dynamic portrait.

formly flattering and positive impression of these portraits contributed to her success, of course: no one complains about being made to look glamorous. Vigée-Lebrun, however, did encourage informal attire for her sitters and a greater degree of intimacy and spontaneity.

Returning finally to France under Napoleon Bonaparte, she lived out her long life painting and entertaining the survivors of the Revolution. In one of her letters to the Princess Kourakin she recalled that a gentleman had drawn her horoscope one evening at a party:

He foretold I should live a long while and become a lovable old woman, because I was not coquettish. Now that I have lived a long while, am I a lovable old woman? I doubt it.[27]

ADÉLAÏDE LABILLE-GUIARD (1749–1803)

Adélaïde Labille de Vertus Guiard/ Vincent, although as distinguished a painter as Vigée-Lebrun, is much

less well known, partly because she did not leave us a diary, but mainly because Vigée-Lebrun outlived her by many years. Labille-Guiard's name changes may also have confused encyclopedists. Her case draws attention to a crucial factor in the recording of women's work; we find women listed under their fathers' names sometimes, sometimes under their husbands', and then, most often, not at all. If you are missing one or the other of these names, if a woman marries more than once, if her name happens to be similar to a contemporary male painter, then the chances are low indeed of accurate recording of her work.

Fortunately, the Baron Roger Portalis was concerned that the excessive attention directed at *la séduisante* Vigée-Lebrun had obscured the reputation of Labille-Guiard. He wrote four long articles for the *Gazette des Beaux Arts,* which include much contemporary material and quotations from Lebreton's necrology on the artist.[28] The story that emerges duplicates in many telling ways the lives of Angelica Kauffmann and Vigée-Lebrun, indicating a pattern of special pressures on women artists, even in the Age of Enlightenment.

Labille-Guiard early learned self-reliance. She was the last of six children born to a merchant family, and we are told that her mother was in ill health and her father negligent of her education. She was, however, always fortunate in her art teachers and learned pastels from Quentin de La Tour, who encouraged her growing sense of vocation. Wanting to extend her scope to oils, she found another teacher living in the neighborhood, François Élie Vincent, a Geneva protestant, who turned out to be an ideal master for her. Augustin Pajou, the sculptor,

was a friend of the family and did a bust of her father, which can be seen in the background of the self-portrait with her pupils Mlles. Capet and Carreaux de Rosemond. Labille-Guiard then did a painting of Pajou sculpting the bust of his teacher Lemoine, which became her reception piece at the Academy. In charming homage to her own teacher, Mlle. Capet then does a painting in imitation of this work. (Figs. IV, 20,21)

Labille-Guiard apparently felt the need to establish a home of her own, and so married Louis-Nicolas Guiard. There was, as Portalis says delicately, never much cohabitation and during the Revolution, she obtained a divorce (as did nearly everyone in Paris). She immediately married her teacher's son, François André Vincent, a painter also, as you can see from his wife's fine portrait of him. (Fig. IV, 22) Before their marriage, their relationship had been a subject of gossip, and an odious pamphlet was circulated, which accused Labille-Guiard of sleeping with him and, even worse, of getting him to work on her paintings. She was enraged by this double insult and called on all her influential friends to stop the distribution of the pamphlet.

Labille-Guiard and other women of her generation demanded recognition in their own right, but the better they painted the more doubts they raised among the misogynist academicians. Labille-Guiard was a virtuoso painter, as her portrait of the Duchess of Parma illustrates. (Fig. IV, 23) Because her work is strong and sure and professional and large, critic after critic echoes the early statement about her, *"Mais c'est un homme que cette femme-lá!"* (But what a man that woman is!)[29] Though this sort of compliment does not do women

Fig. IV, 20 ADÉLAÏDE LABILLE-GUIARD. *Pajou, Sculpting the Bust of M. Lemoine.* 1782.

Fig. IV, 21 MARIE GABRIELLE CAPET. *Portrait of Houdon Modelling the Head of Voltaire.* This work, done in imitation of her teacher Mme. Labille-Guiard, was stolen in 1935 from the museum at Caen and its present location is unknown.

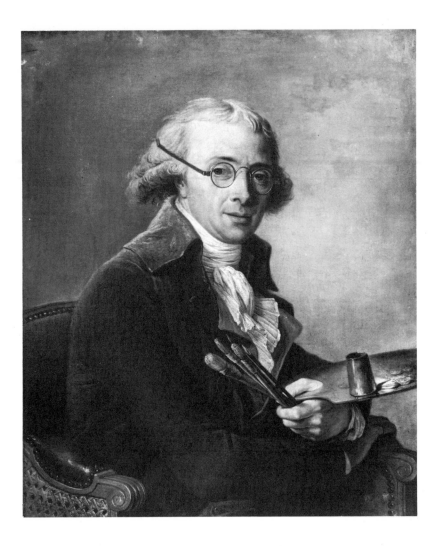

Fig. IV, 22 ADÉLAÏDE LABILLE-GUIARD. *André Vincent.* 1795. Second husband of the artist.

much honor, it is preferable to the charge often made that a man (teacher, father, or lover) has actually done the work. The classic case was that of Margareta Havermann, who had been a student of Jan van Huysum in Holland. When her painting began to rival his, he became jealous and refused to go on working with her. She came to Paris in 1720, sent to the Academy a flower and fruit still life, and was accepted as an *académicienne.* (Fig. IV, 24) Some doubt arose as to the authenticity of her work, which was of an excellence thought to be unique to van Huysum. Havermann's name was stricken from the rolls, and because of this scandal, it was declared that no more women would ever be accepted into the Academy. Indeed, none were admitted for some thirty years, and then only under tremendous pressure.

Labille-Guiard dealt with the same charge some fifty years later by inviting each member of the

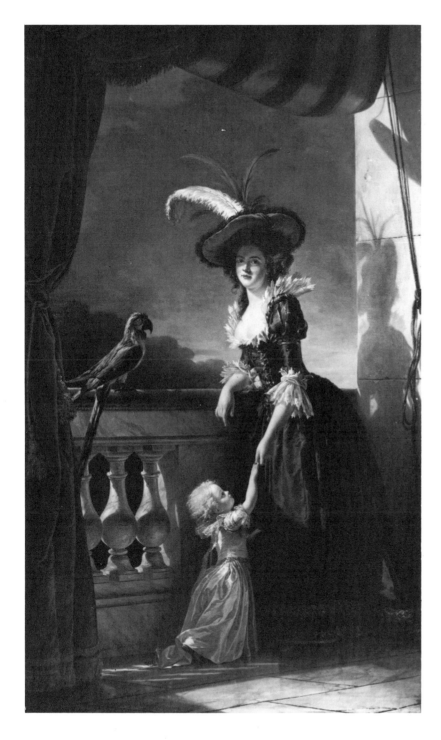

Fig. IV, 23 ADÉLAÏDE LABILLE-GUIARD.
Louise Elisabeth de France. 1788. A
posthumous portrait.

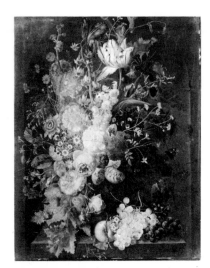

Fig. IV, 24 MARGARETA HAVERMANN. *A Vase of Flowers.* 1716. A fine work by a much maligned artist.

Academy jury to her studio where she painted their portraits, before their very eyes. She was finally accepted into the Academy on the same day as Vigée-Lebrun, and though Vigée-Lebrun was said to have used her connections with the royal family to get in, Labille entered "by the front door," as she bragged. Perhaps this incident was the origin of the alleged rivalry between the two painters. It is hard to tell whether this conflict was contrived by critics, or whether it was a real and mutual competitiveness. Perhaps they had internalized the lesson that only a few places are allowed to women, and indeed in the French Academy of Painting at this period that was literally the rule: four was the maximum number of women members allowed at any one time. Labille-Guiard argued against this arbitrary quota in the debates on reforms during the Revolution; the minutes of the Academy meeting of 1790 record that "*elle a beaucoup parlé.*" Apparently, she spoke to good effect, as it was moved, seconded, and passed to do away with the limit of four; another motion of hers to allow women professors in the art school was also passed, though over opposition, of course.

Labille-Guiard's own deep involvement in the teaching of women students can be seen in this painting she did of herself with two of her students, which was a sensation at the Salon of 1785. (Fig. IV, 25) In 1783, nine students of hers showed their works as a group. Soon designated as the "Nine Muses," they received a good deal of critical attention, much of it like this: "Such an art is pernicious for females, makes them lose a precious *pudeur* (modesty or purity), their most beautiful ornament, and draws them almost always into libertinage."[30] With such attitudes it was difficult to persuade parents to allow their daughters to study art. Out of her concern for students without parental support or other private means, Labille-Guiard had devised a plan for state-subsidized art education for women, which she presented to Talleyrand. Though in the general chaos of the Revolution he never acted on her plan, he did publically commend her as an artist and as a teacher.

Labille-Guiard, now Vincent, painted the members of the Revolutionary government, as she had the sisters of the King: sympathetically, ornamentally, and professionally. For her personally, the worst trauma of the Revolution was the destruction of a vast painting she had almost completed called *The Chevalier Receiving the Order of Saint-Louis,* which she said was going to make all that she produced until then seem merely prelude. This loss was one of the great reverses of her life, but she continued to work until 1803, when she died after sixty-six days of a "cruel malady." The estate sale of her works brought derisory amounts, and the neglect of this great artist since then is also hard to understand. One is bound to suspect that her progressive politics, her feminism, and her uncompromising lifestyle violated and still violates the tolerated view of female professional behavior. It is to be hoped that Anne-Marie Passez's excellent biography and catalog will bring about a reevaluation of Labille-Guiard's importance to the eighteenth century.

ANNE VALLAYER-COSTER (1744–1818)

A quieter life story, the little we know of it, is told of Anne Vallayer-

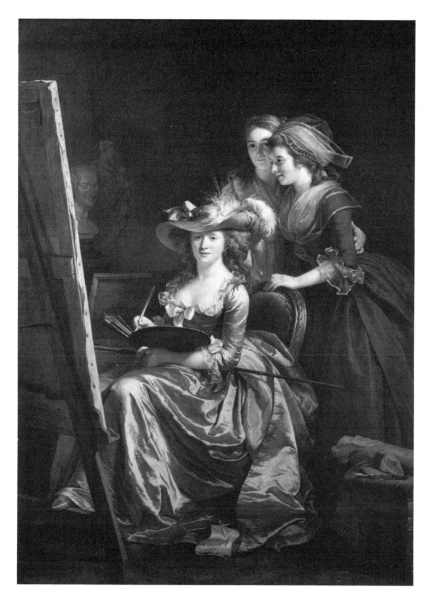

Coster, one of the few other women "allowed in the Academy."[31] Anne Vallayer worked hard, and by 1781, when she married Coster, a lawyer, her marriage contract showed her to be quite wealthy. Charles Sterling calls her, "after Chardin and Oudry, the best French still-life painter of the eighteenth century."[32] (Figs. IV, 26,27)

The Queen arranged lodgings for her at the Louvre, which was a great honor, and Vallayer-Coster demonstrated her loyalty by smuggling some documents for the Queen, thus making it necessary for her to go to the country for a few years during the "troubles." Although she was not particularly political, she, along with 250 other art-

Fig. IV, 28 MARIE-ANNE COLLOT. *Lady Cathcart.*

Fig. IV, 29 MARIE-ANNE COLLOT. *Falconet.*

ists and scholars, signed a petition to take Vigée-Lebrun off the list of émigrés. As her biographer tells us, once received at the Academy Vallayer-Coster continued "to stay discretely in her corner, painting indefatigably away," and in all her nineteen years of membership, the minutes show only six mentions of her name.[33] Perhaps this low profile is responsible for the dearth of biographical detail. Her works, too, reveal more of the aesthetics of her time than they do of the personality of the artist, and thus they have been frequently misattributed and lost. Fortunately Marianne Roland-Michel's handsome catalog has done much to return Vallayer-Coster to visibility.

MARIE-ANNE COLLOT (1748–1821)

The name of Marie-Anne Collot, one of the few women sculptors of this period, is almost unknown today, though she worked on one of the most famous pieces of sculpture in the eighteenth century: the equestrian statue of Peter the Great in Leningrad. She was Étienne Maurice Falconet's best pupil and, by his own admission, more skilled than he at doing portrait busts. In 1766, when Falconet received the commission to do a monument to Peter the Great, Marie-Anne accompanied him as his assistant. They remained in Russia for sixteen years, during which time she helped Falconet with the very difficult statue, modeling the heroic head of the czar.[34] While there, she completed a great many portrait busts for members of the court of Catherine II. (Figs. IV, 28,29)

It is difficult to decipher the complexities of Collot's biography and of her relationship with Falconet. We know that while in Russia she

married Falconet's son. He was a painter, who soon left to study with Reynolds in England. When she joined him, she found herself in a hostile and unappreciative environment and left to seek refuge with the elder Falconet in The Hague. He soon after suffered a paralytic stroke, and Collot became his nurse and companion. Traditionally interpreted as an indication of her generous and selfless nature (she was called "the consoling angel"), a different reading of Falconet's role is suggested in a recent article reevaluating Collot's work:

In Marie Collot he found an able sculptor and a person willing to bear his obstreperous nature. He no longer wished to be bothered with the unrewarding task of portrait sculpture, so he took advantage of his pupil. He encouraged her and probably helped her to some extent, especially at first, but his motives were purely selfish. That her production ceased abruptly in 1783 is further evidence of this. No longer needing her as a sculptor, he made her into his nurse and housekeeper, occupying all of her time. Levecque (Falconet's biographer) visited her and found that she had neglected her art totally since leaving Paris. She had become personally dependent upon her master and with his death she lost whatever ambition remained.[35]

SCHOOL OF DAVID REVISITED: MESDAMES BENOIST, CHARPENTIER, DAVIN-MIRVAULT

Many women artists are identified by that prestigious title *élève de David,* a claim often entered later by families of the artists or the sitters, or by owners and dealers in their paintings. Marie-Guilhelmine Benoist (1768–1826) was actually a student of Vigée-Lebrun and of Labille-Guiard. Mme. Benoist (then de

Laville-Leroux) and several other students did work in Jacques Louis David's school as a temporary arrangement while Vigée-Lebrun's atelier was being remodeled.[36] This is the only recorded connection between David and Benoist, and yet if she is mentioned at all, it is either as his painting student or as the prototype for Émilie in Dumoustier's *Lettres*—such is the astigmatism of history.

Her splendid portrait *La Négresse* is used as an example by Charles Sterling of how "one is constantly coming across remarkable pictures of this period which cannot be assigned to any of the principal artists."[37] (Fig. IV, 32) Such a painting does not emerge fortuitously from the dilettante's brush but must be part of a larger body of work than we now know by this artist.

Very few works can be securely attributed to Mme. Constance Marie Charpentier (1767–1841), née Blondelu, and yet this artist received a gold medal for her work and exhibited in ten Salons with more than thirty genre scenes and portraits. Today most of these paintings are not identified as her work, "either because they are hidden in private collections or because they mistakenly bear the name of better known painters. . . ."[38] A family tradition that the portrait of Mlle. du Val D'Ognes was by the great David proved profitable to someone when a philanthropist purchased the painting in 1917 for $200,000 as "the Metropolitan's David." (Fig. IV, 33) Charles Sterling's careful study posits that it may well be by Charpentier.

The painting is tremendously appealing, an eighteenth-century Mona Lisa really, a "mysterious masterpiece" as François Poulenc called it.[39] André Maurois saw it as "a merciless portrait of an intelli-gent, homely woman against the light and bathed in shadow and mystery . . . a perfect picture, unforgettable."[40] It is not a perfect picture, but it works despite/because of its imperfections, especially in a century when everyone painted almost too well. It communicates to us over the years, as the following poem by Joanna Griffin testifies:

FOR OUR EYES

Who is she that she sees
Her eyes reveal her double vision

 one is the eye of a girl tenderly
 young and light
 sitting, in a white dress with pink
 sash, drawing,
 looking at the woman drawing her,
 harmless occupation

She sits before a broken window does
 that mean anything

 outside the broken window a man
 and woman on a terrace
 they are well dressed they are
 stock characters out of
 centuries of romance he is telling
 her words distilled
 out of those centuries he is in blue
 waistcoat and jacket
 she stands in an attitude of
 receptive grace in a long
 cream-colored gown a success they
 will join the centuries

She does not observe them.
She is looking at the mysteries of
 creation

 with that other dream shadowed
 eye
 pierces form color attitude
 clothing centuries
 I am certain she sees me and I
 begin to see
 we are unusual women, we are
 told,
 caught in our feminine mysteries
 women are not meant to see or tell
 of secrets gleaned from earth and
 sky
 the lie continues through the
 centuries

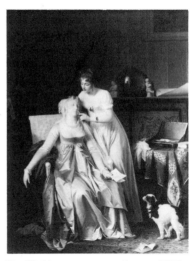

Fig. IV, 30 MARGUERITE GÉRARD. (1761–1836). *The Bad News*. Sister-in-law of Fragonard (whose wife also painted), Gerard's genre pieces were popular in her time.

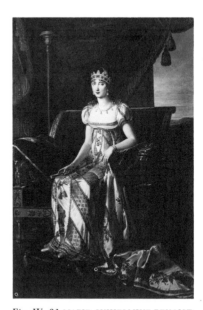

Fig. IV, 31 MARIE-GUIHELMINE BENOIST. *Pauline Bonaparte*. Benoist was famous in her day for her neoclassic portraits of Napoleon and members of his family.

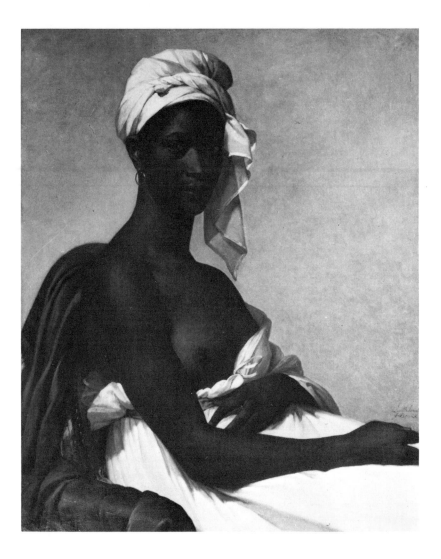

Fig. IV, 32 MARIE-GUIHELMINE BENOIST.
Portrait of a Negress. 1800. One of the
fine and few representations of a black
woman in European art.

I saw at first only her delicate
 beauty
my vision blinded to the vision in
 her eyes

Her back is turned on the centuries
Her dream is my seed
Her vision my task
 to make the centuries see her
 with such clear eyes as hers are[41]

Such creative ambivalence is not
likely to arise from David's didactic
works. And this painting really does
not resemble David's style and com-
position. The question remains:
would Poulenc and Maurois have
lingered before it, had it not been
labeled "David"? Would the Metro-
politan have purchased the paint-
ing, even for less money, had it not
been labeled "David"?

Following the examples of Gas-
ton Brière and Charles Sterling,
Georges Wildenstein has taken a
long look at a painting attributed to
David of the violinist, Bruni, at the

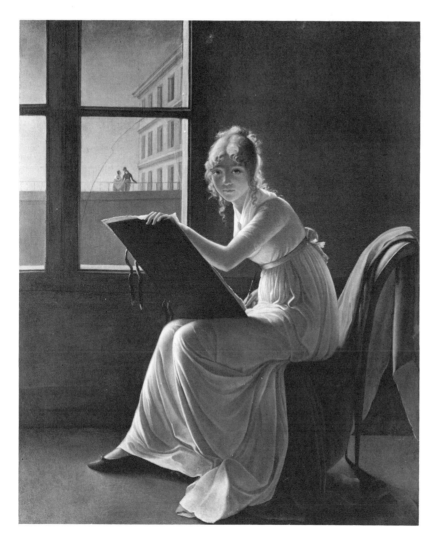

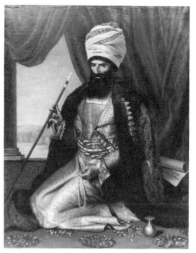

Fig. IV, 33 CONSTANCE MARIE CHARPENTIER. *Mlle. du Val d'Ognes.* "A mysterious masterpiece."

Fig. IV, 34 C. H. FLORE DAVIN-MIRVAULT. *Portrait of Asker Kan* (the Persian Ambassador). 1810.

Fig. IV, 35 ADÉLAÏDE LABILLE-GUIARD. *Portrait of Dublin-Tornelle.* This painting was one of a number incorrectly attributed to David.

Frick collection.[42] With really a minimum of detective work and consultation of Salon catalogs, he has found it to be by a Mme. Davin-Mirvault (1773–1844), listed in the catalog (though not in Délécluze) as a pupil of David. (Fig. IV, 34) The parallel names, Davin/David, undoubtedly facilitated this particular misattribution, but that cannot always have been the cause. The Fogg Museum recently reattributed a portrait of the actor Dublin to La-bille-Guiard. (Fig. IV, 35) In this case there is an actual false signature (David) and a word "badly mutilated, chipped, and overpainted," which must have been her signature.[43]

Aside from Charpentier, Benoist, and Davin-Mirvault, there are surely many other women painters whom we have not yet begun to recognize and reappraise, born out of "that strangely disguised angel," as Margaret Fuller called the Revolution.[44]

5

The Nineteenth Century

The welcome proliferation in the nineteenth century of women artists in every medium, genre, and style makes a complete survey of the nineteenth century impossible in the short compass of this book. After a brief look at early American art, we have, instead, singled out certain highly professional women whose lives and work seem emblematic of the century: Sarah Peale, portrait painter for the new Republic; Rosa Bonheur, the great French animal painter; three American sculptors working in Rome; Lilly Martin Spencer, whose genre paintings were "rays of sunshine in many a hearth and home;" and toward the end of the century, the Impressionists. They are an international lot really, from Rosa, so supremely successful in America to Mary Cassatt, thriving in France, and national divisions no longer seem appropriate. We have dwelled at some length on their individual lives as they seem basic to our own unrolling biographies, like tales told of our grandmothers' grandmothers.

EARLY AMERICAN WOMEN ARTISTS

We wanted to open this section on American art with the portrait of Elizabeth Freeman (Fig. V, 1). Mum Bett, as she was called, wore her scar as a badge of honor, having intercepted a blow directed at her sister when they were slaves. Serving dinner one night, she overheard a conversation about the Bill of Rights, and with the help of the lawyer Theodore Sedgwick, she took her master and indeed the whole institution of slavery to court. She won her landmark case around 1781 and lived until 1829, working as the much respected housekeeper to the Sedgwicks. Asked where she had gotten such an idea, she answered, "By keepin' still and mindin' things."

Fortunately, Mum Bett's portrait did get painted by one of the Sedgwick daughters, and her story did get told by another, Catherine Sedgwick, the novelist.[1] There must be many Mum Betts whose stories are lost. Often in America these local heroes and significant events are taken for granted and then forgotten. All of us should record our family and regional history. Often on lecture trips about the country, we have had the exciting experience of being shown a portrait or a landscape or a silk painting done by "great, great aunt so-and-so," accompanied by a fascinating biography and anecdotes. These are treasures to be preserved.

The Smithsonian's National Collection of Fine Arts is currently organizing an inventory of every American painting up through 1914. This effort will undoubtedly uncover many more Mum Betts. S. DeRenne Coerr, a registrar for the

Fig. V, 1 SUSAN SEDGWICK. *Mum Bett.* (Elizabeth Freeman). 1811.

San Francisco museums, is gathering information for a nationwide index of works by women in public collections.[2] In Richmond, Virginia, we were glad to meet the artist Willie Ann Wright, who researches the distinguished history of women artists in her state. In Ukiah, California, Dr. Boynton catalogs the sensitive portrayals of Indian life done by the local artist Grace Hudson. We are woefully ignorant of Canadian culture, but Elyse Eliot of Calgary is studying women artists, funded in part by the Canadian government. Mary Felstiner and her students at San Francisco State University have begun searching out portraits of indigenous and colonial women in Latin America. There must be many other such local scholars and artists whom we have not yet winkled out of this great bran pie of the Americas.

One of the difficulties for a researcher working on Colonial women artists is, of course, lack of documentary materials. To convey this helpless feeling, we cannot do better than quote Eola Willis, who describes her search for Henrietta Johnston as follows:

The quest for the history of the first woman painter in America has been beset with as many difficulties as stalking the yale, or locating the lair of the unicorn, and the results are not quite so satisfactory, for while the yale has been found in the tombs of Luxor from whence it crossed land and sea to ramp in the arms of Christ College, Cambridge, and the unicorn's unique horn was held as a verity as late as 1862 in the pages of the London Athenaeum, the only verified history of this colonial limner is the notice of her funeral in old St. Philip's Church Register, Volume I, thus: "March 9—Then was buried Henrietta Johnston—1728–9." That she died and was buried is the only record that has been handed down, but in this was carried out the unwritten law of the Carolina code—"A lady's Name should never appear in public print but twice: first to announce her marriage, and again to announce her death." As she died a maid, her history is simply "the shadow of a name."[3]

Henrietta did often sign her own name, fortunately, and we show here one of her pastel portraits. (Fig. V, 2)

The Sharpleses: Ellen (1769–1849) and Rolinda (1794–1838)

More is known of the mother and daughter, Ellen and Rolinda Sharples, because they were members of an active English painting family who did much of their work in post-Revolutionary America. Also Ellen had the good sense to keep a diary, and the Royal West of England Academy, the good sense to preserve it along with other papers of the family, so that when Katharine McCook Knox went to work on the Sharpleses, there was adequate material for a thoroughgoing study.[4] From the diary we learn that Ellen was James Sharples's third wife. Their age difference, plus certain doubts about her husband's sense of financial responsibility may have prompted these sensible remarks in her diary:

I had frequently thought that every well-educated female, particularly those who had only small fortunes, should at least have the power (even if they did not exercise it,) by the cultivation of some available talent, of obtaining the conveniences and some elegancies of life and be enabled always to preserve that respectable position in society to which they had been accustomed. . . .

The continual fluctuation of the funds and other property in which our money had been invested, the uncertainty in mechanical pursuits in

Fig. V, 2 HENRIETTA JOHNSTON. *Portrait of Thomas Moore as a Child.* c. 1725.

Fig. V, 3 ELLEN SHARPLES. *George Washington.*

Fig. V, 4 ELLEN SHARPLES. *A North American Indian.*

which Mr. S. delighted—all had an influence in deciding me, soon after our arrival in Philadelphia where Congress then assembled, to make my drawing, which had been learnt and practiced as an ornamental art for amusement, available to a useful purpose.[5]

One of Ellen Sharples's first serious works was a portrait of George Washington. (Fig. V, 3) Martha Washington, the Marquis de Lafayette, and many other dignitaries are remembered in her miniatures now at Bristol, but none of them is so dignified as her portrait of a North American Indian. (Fig. V, 4) In a country hungry for images of its heroes, with so many new buildings to decorate, public portraiture was a profitable business.

Ellen continued to develop her art in order to be "independent of the smiles or frowns of fortune."[6] Her daughter must have assimilated her mother's philosophy, as we hear that on her thirteenth birthday, Rolinda

drew the portrait of a young lady of her acquaintance in crayons, which was greatly admired for the correctness of the likeness, and which decided her becoming a professional artist. The praises bestowed on her performances, with small gold pieces in exchange, were very exhilarating and made her apply with delighted interest, improving rapidly.[7]

Praise and money, support in both senses, decided Rolinda on her profession. Her mother describes her as "always cheerful and happy, ardently engaged in various intellectual pursuits, particularly that of painting for which she had a decided taste. Exercising it as a profession, she views it as attended with every kind of advantage."[8]

Having returned to England when she was widowed, her mother, ever' solicitous of her daughter's artistic

development, took her to London to see exhibitions and set up lessons for her with various artists. In 1827 Rolinda was elected an honorary member of the Society of British Artists, and she worked day in and day out on such complex paintings as *The Trial of Colonel Brereton,* which we illustrate here along with a self-portrait of the artist and her helpful mother. (Figs. V, 5,6) Tragically, in 1838, "just as she was attaining perfection in her favorite art," Rolinda died of "that most dreadful of all diseases . . . a considerable induration in the right breast," as her mother reports with her customary forthrightness.[9]

Jane Stuart (1812–1888)

Jane Stuart did not receive from her father anything like the loving support given Rolinda Sharples. Asked why he did not instruct this youngest and most gifted of his children, Gilbert Stuart replied: "When they want to know if a puppy is of the true Newfoundland breed, they throw him into the river; if true, he will swim without being taught."[10] Miss Powel, Jane Stuart's biographer, wrote concerning this situation:

It is said that her father had kept her at work filling in his backgrounds, grinding his paints, and let drift her needed instruction in drawing. . . . Once, speaking of her father, Miss Jane owned that he had kept her too busy, when he should have been teaching her to draw, but silence to his faults.[11]

It was fortunate indeed for Stuart's family that Jane did learn to draw even without his direct encouragement, since upon his death in 1828, she assumed nearly full financial responsibility for her mother and sisters, as all the Stuart sons had died young. She promptly opened her

Fig. V, 5 ROLINDA SHARPLES. *Rolinda Sharples and Her Mother.* An early work that catches the close relationship between the two women.

own studio in Boston and proceeded to work not only on portrait commissions but also on lucrative copies of her father's works—especially the *Athenaeum Head* of George Washington. (Fig. V, 7) Copies of this portrait were done by many hands besides Jane's, though hers are acknowledged to be finest and are frequently signed. She was a prolific artist, but a studio fire in the 1850s destroyed much of her work.[12]

In her old age, Jane Stuart recorded her memories of the artists and sitters who visited their household as she grew up. One of these was a miniaturist, Sarah Goodrich, whom Stuart and his family chose as his portrait painter (Figs. V, 8,9):

My mother being very much dissatisfied with the portraits painted of Stuart, implored him to sit to Miss Goodrich, the miniature artist; and, as she was a great favorite of his, she would frequently invite her to the house, hoping he could be induced to sit to her. One afternoon he said,

Fig. V, 6 ROLINDA SHARPLES. *The Trial of Colonel Brereton.* In composing this work, Rolinda made every face a portrait of someone she knew. Colonel Brereton was courtmartialed for failing to fire upon demonstrators; this highly esteemed man committed suicide after four days in court.

Fig. V, 7 JANE STUART. *George Washington.* Jane Stuart supported her family by doing copies of her father's famous portrait.

"Goode, I intend to let you paint me." She seemed to be quite overcome at the idea, as she worshipped his genius. She then came prepared, when he gave her every advantage, considering how much he disliked what he called "having his effigy made."[13]

Aside from some instruction by Stuart and an occasional itinerant drawing master, Sarah had no formal training, and for lack of other materials, she would sometimes paint on birchbark. Works by Sarah and by her sister Eliza are located in Eliza's home, now the local historical society of Templeton, Massachusetts.

SOME WOMEN FOLK ARTISTS

Many women have contributed to that original and varied tradition of American folk art. There are theories that only here, in areas free from intervention of and competition with male artists, can there be found a continuous and developing women's aesthetic. Rachel Maines argues convincingly for taking such arts as crochet and other needlework seriously, finding in too many art historians a "cultural blindness" traceable to our deep-seated prejudice against textiles as a woman-dominated area of society.[14] One of the most striking qualities of folk art in general and women's in particular is the willingness to experiment with nontraditional media—another way of saying that if you really want to do something, you will use whatever is handy rather than languish for want of fancy paints. (Fig. V, 10)

Mary Ann Willson was, from all accounts and from the charm of her *Marimaid,* just such a natural artist. (Fig. V, 11) In 1810 she traveled with a Miss Brundage to Green County, New York, where they homesteaded together in what was then the wilderness. The historical novel *Patience and Sarah* reconstructs their life together into a wonderfully warm and touching love story.[15] Painting on the back of scraps of used paper with brilliant colors made from the juice of ber-

Fig. V, 8 JANE STUART. *Portrait of Gilbert Stuart.* Jane herself tried her hand at a portrait of her father. Note the famous Washington in the background.

Fig. V, 9 SARAH GOODRICH. *Gilbert Stuart.* One senses here that he indeed disliked "having his effigy made."

ries and native plants, Mary Ann Willson sold her works for twenty-five cents. We show several scenes from her *Prodigal Son* series. (Figs. V, 12–15)

Shaker spirit drawings, like the remarkable one shown here, were usually anonymous creations of the Shaker sisters, divinely inspired by their deceased founder, Mother Ann Lee, who fled England in 1774 with her followers to establish communities in New England.

(Fig. V, 16) The sect lived celibate lives, believed in the equality of the sexes, and eagerly awaited the Second Coming of Christ in female form.

Very little is known of the lives of most folk artists. Some, like Eunice Pinney, were well off and literate. (Fig. V, 17) Deborah Goldsmith, an itinerant portrait painter, provided us with glimpses of ordinary people of the time. (Fig. V, 18) Drawing and painting gradually became as

Fig. V, 10 PRUDENCE PUNDERSON. *The First, Second, and Last Scene of Mortality.* c. 1775. A meditation on the stages of life, worked in silk thread.

Fig. V, 11 MARY ANN WILLSON. *Marimaid.* A calico mermaid holding symbols of power.

much a part of a young girl's education as needlework. While these watercolors were rarely original compositions—usually they were copied from lithographs or composed from stencils—the delight experienced in their making often led to something truly original. (Figs. V, 19,20)

Here, as with quilts and other folk arts, we see the anticipation of ideas and forms later developed by twentieth-century artists, who frequently owe a large debt to the untrained but spontaneous eye and hand of the nineteenth-century folk artist. The original freshness of the American vision, along with the pervasive need for something beautiful to adorn a bare wood wall, animate these early works.

Currier and Ives were to build a whole business out of this impulse to decorate with seasonal or regional prints, and it is not generally recognized that many of the artists on their staff were women. Leila

Bauman's static scenes of movement are illustrated here, but it was Frances Flora Bond Palmer (1812–1876) who was most identified with the company. (Figs. V, 21–23) She worked for Currier and Ives until she died at sixty-four. Her husband, Edward Palmer, meanwhile "pursued no other trade than that of being a gentleman." In 1859 he "surprised no one by falling downstairs while intoxicated and breaking his neck."[16] Fanny Palmer, always energetic and charming, executed all sorts of American subjects, from cozy partridge families and landscapes on Long Island to the technological adventure we show here.

SARAH MIRIAM PEALE (1800–1885)

The famous "Painting Peales" identified with the European academic tradition. Indeed, Sarah's uncle, Charles Willson Peale, made a point of naming his sons Rem-

Fig. V, 12 MARY ANN WILLSON. *The Prodigal Son Taking Leave of his Father.*

Fig. V, 13 MARY ANN WILLSON. *The Prodigal Son Wasting his Substance.*

Fig. V, 14 MARY ANN WILLSON. *The Prodigal Son in Misery.*

Fig. V, 15 MARY ANN WILLSON. *The Prodigal Son Reclaiming His Father.*

Fig. V, 16 HANNAH COHOON. Spirit Drawing. 1854. "The bright silver color'd blaze streaming from the edges of each green leaf resembles so many bright torches." When Hannah asked the spirit of Mother Ann what tree this was, she answered, "The Tree of Life."

brandt Peale, Rubens Peale, etc. He obviously believed in women's artistic potential, as his daughters were as auspiciously (if cumbersomely) named Sofonisba Anguissola Peale, Rosalba Carriera Peale, Sibylla Merian Peale, etc. In a letter to his daughter Angelica Kauffmann Peale Robinson, he described some lectures he was giving in which "I have launched forth to prove that the female sex has been absurdly called 'the weaker vessel,' by which old adage much injustice has been done to the fair sex."[17]

Sarah Miriam Peale studied first with her father, James, and later with Charles Willson Peale. She was close friends with another American painting family, the Sullys, and Thomas Sully, who also encouraged his own daughters' talents, "frequently took Anna and Sarah

Fig. V, 17 EUNICE PINNEY. *Mrs. Clarke the York Magnet.* 1821. Taking her inspiration, perhaps, from David's *Mme. Recamier.*

Fig. V, 18 DEBORAH GOLDSMITH. *The Talcott Family.* 1832. Note the beautiful details of interior decoration, often also the work of women.

Fig. V, 19 BETSY LATHROP. *Venus Drawn by Doves.* A schoolgirl's romantic vision.

Fig. V, 20 SUSAN MERRETT. *Fourth of July Picnic at Weymouth Landing.* c. 1845. All of the figures are tiny paper cutouts individually painted and pasted on a watercolor background, forming an early kind of collage.

Fig. V, 21 LEILA T. BAUMAN. *Geese in Flight*. c. 1870. The American preoccupation with modes of transport is already in evidence here and in the next two illustrations.

Fig. V, 22 FRANCES FLORA BOND PALMER. *The Route to California*.

Fig. V, 23 LEILA T. BAUMAN. *U. S. Mail Boat*. c. 1860.

Peale to lectures on artistic anatomy."[18]

What launched Sarah so definitively into her career as a professional while the other Peale women remained merely assistants? We do know that she early determined never to marry, despite her manifest charms of person. (Fig. V, 24) Her uncle writes of her in her youth "as usual . . . breaking all the beaux' hearts and won't have any of them."[19] He also observed that she "didn't seem fond of painting and only worked hard when she was promised profit," which may well be the definition of a professional! Remember Rolinda Sharples's enthusiasm for the "small gold pieces" . . .

Sarah Peale could have easily slipped into the profitable but inhibiting pattern of Jane Stuart, making copies of others' works. Indeed, in a letter written when she was nineteen, Sarah complains to her cousin Titian Peale: "I have been busy for a week past finishing my picture for the Academy [sic] today I have been assisting papa with one of his which has tired me much."[20] As all secretaries and other assistants know, there is a special fatigue that comes from doing work not your own, as well as a special energy that comes from working for yourself. Sarah somehow got access to this kind of energy, whether because she did not marry, or because she was stimulated by the possibility of making her own money, or because she moved away from her father's influence, or some combination of all three of these factors. John Mahey describes Sarah Peale's special style as being a synthesis of Charles Willson Peale's insistence on good draftsmanship and her cousin Raphaelle's concern for color.

Her procedure was clear, and in the best Peale tradition. First came the drawing. From the drawing developed the design. The design was then colored in to complete the composition. Great care was taken to render with fidelity the outward appearance of things . . . the delight taken in rendering fabrics, laces, fur, bits of jewelry, eye glasses, books, and pamphlets. One comes away from a Sarah Peale portrait remembering these things, for they give the pictures life and vitality, and a visual interest essential to the success of the compositions.[21]

During her twenty-two years in Baltimore, she pursued a successful career, fulfilling numerous important commissions. (Fig. V, 25) We are showing here the posthumous portrait she did of the mayor of Baltimore and her memorable portrait of Senator Wise. (Figs. V, 26,27) The portrait of *Mrs. Denny* illustrates that special quality of most of Sarah Peale's portraits—they look like people we know, shown in their sweetest and most dignified mien, though without the degree of idealization we saw, for example, in Vigée-Lebrun's portraits. (Fig. V, 28)

Many of Sarah Peale's works have been lost or misattributed, and it is to be regretted, as John Mahey and Wilbur Hunter have pointed out, that we know so little of her mature work from the St. Louis period and later. Let us hope some of these late pieces will re-emerge. Even with what we have now, she is, as Mahey says, "in an age of severe male domination in the arts . . . surely a phenomenon to be reckoned with."[22]

ROSA BONHEUR (1822–1899)

An even more remarkable phenomenon, Rosa Bonheur, working in France, transcended male domination and nationality to become the

MISS SARAH M. PEALE,
PORTRAIT PAINTER,
HAS REMOVED HER PAINTING ROOM from the Museum in Holiday street, to No. 123, BALTIMORE STREET, over the Store of Mrs. Fosdick, jy 29 eo4t

Fig. V, 24 SARAH MIRIAM PEALE. *Notice from the Baltimore American.* July 31, 1829.

Fig. V, 25 SARAH MIRIAM PEALE. *Self-portrait.* c. 1830.

Fig. V, 26 SARAH MIRIAM PEALE. *John Montgomery*. 1830. The artist was paid $100 for this portrait.

Fig. V, 27 SARAH MIRIAM PEALE. *Henry A. Wise*. The handsome Senator Wise later became governor of Virginia.

most successful painter of the century. From her first ABC composition book, Rosa showed her love for painting animals and kept a complete menagerie in the family apartment—her favorite goat had to be carried down six flights of stairs by her brothers for an occasional airing.[23] (Figs. V, 29,30) Her father was a Saint-Simonian and thus "an enthusiastic apostle of humanity" to whom Rosa felt she owed "the great and proud ambition that I have conceived for the sex to which I gloriously belong and in which I shall maintain independence until my last day."[24] When asked why she never married, her response was, *"Que voulez vous? J'ai préféré conserver mon nom."* She loved to see the money come rolling in ("I mean to earn a good deal of the 'filthy lucre,' for it is only with that you can do what you like").[25] Toward the end of her life, she speculated that her critics

Fig. V, 28 SARAH MIRIAM PEALE. *Mrs. Denny*. c. 1835.

Fig. V, 29 ROSA BONHEUR. *Sheep.* Rosa Bonheur gave up sculpting in order not to compete with her brother Isidore. The promise of this early work and the sculptural quality of the figures in her paintings make us regret the sacrifice.

Fig. V, 30 ROSA BONHEUR. *Study of a Pig.*

could forgive her everything but being a woman.[26] She was honorary president of the Society of Women Painters and Sculptors but felt that ideally men and women should compete with one another in exhibitions and share equally in the honors. Rosa Bonheur's honors were many, and the one she valued most, the Cross of the Legion of Honor, was for the first time presented to a woman by a woman in 1864. Empress Eugénie, acting then as regent, "had wished that the last act of my regency be dedicated to showing that in my eyes genius has no sex."[27]

Bonheur's own feminism was clear enough. She smoked cigarettes and cut her hair short. (Fig. V, 31) Though she had several official costumes into which she would struggle when royalty came to call, she usually wore a simple smock and trousers, for which privilege she had to request a special permit from the police. (Fig. V, 32) She claimed the exigencies of her work in the stockyards as excuse for the practical garb, though she admitted, too, to being a great admirer of George Sand. Bonheur's personal picturesqueness and her professional success made her a target for the usual ridicule and misrepresentations, and it was not until we began to read her own lively and humorous letters that we came to see her fully as a person as well as a painter.

We have been quoting copiously from Anna Klumpke's intimate biography, written at the artist's behest and published soon after her death, but a contemporary interpretation of "The Great and Good Rosa Bonheur" is certainly called for. Rosa herself said that no man could write her biography.[28] And indeed, who can be sure even all women would understand the passion and purity

of her relationship with both Nathalie Micas and Anna Klumpke? Rosa and Nathalie had been friends since they were young girls; it was, the story goes, Nathalie's own father on his deathbed who blessed them both and told them to stay together always.[29] Nathalie's mother lived with the two women, and their letters show how much they all cherished one another. Not everyone in Rosa's family approved of the close relationship, though as Rosa points out, had she left home to get married, no one would have complained. And she forthrightly states that had she been a man, she would have married Nathalie, and "they would not have been able to invent all those dumb stories. I would have created a family, I would have had children who would have inherited from me, and no one would have had the right to protest."[30] She also puts an end to any speculation with the following succinct statement: "I am a painter. I have earned my living honestly. My private life is nobody's concern."[31]

Nathalie was an exemplary companion, and in her own right an interesting woman, as one can tell from her letters and from the anecdotes about her. One story is especially intriguing, and sad also. Nathalie invented a special express-train brake. Rosa built a testing ground for her at their chateau at Bly, and the brake worked perfectly. All were thrilled—Rosa said she could still hear the applause of the small audience assembled—but Nathalie could never get anyone to buy the design, "as the project had emerged from a feminine brain." A few years later, Rosa dryly recounts, some small changes were made in the design by an Englishman, who then sold it to the railroads for a considerable

SECRÉTARIAT
GÉNÉRAL

2ᵉ BUREAU.

N° 262.

Signalement.

Taille : m. /
Âge de ...
Cheveux ...
Sourcils ...
Front ...
Yeux ...
Nez ...
Bouche ...
Menton ...
Visage ovale
Teint ...

Signes particuliers :

Signature du porteur.

PRÉFECTURE DE POLICE.

PERMISSION

DE TRAVESTISSEMENT.

(renouvellement)

Paris, le 12 Mai 1857

NOUS, PRÉFET DE POLICE,

Vu l'ordonnance du 16 brumaire an IX (7 novembre 1800);

Vu le Certificat du Sr Cazalis, Docteur demeurant en médecine de la Faculté de Paris,

Vu en outre l'attestation du Commissaire de Police de la section du Luxembourg,

AUTORISONS la Demoiselle Rosa Bonheur, demeurant à Paris, rue d'Assas, n° 32, à s'habiller en homme, pour raison de santé, sans qu'elle puisse, sous ce travestissement, paraître aux Spectacles, Bals et autres lieux de réunion ouverts au public.

La présente autorisation n'est valable que pour six mois, à compter de ce jour.

Pour le Préfet de Police,
et par son ordre,
LE SECRÉTAIRE-GÉNÉRAL,

LE CHEF DU 2ᵉ BUREAU
DU SECRÉTARIAT GÉNÉRAL

Fig. V, 31 Photograph of Rosa Bonheur, smoking.

Fig. V, 32 Authorization for Miss Rosa Bonheur to dress herself as a man "for reasons of health" (1857).

Fig. V, 33 ANNA KLUMPKE. *Rosa Bonheur.*

sum.[32] A book should be written on unrecognized women inventors!

After Nathalie's death in 1875, Rosa went into a decline, and not until the young American painter Anna Klumpke came to visit in order to do Bonheur's portrait, did she renew interest in her chateau, her painting, and her already legend-ary life story. (Fig. V, 33) With the single-minded imperiousness of the old and famous, and of the passionate lover, Rosa Bonheur laid claim to Anna Klumpke, insisting in 1898 that she give up her own career to come live with her. She also enjoined her to write the biography that Nathalie had not lived to do

Fig. V, 34 ROSA BONHEUR. *The Horse Fair.* 1853–55. She got the idea for this work at a fair and thought of it as paralleling the famous friezes from the Parthenon.

Fig. V, 35 ROSA BONHEUR. *Buffalo Bill on Horseback.* 1889. This beguiling portrait shows the admiration Bonheur felt for Buffalo Bill (and his horse) who came to visit her in France.

and further planned that Anna be buried next to her and Nathalie. Let us hope there is no jealousy in heaven, where Rosa was convinced that she and her worshiped mother, and Nathalie and her mother, and Anna (and presumably her mother and sisters, too) would all one day be together. As she ordered inscribed on her tomb: *"L'amitié, c'est l'affection divine"* (Friendship is divine affection).

Bonheur's immortality here below is assured by such works as *The Horse Fair,* first exhibited in the Salon of 1853 and now permanently displayed at the Metropolitan Museum in New York. (Fig. V, 34) Her animal paintings in landscape retain their impact in part because of their lack of allegory, their unaffected naturalism. The international influence of this artist must have been as important to nineteenth-century women art students as Angelica Kauffmann's was in the eighteenth century. Louise

Abbema, writing in 1903, remembered that:

While still a little girl, I heard Rosa Bonheur much spoken of, and it was her talent and her fame that decided me to become an artist. I began drawing with ardour, yearning for the time when I too should be a celebrated woman painter, a prospect which seemed to me, and indeed which still seems, one of the finest attainable. [33]

And many women became ardent practitioners of this "finest attainable" art. Anna Bilinska (1858–1893), Mary Newton (1832–1866), Thérèse Schwartze (1851–1918), all "sisters of the palette" (in Rosa Bonheur's words), look out from their self-portraits, proudly identified by the tools of their trade, dressed in work clothes instead of fine feathers. [34]

AMERICAN ARTISTS ABROAD

Expatriate American sculptors, sis-

Fig. V, 37 MARY NEWTON. *Self-Portrait.*

Fig. V, 38 THERESE SCHWARTZE. *Self-portrait.*

ters of the chisel perhaps, banded together in what must have been one of the first women artists' support groups. Dubbed by Henry James "the white marmorean flock," they lived in Rome where they had access to marble and occasionally even to models.[35] Originally, most of them were born and educated in New England and were filled with the aspirations and visions of the time. Independent and adventurous, they shared feminist concerns and opposed slavery of any kind. While these sculptors received considerable attention (and numerous commissions), they were laughed at by many.

Harriet Hosmer (1830–1908)

The most eccentric and vocal of the

Fig. V, 39 Photograph of Harriet Hosmer at work on her statue of Thomas Benton.

group, Harriet Hosmer was, like Rosa Bonheur, considered rather bizarre with her masculine attire, her midnight rides through Rome, and her taste for the monumental. A contemporary biography and collection of her letters unfortunately tends to reinforce this view.[36] However, in a perceptive letter to the Reverend Phebe A. Hanaford, one of the first clergywomen in America, she describes her own admirable attitude toward such criticism:

What a country mine is for women! Here every woman has a chance, if she is bold enough to avail herself of it; and I am proud of every woman who is bold enough. I honor every woman who has strength enough to step out of the beaten path when she feels that her walk lies in another; strength enough to stand up and be laughed at if necessary. That is a bitter pill we must all swallow at the beginning; but I regard these pills as tonics quite essential to one's mental salvation. . . . But in a few years it will not be thought strange that women should be preachers and sculptors, and everyone who comes after us will have to bear fewer and fewer blows. Therefore I say, I honor all those who step boldly forward, and, in spite of ridicule and criticism, pave a broader way for the women of the next generation.[37]

And Harriet Hosmer, despite her diminutive size and naive public manner, did assume heroic proportions in the eyes of women artists.

Her unusual childhood in Boston and St. Louis accounted for much of her strength and indomitable spirit. Her mother, sister, and brothers all died early, and the anxious father, trying to preserve Harriet's health, raised her in a very unconventional manner. Instead of cosseting and repressing her, he gave her maximum exposure to physical activities and the out-of-doors.[38] He also indulged his daughter to the

point where she was healthy but incorrigible. Unable to cope with the result of his child-raising theories, he sent Harriet off to the school of Mrs. Charles Sedgewick in Lenox, Massachusetts. It was here that she had the opportunity to meet Fanny Kemble (the actress who wrote so intelligently and effectively on slavery), Nathaniel Hawthorne, and Ralph Waldo Emerson, as well as the man who was to be her principal patron, Wayman Crow of St. Louis.

Mr. Crow arranged for Harriet to attend anatomy classes at the university in St. Louis (where she is said to have carried a pistol to defend herself on her walks to and from classes), and here she began to sculpt in earnest. She also developed her mountain-climbing prowess; Mt. Hosmer in Missouri is named for her.

Later Harriet met Charlotte Cushman, the American actress, whose home abroad sheltered many women artists.[39] Cushman offered to sponsor the young woman in Rome, and Harriet's father agreed to let her go. Once there, Harriet promptly persuaded John Gibson, the foremost sculptor of the time, to take her as a student, and she soon achieved considerable renown—as a sculptor and as a wild American. Hawthorne wrote in her defense:

She was very peculiar, but she seemed to be her actual self, and nothing affected or made up; so that, for my part, I gave her full leave to wear what may suit her best, and to behave as her inner woman prompts.[40]

Hosmer's first success was *Puck,* a small marble cherub seated on a toadstool. It suited the taste of the time perfectly and made Harriet's reputation, as the replicas did her fortune. During the 1860s, she pro-

duced her major work, including the monumental statues of Zenobia and Thomas Hart Benton, three public fountains, and numerous "ideal statues." (Figs. V, 39–41)

Harriet Hosmer, like almost all of the "white marmorean flock," never married and was sustained largely through her friendships with women. She wrote:

> I am the only faithful worshiper of Celibacy, and her service becomes more fascinating the longer I remain in it. Even if so inclined, an artist has no business to marry. For a man, it may be well enough, but for a woman, on whom matrimonial duties and cares weigh more heavily, it is a moral wrong, I think, for she must neglect her profession or her family, becoming neither a good wife and mother nor a good artist. My ambition is to become the latter, so I wage eternal feud with the consolidating knot.[41]

Harriet Hosmer's unconventional way of life, her skill, and her success served as example for a whole generation of neoclassical women sculptors who considerably raised the public estimation of women. Hawthorne, again, spoke eloquently of the "moral likeness" of Louisa Lander, who modeled a bust of him and was to serve him as a model for the women artists in his novel *The Marble Faun:*

> During the sitting I talked a good deal with Miss Lander, being a little inclined to take a similar freedom with her moral likeness to that which she was taking with my physical one. There are very available points about her and her position: a young woman, living in almost perfect independence, thousands of miles from her New England home, going fearlessly about these mysterious streets, by night as well as by day; with no household ties, nor rule or law but that within her; yet acting with quietness and simplicity, and keeping, after all, within a homely line of right.[42]

Edmonia Lewis (1843–?)

Certainly one of the most enigmatic figures in this group was Mary Edmonia Lewis. (Fig. V, 42) The daughter of a black man and a

Fig. V, 40 HARRIET HOSMER. *Zenobia in Chains.* Zenobia, the defeated queen of Palmyra is treated here with all the respect and honor that the male military heroes received from male artists.

Fig. V, 41 HARRIET HOSMER. *Beatrice Cenci.*

The Nineteenth Century **81**

Fig. V, 42 **Photograph of Edmonia Lewis.**

Fig. V, 43 EDMONIA LEWIS. *Hagar.* 1875. "I have a strong sympathy for all women who have struggled and suffered."

Chippewa Indian woman, she was orphaned at the age of three and was raised by her mother's tribe near Albany, New York. Her Indian name was Wildfire, and her childhood was spent out-of-doors, fishing, swimming, wandering with her people. She did have occasional contact with white schools and made her way to Oberlin College in 1859. Oberlin had pioneered in admitting blacks of both sexes, and Edmonia found many friends and opportunities there.

Her life at Oberlin was marred by a serious and unsavory scandal. Two of her roommates, a few days after they had teased Edmonia (about what we shall never know), were stricken with stomach pains and nearly died. They accused Edmonia of poisoning them. She did not respond immediately to the charges and neither did the local authorities, largely because of sensitive racial issues. A vigilante band was formed to exact revenge, and one night, as Edmonia stepped out the door, she was dragged to a nearby field and beaten. When she recovered sufficiently to be present at a preliminary hearing, John Mercer Langston, the first black lawyer in Ohio, brilliantly defended her.[43] After two days of cross-examination, Langston asked the court to dismiss the case due to insufficient evidence. Edmonia was discharged and carried from the courtroom on the shoulders of her admirers.[44]

Edmonia left Oberlin shortly thereafter, making her way to Boston armed with a letter of introduction to the abolitionist William Lloyd Garrison, who arranged for her to study sculpture in the studio of Edward Brackett. From the beginning, her works were sensitive to personal and political issues. For example, she made a medallion of John Brown and numerous copies of a bust of Robert Gould Shaw, leader of a black regiment in the Civil War. With the proceeds, she set sail for Rome and became part of the circle of women artists around Charlotte Cushman. Her work in Rome continued to center on outcasts like *Hagar.* (Fig. V, 43) She also executed ethnic group studies such as *Forever Free, The Old Arrow Maker and His Daughter,* and *Hiawatha's Wooing,* very early attempts at finding subject matter in her own racial and sexual oppression. Her portrait bust of Abraham Lincoln shows the wish for a political hero, for a savior.

Edmonia Lewis's success seems to have lasted no more than ten years. She exhibited in the Philadelphia Exposition of 1876 and shortly thereafter dropped from sight; not even the date of her death is known.

Anne Whitney (1821–1915)

Along with Edmonia Lewis, Ann Whitney was one of the most politically aware and active sculptors of the nineteenth century.[45] Raised, like Harriet Hosmer, in Watertown, Massachusetts, she early embraced the linked causes, abolitionism and feminism, carrying on long talks with her sister about possible alternatives to marriage. Her first creative efforts were in poetry. She was an excellent reader of her own and her contemporaries' works and gave benefits for the women's hospital, which Elizabeth Blackwell was then trying to establish in Boston. One of Elizabeth Blackwell's brothers was married to the well-known feminist, Lucy Stone; the other married Antoinette Brown, the first ordained woman minister in America. The influence of these women upon Anne Whitney was a lasting one.

Her move to sculpture seems to have been prompted by an increasing need to reach a larger audience in order to communicate her powerful vision of liberation—for blacks and for women. These are the central themes of her work throughout her long and productive life. Her two earliest full-scale works were *Lady Godiva,* about to sacrifice her own pride and modesty for the sake of the oppressed villagers, and *Africa,* where a black woman waking from sleep allegorically represents the emergence from slavery.

She left for Rome in 1867, the same year as Edmonia Lewis, working there four years. Sensitive to the social issues of Italy also, she modeled *Roma* as an old beggarwoman. (Fig. V, 44) The work caused such indignation in the Papal Court that it had to be moved to Florence.

Upon Whitney's return to America in 1871, she began to work on commissions for public statuary—a realm in which many women were notably successful. After completing a marble statue of Samuel Adams for the Capitol building, Whitney entered the competition for a memorial to Charles Sumner, the abolitionist senator from Massachusetts. (Fig. V, 45) The entries were all numbered to insure fairness, and the judges chose Anne Whitney's model. However, when her identity was discovered, the commission was revoked and given to a male artist. She took this very hard indeed, but with characteristic courage wrote to her family: "Bury your grievance. It will take more than a Boston Art Committee to quench me." Indeed, twenty-seven years later, in 1902, the huge bronze statue of Sumner was placed in front of the old Harvard Law School, a monument to uni-

Fig. V, 44 ANNE WHITNEY. *Roma.* The medallions in the hem of her dress allegorically portray the decline of Rome.

Fig. V, 45 ANNE WHITNEY. *Charles Sumner.* "It will take more than a Boston Art Committee to quench me."

Fig. V, 46 VINNIE REAM HOXIE. *Lincoln.* When she received the commission to do this work, Congress objected violently. The statue now stands in the Capitol.

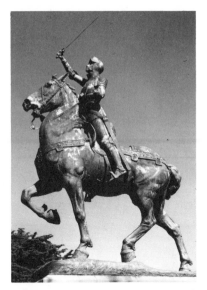

Fig. V, 47 ANNA HYATT HUNTINGTON. *Joan of Arc.* One of the inheritors of the "marmorean flock," she was known for her heroic themes, such as this one, and for her dramatic statues of wild animals. Joan's sword has been repeatedly removed by vandals; recently it was replaced by a red flag!

Fig. V, 48 MALVINA HOFFMAN. *Mother and Child of the Kalahari Bushman Tribe.* She was asked to do a series depicting the different races.

versal justice, "a justice that includes the woman sculptor."[46]

AMERICAN ARTISTS AT HOME

The effort of American women artists to gain admittance to art schools and particularly to life-drawing classes paralleled many aspects of women's struggle for equal opportunity in the nineteenth century, in honor of which we picture here two leaders of the early women's movement, Elizabeth Cady Stanton and Susan B. Anthony. (Figs. V, 49,50) In an age when anatomy was learned in medical school and women were barred from medicine, they found it difficult to master the basic elements of human figure drawing—and then were criticized for their innate inability to model the glorious male thigh![47] Those artists who could not go to Europe for study had to resort to drawing and modeling from plaster casts of Greek and Roman statuary, and even this was difficult. In 1848, for instance, the nude statuary gallery of the Pennsylvania Academy of Fine Arts was only open to women between ten and eleven on Mondays, Wednesdays, and Fridays, and in 1856 it was deemed necessary to attach "a close fitting, but inconspicuous fig leaf to the Apollo Belvedere, Laocoön, Fighting Gladiator, and other figures as are similarly in need of it."[48]

Nonetheless, women were entering art schools in increasing numbers and pressure was building to provide them with something other than a cow to model. (Fig. V, 51) Obtaining access to schools and models would give only partial victory. There remained the struggle for more women instructors, which continues to the present day. And there were those conflicts Harriet

Hosmer described in her ode to celibacy between a full commitment to art and family demands. When, as with Lilly Martin Spencer, "the hand that rocked the cradle held the brush," it was frequently at great personal cost.

Lilly Martin Spencer (1822–1902)

Who is Lilly Martin Spencer? we are often asked on our lecture tours, and the answer is given grandly by a contemporary of hers:

Let Men . . . know that with the skill of her hands and the power of her head, she sustains a family . . . Aye, sustains them a thousandfold, better than she could have done with the needle or the washtub, and gives out to the world besides, the rich treasures which become the rays of sunshine in many a heart and home. Heaven bless thee, Lilly Martin Spencer.[49]

More prosaically, she was probably the best known American genre painter of the mid-nineteenth century. She was born in Ohio to a family of immigrants. Her father taught French in a nearby college and educated his children at home. Both he and Lilly Martin's mother were involved in cooperative reform societies, the abolition movement, and women's suffrage, and so they of course encouraged their daughter's desire to be an artist. Her father agreed to take her to Cincinnati, where she met and studied with various itinerant portrait artists. She refused an offer to travel to Europe for formal training and remained essentially a self-taught artist. She was often to lament her choice—particularly when she began to compete seriously with more sophisticated artists of the East Coast.

While still in Cincinnati, she married Benjamin Rush Spencer. A friend wrote to Lilly Martin Spencer

at the time of her marriage: "glad to hear you determine to stick to painting . . . I was fearful matrimony would put an end to painting—I hope not."[50] In fact, painting was the only visible means of support for the Spencers. Benjamin made several unsuccessful sorties into the labor market but was repeatedly drawn back to assist with the numerous children (she bore thirteen, seven lived).

The Spencers found it necessary to move to New York, where Lilly's work could bring a higher price. The competition, however, was intense, and Lilly had to study and work much harder to support her family than she had in Ohio. She was also making the difficult discovery that in order to earn money for her work, she had to meet the public's demand for sentimental scenes, of which *The Young Husband: First Marketing* is an excellent example. (Fig. V, 52) What is more, according to the prudent ad-

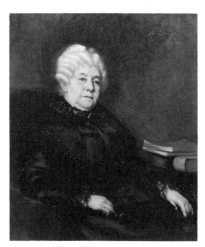

Fig. V, 49 ANNA KLUMPKE. *Elizabeth Cady Stanton.*

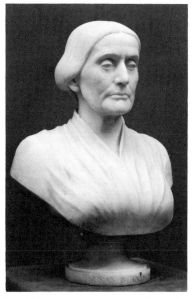

Fig. V, 50 ADELAIDE JOHNSON. *Susan B. Anthony.*

These heroic busts of our "Founding Mothers" show the women artists' desire to commemorate those historical figures most meaningful to them. The prime example of such interaction between art and politics is found in the life of Sylvia Pankhurst, a devoted worker for women's suffrage in England, and later for other revolutionary movements. In 1909 she painted a series of twenty-foot-high panels to serve as backdrop for the Women's Social and Political Union General Meeting. The pursuit of her art, however, had often to be put aside for other kinds of political action, in what she felt was a necessary sacrifice.

Fig. V, 51 THOMAS EAKINS. *Ladies Modeling Class at the Pennsylvania Academy of Fine Arts* (photograph). c. 1883. Forbidden access to nude human models, they are doing their best to learn the mysteries of anatomy from this unlikely model . . .

Fig. V, 52 LILLY MARTIN SPENCER. *The Young Husband: First Marketing*. 1856. The model may well have been her own husband.

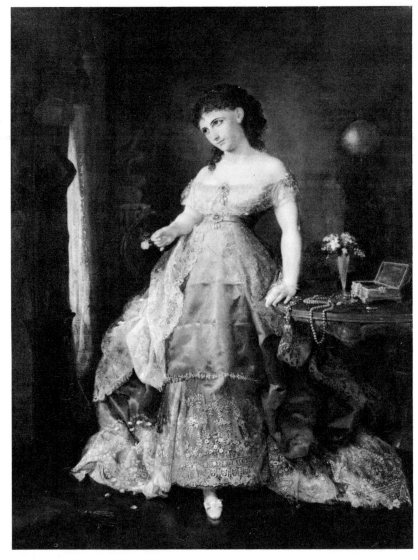

Fig. V, 53 LILLY MARTIN SPENCER. *We both Must Fade*. 1869.

vice of a friend, she had to be willing to make numerous copies of each work—something Lilly Martin Spencer was loathe to do. Her friend wrote:

The question then arises why you have not sold many more pictures— It is only because instead of two pictures of your peculiar "genre," you have not had twenty. The plain truth is that pictures remarkable for Mater-

nal, infantine and feminine, expressions, in which little else is seen but flesh, white drapery, and fruits, constitute your triumphs, according to popular estimations Correggio is only known to posterity by subjects of your "genre."[51]

Lilly heeded this advice and for the remainder of her life devoted herself to domestic scenes. Many of these were, in turn, purchased by

lithography firms, and numerous re-productions were made for American and occasionally for European households.

She did manage to imbue some of her portraits, allegorically, with her philosophical concerns, as we see in *We Both Must Fade.* (Fig. V, 53) Ostensibly a life-size rendering of one of the daughters of a wealthy New York family, the exquisitely detailed ice-blue gown, the rose, the young subject, were all appropriate emblems for her exploration of the *vanitas* theme. As Joshua Taylor points out in the introduction to *The Joys of Sentiment,* "Mrs. Spencer accepted the view that ruminations on mortality were no less real for being brought to mind in an inescapably modish and domestic environment."[52]

· Lilly Martin Spencer did achieve a certain degree of fame in her own lifetime but never the financial success she urgently needed. Her continuous hard work just barely kept her large family afloat. The decades of the '80s and '90s were to see the decline in domestic genre painting, and by 1889 she was receiving no more than ten dollars for her paintings and was often forced to use her work as barter in lieu of cash to pay her household expenses. She nevertheless continued to paint until her death at the age of seventy-nine, having spent the morning of her last day on earth at her easel. (Fig. V, 54)

THE IMPRESSIONISTS

After All, Give Me France—Mary Cassatt (1845–1926)

"I hated conventional art," said Mary Stevenson Cassatt, but then she came of a different social class than Lilly Martin Spencer, she never married, and she went to Paris to study. She had very little choice, she felt, as the limitation of the art schools in America she was sure would condemn her to mediocrity. Her study at the Pennsylvania Academy confirmed her conviction that only abroad would she thrive, and indeed when she got to Paris and saw the work of Edouard Manet, of Gustave Courbet, of Degas, "I began to live."[53]

It was Degas who first was interested in her work and who proferred the invitation, which she accepted with alacrity, to join the group we now know as the Impressionists, though they called themselves Independents. They also became personal friends, though as Degas was an extremely difficult man and as Cassatt had rather firm opinions also, they were often estranged.[54]

Her Main Line Philadelphia family, though they later "came around," did not at first know quite what to make of all this. Her brother, Aleck, wrote home patronizingly that, "She is in high spirits as her picture has been accepted for the annual exhibition (1872) in Paris. . . . Mary's art name is 'Mary Stevenson' under which name I suppose she expects to become famous, poor child."[55] Perhaps that is where the phrase smart-Aleck began!

A few years before she had written quite seriously, despite her laughing tone, about a friend of hers, "She is only an amateur and you must know we professionals despise amateurs."[56] How do women artists begin to see themselves as professionals? Usually when they need a profession, which Mary Cassatt did not really, though as her mother said: "Mary is at work again, intent on fame and money she says. . . . After all a

Fig. V, 54 Photograph of Lilly Martin Spencer. c. 1900.

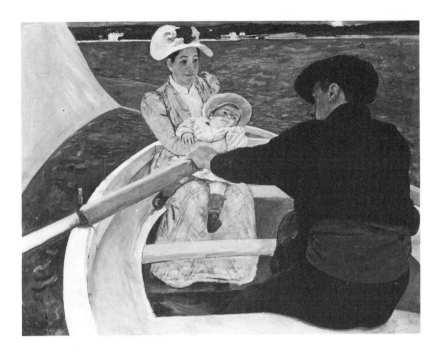

Fig. V, 55 MARY CASSATT. *The Boating Party.* 1893/94. Out for a Sunday sail with the baby along, hot and wiggling in his mother's arms—not much like Renoir's boating parties.

woman who is not married is lucky if she has a decided love for work of any kind and the more absorbing it is the better."[57] Many women in her class, even unmarried women like herself, managed somehow without that "decided love for work of any kind," staying in the bosom of their families, nursing the old, the ill, without fame or money. Had Mary not insisted upon coming to Paris, she might have suffered a similar fate.

The key to Mary Cassatt's different destiny is in that proud title, Independent.[58] By her own independent will she became an artist and found acceptance among her true peers (her "true Masters" as she called them) without ever deviating an inch from their creed. Years later, for example, she turned down the prestigious Lippincott Prize: "I, however, who belong to the founders of the Independent Exhibition must stick to my principles, our principles, which were, no jury, no medals, no awards. . . . Liberty is the

first good in this world."[59]

Interestingly, she never deviated from her family or class loyalties either, remaining entirely American in accent and essence though she lived nearly all of her long, productive life in France. She took care of her opinionated and stubborn papa and her ailing mother and sister until she was left alone with her servants in a chateau in war-torn France. Nearly blind, she still

loved flowers, above all roses. She always had two massive bushes in front of the Chateau of which she was very proud. No one ever had the right to cut a rose. She did this herself when she wished to make a gift and even though blind she knew the color.[60]

What, indeed, was the importance of this finest of American women painters, as she is usually described? It always sorrowed her that she was so little known in America during her lifetime when the more conventional artists like Ce-

cilia Beaux, Fidelia Bridges, Violet Oakley were in vogue.[61] One of her rare visits to this country was heralded in the society columns as follows:

Mary Cassatt, sister of Mr. Cassatt, president of the Pennsylvania Railroad, returned from Europe yesterday. She has been studying painting in France and owns the smallest Pekingese dog in the world.[62]

And here she had been dancing with elephants! Aside from her own elegant and experimental art, it is due to Mary Cassatt, her taste and her belief in the art of her Impressionist friends, that America has so many fine paintings from this period in its museums and private collections. When the Havemeyers toured Europe, Mary would drop her own work and take them around to studios and dealers. We should be grateful to Mary Cassatt for persuading, for example, the millionaire James Stillman that a Manet might be a "better investment" than the Jean Baptise Greuze he found more to his personal taste. She had a good eye also for work of the earlier masters, finding them in unlikely piles of canvases in junk shops. As one of her biographers says, Mary Cassatt "not only furthered, in fact almost created, an interest in French Impressionism, but also rediscovered El Greco and had a great interest in Italian, Dutch, and Flemish art alike."[63]

In her early work she was responsive to the influence of Quentin de la Tour, Correggio, Hals, and Rubens, as well as of her modern friends. We can also see how well she had assimilated the lessons of the Japanese prints, the *Great Wave* as it was called in a recent exhibit featuring many of her prints at the Metropolitan Museum. (Figs. V, 55, 56) Her graphics deserve far more attention. In paintings as in

the prints, Cassatt is determinedly unsentimental in her treatment of the classic subject matter of mothers and children. When someone tried to compare her to Vigée-Lebrun, she harrumphed, "She painted herself."[64] It is true that Mary Cassatt rarely did that, and as she was not herself a mother, these feeling works are tributes to her special combination of objectivity and empathy. (Fig. V, 57)

Much of Cassatt's philosophy and feminism emerge in the correspondence connected with her mural for the Woman's Building (designed by Sophia G. Hayden) at the World's Columbian Exposition in Chicago in 1893. (This idea has risen like a phoenix in the Woman's Building in Los Angeles.) We will quote a portion of one of Cassatt's letters where she describes the mural, as alas the work itself has since disappeared.

I have tried to express the modern woman in the fashions of our day and have tried to represent those fashions as accurately and as much in detail as possible. I took for the subject of the center and largest composition young women plucking the fruits of Knowledge and Science. That enabled me to place my figures out-of-doors and allowed of brilliancy of color. I have tried to make the general effect as bright, as gay, as amusing as possible. The occasion is one of rejoicing, a great national fete. I reserved all the seriousness for the execution, for the drawing and painting. My ideal would have been one of those admirable old tapestries brilliant yet soft. My figures are rather under life-size although they seem as large as life. I could not manage women in modern dress eight or nine feet high. An American friend asked me in rather a huffy tone the other day, "Then this is woman apart from her relations to man?" I told him it was. Men I have no doubt are painted in all their

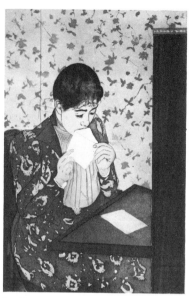

Fig. V, 56 MARY CASSATT. *The Letter.* Here the influence of the Japanese prints is especially apparent.

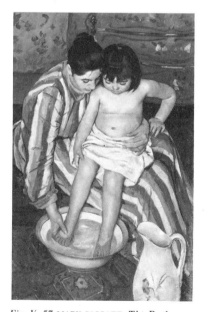

Fig. V, 57 MARY CASSATT. *The Bath.* 1891. This painting has an aesthetic reality; real also are the weight of the child on the knee, the wet foot in the hand.

vigor on the walls of the other buildings; to us the sweetness of childhood, the charm of womanhood, if I have not conveyed some sense of that charm, in one word if I have not been absolutely feminine, then I have failed. [65]

An interesting and controversial statement, when we think of how many women artists deny their "feminine" side. However "absolutely feminine" Cassatt succeeded in being, Paul Gauguin said, comparing her work to that of Berthe Morisot, "She has as much charm, but she has more power." [66]

Berthe Morisot (1841–1895)

Morisot's presence among the Impressionists is much less surprising certainly than that of Mary Stevenson Cassatt from Philadelphia. She was after all the great granddaughter of Jean Honoré Fragonard. Yet she and her sister were first given drawing lessons in order to make charming little pictures as presents for their papa. Paul Valéry, who married Morisot's niece Jeannie Gobillard, comments in introduction to one of the several pieces he wrote on his aunt:

There is a contradictory quality in the middle class which makes them suddenly produce artists, where nothing in the tastes, manners, or aspirations of such well-ordered families might warrant [67]

The girls' drawing master, M. Guichard, after working with them for a while, gave their mother fair warning:

Considering the character of your daughters, my teaching will not endow them with minor drawing room accomplishments; they will become painters. Do you realize what this means? In the upper-class milieu to which you belong, this will be revolutionary, I might almost say cata-

strophic. Are you sure that you will not come to curse the day when art, having gained admission to your home, now so respectable and peaceful, will become the sole arbiter of the fate of two of your children? [68]

Mme. Morisot was not frightened off, as many bourgeois *mamans* might have been, and in fact, she seems to have encouraged the girls' sense of themselves as painters. In a letter she describes getting their studio in order, stretching and hanging the canvases she finds in every corner. She even shows herself to be the perfect Impressionist viewer: "It breaks my heart to see all the works of each season thrown into corners; some of them bring back to me impressions of the moments when you were doing them—all your efforts, your labours, a part of yourselves." [69] She early saw that these works might someday have "value in eyes other than mine," and that is an important leap of faith for the fond parent. [70] No sugary stage-mother type, Mme. Morisot's tone in these family letters is often ironic, philosophical even. She may have been more of a feminist than her daughters, commenting dryly: "Men indeed have all the advantages, and make life comfortable for themselves; I am not spiteful, but I hope there will be a compensation." [71] Someone ought to write a special monograph on the mothers of women artists. Though Berthe occasionally complained that her mother was more critical of her daughters' work than of anyone else's, generally both parents supported their education as painters (and put up with all their artist friends, which was perhaps even more of an adaptation). [72]

Berthe and Edma went on to study with Jean Baptiste Camille Corot. He warned them, charm-

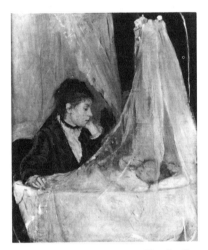

Fig. V, 62 BERTHE MORISOT. *The Cradle.* 1873. Overreproduced but still exquisite early Morisot.

Fig. V, 58 BERTHE MORISOT. *The Artist's Sister, Mme. Pontillon, seated on the grass*. 1873. This early work, sometimes called "the Green Parasol," figures Edma who studied art with Berthe until her marriage.

ingly, "not to think too much about Papa Corot. Nature itself is the best of counselors."[73] Berthe also studied sculpture with Aimé Millet, who wrote the sisters some compliments he had overheard on their work in the hope that they would find in them "a bit of encouragement to make you continue in the path you are following."[74]

So these two young women did receive encouragement, and meeting Manet in 1867 (introduced by Henri Fantin-Latour) was another important factor in Berthe's development at least. Edma was soon to marry and, according to Bataille and Wildenstein's account, "renounced" painting from this time forward, doing only a portrait of her husband.[75] Why did she not continue, one wonders? Berthe, in her letters to her sister, seems at times almost to envy Edma's freedom from the worry and ambition "to do something at least fairly good" but acknowledges also: "Men incline to believe that they fill all of one's life, but as for me, I think that no matter how much affection a woman has

for her husband, it is not easy for her to break with a life of work."[76] (Fig. V, 58)

Berthe, too, had married, five years after Edma, but her husband, being the brother of Edouard Manet, was perhaps a more positive factor in her work than Edma's naval-officer husband. In fact, Eugene Manet once challenged to a duel a critic who had referred to the second Impressionist Exhibition as "organized by five or six lunatics, one of whom is a woman."[77] Eugene was attentive in less dramatic ways also, as we can see in the following excerpts from a characteristic letter:

All the rest of the day was devoted to your affairs. . . . The Impressionists have all asked many questions about you and wanted to know whether you would come to see the exhibition. . . .

The painting you began in your room is very good. Finish it and send it. Give me the size of the canvas and I will order a frame for it in advance. Your pictures at Portier's seemed very good to me.[78]

Fig. V, 59 EVA GONZALES. *Reading in the Forest*. This interesting artist and contemporary of Morisot died at thirty-four in childbirth.

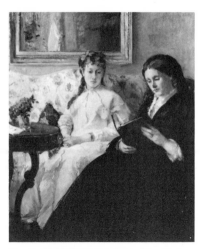

Fig. V, 60 BERTHE MORISOT. *The Mother and Sister of the Artist.* This painting was "agonizing" to Morisot because of Manet's well-meant interference.

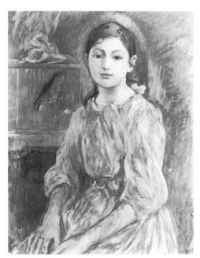

Fig. V, 61 BERTHE MORISOT. *The Artist's Daughter with a Parakeet.* One of her many loving portraits of her lovely daughter, Julie.

Her relationship to her brother-in-law was ambivalent. She certainly felt displeased and jealous when Edouard Manet began to use the young artist Eva Gonzales (1849–1883) as a model instead of her.[79] (Fig. V, 59) She worried about his undue influence on her painting, complaining of a picture she was working on: "as a composition it resembles a Manet. I realize this and am annoyed."[80] Once he came to tea and she made the mistake of asking his advice on a canvas she was having trouble with:

He took the brushes and put in a few accents that looked very well; mother was in ecstasies. That is where my misfortunes began. Once started, nothing could stop him; from the skirt he went to the bust from the bust to the head, from the head to the background. He cracked a thousand jokes, laughed like a madman, handed me the palette, took it back; finally by five o'clock in the afternoon we had made the prettiest caricature that was ever seen. . . . My mother thinks this episode funny, but I find it agonizing.[81]

We illustrate here the painting that was the subject of this tribulation and leave it to our readers to imagine the feelings of paralysis and politeness and pain Berthe must have experienced at this takeover by the male expert! (Fig. V, 60)

Berthe Morisot was filled with doubts as to the worth of her work and, indeed, of life itself. Often an "insurmountable laziness" would overcome her, a classic case of creator's *accidie,* like Carriera's famous "sad days." Mme. Morisot speaks of "our nervous and febrile dispositions" as if it were a family trait, and Berthe certainly found much in her time to despair over, aside from the dry periods in her own work.[82]

Of course, her life included other moods as well, and friendships with Pierre Auguste Renoir, Stéphane Mallarmé, Degas, and other creative people gave her much pleasure. Morisot's Thursday night dinners were precious to her and to the regular guests. And the love she felt for Julie, her daughter, glows from the many studies she did of her. (Fig. V, 61) Morisot's courage and independence in her work are impressive. Her former teacher Guichard had written severely to her mother:

I have seen the rooms at Nadar, and wish to tell you my frank opinion at once. When I entered, dear Madam, and saw your daughter's works in this pernicious milieu, my heart sank. . . .As painter, friend, and physician, this is my prescription: she is to go to the Louvre twice a week, stand before Correggio for three hours, and ask his forgiveness for having attempted to say in oil what can only be said in water-colour . . . she must absolutely break with this new school, this so-called school of the future.[83]

Fortunately, she did not follow this medical advice and continued to associate with these so-called madmen and also to push her own experiments further with each painting.

The much reproduced *Cradle,* while charming, is an early work, and should not be taken as the ultimate achievement of Morisot's style. (Fig. V, 62) As you look through the books available on Morisot's art, you will see that she did indeed succeed in saying in oil "what can only be said in watercolour." Her sense of the fleeting moment became both the content and the form of her work, and she had in full measure what Valéry called "the will to reduce all things to allusion."[84] (Figs. V, 63–65) Her late self-portrait and her last brave

Fig. V, 63 BERTHE MORISOT. *The Cherry Pickers.* Many preliminary studies led up to this masterpiece.

Fig. V, 64 BERTHE MORISOT. *Self-Portrait.* 1885. She seems to be looking into the vanishing point.

Fig. V, 65 One of Morisot's many swans, emblems for her of the beauty of the fleeting moment.

Fig. V, 66 SUZANNE VALADON. *Self-portrait.* This striking self-portrait of Suzanne in her prime shows her power as a person and as a painter.

letter to her daughter show that she could accept the consequences of her philosophy and aesthetics without flinching:

My little Julie, I love you as I die; I shall still love you even when I am dead; I beg you not to cry, this parting was inevitable. . . . Work and be good as you have always been; you have not caused me one sorrow in your little life. [85]

Berthe Morisot's art and her writing are too often dismissed as fragile nothings; actually they are tough nothings and, if carefully considered, can tell us much about our twentieth-century reality. Let us not forget in the present plethora of Impressionist reproductions that in those days it took some courage to be so identified. Morisot and Cassatt, however bourgeois, were both revolutionaries.

Suzanne Valadon (1867–1938)

No one ever accused Suzanne Valadon of being bourgeois, and she was probably more anarchist than revolutionary. Degas and Henri de Toulouse-Lautrec were the first to see Suzanne Valadon's potential when everyone else saw her only as an artist's model. The first time Degas looked at her portfolio with those "tough and supple" drawings, he said to her: "Yes. It is true. You are indeed one of us."[86]

Certainly the skill and style she found somewhere within her own nature were surprising. She never had formal training, and yet her work developed independently along the lines of the best of post-Impressionism. The only person Valadon ever imitated was the medieval outlaw poet François Villon. According to her biographer, she called herself "Mademoiselle Villon" as a child and practiced a walk and a devil-may-care attitude modeled on her imagined hero/father. She was a street gamin who

might have thought herself at the acme of her ambition when she got her first job—with a circus. But a fall from the flying trapeze forced her to find some more *terre à terre* vocation, and she began modeling in the artists' studios in Montparnasse. Thus literally accidentally, Valadon found her true vocation:

I remember the first sitting I did. I remember saying to myself over and over again, "This is it! This is it!" Over and over I said it all day. I did not know why. But I knew that I was somewhere at last and that I should never leave.[87]

Our cover artist had indeed found her right place, and ironic it is that she is usually mentioned in art history texts only as the mother of Maurice Utrillo. She taught him to paint, after all (in the hopes it would keep him from wasting his substance), and with the clever management of her husband, André Utter, their combined paintings brought the family a good deal of money.

Before this comparative affluence (which Suzanne celebrated in var-

Fig. V, 67 SUZANNE VALADON. *Adam and Eve.* An amusing and personal interpretation of an old myth.

Fig. V, 68 SUZANNE VALADON. *The Nets.* The three interlaced figures, all modeled by her husband, André Utter, represent one of the earliest ventures by a woman to paint the male nude.

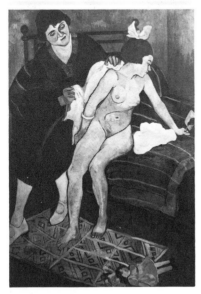

Fig. V, 70 SUZANNE VALADON. *The Abandoned Doll.* Here a most common scene in life, but an unusual one in art—the mother is explaining to her daughter the changes taking place in her body. Abandoning her doll, the child searches the mirror to see if these effects are going to show.

ious forms of conspicuous consumption, such as feeding her cherished cats caviar every Friday), Suzanne Valadon had been kept by a banker in high style. She rode about the Butte "in her trap drawn by a mule with little brass bells in his mane and with his tail plaited with bright silk ribbons—a pair of wolfhounds at her feet and a parrot in a cage beside her."[88] The banker finally moved her to the suburbs in a vain attempt to keep her to himself (she was carrying on a tender and tragic affair with the composer Erik Satie at the same time), but the charm of the bourgeoisie was too discreet for flamboyant Suzanne. (Fig. V, 66)

Soon she had moved back into the drafty studio on the Butte with her son and with his friend, André Utter, who became her lover and then husband, though some twenty-one years her junior. From this period date her joyous and sensual paintings that figure Utter in all the starring roles, as you can see. (Figs. V, 67, 68) Valadon's psycho-

logical insights into the French middle class family can be felt in her great portraits and intimate genre scenes. (Figs. V, 69, 70) The still lifes, too, with their strong outlines and fiery coloring, reflect her unquenchable *joie de vivre.*

It was during the feverishly gay years before the war, and the difficult years during and after it, that Suzanne gained her reputation for eccentricities even in that colorful quarter where their neighbors were Raoul Dufy, Georges Braque, and Gino Severini; Amedeo Modigliani was one of their best friends. Suzanne kept a goat in her studio, not in imitation of Rosa Bonheur but, she said, to eat up her bad drawings.[89] Animals often figured in her anecdotes: "One night sightseers were flabbergasted to see her before *Chez Ma Cousine* milking a mare into a wine glass and drinking the milk with apparent pleasure."[90] She took to wearing a corsage of fresh carrots . . .

Well, if only a portion of the legend is true, it was a spectacular

life. The ravages it took on her are painted with customary honesty in the late self-portraits. (Fig. V, 71) Valadon lived out her last years in comparative loneliness, estranged from Utter, even from Utrillo. A handsome youth named Gazi, who called her *Mémère,* cared for her and tried to convert her to his particular brand of mystical Catholicism toward the end.

A moving story of this last period is told by her biographer. Valadon visited the 1937 Exhibition of European Women Painters at the Musée du Jeu de Paume. For more than three hours she looked closely at the canvases by Vigée-Lebrun, Morisot, Séraphine Louis, Marie Laurencin, Marie Blanchard, Gonzales, and others. That evening she said to the friend who had gone with her:

You know, *chérie,* I often boasted about my art because I thought that was what people expected—for an artist to boast. I'm very humble after what we have seen this afternoon. The women of France can paint too, *hein?. . . .* But do you know, *chérie,* I think maybe God has made *me* France's greatest woman painter.[91]

She was remarkable in every way, and her vital, adventurous work serves as a suitable introduction to the painters in our next chapter.

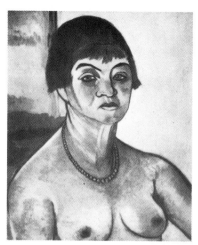

Fig. V, 71 SUZANNE VALADON. *Self-portrait.*

6

"New Forms and Stranger" 1890-1920

The turn of the century was an adventurous time in all the arts and many of the liveliest of the artists came to Paris, of course, to enjoy its fabled, international atmosphere as memoirs of the period convey. Nina Hamnett, an artist from England, was one of those who never felt as free anywhere else, and with good reason!

I lived at the flat at Chiswick with my Grandmother. I wore a stiff linen collar and tie and corsets with bones in them. A few years later I cast them aside. My Grandmother and an elderly cousin said that it was indecent and disgraceful and women's backs were not strong enough to support themselves; I am now forty-one and my backbone has not yet crumpled up.[1]

Not everyone had the strength to resist these pressures, as we see from Beatrice Glenavy's memoirs:

My father seemed to think that for a young girl "going to Paris" was going to something worse than death. In every way he tried to dissuade me, saying, "if you go to Paris, who will help your mother with the children?" and adding, "if you go to Paris it will break your grandmother's heart." I think these arguments carried little weight with me. I had heard George Moore say something about women "taking their art lightly as if across a fan," and [my teacher] John Hughes had said, "Women can be great queens or great courtesans but they seldom become great creative artists."

I did not think I had much chance of becoming a great queen or a great courtesan and the possibility of becoming a creative artist of any importance seemed just as remote. I decided to stay at home.[2]

However, many other women artists did rebel, did slip their corsets, and did come to Paris. Their experiences read differently than those of their male counterparts:

I had no desire for marriage or children; the idea of being shackled to a family frightened me. I saw in it the loss of my cherished freedom and the cramping of my work, and work for me counted more than anything. None the less, I could no longer stop myself from learning what love was, as everybody finds out in the end. I was old enough, I had no desire to be an old maid, and everything in me, soul and body, was longing for a man who could give me confidence and make a woman of me—a happy woman, but no man's slave. And that was precisely the difficulty.[3]

Precisely. Many biographies remain to be written of these women, who were to change preconceptions (their own and society's) about class, sex, and art. Marie Blanchard, Chana Orloff, Sakharova, Louise Hervieu, Hélène Perdriat, Louise Breslau, Valentine Prax, Chériane, Hermine David, Charmy, Wassileff, Nélie Jacquemart, Camille Claudel, Jacqueline Zay, Berenice Abbott are just some of the names of Parisian and expatriate artists that recur. Many were the eccentric sisters more or less self-

Fig. VI, 1 GWEN JOHN. *Self-portrait.* 1900–1905. "The mysterious sister who lived in Paris."

exiled by what we would now call dryly, differing life-styles. We have chosen to discuss first in some detail Gwen John, Romaine Brooks, and Florine Stettheimer. These subtle and sophisticated women were faithful to their own visions, no matter what the consequences.

Fig. VI, 2 GWEN JOHN. *Girl with Bare Shoulders.* In this dual portrait of her friend Fenella Lovell, Gwen John painted her clothed and unclothed in imitation of Goya, who had done two such versions of his model.

Fig. VI, 3 GWEN JOHN. *Nude Girl. Fenella desnuda.* 1909.

SOME OF THE MYSTERIOUS SISTERS

Gwen John (1876–1939)

In Carrington's diary entries about Augustus John's extraordinary *ménage,* Gwen John figures only as "the mysterious sister who lives in Paris," but now that Michael Holroyd's biography on Augustus is published, we know a bit more about her.[4] Often described as a shy, intensely private person, Gwen John was an original, as we sense in her quietly emphatic self-portrait. (Fig. VI, 1) Her flamboyant brother admired her work and appreciated her need for privacy and her eccentricity, though he had some doubts about her cats and her later preoccupation with Catholicism. Gwen John's own feelings about her family emerge quite clearly in her description of a visit her father had paid her in Paris:

. . . not because he has wished to see me or I to see him, but because other relations and people he knows think better of him if he has been to Paris to see me! And for that I have to be tired out and unable to paint for days. And he never helps me to live materially—or cares how I live. Enough of this. I think the Family has had its day. . . . We don't go to Heaven in families now—but one by one.[5]

She was also able to say, "My religion and my art—they are all my life." A friend of Rodin's, Gwen John modeled for some of his sculptures, and she carried on long correspondences with Rilke and with Maritain.

She seems to have had a strong sense of her worth as a painter: "When asked her opinion of an exhibition of [Paul] Cézanne's watercolours, her reply, scarcely audible, was: 'These are very good, but I prefer my own.' "[6] The two portraits, clothed and unclothed, of Fenella Lovell, demonstrate her willingness to take on Francisco Goya himself! (Figs. VI, 2, 3) A sensitive critic sees in the comparison and contrast of these two portraits an uncovering that is "a consequence of growing trust. The eyes and mouth have softened, and although the figure is in exactly the same position as before all tension has gone."[7] We see also in these two works the woman artist's willingness to draw female bodies of a type rarely seen in art. "A search for 'strange form' is what the best drawing has always been concerned with. . . ."[8]

Romaine Brooks (1874–1970)

"New forms and stranger," Virginia Woolf was to cry out for in *Orlando,* and many of the women artists and writers of the early twentieth century were changing shapes and sex roles even more rapidly and radically than did Orlando.[9] Another wonderfully comic book (its author, Djuna Barnes calls it a "slight satiric wigging"), entitled with misleading propriety *The Ladies Almanack,* is a *roman à clef* about this creative group of sapphists.[10] Meryle Secrest's recent biography of Romaine Brooks provides many keys to the whole group, while exploring in depth the complex personality of this determinedly dilettante painter.

Secrest tries to analyze the dangerous effects of money, of social position, and of sex roles on Brooks in terms that can be generalized to apply to many upper-class women artists (as Woolf pointed out with Vita Sackville-West in *Orlando*):

Because she could paint at whim, she did so erratically; clinging to an artistic vocabulary that was becoming increasingly out of style. She was never

Fig. VI, 4 ROMAINE BROOKS. *Renata Borgatti*, a pianist who played like "a man of undisciplined genius."

Fig. VI, 5 ROMAINE BROOKS. *Ida Rubinstein.* 1917. A dancer in the Ballet Russe. Cocteau saw her as the pungent perfume of some exotic essence.

forced by economic circumstance to work steadily and become a painter to be reckoned with, instead of an ignored one.[11]

As with many women, Brooks's weaknesses became her strengths, her defensiveness, her solitude. "We are what we can be, not what we ought to be," she acknowledged.[12]

The rare portraits she made of her artistic friends, while evocative of the era, reveal Brooks's special vision with their muted coloring, the isolation of the figure in space, and the ascription to them of symbolic, as well as individual status. (Figs. VI, 4–6) They disclose more than the subjects perhaps wished, which is why the esthete Robert de Montesquiou called her "the thief of souls." Her drawings, depending as they do on her unconscious material and an uncannily fluid line, now seem almost more interesting. (Fig. VI, 7) Many of the drawings

are reproduced in her biography. An exhibition catalog of drawings and paintings is available from the National Collection of Fine Arts in Washington, D. C., which owns many of the enigmatic works of this far from native daughter.[13]

Florine Stettheimer (1871–1944)

A very different personality, though equally cosmopolitan, dilettante, and difficult, as her poem shows:

The world is full of strangers.
They are very strange.
I shall never meet them.
It is easy to arrange.[14]

Florine Stettheimer, like Romaine Brooks, specialized in portraits of her famous friends, but her mother and elegant sisters are the central figures in most of her icons, as they were in her life. (Fig. VI, 8) The series of cathedral paintings, apotheosizing various aspects of New York

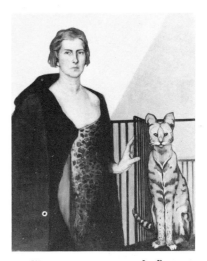

Fig. VI, 6 ROMAINE BROOKS. *La Baronne Émile d'Erlanger.* Beside her sits a beast said to bear an uncanny resemblance to the lady's husband.

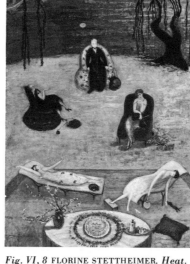

Fig. VI, 8 FLORINE STETTHEIMER. *Heat.* 1918. Her mother's midsummer birthday party seems to have had an ennervating, isolating effect upon the sisters.

Fig. VI, 7 ROMAINE BROOKS. *The Mummy.* Brooks said these drawings were her "indelible thoughts."

Fig. VI, 9 FLORINE STETTHEIMER. *The Cathedrals of Wall Street.* 1939. A pantheon of American heroes. Each carefully chosen detail contributes to the satiric impact of these icons.

in its flapper period, are early examples of the satirical allegory so favored by women artists of the twentieth century. (Figs. VI, 9–11) Linda Nochlin, speaking in a recent *Ms.* forum on the arts, said of Stettheimer's style:

She knew what the avant-garde was doing—Marcel Duchamp and other innovators were her friends. But eventually she said No to both the academic and the avant-garde modes, and went on to invent something of her own, something private, something that was called "feminine." She's being appreciated more fully now; we're ready to look at her work in its totality, not just as negatively "bizarre, feminine form," but as a conscious step, radical in the twenties and thirties.[15]

Her official biographer, Parker Tyler, tells of Stettheimer's ambivalence, indeed terror, about exhibiting her work in anything but her own carefully arranged environments. It is thus the more miraculous that she actually committed herself to design the decor for the Gertrude Stein and Virgil Thompson opera, *Four Saints in Three Acts.* Fortunately, "Florine staged herself; she was stage-minded."[16] She carried through her vision, instructing the theatre professionals in her special theories of lighting. The stage was bathed in white light from start to finish; all the parts were played by black singers; and the sets were entirely of cellophane. The effect was, by all accounts, tremendous and the staging of *Four Saints in Three Acts* was an event in American theatre. The modern adaptation of religious modes so energetically pursued in this opera undoubtedly influenced Stettheimer in her choice of the cathedral metaphor for the series of paintings already mentioned. One wishes she had been able to bring herself to

Fig. VI, 10 FLORINE STETTHEIMER. *The Cathedrals of Fifth Avenue.* 1931. This is the world's marriage and Tiffany diamonds in the sky and a dollar-sign grille on the Rolls Royce tell us much about the origins of this ritual.

Fig. VI, 11 FLORINE STETTHEIMER. *The Cathedrals of Art.* 1942. In her last (unfinished) work, Florine attends, as godmother, the difficult birth of modern art.

undertake more such public collaborations where she could test herself "as part of a larger world rather than as a little world in herself."[17] But then her life and her art made an undeniable unity, and it is hard to imagine her suddenly ceasing to be the princess so sensitive to the pea.

Indeed, there is that quality about all these women: John, Brooks, and Stettheimer. They are impossible to categorize. We speak of Whistler's influence on John and Brooks, but that does not really prepare us for the elusive, feminine world evoked by John or the lonely dignity in Brooks. Stettheimer is called a "sophisticated American primitive," whatever that means.[18] They have had neither the support nor the restrictions of belonging to any one school. Such words as sensitive and singular are usually invoked to describe them. We prefer Florine's sister's description: "We may be virgins, but we know the facts of life."[19]

Séraphine de Senlis (1864–1934)

Séraphine was as thin-skinned as

Fig. VI, 12 Photograph of Séraphine de Senlis.

Fig. VI, 13 SÉRAPHINE DE SENLIS. *Tree of Paradise.*

any of these others, and much more visionary. A nameless foundling, she grew up tending goats and later worked as a maid in Senlis. She always painted, using the oil in her votary lamp to the Virgin to mix her paints. One summer she cleaned the rooms of a vacationing art critic, Wilhelm Uhde (he was the "discoverer" of Henri Rousseau). When he came across her work, he knew he had made another discovery. As he put it, this was no mere study of fruits and flowers but inspired work done with medieval fervor and with remarkable technique as well.[20] He gave Séraphine's work considerable publicity and provided her with larger canvases and better paints.

Art students came all the way from Paris (she herself never saw the city) to learn how she got the gold to glitter as it does in this iridescent *Tree of Paradise.* (Figs. VI, 12, 13) However, she put a sign on her door that said, "Mlle. Séraphine is not receiving," barricaded herself in her room with a complicated set of locks whenever she painted, and thus the secret of her brilliant color died with her. Her visions became increasingly apocalyptic, and after she announced to everyone in the village that the world was coming to an end (in the 1930s), she was locked up in an asylum where she died.

Séraphine was another of those eccentrics, exempt by their sex and by their class status (either very low or very high) from the dubious disciplines of professionalism. Women artists on these levels have so little to lose that they can venture all, and thus are free to develop in their own ways. They contribute a special element to the study of art, and should never be ignored or overlooked. Think of the Séraphines painting all over the world who just

do not happen to clean house for an art critic with the special sensibility of Uhde! We may never see their works but want to honor them in this book, all these invisible artists, as examples of the indomitableness of human creativity.[21]

THE AVANT-GARDE

Brooks, John, Stettheimer, and Séraphine are connected through their eccentricities, their reluctance to exhibit, and their absence of identification with any school of painting. The next group of artists in this chapter—Laurencin, Carrington, Münter, Modersohn-Becker, Delaunay, Goncharova, and others—identified deeply with contemporary movements in art. They are also, not coincidentally, linked with well-known male artists of the period, and we will try to understand some of the effects of these relationships upon their development as artists. After all, the issue cannot help but interest those of us seeking to establish relationships such as Vita Sackville-West describes: "we have never interfered with each other, and strangely enough, never been jealous of each other."[22]

The father/artist/teacher so predominant in the biographies of women artists up through the nineteenth century now becomes the husband/lover/artist, introducing new emotional complexities. Independence from the father is at least in theory encouraged but *not* from the husband. Even when the men themselves respected their companions' work, the community often subjected them to the niggling indignity of being treated only as the wife of The Artist.[23] We will see that few, if any, of these women ever allowed themselves to consider their work above that of their hus-

bands'. Such assumptions can certainly be damaging—psychologically and artistically—as we shall see in the following story of Carrington.

Carrington (1893–1932)

Carrington, a promising young art student at the Slade, threw off her middle-class origins and her first name (Dora), got a room of her own, and found there the three demons: Loneliness, Laziness, and Lust. In trying to share her room and remain whole, she lost herself as a painter. The editor of her *Letters* says:

> The greatest of her, or perhaps I should say of our, misfortunes was that the men she loved and lived with after her breach with Mark Gertler cared little for painting. It did not occur to Lytton Strachey, or to Ralph Partridge, that her painting should be put first. Gertler was too much of an egotist to encourage her and work with her.[24]

Somewhere along the way, at a house party at Lady Ottoline Morrell's, in fact, Carrington made a choice. Her sensitive portrait of the writer Lytton Strachey shows the tender and respectful admiration that she felt for her beloved friend. (Figs. VI, 14, 15) It was her absorption in their developing relationship, her desire to make herself indispensable, that drew her away from her easel. She saw being a serious artist only as a kind of alternative—something to do should the relationship fail.

She began to avoid large canvases or difficult conceptions, "as I know I shall then despair and give up the composition before it is finished."[25] She herself blamed domestic duties and what she called getting "merged into" others' activities for interrupting her painting. "I am not strong enough to live in the world of people and paint"[26] As she stopped developing her art, she became bored by it: "the result is so dull it hardly seems worth beginning."[27] That can be fatal. She did not get enough attention for do-

Fig. VI, 14 CARRINGTON. *Portrait of Lytton Strachey.* As a prank, Carrington stole into Lytton's bedroom intending to shear him of this luxuriant beard. But at the crucial moment, he opened his eyes and caught her.

Fig. VI, 15 CARRINGTON. *The Millhouse at Tidmarsh.* The charming setting Carrington prepared for Lytton Strachey.

Fig. VI, 16 VANESSA BELL. *Virginia*. This fine composition stands as a sensitive tribute of one gifted sister to another.

ing her art and so she did not give enough attention to it.

Vanessa Bell (1879–1961)

However, Bloomsbury did not have such a daunting effect on all its potential women artists. Vanessa Bell never stopped painting, come children, servant problems, even the horror of losing a son in the Spanish Civil War. It should be said that she received every encouragement from her family, from Roger Fry, and from her companion, the painter Duncan Grant. Perhaps the attention now being lavished on the Bloomsbury Group will bring about a reassessment of her *oeuvre*. (Fig. VI, 16) As Richard Morphet says in his essay to the exhibit catalog of her drawings and paintings:

Although the detailed research for which Vanessa Bell's body of work calls is in its infancy, it is increas-

ingly apparent that her achievement has far greater richness, individuality and historical significance than was generally claimed at the time of her death in 1961, and the outlines of a more ambitious estimate of her importance are already clear.[28]

Marie Laurencin (1885–1956)

Marie Laurencin's art receives a lot of attention, and when the question of women artists is raised, people often proudly produce her name. It is possible, however, that we would not even know of her delicate mythological creations, had she not been identified with the poet and art critic Guillaume Apollinaire. (Figs. VI, 17, 18) One wonders if she would have painted in a quite so determinedly pastel and "feminine" style if she had not felt pushed into it by the need to differentiate herself from such strong in-

Fig. VI, 17 MARIE LAURENCIN. *Group of Artists*. 1908. Gertrude Stein bought this, the first painting Laurencin ever sold. Reading from left to right: Picasso, Fernande Olivier, Apollinaire, and the artist.

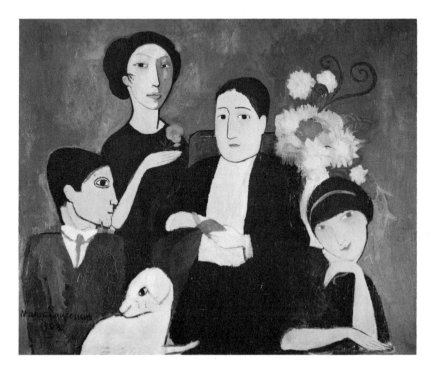

Fig. VI, 18 MARIE LAURENCIN. *Girl with a Dove*. 1928.

fluences as Pablo Picasso and Braque. She made a place for herself by her very separateness and received that approval that seems to come to those women who do not try to compete with male artists on their own ground. Apollinaire complimented her work for retaining "all the charm of decoration."[29] Sonia Delaunay said of Laurencin's art: "I hate it."[30] She herself said semi-mockingly: "Generally I paint to calm my nerves, and that is no easy task." She identified her ambition for her paintings, nearly always of actresses and dancers, as follows:

My ambition is that men should have a voluptuous feeling when they look at the portraits I paint of women. Love interests me more than painting. My pictures are the love stories I tell to myself and which I want to tell others.[31]

Gabriele Münter (1877–1962)

Of her relationship to Wassily Kandinsky, Münter herself tells the story: "I held to Kandinsky. I gave myself no worth next to him. He was a holy man."[32] She had always intended to be an artist, but the turning point came when she enrolled in the Phalanx School in Munich where the Russian-born painter taught. Kandinsky was alternately amazed and exasperated by this young woman's personal style, remarking, "You are hopeless as a student—one can teach you nothing."[33] Münter nevertheless found in him (as so many would in the next decades) the inspiration she needed to press forward her claims as artist in her own right.[34] "He loved, understood, treasured, and encouraged my talent."[35] She was totally devoted to him, though her art was actually closer in spirit and style to Alexei Jawlensky.

For over a decade Kandinsky and Münter lived together. Kandinsky, who was already married and could not obtain a divorce in the Russian Orthodox Church, was plagued by guilt, and the relationship was not an easy one. Together with Jawlensky and Marianne Werefkin, they formed the core of what was to become the Blue Rider school. (Figs. VI, 19, 20) And it was Münter who provided the hospitable environment for so many of their gatherings; she, like Carrington, sought above all to be useful.

When in 1914 the World War broke out in Europe, Kandinsky, along with most of the Russian community abroad, returned home. In fact, their relationship was exhausted, and the war was the outer event that signaled the end of their life together. Münter went to live in Stockholm for the next few years, and her paintings from this time reveal the tension and isolation she suffered. Instead of brilliant landscapes and portraits of her friends, she turned to thoughtful, frequently melancholy studies of women. (Fig. VI, 21) Then, in 1918 the paintings stop; the trauma of separation from Kandinsky seems to have jarred her very sense of herself as an artist.

In 1931 she returned to Murnau, where she was to live for the remainder of her long life. (Fig. VI, 22) Slowly she resumed her painting. These later works seem to represent a kind of interior meditation, as a 1960 review implies:

Her lamps and chairs and flower vases are part of an autobiography, her still lifes always halfway to domestic interiors, such is the feeling of personal association about them, the familiarity of the unseen room they are in. They are not sentimental paintings nor yet necessarily happy ones[36]

Fig. VI, 19 GABRIELE MÜNTER. *Portrait of Marianne Werefkin.* 1909.

Fig. VI, 20 MARIANNE WEREFKIN. *Self-portrait.* 1908. Both these portraits are interesting and their differences are, too.

Fig. VI, 21 GABRIELE MÜNTER. *Thinking*. 1917. Such introspective paintings emerged after Münter's separation from Kandinsky.

Fig. VI, 22 GABRIELE MÜNTER. *View of the Mountains*. 1934. The alpine landscape near Murnau dominated her art.

In 1957, on the occasion of her eightieth birthday, Münter donated to the city of Munich 120 paintings of Kandinsky's, which she had stored since before World War I. The exhibition of these works (along with 60 of her own oils) caused a sensation in the art world and an enhanced appreciation of Münter's work as well as that of her famous friend.

Paula Modersohn-Becker (1876–1907)

To sleep among my paintings is beautiful. My studio is very light during moonlit nights. Upon waking I quickly jump up and I look at my work: my paintings are what first meets my eye.[37]

This intimate communion with one's work was utterly necessary to Paula Modersohn-Becker's creative process, and yet it proved to be a situation rarely achieved in her short life. The young Paula received little encouragement from her family to pursue art, though her aunt invited her for a rewarding year of study in London when she was sixteen. Her parents then urged her on the safe path of the kindergarten teacher, but after graduating from teachers' college, she asked for a year at the Art Academy in Berlin. Unfortunately, her first exhibit, at Bremen in 1897, was poorly reviewed, and her parents withdrew their support.

Soon after, Paula married Otto Modersohn, a landscape painter living in the rural art colony of Worpswede, where Paula had begun to visit in 1897. Initially drawn by the beauty of the place, she set up her studio there and began to work. She soon became fast friends with the sculptor Clara Westhoff.[38] Both these young women made a romantic impression on the poet Rainer Maria Rilke, though he omitted men-

tion of either of them in his 1903 monograph on the artists of Worpswede. Ironically, Worpswede painting, derivative and sentimental, receives little attention today.[39] In Paula's diaries she repeatedly speaks of their deep friendship and of the loss she felt when Clara and Rilke married and moved further and further (in every sense) away from her. (Fig. VI, 23)

Otto Modersohn was a widower, considerably older than Paula. He had a young daughter, Elsbeth, who came under Paula's care and into her paintings and diaries; the realities of domestic life interfered with Paula's work time. Her diary reveals the isolation and disillusionment she felt:

My experience is that happiness does not increase in marriage. Marriage removes the illusion, deeply imbedded previously, that somewhere there is a soul-mate (Schwesterseele). One feels twice as strong what it means not to be understood, because one's previous life was a driving desire to find another being, one that might understand. But might it not be better without this illusion, eye to eye with the great truth. I write this in my kitchen account book, sitting in my kitchen, preparing a roast of veal, Easter Sunday, 1902.[40]

Despite the genuine respect her husband felt for his wife's work—and he said in his diary, "she is really a great painter . . . she has something quite rare. No one knows her, no one esteems her. This will all be quite different some day"—Paula found less and less in Worpswede (or in her marriage) to nourish her art.[41]

Between 1900 and 1907 (the year of her death) Paula made four sojourns to Paris, absorbing there the influence of post-Impressionist painting, particularly the work of Vin-

cent van Gogh, Gauguin, and Cézanne. She questioned the prevailing aesthetic of naturalism and confided in her diary:

I believe that when painting, and especially when conceiving a painting, one should not give too much thought to nature. Make the color sketch exactly as one feels the colors were in nature at that time. But what counts are my personal feelings.[42]

She wanted to "express the soft vibrations of things, texture in itself. The strange expectant quality that hovers over matte objects (skin, Otto's forehead, fabrics, flowers) that I must strive to convey in its great, simple beauty."[43]

In a letter to Clara Rilke-Westhoff she spoke of Cézanne as "one of the three or four major forces in art who left their mark on me: like a strong wind or a great event."[44] Paula, like Mary Cassatt, was stimulated by the Japanese art she viewed in Paris in 1903. It provided her with a further indication of Worpswede's limitations and the outlines of a new direction for her own work.

"Today I visited an exhibition of early Japanese paintings and sculpture. What great inner oddity in these things. Our own art seems to me as yet much too conventional."[45] She was impressed by an exhibit of Egyptian art:

Now I feel strongly how much I can learn from antique heads. . . . I begin to feel that when drawing from nature I will have to search for more striking forms and overlapping of planes. I do have a feeling for the intersecting and the overlapping of things. I must carefully work on it and refine it. I want to draw more when I return to Worpswede.[46]

These visits to Paris were like fresh air, and she returned from each determined to work harder—both at her art and her marriage. But the task of bringing the two together seemed impossible, and she felt her creativity stifled by the narrowness of Worpswede. By February 1906 she had separated from her husband and settled once more in Paris: "Now I have left Otto Modersohn and I stand between my old

Fig. VI, 23 PAULA MODERSOHN-BECKER. *Rilke.* 1906. An unfinished portrait of her friend, the poet.

Fig. VI, 24 PAULA MODERSOHN-BECKER. *Seated Nude.* 1906. The young girl establishes in such moments a sense of her symbolic space. The nudity functions here symbolically also, an indication of ritual purity, as is the masklike face.

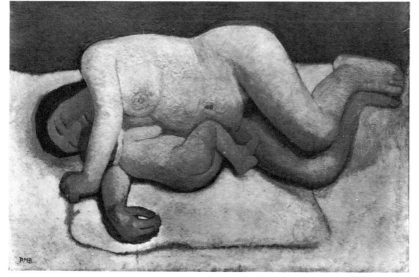

Fig. VI, 25 PAULA MODERSOHN-BECKER. *Mother and Child.* 1907. Here the sensuality rather than sentimentality of mothering is represented.

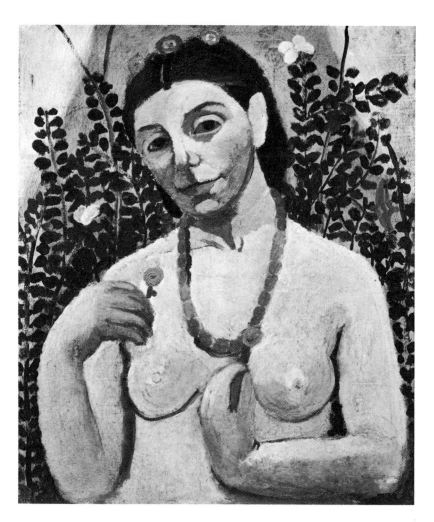

Fig. VI, 26 PAULA MODERSOHN-BECKER. *Self-portrait.* 1906. "And finally you saw yourself as fruit, / Lifted yourself out of your clothes and carried / that self before the mirror, let it in / up to your gaze; which remained large, in front / and did not say: that's me; no, but: this is."

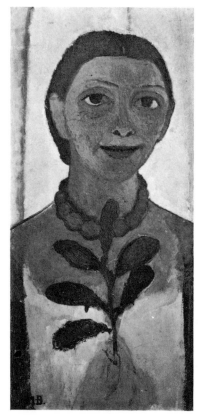

Fig. VI, 27 PAULA MODERSOHN-BECKER. *Self-portrait.* 1907. This is the last of Modersohn-Becker's lucid, searching, self-portraits.

life and my new. What will the new one be like? And what changes will I make in the new?"[47] Paula was ecstatic about her new freedom. She wrote to her sister in May of that year, "I live the most intensely happy time of my life."[48] But pressure to return home was heavy both from her husband and from her own family. The following letter is archetypal and must have been written in various versions by many women during such times:

My Dearest Mother,

That you are not angry with me! I was so fearful that you might be angry. It would have made me sad and bitter. And now you are so good to me. Yes, mother, I could no longer bear it, and don't think I can ever bear it again. Everything was too small for me. It became less and less what I needed.

I am beginning a new life. Don't intrude on it . . . let me be. It is beautiful. Last week I lived like I was drunk. I think I created things that are good.

Don't be sad about me. If my life

Fig. VI, 28 SONIA DELAUNAY. *Market at the Minho.* 1915. This vibrant, colorful painting stemmed from the Delaunays' experiences in Portugal.

won't take me back to Worpswede that does not mean that the eight years I spent there were not good.

I find Otto very touching. This, and thoughts of you, make my path a difficult one.

I am your child.[49]

However, Otto was too persuasive (he promised her a larger studio all to herself); she did return to married life and soon became pregnant. Three weeks after the difficult birth of her daughter, Paula died suddenly of heart failure.

Of the 259 paintings she completed in her short life, she only sold one. While her style has affinities with German Expressionism, no one at that time understood her prophetic direction, and she worked without any support. Her subject matter was not "significant" in the accepted sense. Paula found her models in the poorhouse, usually young girls or old women; she was fascinated by the harsh lives and dialect of the peasant women around Worpswede. Afraid

of none of the "distortions," she painted adolescence, pregnancy, poverty, old age with equally loving attention. Her figures sit like statues, around them flowers, vases, beads, crowns, props for some private festival of growth and fruitfulness. These images recur in her many self-portraits with the same unflinching gaze within and without. In these iconlike paintings, Paula Modersohn-Becker is constructing a mythology for us all out of the still moments in women's lives. (Figs. VI, 24–27)

Sonia Delaunay (b. 1885)

Certainly there are few couples who have achieved so successful a merging of artistic and personal concerns as Sonia and Robert Delaunay. Together they worked out the tenets of Orphism, and the paintings reproduced here demonstrate their theories of color and rhythm. (Figs. VI, 28, 29) Sonia Delaunay's creative and expansive en-

Fig. VI, 29 SONIA DELAUNAY. *Triptych.* 1963.

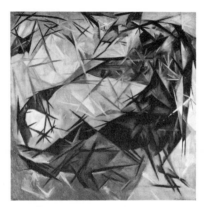

Fig. VI, 30 NATALIA GONCHAROVA. *Cats.* 1911–12. This is Goncharova's earliest Rayonnist work and conveys the almost electrical energy of the universe and of her subjects.

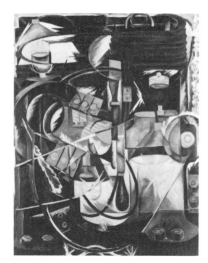

Fig. VI, 31 NATALIA GONCHAROVA. *Dynamo Machine.* 1913.

Fig. VI, 32 NATALIA GONCHAROVA. *Le Coq d'Or.* 1914. Working with Diaghilev and the Ballet Russe, Goncharova achieved a great success with her brilliantly colored sets for Rimsky-Korsakoff's *Le Coq d'Or.*

ergy undoubtedly influenced her husband's artistic development in ways not always acknowledged. Jacques Damase, in his deeply appreciative book on Sonia Delaunay, states that she was always "a collaborator rather than a disciple."[50] This may be something of an understatement.

The value of Sonia Delaunay's own contribution to the arts of the twentieth century can hardly be overestimated. We owe perhaps to her more than to anyone else the penetration of abstract art into everyday life. She began these experiments with a patchwork blanket for her infant son in 1912. It was a tradition in her homeland (the Ukraine) to make a pieced baby blanket, though this one was hardly traditional in design.

Like her close friend, Sophie Täuber-Arp (1889–1943), she did not stand back from experimentation in the so-called minor arts. She designed furniture, tapestries,

books, did an enormous mural on aviation, even painted cars. Her collaboration with Sergei Diaghilev and Igor Stravinsky was enormously successful, and her stage designs and costumes had considerable impact on the world of fashion. Working with the Jacques Heim boutique, she designed a series of "simultaneous" fabrics and clothing that discarded the clutter of Edwardian dress for a new focus on simple forms and bright, primary colors.

Sonia Delaunay's painting and graphics have always been the core of her creative life, stimulating and inspiring her work in various fields of design. However, she chose not to exhibit these paintings during her husband's lifetime. As Damase notes, "Sonia Delaunay has always stood aside in order to bring to the fore her late husband's works."[51] She only began to show in 1953. A major retrospective of the Delaunays' work was held at

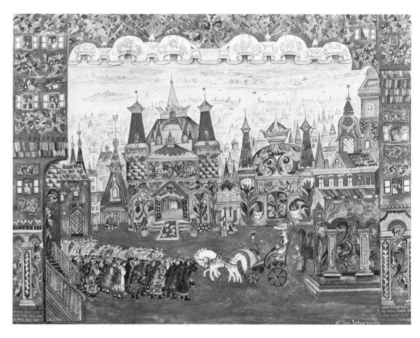

the Louvre in 1964, a very great honor.

Natalia Goncharova (1881–1962)

Natalia Goncharova (1881–1962) and her friend Mikhail Larionov (whom she married on her seventy-fourth birthday after fifty-five years of living and working together) led the movement to bring Russian art into the twentieth century during the period from 1908 to 1914.[52] Initially drawn to French post-Impressionism and German Expressionism, Goncharova and Larionov determinedly withdrew from the West to develop a unique and powerful form of abstraction known as Rayonnism. (Figs. VI, 30, 31) Like the Delaunays, they were fascinated with the aesthetic implica-

tions of electric light. In a characteristic display of creative energy, Goncharova completed some 700 canvases on light for an exhibit in 1913. The whole phenomenon of industrialization permeated their art and that of their contemporaries, and they were also influenced by Russian icons and by folk art. When in 1915 they left Russia, she worked in Switzerland and then Paris with Diaghilev and the Ballet Russe. Her dazzling stage sets emerge from her integration of the double inheritance, past and future, that was one of the strengths of her contribution to the Avant-garde. (Fig. VI, 32)

For the artists of that important generation who did not leave Russia, we have much less information. Fortunately, the Leonard Hutton Galleries' exhibit, *The Russian*

Fig. VI, 34 ALEXANDRA EXTER. *Still Life.* 1913.

Fig. VI, 36 MARTHE DONAS (1885–1967). *Still Life, No. 29.* 1917. This early abstract artist from Belgium accomplishes wonders in this collage where the objects dissolve and reappear in the textures of the cloths.

Fig. VI, 37 RUZHENA ZATKOVA (1880–1924). *Struggle of Objects for Supremacy.* 1916. The Czech painter, Zatkova, makes objects disappear and reappear also on this tea table, where objects struggle for supremacy and threaten to overwhelm it—a true image of the twentieth century. She was connected with Goncharova and with the Italian Futurists.

Fig. VI, 33 LIUBOV POPOVA. *Architectonic Painting.* 1917. Popova's later works are very exciting, brushed onto rough board, and leaving the impression of lightning-swift movement.

Fig. VI, 35 OLGA ROZANOVA. *Directional Lines.* 1916.

Fig. VI, 38 RUZHENA ZATKOVA. *The Monster of War.* 1918. She moved naturally to collage and her work, made with narrow bands of metal riveted together in curves and vaultings and shaded with color, conveys the grim machinelike inevitability of the first world war. She dares to be ugly.

Fig. VI, 39 HANNAH HÖCH (b. 1889). *Cut with the Kitchen Knife through the Last Weimar Beer Belly Cultural Epoch.* 1919. In her collages, Höch uses fragments from her own life, newsprint, autographs, bits of letters. Her aim, "I should like to wipe out the solid borders that we human beings, in our self-confidence, tend to draw around everything within our reach. I wish to demonstrate that little is also big, and big is also little, and that the only thing that changes is the standpoint from which we judge so that all our human laws and principles lose their validity."

Avant-Garde (1908–1922), held in 1971, gives us glimpses of some important women artists.[53] Alexandra Exter (1882–1949) was active in theater design and painted a series of brilliantly colored Cubist still lifes. She and Varvara Stepanova (1894–1958), wife of Aleksandr Rodchenko, continued to work prolifically during this difficult period in the Soviet Union. Liubov Popova (1889–1924) and Olga Rosanova (1886–1918) were deeply involved in the Russian Revolution and the reconstruction of Soviet society in the early twenties. (Figs. VI, 33–35) Sincerely committed to the proletariat, they sought to bring their Constructivist art to the factory and to the whole field of industrial design. Popova was quoted as saying: "No artistic success has given me such satisfaction as the sight of a peasant or a worker buying a length of material designed by me."[54] Popova's early

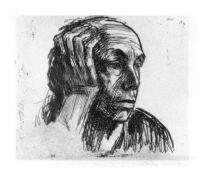

Fig. VI, 40 KÄTHE KOLLWITZ. *Self-portrait.* Kollwitz's face, which she was to draw and sculpt over one hundred times in her life, tells us more about her than any written biography.

Fig. VI, 41 KÄTHE KOLLWITZ. "*. . . resting in the peace of His Hands.*" 1936. In this tombstone she carved for herself and her family, Kollwitz's face is seen once again free of all tension, fatigue, and age.

Fig. VI, 42 KÄTHE KOLLWITZ. *Mary and Elizabeth.* Images of hope were hard to find, but in this woodcut she shows the two women tenderly sharing within them the hope of new birth, life after death.

death was. deeply mourned. Igor Malevich stitched her funeral banner and carried it before the cortege.

KÄTHE KOLLWITZ (1867–1945)

Käthe Kollwitz, that giant of our century, also sought a way of working out the relationship between the artist and society, between the personal and the political. She was satisfied with stark black and white, never deserted the human figure, saw beauty in poverty, made us see the horror of hunger and war, and left a record of her time that far transcends it. (Figs. VI, 40, 41)

She struggled also to balance family demands and artistic ones. "You will find it hard to combine the two," her father told her. When she married young, he was bitterly disappointed as he had seen to it that she got art training: "Unfortunately I was a girl, but nonetheless he was ready to risk it."[55] And it was a risk —her sister, Lise, so talented that Käthe admitted to being jealous, did not continue her art after marriage. Käthe Kollwitz, however, managed to combine the two, though it was never easy. Her niece wanted it made clear that Kollwitz did have domestic help, lest it "hopelessly discourage those women who struggle in vain to manage husband, children, household, and do something besides."[56] But what else saved Kollwitz's art: her sense that, as she said, her art had a purpose and that purpose was "to be effective in this time when people are so helpless and in need of aid"; her sense that, as she said to her son, "As you, the children of my body, have been my tasks, so too are my other works."[57] That infinitely sensible perspective is hard for most mothers to achieve.

Kollwitz's perspective was to be tested terribly and finally established by the death of her younger son, Peter, in the first weeks of World War I. Kollwitz saw better than anyone the irony of the old sending out the young to kill one another off, and she saw, too, that something in the young welcomed battle. Peter's death was to rouse her "implacable opposition to war" and was to unite her through her art with all mothers who offer up their children in meaningless sacrifices. (Figs. VI, 42–45)

She labored for years on a monument to Peter, brooding over its composition and finally dropping her initial plan that had included the fallen hero. She sculpted instead figures of the mourning parents, alone, with her face and her husband's, and they kneel now at Peter's grave in a soldiers' cemetery in Belgium, eternal reminders of the "burden of survival," as it is called in *Lear.* In the process of this second birthing of Peter, Kollwitz found what she needed:

Strength is what I need; it's the one thing which seems worthy of succeeding Peter. Strength is: to take life as it is and, unbroken by life—without complaining and overmuch weeping —to do one's work powerfully.[58]

And it was this work-imperative that must have kept her going through all the trials ahead. Here was another tie she had with the working class. She experienced her first bonding with the proletariat as an aesthetic choice, almost a question of style (Fig. VI, 46):

My real motive for choosing my subjects almost exclusively from the life of the workers was that only such subjects gave me in a simple and unqualified way what I felt to be beautiful Middle-class people held no appeal for me at all. Bourgeois life as a whole seemed to be

Fig. VI, 43 KÄTHE KOLLWITZ. *Twins*. 1935. "Last night I dreamed once more that I had a baby. There was much in the dream that was painful, but I recall one sensation distinctly. I was holding the tiny infant in my arms and I had a feeling of great bliss as I thought that I could go on always holding it in my arms. It would be one year old and then only two, and I would not have to give it away."

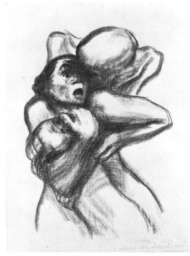

Fig. VI, 44 KÄTHE KOLLWITZ. *Death Snatching a Child*, the nightmare side of the same dream.

Fig. VI, 45 KÄTHE KOLLWITZ. *Pietà*. An unusual Pietà, small and of dark bronze. The mother looks more thoughtful than pious, as she contemplates the broken body of her son.

pedantic. . . . I was gripped by the full force of the proletarian's fate . . . portraying them again and again opened a safety-valve for me; it made life bearable.[59]

It was much more than a safety valve for her, of course. Her effective posters became tools of political education calling for attention to the issues of abortion, hunger, alcoholism, the need for children's playgrounds, worker safety, and aid to Russia. (Figs. VI, 47, 48)

Here again her politics and her aesthetics joined. She was determined to work simply and inexpensively, so that workers might own her prints. She found herself in complete agreement with Max Klinger's defense of drawing and graphic techniques as best able to express the darker aspects of life.[60] Her sense of the sufficiency of black and white comes from her belief in the power of line and gesture. And she insisted upon the human figure, "but it must be thoroughly dis-

tilled."[61] The real secret of her impact is that her works are all "extracts of my life. . . . Never have I done a work cold . . . but always, so to speak, with my blood."[62] As her art reflected so directly private suffering and political oppression, she was able to say when challenged by the Nazis: "One word in conclusion: I stand by every work I have ever produced."[63]

Käthe Kollwitz did over 100 drawings, lithographs, and sculptures of herself. (Fig. VI, 49) It is in these self-portraits, which evoke in us such a strong sense of identification, that her face becomes our own. Their androgynous quality confirms her statement that "bisexuality is almost a necessary factor in artistic production: at any rate, the tinge of masculinity within me helped me in my work."[64] Her face came to reflect more and more the faces of the workers she early identified with; the inner suffering and beauty of their spirits are shown in the lineaments of her own features.

Fig. VI, 46 KÄTHE KOLLWITZ. *Working Woman.* "The proletariat was my idea of beauty. The appearance of typical members of the working class fascinated me, and it was a challenge to reproduce it. It was only later, when I really got to know about the want and misery of the working classes through my close and personal contact with them, that I felt I also had a duty to serve them through my art."

Fig. VI, 47 KÄTHE KOLLWITZ. *Karl Liebknecht Memorial.* Along with Rosa Luxemburg, Liebknecht was murdered in the abortive revolution of 1919. Kollwitz noted in a letter that: "He looked very proud. There were red flowers around his forehead, where he had been shot."

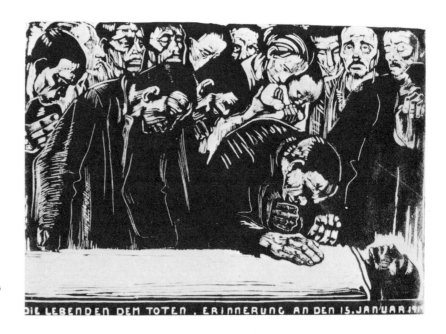

DIE LEBENDEN DEM TOTEN . ERINNERUNG AN DEN 15.JANUAR 19

Her stoical strength was to be tested again; as she said: "The war accompanies me to the end." Long before World War II officially began, in 1927 in fact, Kollwitz recorded that she had dreamed there would be another war. "And in the dream I imagined that if I dropped other work entirely and together with others devoted all my strength to speaking against the war, we could prevent it. . . ."[65] And then in one of her last conversations with her granddaughter, Jutta, she gave this profession of her faith in the future. "But one day, a new ideal will arise, and there will be an end to all wars. I die convinced of this. It will need much hard work, but it will be achieved."[66]

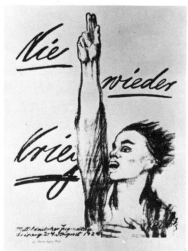

Fig. VI, 48 KÄTHE KOLLWITZ. *Never Again War!* "When you are grown, you must adjust to life, but never again to war," Kollwitz wrote to her son, Hans.

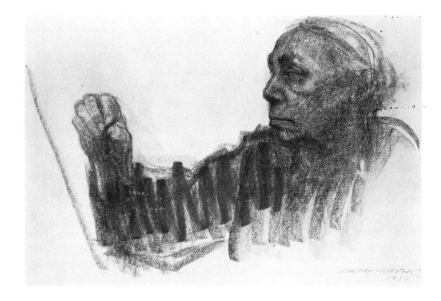

Fig. VI, 49 KÄTHE KOLLWITZ. *Self-portrait with a Pencil.* "For the last third of life there remains only work. It alone is always stimulating, rejuvenating, exciting and satisfying."

7

The Present Moment

Fig. VII, 1 BARBARA HEPWORTH. *Dag Hammarskjöld Memorial.* 1964. ". . . I had to work to the scale of twenty-one feet and bring into my mind everything my father had taught me about stress and strain and gravity and windforce. Finally all the many parts were got out of St. Ives safely, and when assembled in a big London studio they stood up in perfect balance. This was a magic moment."

Barbara Hepworth (1903–1975)

The Dag Hammarskjöld Memorial by the late Barbara Hepworth, one of the great sculptors of our century, serves as fitting transition from Käthe Kollwitz, and, indeed, this free-standing, three-dimensional form comes refreshingly to the eye. (Fig. VII, 1) "We return always to the human form—the human form in landscape," and since Hepworth's childhood the standing form has been, "the translation of my feeling towards the human being standing in landscape."[1] As with Kollwitz, gesture is her medium and feeling, her source. Her definition of sculpture: "Sculpture is a three dimensional projection of primitive feeling: touch, texture, size and scale, hardness and warmth, evocation and compulsion to move, live and love."[2] Her work emerges in classically abstract and yet organic form. "I rarely draw what I see—I draw what I feel in my body."[3] As early as 1931, a year before her friend and colleague Henry Moore began making his famous holes, Hepworth pierced her forms, taking "the most intense pleasure" in building her own "sculptural anatomy." (Fig. VII, 2) Piet Mondrian and Hans Arp were important influences, as was the abstract painter Ben Nicholson.

She remembers, however, that while their studios were most austere, her own was "a jumble of chil-dren, rocks, sculptures, trees, importunate flowers, and washing."[4] The startling fact that she and her second husband, Ben Nicholson, produced triplets cannot be left out of any account of Barbara Hepworth's triumph "no matter what the odds."[5] While Hepworth found incorporating "family, children, everything" an inspiration and a useful discipline, she did say about the experience of triple motherhood: "Three children of the same age want everything at the same time; but individually."[6]

Her balancing of this three-ring circus with her art was as sensible in its perspective as Kollwitz's and as affirmative: "my home came first but my work was there always."[7] Hepworth shares with Kollwitz the conviction that out of pain and loss must be salvaged the making of "some beautiful object . . . as a kind of present."[8] Her first son, Paul, was killed flying over Thailand, and working proved, "the only way I can go on."[9] Ever since, death and flying and going on are clustered in her poetic mind, and she wrote:

To go on seemed sensible. To descend a very hard discipline. I would like to be an astronaut and go round the moon, and maybe remain in orbit for ever. But I would not like to land in case the light of the moon went out forever and all poetry die and deeper anguish descend on this anguished earth.[10]

Hepworth, philosopher/poet/activ-

Fig. VII, 2 BARBARA HEPWORTH.
Pendour. 1947.

ist, "involved through my work" in all the world's anguish, will be much missed.

Her affirmative, musical, often huge sculptures make her the rightful heir of Sabina von Steinbach and all those women of the past who "thought big." The tombstone she designed for herself at St. Ives is three feet over the permitted height! She thought a suitable epitaph would be the title she chose when named a Bard of Cornwall: *Gravyor* (sculptor).[11] Hepworth complained about people always assuming she was a large woman. "It's not the strength which does it, it's a rhythm."[12] Strength could ruin the stone, as she never tired of pointing out. Her sculpting tools, her two hands, she describes as follows:

My left hand is my thinking hand. The right is only a motor hand. This holds the hammer. The left hand, the thinking hand, must be relaxed, sensitive. The rhythms of thought pass through the fingers and grip of this hand into the stone.

It is also a listening hand. It listens for basic weakness of flaws in the stone; for the possibility or imminence of fractures.[13]

She said of her gift with characteristic confidence: "I'm not afraid, you see. I know how to carve. No credit to me. I was just born like that."[14]

Georgia O'Keeffe (b. 1887)

"The truth is I've been very lucky," echoes Georgia O'Keeffe in response to the flood of letters asking her for advice and guidance. " 'Go home and work.' That's all I can tell anyone."[15] She did not find her independent vision by luck however; it took time and hard work. Though she had made up her mind at the age of ten to be an artist, academic art in America in 1905 was not to her liking. "I began to realize that a lot of people had done this same kind of painting before I came along. It had been done and I didn't think I could do it any better."[16] Imitation has always been impossible for O'Keeffe. She stopped painting in 1908, and it was not until she met a sympathetic teacher at the University of Virginia in 1912 that she began to work again. For a while she divided her time between painting and art education in northwest Texas, where the land was so dry there were no flowers for her students to paint. "That was my country—terrible winds and a wonderful emptiness."[17]

She began to strip away the layers of influence from teachers, critics, other artists:

I . . . found myself saying to myself

Fig. VII, 3 GEORGIA O'KEEFFE. *Single Lily with Red.* 1928. The flower was redeemed as proper subject matter for art by this fine American painter.

Fig. VII, 4 GEORGIA O'KEEFFE. *Cow's Skull with Calico Roses.* 1931. Quite accidentally one day she laid an artificial flower on one of the cow skulls she picked up on the desert. "And when I came back the rose in the eye looked pretty fine, so I thought I would just go on with that."

—I can't live where I want to—I can't go where I want to—I can't do what I want to—I can't even say what I want to—. Schools and things that painters have taught me even keep me from painting as I want to. I decided I was a very stupid fool not to at least paint as I wanted to.

I realized that I had a lot of things in my head that others didn't have. I made up my mind to put down what was in my head.[18]

O'Keeffe began drawing "what was in her head" in a series of abstractions, which she showed to a friend, Anita Pollitzer, enjoining her not to show them to anyone. Her friend promptly took them to the photographer Alfred Stieglitz, in whose Gallery 291, such innovators as Arthur Dove, Marsden Hartley, and John Marin met and exhibited along with O'Keeffe:

The relationship that Stieglitz and I had was really very good, because it was built on something more than just emotional needs. Each of us was really interested in what the other was doing. . . . Of course, you do your best to destroy each other without knowing it—some people do it knowingly and some do it unknowingly. But if you have a real basis, as we did, you can get along pretty well despite the differences."[19]

Stieglitz's 500 photographs of O'Keeffe are testament to that relationship.

The human figure never appears in her own work: "I have sat to so many artists that I would never ask anyone to do the same for me."[20] What inhabits her paintings are rocks, dead leaves, what Zelda Fitzgerald called "cosmic oyster shells," bones, and above all, flowers (Fig. VII, 3):[21]

Nobody sees a flower—really—it is so small—we haven't time—and to see takes time like to have a friend takes time. . . .

So I said to myself—I'll paint what I see—what the flower is to me, but I'll paint it big and they will be surprised into taking time to look at it—I will make even busy New Yorkers take time to see what I see of flowers.[22]

O'Keeffe finally redeemed the flower as proper subject for serious painting and then confused everyone by combining it with bones. (Fig. VII, 4) In 1931 O'Keeffe began painting bones—bleached pelvis bones and skulls that she found on her walks in the desert. Some people saw in this imagery a strong obsession with death, but: "To me they are strangely more living than the animals walking around. . . . The bones seem to cut sharply to the center of something that is keenly alive on the desert even tho' it is vast and empty and untouchable—and knows no kindness with all its beauty."[23]

This passion for empty space recently led O'Keeffe to make a series of air journeys. (She had never traveled much and when she did, it was to see the land—not the museums.) The powerful impact on her perspective resulted in paintings of sinuous rivers, lightning storms, clouds. The huge (twenty-four-feet wide) *Sky above Clouds* paintings give an extraordinarily spacious effect. Do not go to see them without a parachute!

While it is generally acknowledged that O'Keeffe has desentimentalized the flower, not enough mention is made of the humor in so many of her works, the Zen-like acceptance of the solidity of the rock as being no more or less present than the emptiness of space. O'Keeffe's paintings spring from the "real" image into the abstract through magnification and isolation. They evoke in us recognition of familiar forms: the folds; recesses,

spaces of a flower seen as clearly as canyons and hills. People like to associate with these images, but O'Keeffe herself has always been disconcerted by attempts to interpret them. She has said over and over that she simply paints what she sees. "It's just that what I do seems to move people today, in a way that I don't understand at all."[24]

Louise Nevelson (b. 1899)

If O'Keeffe knew at age ten that she was to be an artist, Nevelson was only nine when someone asked her what she wanted to be when she "grew up": "I want to be a sculptor, I don't want color to help me."[25] And now, after a lifetime of fulfilling that prophecy, she announces with the same confidence Hepworth felt: "I've been sculpting for many years. It's almost like breathing for me."[26]

Nevelson works in a variety of media, but she is most identified with her remarkable environments, assemblages of objects with every possible shape into one new shape; Cindy Nemser uses the word *tableaux* to describe their

Fig. VII, 5 LOUISE NEVELSON. *Sky Cathedral.* 1958. All the rubbish of Manhattan is transformed by this artist into "phantom architecture."

Fig. VII, 6 LOUISE NEVELSON. *Untitled.* 1957. "The dips and cracks and detail fascinate me."

Fig. VII, 7 LOUISE NEVELSON. *Illumination—Dark.* c. 1959.

Fig. VII, 8 AUGUSTA SAVAGE (1900–1962). *Lift Every Voice and Sing.* 1939. This harp of humanity, titled from the anthem by James Weldon Johnson, was commissioned by the World's Fair in 1939. Unfortunately, no money had been allocated to cast the statue in bronze and it was destroyed by bulldozers along with all the other "temporary structures" when the fair was over!

stage presence. This unity is mainly structural, but it is aided by the no-color, be it black, white, or gold, endowed each object. The effect is rarely stark; indeed, baroque is a word used often in connection with Nevelson's aesthetic. Her work plays back and forth between such paradoxes as: opacity and transparency, repetition and variety, detail and overall design, classic and baroque, unity and disparity. (Figs. VII, 5–7) She has accomplished her goal, which was to make "a statement that was *mine*," though she admits also: "as independent as we are, we have to have roots."[27]

For her, as for O'Keeffe, the struggle has sharpened her tongue, and she shares O'Keeffe's dismay over people's unwillingness to really look: "What do you need with windows when you don't have eyes?"[28] Speaking of her son's being off at war, she reminds us of Kollwitz and Hepworth: "If I have sorrow or enjoyment, my works go along with me. They are not just forms as such. Somehow, they have a life of their own and they reflect me."[29]

Hepworth, O'Keeffe, Nevelson—these three free-standing forms represent for us a generation of women philosopher/artists who have compelled the world to acknowledge their accomplishments and, by inference, every woman's potential for such accomplishments. The ubiquitous question, why are there no great women artists? sounds as irrelevant as it is when we consider their work.

Lois Mailou Jones (b. 1905)

It is never safe to argue from silence, as we noted in chapter I, and Lois Mailou Jones is the living answer to the charge that there are no black or other third world American women artists to include in art

history textbooks and classes. Beginning her formal art education at the School of the Museum of Fine Arts in Boston, Lois Jones found herself being absorbed into design rather than the fine arts. "I knew that my name would not go down in history," she said, and so after teaching for a while, she went off to Paris to study, on the advice of the sculptor Meta Warrick Fuller (1877–1967) and of Mary Beattie Brady of the Harmon Foundation.

It was in Paris that she first felt free to paint and "I worked every day," she remembers.[30] Upon her return to this country in 1938, Jones had an exhibit at the Vose Gallery in Boston, considered a major breakthrough for a black artist at that time. Her work during this period consisted of excellently done impressionist scenes of Paris. It was not until the early 1940s when she met the aesthetician Alain Locke that she began to paint works like *Mob Victim,* which explicitly dealt with her own background as a black American. (Figs. VII, 9, 10) Later in the fifties her marriage to Vergiaud Pierre-Noel took her often to Haiti, which had yet another influence on her style, and then a sabbatical leave in Africa again changed her imagery. Indeed the span of this distinguished artist's work covers so much of the development of twentieth-century art that it could be a textbook in itself. She is a model for us all.

Professor Jones has been teaching at Howard University in Washington, D.C. for forty-five years, and so has herself influenced several generations of artists (among them Elizabeth Catlett, whom we shall be seeing later). She is currently working on a collection of slides of black women artists for Howard University, which will be a valuable resource, as she has taught many of

the artists! We found in compiling the Third World American Women Slide Lecture what a rich area this is for research and we met some fine artists and art historians who are involved in such projects.[31] It takes only a little analysis to see the pattern of neglect, exclusion, condescension, and downright exploitation in the treatment of women artists of color in this country. The double bind of racism and sexism cramps creativity; training is almost impossible to obtain. The special demands on third world women to be practical and to support their families and to "keep it all together" have certainly influenced their development in the arts. The wonder is, as Benny Andrews says, that they

Fig. VII, 9 LOIS MAILOU JONES. *Meditation (Mob Victim).* 1944. The sitter for this work had actually witnessed a lynching in his youth and posed as he remembered the victim standing. The artist originally painted a rope around his neck, but she later deleted it.

Fig. VII, 10 LOIS MAILOU JONES. *Moon Masque.* 1971. This work illustrates an idea from African art—the use of collage areas to complement flat design. The patterns are personal interpretations of African motifs.

Fig. VII, 11 MARY BETH EDELSON. *Some Living American Women Artists*. 1972 *Dramatis personae* at this "Last Supper" (l. to r.): Lynda Benglis, Helen Frankenthaler, June Wayne, Alma Thomas, Lee Krasner, Nancy Graves, Georgia O'Keeffe, Elaine DeKooning, Louise Nevelson, M. C. Richards, Louise Bourgeois, Lila Katzen, Yoko Ono; Guests: (clockwise) Agnes Martin, Joan Mitchell, Grace Hartigan, Yayoi Kusama, Marisol, Alice Neel, Jane Wilson, Judy Chicago, Gladys Nilsson, Betty Parsons, Miriam Schapiro, Lee Bontecou, Sylvia Stone, Chryssa, Suellen Rocca, Carolee Schneeman, Lisette Model, Audrey Flack, Buffie Johnson, Vera Simmons, Helen Pashgian, Susan Lewis Williams, Racelle Strick, Ann McCoy, J. L. Knight, Enid Sanford, Joan Balou, Marta Minujin, Rosemary Wright, Cynthia Bickley, Lawra Gregory, Agnes Denes, Mary Beth Edelson, Irene Siegel, Nancy Grossman, Hannah Wilke, Jennifer Bartlett, Mary Corse, Eleanor Antin, Jane Kaufman, Muriel Castanis, Susan Crile, Anne Ryan, Sue Ann Childress, Patricia Mainardi, Dindga McCannon, Alice Shaddle, Arden Scott, Faith Ringgold, Sharon Brant, Daria Dorsch, Nina Yankowitz, Rachel bas-Cohain, Loretta Dunkelman, Kay Brown, CeRoser, Norma Copley, Martha Edelheit, Jackie Skyles, Barbara Zuker, Susan Williams, Judith Bernstein, Rosemary Mayer, Maud Boltz, Patsy Norvell, Joan Danziger, Minna Citron.

have survived at all.[32] Yet survive they have and in impressive numbers and quality and variety. Third world women are organizing in their own behalf exhibitions, demonstrations, mural projects, and other such important activities in the long struggle to return art to the people.

"THE BURNING GROUND OF THE PRESENT"

There have been many great women artists active (if not always acknowledged) in the twentieth century. This is not the place to recapitulate all the schools of modern art, and indeed, we do not have the space to do so. To list names here would inevitably mean invidious omissions, and Mary Beth Edelson has imaginatively organized a magnificent banquet in their honor! (Fig. VII, 11) Fortunately, contemporary artists can and do speak for themselves through their exhibits, inter-

views, and support groups. We are showing just a few examples from Surrealism, Abstraction, Abstract Expressionism, Minimalism, Photorealism, and finally, the new Feminist Art. So much of recent art depends upon direct experience, elaborate technology, or, at the very least, color reproduction; there is no way we can do justice here to the subtle values of paintings by Agnes Martin or dynamic performances by Eleanor Antin. (Figs. VII, 12–23)

Fig. VII, 12 MARIA ELENA VIEIRA DA SILVA. *Labyrinth.* 1956. "When I make a painting, I always forget what I may have seen." Vieira da Silva's shimmering images are frequently derived from architectural forms and through the broken surfaces of the canvas, one glimpses the original object intermittently.

Fig. VII, 13 I. RICE PEREIRA. *The Celestial Gate Sways on the Ringing Swells.* Pereira helped to make abstract art possible for many of us because of her own faith in it, her understanding of space and light, her fascination with the fourth dimension, her experiments in different media. She was open to unconscious material, but still used the control of form. In this work, the forms are solid and yet they float, which reassures the age-old wish for both gravity and grace.

Fig. VII, 15 LEE KRASNER. *The Guardian.* 1960. Working with courage and devotion to her own vision in the severely male-dominated New York school of Abstract Expressionism, Krasner's powerful abstractions merge with the organic into what she calls "the ever present."

Fig. VII, 14 LOREN MACIVER. *Skylight Moon.* 1958. MacIver has never relinquished the object in her painting. She has retained a feeling of wonder for the simplest things in view. Her windows and skylights allow for vision also and her work approaches pure abstraction.

Fig. VII, 17 GRACE HARTIGAN. *Grand Street Brides.* 1954. "I am very interested in masks and charades—the face the world puts on to sell itself to the world. I have always been interested in empty ritual. I bought a bridal gown at a thrift shop and hung it in the studio. Every morning I would go out and stare at the windows and then come in and paint."

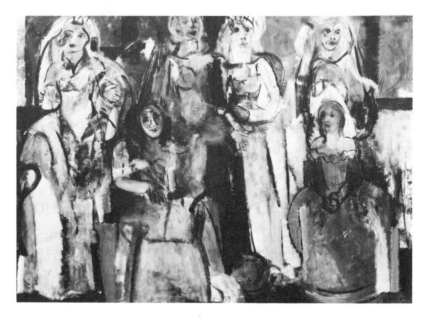

Fig. VII, 18 JOAN SNYDER. *Soft Pocket Song.* 1973. Like many artists today, Joan Snyder claims her subject matter is the paint and that she is not willing to have "beautiful" works; she wants "tear the art out of the flesh" pictures. A soft pocket has been created out of the flesh of this painterly piece.

Fig. VII, 19 LEE BONTECOU. *Untitled.* 1961. The sense of vulnerability, of being a target and needing armor, paradoxical images, based at least somewhat on the primitive folk art motif of the teethed vagina and the psychological archetype of the devouring mother, the teeth mother. It takes a woman artist to think of installing zippers in a chastity belt!

Fig. VII, 16 JOAN MITCHELL. *Lucky Seven.* 1962. Joan Mitchell works with control and accident, with arm-long arc strokes and the gravitational pull of the drops, to construct these vibrant, beautifully colored pieces.

Fig. VII, *20* EVA HESSE. *Sans II*. 1968. This tremendously important and influential sculptor (who died at thirty-three) accepted chaos and accident as part of her medium, eschewed the seductions of color, experimented with all sorts of plastics and synthetic fibers to make monuments to transiency.

Fig. VII, *21* NANCY GRAVES. *Variability and Repetition of Similar Forms.* 1971. From the Shaman series by this infinitely variable artist, the work is made up of such exotic and powerful substances as the following: steel, latex gauze, oil, marble dust, acrylic, and wax. Out of this witches'-brew comes a magical mobile.

Fig. VII, *22* MARY BAUERMEISTER. *Sketch for Tanglewood Press.* 1966. "To find out what I know or want is the actual reason why I paint." Bauermeister uses optical lenses to turn black lines into color by defraction and to unfix all dimensions and illusory sureties generally. She will sometimes cross out something she doesn't like or write on it "cancelled," as if the art object were nothing more than a draft.

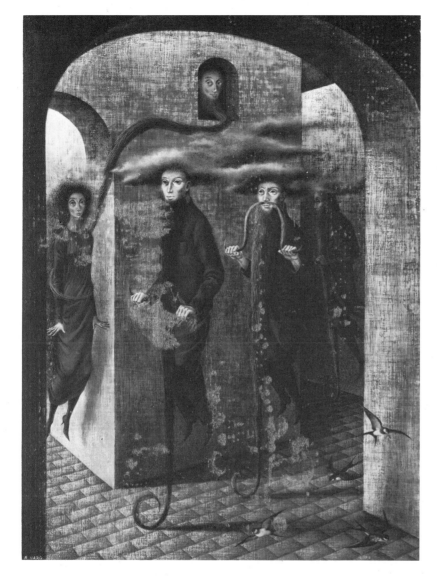

Fig. VII, 23 CECILE ABISH. *About Face.* 1974. The artist's philosophy is as follows: "Duration of the sculpture is possession of a surface." She has accepted the fact that the surfaces upon which she works do not belong to her; she even enjoys that fact and works *with* it. "Everywhere surfaces await the coming of sculpture. . ."

Fig. VII, 24 REMEDIOS VARO. *Capillary Movement.* A reversal of the Rapunzel myth. These learned gentlemen have their heads in the clouds, while they navigate by their handlebar mustaches.

The Surrealists

. We have chosen to emphasize the contributions of the neglected women Surrealists. Surrealism has always claimed special affinities with women, and certainly many extraordinary women artists have received from it stimulus, permission, and context to develop their own mad and wonderful "outsider" visions. In the rush of popular (and of publishing) response to Surrealism, just a few names, and all of them male, have attracted disproportionate attention. Leonor Fini, Leonora Carrington, Meret Oppenheim, Toyen, Remedios Varo, Elena Garro, Joyce Mansour, Jane Graverol, Dorothea Tanning are all mentioned by Gloria Orenstein in her ar-

Fig. VII, 25 REMEDIOS VARO. *The Vegetarian Vampires*, who for lunch have watermelons, tomatoes, strawberries, and a rose. Their pet chickens have grown an extra set of drumsticks.

Fig. VII, 26 REMEDIOS VARO. *The Useless Science or the Alchemist.* The scholar has dug himself in completely. The artist's father was an hydraulic engineer, the source of some of this imagery.

ticle "Women of Surrealism."[33] We show a few of these artists here, but a whole book is needed and an exhibit also.

Remedios Varo's work receives tremendous response from all who see it, and yet there is no book on her in English.[34] We are thus especially grateful to Walter Gruen, hus-

band of the late Remedios Varo (1913–1963), for permission to reproduce some of her fantastical paintings in our survey. (Figs. VII, 24–27) Another surrealist and one of Varo's best friends. Leonora Carrington's art and philosophy were featured in a recent *Ms.* article.[35]

Works by Leonor Fini (b. 1918) ap-

pear throughout this book, thanks to the generosity of the artist, and there are available books and articles on her, generally in French.[36] (Figs. VII 28, 29) She has lived everywhere and known everyone. She continues to develop her own unorthodox style, according to the promptings of her rich, mythopoeic imagination, through "submission to the unconscious which is the only freedom possible."[37]

Dorothea Tanning's (b. 1910) important early *oeuvre* is described only in Alain Bosquet's difficult to obtain French monograph.[38] She has recently had a retrospective in Paris where she lives and is working now in soft sculpture. Tanning does not seem anxious to increase her reputation in this country, though/or because she was born and raised in Illinois. In her wonderfully to-the-point biographical sketch in Bosquet's book, she describes her flight from home and her transports when, in 1937, she attended the *Fantastic Art, Dada, and Surrealism* exhibit at the Museum of Modern Art and "knew, henceforth, where to find her friends."[39]

Is it important that Frida Kahlo (1910–1954) knew the high priest of Surrealism, André Breton? Or would she not have found her own way without any such foreign influence? He wrote of her: "an indeed feminine art, that is to say at the same time the most pure and the most pernicious: a ribbon tied around a bomb."[40] Her use of Surrealism was a kind of joke that some people got and others took seriously. Her black humor, her white invincibility, the red and green accents of blood and rebirth are all acted out in the dramas of her paintings, where the meaning is all too clear.

Frida began to paint in her youth when bedridden by a terrible accident, *"por puro aburrimiento,"* as she said, and her last painting was done from a wheelchair after her leg had been amputated. Illness was the most important factor in her life, looming even larger than Diego Rivera, whom she married (twice, in fact), and images from hospitals are part of her real and her symbolic landscapes. But her paintings will tell the story better than we can.[41]

Fig. VII, 27 REMEDIOS VARO. *The Phenomenon of Weightlessness.* The astronomer has succeeded in breaking gravity's hold on the earth and everything is shifting and heaving.

Fig. VII, 28 LEONOR FINI. *The Lesson on Botany.* 1974.

Fig. VII, 29 LEONOR FINI. *Wrapped in Silence.* 1961.

The Present Moment **133**

Fig..VII, 30 MERET OPPENHEIM. *Object (Breakfast in Fur)*. 1936. This fur-lined tea cup is a famous Dada piece, though few people recognize it as the work of a woman.

Fig. VII, 31 KAY SAGE. *No Passing*. 1954. Perhaps a gallery of unpainted pictures.

Fig. VII, 32 FRIDA KAHLO. *The Broken Column*. Frida wore this kind of brace, and felt this kind of pain.

Fig. VII, 36 FRIDA KAHLO. *Roots*.

Again the self-portraits are diary pages really, public disclosures of the unique self in a way that universalizes the revelation.[42] *The Broken Column* shows the reality of the accident's damage to her spinal column. (Fig. VII, 32) Frida always bedecked herself gorgeously in festive native dress and exotic jewelry, projecting quite a different image than does this orthopedic corset, but in her paintings, she is willing to bare her breast like some modern St. Sebastian, acknowledging the long crucifixion of pain.

Tears, the barren landscapes, the dark eyebrows meeting, the vascular system of plants and humans, all these images recur in her works. Some of her paintings

are cosmic and complex visions in extraordinarily small compass. Others zero in on one scene from Frida's struggle with Diego. (Fig. VII, 33) Using one of her favorite forms, the *retablos* painted of miracles in Mexican shrines, she shows herself encased in one of Diego's oversize suits, surrounded by her shorn hair. She is proving a point, and the popular song written above reiterates it.

The most painful of her paintings deal with her own miscarriage. Frida wanted so much to have a child by Diego, but her body could not hold it to term. She took up the scene again and again, sometimes painting the blood out over the frame as if to warn us that life and art cannot be kept separate. (Fig. VII, 34) A more cosmic vision of birth can be found in her mural in miniature, *The Birth of Moses,* a congregation of heroes. (Fig. VII,

35) Kahlo went on to paint her body and blood replenishing the very roots of the earth. So many of her works show the renewal of stale, static, barren situations by violent suffering and sacrifice. (Fig. VII, 36)

At the age of forty-four Frida Kahlo died in the house where she was born. It is now the Museo Frida Kahlo, devoted to her memory, her collections of folk arts, and her own glowing, telling works.[43] People who have visited the museum in the suburbs of Mexico City, tell us that it is nearly always deserted and that the air seems heavy with portent, as if some calamity had just occurred.

Feminist Art

Frida Kahlo has become, by her personal and artistic honesty and heroism, *La Patrona* (patron saint) of all those women artists strug-

Fig. VII, 33 FRIDA KAHLO. *Self-portrait with Cropped Hair.* "You see, if I loved you it was for your hair—now that you've cut it off I don't love you any more."

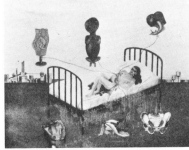

Fig. VII, 34 FRIDA KAHLO. *My Miscarriage.* One of several depictions of her own miscarriage.

Fig. VII, 35 FRIDA KAHLO. *The Birth of Moses.* Frida painted this remarkable work after reading Freud's analysis of Moses's birth.

Fig. VII, 37 FRANCES GILLESPIE. *Self-portrait,* following in the tradition of honest disclosure begun by Modersohn-Becker. The artist is also working on a nude painting of her young daughter, an exercise in trust between women.

Fig. VII, 38 CHARLEY TOOROP. *Self-portrait.* This late Dutch painter's face sums up that nerve-end intensity of many women's faces in this modern world.

gling to find an art form to contain their own broken columns, their own transfigurations. Artist/woman is as important to them as woman/artist. Joan Snyder, in a recent *Ms.* forum on art, noted that: "Women tend to be more autobiographical in their work than men."[44] Now that more and more women are coming to recognize their own lives as interesting and universal and proper subject matter for art, their women's content can become visible and uncensored. This art can now be seen in a context and by an audience that is not ashamed of it, that indeed is buoyed up by the energy of disclosure. (Figs. VII, 37–39) It is "a sort of defiance," as Lucy Lippard says.[45]

Some artists have been able to defy current art trends right along, without support groups or models. For example, except that as an example she is always the exception, Alice Neel, a rebel who did figure painting (and what figures!) when no one else dared to, is now at seventy-five finally coming into her own, exhibited and reproduced everywhere. In answer to the "compliment" that she paints like a man, she says, "I always painted like a woman, but I don't paint like a woman is supposed to paint. Thank God, art doesn't bother about things like that."[46] She goes on to say, however, the world does, and many women artists were influenced and inhibited by fear of being identified as painting like a woman. Judy Chicago describes two patterns in the lives of the women artists she and Mimi Schapiro visited: those who worked in almost total isolation, finding their content in their experience as women and having little or no contact with the art community; and "those whose work was more neutralized as Mimi's and mine had

been," through their connection with the art world.[47] These two patterns are merging now, as women artists begin to learn from one another, trust one another, benefit from better communication brought about by such groups as A.I.R., Artemisia, Front Range, San Francisco Women's Art Center, WEB, and the Feminist Studio Workshop at the Woman's Building.[48]

In art, as in literature, medicine, education, religion, and politics, women are challenging the accepted views of "professionalism." Authorities, guilds (official and unofficial), complex and expensive technology, competitiveness, and mainstream values have been used to exclude women for too long. Lucy Lippard describes some of the forms this discrimination can take, for example: "refusing to consider a married woman or mother a serious artist no matter how hard she works or what she produces."[49] An excerpt from a letter sent us by a married woman/mother/artist shows how all three roles can, with struggle, come together:

Every year I am able to work longer, painting all day long as I can, and then trying to get into gear with my kids when they come home. I have little time for companionship with other women. The better I get, the more my husband helps and understands me, since he is an artist and understands that struggle. He is not a woman, but he is getting better all the time. It is getting so we are two artists sharing the same life and concerns.

An important change from the "That's so-and-so's wife; I think she paints, too" syndrome!

Yet another problem comes from the anomalous position of women in the "unfortunately influential social life of the art world (if she comes to the bar with a man she's a sexual

appendage and is ignored as such; if she comes with a woman she's gay; if she comes alone she's on the make). . . ."[50] Dealers are reluctant to take on a woman artist because "women's art does not sell," or "we have our woman."[51] The corrupt practice of selecting only a few "greats" in order to inflate the commercial value of their works has done untold damage to many fine women and men artists and has distorted the face of art as it is perceived by those outside the ever-narrowing art world.

Political people have, after all, been warning us for some time that a revolution in form is not necessarily revolution enough.[52] Elizabeth Catlett said in a recent "non-political" visit to this, her native country: "Art for me now must develop from

Fig. VII, 39 AUDREY FLACK. *Self-portrait.* 1974. Flack's photo-realist still lifes, her explicitly political pieces, and her portraits give us a vision of the real world restored, as Cindy Nemser says, to its inherent splendor, made lovely again by a purifying bath of light.

Fig. VII, 40 JUDY CHICAGO. *Female Rejection Drawing.* 1974. This work, one of a series, was recently exhibited in San Francisco, and people, drawn by the power of the image, stayed to read every word of the statement, which is part of the painting.

Fig. VII, 41 JUDY CHICAGO. *George Sand* (from the Reincarnation Tryptich). 1973. This work is from "The Great Ladies" exhibit, which emerged from a year of intense study of creative women of the past.

a necessity within my people. It must answer a question or wake somebody up or give a shove in the right direction—our liberation."[53] Is this going to result in art that is "too personal," "too didactic," "too political"? Of course, the answer here is that *all* art is political, even and especially that which gets accepted by the Art Establishment; only because the "message" of mainstream art is less threatening is it less noticed.[54] Judy Chicago wonders if there is "a way for abstract art to have the same kind of impact on values that representational art and performances of Womanhouse had provided."[55] She herself has pledged "to make my work openly subject-matter oriented (while still being abstract) and to try to reveal intimate emotional material through my forms."[56] (Figs. VII, 40,41) Released from the pressure to neutralize any imagery that might identify us as female, we are exploring often taboo areas, and as Kandinsky said of an earlier revolution:

To each spiritual epoch corresponds a new spiritual content which that epoch expresses by forms that are new, unexpected, surprising, and in this way aggressive.[57]

From her experiences in feminist art education, Judy Chicago explains:

As students become successively more connected with themselves as women, they usually go through a stage of making very overt art. This art is often awkward because it is an attempt to articulate feelings for which there is, as yet, no developed form language. As the women develop as artists, they build skills that are relevant to their content. Their work improves and they become more sophisticated, but that sophistication is built on a solid, personal foundation and is not the result of imitating prevailing art modes.[58]

Mary Beth Edelson recently held an exhibition at the Henri Gallery in Washington, D.C., called *Women's Lives* in which each work commemorated a different aspect of our lives. Under each piece was placed a table and stool, writing materials, and wooden file boxes. A person coming to the show was expected to look at, say, the piece called *Blood Mysteries* and then sit down and write or draw out her own story of menstruation, leaving it in the box to become part of the ongrowing exhibit. (Figs. VII, 42,43) Mary Beth thus shows us that she needs us and trusts us to tell our stories, to tell the truth, to be artists, all of us; she shows that she is bored with the isolation of the artist, the closedness of so many "openings."[59]

The professional women artists from the past derived tremendous satisfaction from their sharing. It is not conducive to creativity to have no audience, as Virginia Woolf complained during the war (and just before her suicide). Sonia Sekula (also a suicide) wrote in a letter to Betty Parsons in 1956: "Would like to paint on a big canvas, in my mind I try and try to do it—but am subconsciously discouraged at having to hide it all again in some dusty storage place—Gave up the studio as I don't know where to go next. . . ."[60] The importance of support for male artists has always been recognized, as we see in the following sympathetic quotation about Thomas Eakins:

There can be no doubt that his art was affected by lack of recognition. Any artist, no matter how strong, is in some degree dependent on a sense of solidarity with the society of which he is a part.[61]

Women artists, too, "no matter how strong," continue to feel the deleter-

Fig. VII, 42 MARY BETH EDELSON. *Blood Mysteries.* 1973. Part of a recent exhibit called "Women's Lives."

Fig. VII, 43 MARY BETH EDELSON. *Blood Mysteries.* Detail.

The Present Moment **139**

Fig. VII, 44 MIRIAM SCHAPIRO. *Shrine.* 1962. The combination of her earlier architectonic forms with these flowered fabrics was for the artist an experience of liberation and of synthesis.

Fig. VII, 45 FAITH RINGGOLD. *Bernice Mask.* From the Family of Woman series. 1974. An activist in many realms. Ringgold has turned her strongly satiric and strongly loving eye on the civil rights struggle in the sixties in much-reproduced works like *The Flag is Bleeding.* Her recent work has turned more to affirmative images from black culture, like this sculpture. Her mother, Willi Posey, is the artist who makes the clothing for Ringgold's life-size figures.

ious effects of general lack of recognition. As Linda Nochlin reminds us: "I would like to point out that men artists have never felt a reluctance to join together to make their position clear."[62] She adumbrates this position as:

Not all women artists are feminists; not all feminist artists wish to incorporate their feminist identity into their art works, and certainly, even if some of them do, none of them will do it in the same way. Miriam Schapiro's collages are unique and deeply personal statements: they are by no means programmatic or didactic in their intentions or their effects. They do, however, in their splendor and novelty, suggest one of the many possible modes of interaction between feminism and art, in which the woman artist's consciousness of her identity can function with the same force and validity as did the Abstract Expressionists' awareness of their identity

as Americans in the forties and fifties. The impact of the Women's Movement has already made itself felt in the art world in a variety of significant ways; it is predictable that in the seventies, women, freed from the demands of traditionally feminine roles and the compulsion to react against them by adopting equally stereotyped masculine stances, or perhaps operating in an area of creative tensions generated by the very consciousness of opposing options, will play an increasingly dominant role in the shaping of art.[63]

More options, creative pluralism, honesty, new standards, provide "a daring way out of the reductive corner into which mainstream abstraction has painted itself in the last few years."[64] (Fig. VII, 44)

It is not just the return of the human figure, though that is a significant aspect of it—Jenny Snider speaks movingly of her acute em-

Fig. VII, 46 NIKI DE SAINT-PHALLE. *Black Venus.* 1967. Her playful black venuses never threaten by their bulk. In Stockholm the artist constructed an enormous figure called *hon* ("she"). Visitors to the exhibit entered at her vagina and walked around inside.

Fig. VII, 47 LEONOR FINI. *The Ideal Life.* 1950. Fini said in a recent conversation, "I live with my few friends and my many cats."

Fig. VII, 48 ELIZABETH CATLETT. *Homage to my Young Black Sisters.* 1969. (Two views.) This American artist, living in Mexico, wished to do something to honor the struggle for liberation by black women in this country and everywhere.

Fig. VII, 49 BETYE SAAR. *The Liberation of Aunt Jemima.* 1972. This artist understands the power of dolls and in fact has been collecting commercial (and derogatory) images of black women for some time, the better to use them in her own affirmative doll-house-type box constructions, such as we see here. As Samella Lewis says, this grinning image is transformed from a "mammy" doll into an aggressive warrior for black liberation . . . the real Aunt Jemima will be free.

barrassment when actual arms and legs began showing up in her grids and friezes.[65] Nor is it a return to the "patient adhocism" of quilts.[66] It is not a return to anything, as we read it, but a radical reaching out to claim for art that "insubstantial terri-tory" of the human heart.[67]

For what more terrifying revelation can there be than that it is the present moment? That we survive the shock at all is only possible because the past shelters us to one side, the future on another.[68]

Fig. VII, 50 MARY BETH EDELSON. *Great Goddess Series.* 1975. "Reaching across the centuries we take the hand of our ancient Sisters."

Fig. VII, 51 BARBARA CHASE-RIBOUD. *Confessions for Myself.* 1972. "Barbara Chase indicates the limits of her horizons: '. . . to salute that power that exists in all beings in the form of Illusion. Reverence to Her. All reverence to Her. Reverence . . .' "

Ladies of the Jade Studio: Women Artists of China

ANCIENT CHINA: THE PEOPLE OF SILK

The Seres make precious figured garments resembling in color the flowers of the field, and rivaling in fineness the work of spiders.[1]

Women's contributions to the arts of China are celebrated as beginning around 3000 B.C., when the legendary Yellow Emperor's consort invented and taught to the people the techniques of spinning, dying, and weaving silk. This contribution to civilization was so important that until the revolution of 1911, the reigning empress annually made a sacrifice to the Yellow Emperor's consort. We do have evidence that silk was in existence in the Shang dynasty (eighteenth to twelfth centuries B.C.) and that it was highly regarded, as it is frequently mentioned in the earliest examples of Chinese writing, the famous oracle-bone inscriptions.

Throughout Chinese history the production and decoration of silk has been largely the work of women. Caring for the sensitive silkworms that dislike noise, movement, and even strong odors, unraveling the silk cocoons, winding the fibers, dying, and finally weaving them is a tedious process. Besides coaxing their charges to consume carefully prepared mulberry leaves, some especially devoted women carried cocoons around in their long sleeves or bosoms to keep them warm. (Figs. VIII, 2, 3)

Images of women and silk are already closely related in the earliest collection of poetry, the *Shih Ching* (first millenium B.C.); silk fibers and fabric make for a rich variety of poetic metaphors. In these two songs by Tzu Yeh, a fourth-century wineshop girl, we again see the importance of silk in women's lives:

Winter's here—
October,
November.

By myself
I bind the
unreeled silk.

Winter's clothes
are not yet
stitched and hemmed.

Tall men call
me "love," and
I work on.[2]

In the early days of our affair,
Our two desires had one design.
But, patterned silk in a broken loom?
Imperfect silk is all you'll get.[3]

Silk was indeed one of the wonders of China; its texture and deep color fascinated foreigners unacquainted with such delicate fabric and contributed significantly to the inauguration of trade between China and the West. In fact, China owes her first Western name to this feminine art: the Greek *Seres* (People of Silk) came from the Chinese word for silk, *ssu*.[4] It was through

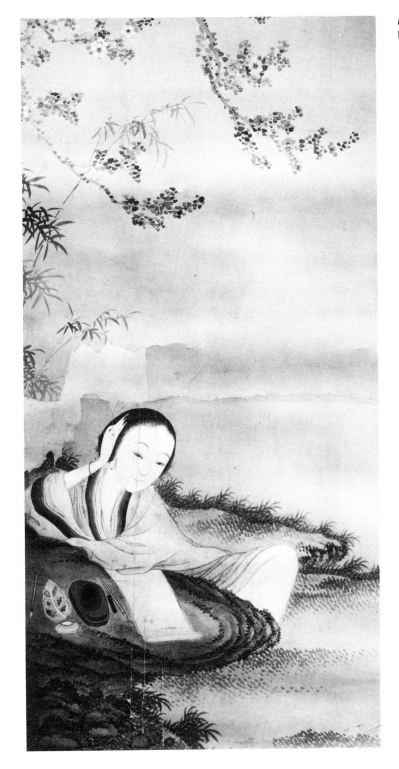

Fig. VIII, 2 Women tending silkworms. Woodcut.

Fig. VIII, 3 Women reeling silk filaments. Woodcut.

the textile arts, not through the now more prestigious "fine" arts, that East and West first exchanged ideas and culture. In the Roman Empire, which traded extensively with China, silk was valued so highly that it was worth more than its weight in gold.[5]

As the manufacture of silk became increasingly profitable, guilds and workshops formed, and the miraculous silkworm was even smuggled out of China. But it seems that foreign poachers did not have the sensitive touch needed for cultivating the temperamental creatures and turning their weblike filaments into cloth. To remedy such problems, Japanese workshops requested the assistance of four Chinese girls to operate silk looms.

After trade on the famous Silk Road through Turkestan slacked off, the West again lost commercial contact with China until relations were resumed during the Yüan dynasty. In Medieval Europe the church imported Chinese silk to make wall hangings. Imagine the cross-cultural process that produced such unusual juxtapositions as an embroidered-silk wall hanging of St. Anthony of Padua and Jesus surrounded by Chinese phoenixes and Far Eastern landscapes—but, as we have seen in chapter II, medieval nuns were not fussy about conformity![6]

The painstaking process of spinning, weaving, and embroidering silk ruined many women's eyesight. Compassion for these anonymous craftswomen is expressed in the following poem by Ch'en T'ao, a concubine of a Sung prime minister:

Her Husband Asks Her to Buy a Bolt of Silk

The wind is cruel. Her clothes are worn and thin.
The weaver girl blows on her fingers.
Beside the dark window, back and forth,
She throws the shuttle like a lump of ice.
During the short Winter day
She can scarcely weave one foot of brocade.
And you expect me to make a folk song of this,
For your silken girls to sing?[7]

The finished embroidery, with stitches so tiny one might mistake it for a painting, certainly does not deserve to be dismissed as a minor, domesticated art. (Fig. VIII, 4) Most textiles are unsigned, but some women did manage to have their embroideries recognized as art. In the fifteenth century the famous women of the Ku family, working in a studio called "Garden of the Fragrance of Dew" in Shanghai, embroidered silk panels that were praised as "one of the wonders of the world."[8] The fine work of the Ku women can be identified by the stitch technique, composition and coloring, and the variety of facial expressions and posture.

THE EARLY CENTURIES A.D.: THE FOUR TREASURES OF THE LITERARY STUDIO

As well as being used for interior decoration and clothing, silk was the first versatile writing material. Writing on silk was more easily accomplished than carving on bone, stone, or shell and could be stored more conveniently. From silk it was only a few steps to paper; silk rags and finally tree bark and other materials were used to produce the world's first paper in second-century China (while Europeans awaited its "invention" in the thirteenth century).[9] Little did the Yellow Emperor's consort know, when she probed the secrets of the silkworm several millenia before, that

Fig. VIII, *4* Embroidered imperial dragon. Ming dynasty.

her discoveries would lead to trade with the West and to a momentous advance in written language—or did she?

In A.D. 102, an imperial concubine by the name of Teng, just made empress, declared that instead of receiving the usual "precious and beautiful tributes from various countries," she would rather have only *chih* (paper or its silk-fiber precursor) and ink-cakes.[10] This account, mentioned in the *Hou Han Shu,* the official history of the Later Han dynasty (A.D. 25–220), does not say what plans Empress Teng had for all that paper and ink! It is known that the empress was well educated, having studied classical writings, history, astronomy, and mathematics under the noted woman historian Pan Chao.[11] After

the emperor's death in 105, Empress Teng became regent and until her death in 121, ruled China with Pan Chao's assistance.[12]

Women also had a hand in the production of ink, another treasured commodity in China. (Fig. VIII, 5) Fine ink was made of lampblack, glue, and a light scent (such as musk) carefully prepared and pressed into sticks. By the third century A.D. the "four treasures of the literary studio" were in use: paper, brush, ink, and ink-stone. Silk and paper, ink and paint are interchanged in such a way that strict division of painters and calligraphers is impossible. Both required skill in handling the brush, and both were held in high esteem artistically. Chinese women artists were often calligraphers and poets as well. Creating with ink and brush, they embodied a concept that is inherent in the semipictographic Chinese written language itself—the unity of visual and verbal expression. A painting with a poem written upon it is appreciated on several levels: for its painting style, poetic content, and calligraphy. Brush strokes, whether in writing or painting, express one's character.

CHIN DYNASTY (265–420): WEI SHUO AND CHU CHING-CHIEN, CALLIGRAPHERS

In ancient China few women, even of the aristocracy, were literate. However, women did make a place for themselves in the lineage of great calligraphers. The calligraphic lineage of Wei Shuo (or Wei Fu-jen, "Lady Wei") goes back to the master Ts'ai Yung, whose daughter Wen-chi was the teacher of Chung Yu, upon whose style Wei's is founded. Her calligraphy was of the angular *li* style and is described in Chang Yen-yüan's *Fa-*

Fig. VIII, 5 Women making ink sticks. Woodcut.

shu yao-lu (Catalog of Famous Calligraphy): "Her art was like the breaking of ice in a crystal jar, or the glowing of the moon over a tower of jewels; graceful as a tree in fragrant blossom, and soothing as a clean breeze."[13]

Wei Shuo wrote a manual called *Pi-chen t'u* (Diagram of the Battle Array of the Brush), in which she compared calligraphy to the art of war. Writing in 348, Wei begins her book by appealing for strength and "bone" in writing, lamenting that "in this modern age people do not study the old masters."[14] This observation prompted her to compile her manual to "give this information to my descendants as a permanent model, and I hope that men of culture *(chün tzu)* in the future will look it over at times."[15] Wei Shuo's wish was fulfilled, as *Pi-chen t'u* did indeed serve as guidance for later calligraphers and painters as well, such as Chang Seng-yu (fifth to sixth centuries), whose painting was inspired by the "sharpness of swords and spears" from Wei's book.[16]

Wei starts with the basics, describing the best materials for making high-quality brushes, ink, and paper and recommending, for instance, the hair of hares from Chung-shan (gathered in the eighth and ninth months) and soot from the pines of Lu-shan mixed with glue of Tai-chün (to make ink-sticks as hard as stone). First, one should learn how to hold the brush properly and practice writing large characters, sending forth the brush "with all the strength of your body."[17] One should always pay attention to balance, so as not to produce sloppy calligraphy:

The writing of one who has strength of brush is "bony" and the writing of one who is weak in brush is "fleshy." Writing that is bony with

little flesh is called "muscular"; writing that is fleshy with little bone is called "ink hog." Writing that has much strength and is rich in muscle is sacred; writing without strength and muscle is sickly.[18]

Wei Shuo's system involves seven basic brush strokes, which she describes in colorful detail. The first is "like a line of clouds stretching a thousand miles, not distinct but having form"; the second is "like a rock falling from a high peak, bounding but about to crumble"; the third is "clean cut like [the horn of] a rhinoceros and [the tusk of] an elephant"; the fourth resembles "a shot from a crossbow one hundred *chün* in strength"; the fifth is like an "old vine ten thousand years of age"; the sixth is like "breaking waves and rumbling thunder"; and the seventh resembles "sinews and joints of a strong crossbow."[19] Wei's brush technique is applicable to painting as well; her use of nature metaphor in describing the "seven strokes" is particularly reminiscent of landscape painting.

She concludes her manual with a discussion of the modes of using the brush and advises that quickness of mind is more important than rapid hand manipulation: "In the mind are the parts and for each character the form is made. In this manner the highest excellence is attained. Thus ends the way of writing. Made and recorded in the fourth year of Yung-ho [A.D. 348]."[20] No sample of Wei Shuo's writing survives, but her teachings profoundly influenced later schools; not only did she leave us her manual, but her student Wang Hsi-chih is remembered as the greatest calligrapher of all time.

Chu Ching-chien, also of the Chin dynasty, is remembered for her brushwork, too, although she was not a calligrapher per se. Chu is listed as one of the "teachers of great influence" in *Pi-ch'iu-ni chuan (Biographies of Famous Chinese Nuns)*, an unprecedented work compiled in the sixth century.[21] While the only previous book devoted to women, *Lieh-nü chuan (Biographies of Exemplary Women)*, emphasized such Confucian virtues as chastity, obedience, and motherly love, the heroines of *Pi-ch'iu-ni chuan* are complimented for their intelligence, strength, and determination, even when it led to unfilial conduct. As a child Chu loved learning, and when orphaned, she supported herself by teaching calligraphy and playing the lute. Her greatest accomplishment was the founding of the first Buddhist convent in China.

T'ANG AND SUNG DYNASTIES (618–907 AND 960–1279): HSÜEH T'AO, KUNG SU-JAN AND YANG MEI-TZU, SYNTHESIZERS OF LITERATURE AND VISUAL ART

T'ang dynasty, a golden age of the arts, was a period of many developments in painting. We begin to have more records of individual painters, and though few works by women survive, their names are listed among the memorable artists of the T'ang.

Hsüeh T'ao (c. 760), a singing girl from Ch'ang-an, was born into a poor family in the capital. She moved to the southwestern province of Szechuan and, after her father's death, was sold by her poverty-stricken mother to a brothel there. Later, Hsüeh became a recognized poet; she associated with such famous poets as Po Chü-i and attended banquets and poetry contests given by the governor of Szechuan. In fact, she was so popular in literary circles at the "second cap-

Fig. VIII, 6 KUNG SU-JAN. *Consort Ming Crossing the Frontier.* Early 12th c. Section of a handscroll, almost seven feet long.

ital" that the nephew of Tu Fu praised her as being second only to Po Chü-i.[22] At her retreat at Washing Flower Creek, she produced uniquely decorated paper for poetry; these "pine blossom pages" were to be referred to for centuries as *Hsüeh T'ao chien* (Hsüeh T'ao paper). Hsüeh's synthesis of the arts of poetry and painting was prophetic of later developments in Chinese painting.

Several centuries later, Kung Su-jan (early twelfth century), a Taoist nun, painted a remarkable handscroll entitled *Consort Ming Crossing the Frontier*. (Fig. VIII, 6) The only inscription on the scroll itself says "Painted by Kung Su-jan of Chen-yang," and as the artist is not mentioned in historical texts on painting, we know much less about her than we know about the subject of the scroll. The story of Ming Fei (Consort Ming) is a favorite in

China. Wang Shao-chün, who did not earn her imperial title until later, was a woman of humble origin who managed to work her way into the royal household. When the Han Emperor Yüan requested portraits of the ladies in his court, Wang Shao-chün refused to bribe the court painter into producing a flattering picture, as was customary for those who sought imperial favor. The result of her integrity was tragic. When it came time for the emperor to choose a woman from his court to send off as a bride tribute for the barbaric king of the northern Hsiung-nu tribes, Wang was selected on the basis of her portrait, as it was the ugliest. When the emperor saw the beautiful and patriotic lady riding away, he realized what had happened and had the corrupt painter executed, but it was too late to save Wang Shao-chün. She was miserable in the

Hsiung-nu kingdom, living in a tent on the frontier, and when her eighty-year-old husband died, she hanged herself, having fulfilled her duty to China. It is said that her grave became a landmark, the only green spot on those barren wastelands. Wang is remembered by her honorary name, Ming Fei, the "Bright Concubine."

Many questions surround the identity of the calligrapher Yang Mei-tzu. (Fig. VIII, 7) Some claim that she was the empress herself, whose surname was Yang, while others believe that Yang Mei-tzu (Younger Sister Yang) was the sister of the empress.[23] We know she was connected with the Southern Sung court, as she used imperial seals (such as the dragon shown here) to stamp pieces of her calligraphy.

Examples of Yang Mei-tzu's calligraphy can be found on many paintings of the Southern Sung period, particularly those by Ma Yüan. Some of these are signed by the artist and inscribed by Yang Mei-tzu, but others are anonymous or attributed to famous painters of the day. Although Yang Mei-tzu was reportedly a flower painter herself (none of those works survive), nowhere is it suggested that any of the works bearing her inscriptions could well have been painted by her.

YÜAN DYNASTY (1279–1368): KUAN TAO-SHENG, MASTER OF MONOCHROME

Nowhere do the arts of calligraphy and painting overlap so much as in monochrome landscapes, with their abstract bamboo and crooked pines. Legend has it that bamboo painting was invented by a certain Li Fu-jen (Lady Li) of the Five Dynasties period (A.D. 907–960), a rep-

utable scholar, calligrapher, and painter from Szechuan. She was captured and carried off by invaders, who imprisoned her in a desolate but apparently comfortable place. While sitting alone one night in her southern study, gazing at the shadow of bamboo on the moonlit paper windowpane, it occurred to her to trace its outline in ink.

Kuan Tao-sheng (1262–1319), another artist who excelled in both painting and calligraphy, is remembered as one of the finest bamboo painters. She wrote a treatise on "The Bamboo in Monochrome," and also did paintings of plum blossoms, orchids, landscapes, and Kuan-yins, many of which are extant.

Kuan lived at a tumultuous time in Chinese history; she saw the fall of the Southern Sung dynasty in 1279 and the establishment of the Yüan dynasty under the Mongols. She and her husband, Chao Mengfu, lived in poverty for many years, as Chao, a minor official, lost his job when the new dynasty was founded. In 1286, upon the request of Kublai Khan, Chao became the court calligrapher for the Mongols —an appointment that branded him as a traitor in the eyes of many loyal Chinese who were vehemently opposed to collaboration with the invaders. But Chao argued that some Chinese traditionalists were necessary in the new government to see that their heritage was ensured of survival. He rose quickly in the official hierarchy, and both he and Kuan were well received in the Yüan court.

Kuan, a devout Buddhist, transcribed scriptures for famous monks (and nuns?), and her calligraphy was so highly regarded that the emperor requested that she make a copy of *Ch'ien-tzu wen* (Thousand Character Classic) for

Fig. VIII, 7 YANG MEI-TZU. Calligraphy. c 1200. Stamped with the dragon seal and inscribed with the following poem, signed "Yang Mei-tzu":

My make-up thin and faded, scent a trace and nothing more.
Yet here before my eyes Spring's beauty still makes sport.
You said a year blooms quickly and as quickly dies.
Yielding to the boredom of luxury, I long for the land of wine.[24]

Fig. VIII, 8 KUAN TAO-SHENG. Calligraphy. c. 1300. A portion of a letter to her aunt.

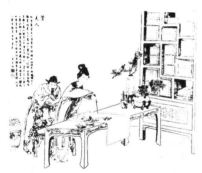

Fig. VIII, 9 Kuan Tao-sheng and her husband in the studio. Woodcut.

Fig. VIII, 10 KUAN TAO-SHENG. *The Slender Bamboo of Spring.* c. 1300. The poem inscribed by the artist is in praise of the bamboo grove through which she strolled with her children on a fine spring day.

Fig. VIII, 11 KUAN TAO-SHENG. *Kuan-yin With Fish Basket.* 1302. Done in the Ch'an Buddhist ink-sketch manner. Inscriptions by Chao Meng-fu and Ming-pen, the most famous Ch'an teacher of his time.

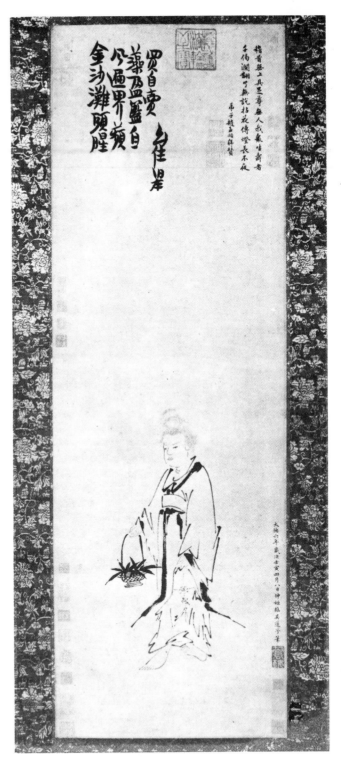

the imperial collection. Her transcription of this ancient text was fashioned into a scroll mounted on brocade with a roller of jade. Kuan's letter to her aunt illustrates both her writing and her painting style; both her characters and her bamboo are concise yet free, legible but full of spirit. (Fig. VIII, 8)

Kuan did some paintings with Chao, a famous artist himself, and he sometimes wrote poems and comments on her works. Their romance was a favorite subject for stories and plays, apparently one of those rare matchings of talent and temperament. (Fig. VIII, 9) They had nine children. Kuan accompanied Chao on his official travels, an unconventional step for a woman at this time. It was during such a trip that she became ill and died in Shantung.

One can see from the examples of her work shown here why Kuan Tao-sheng was considered a master of monochrome painting. The detail of the bamboo in *The Slender Bamboo of Spring* is illustrative of her expertise; the brush strokes are spontaneous, not daring to settle for an instant. (Fig. VIII, 10) Indeed, Kuan does not exhibit the fault that Wei Shuo referred to as "ink hog." Her *Kuan-yin with Fish Basket* is an unusual portrayal of the goddess and is easily recognizable as the work of a hand trained in calligraphy. (Fig. VIII, 11) The scope of *A Bamboo Grove in Mist* contradicts a common and unfounded criticism of women painters: that they have talent only on a small scale. (Fig.

VIII, 12) Of course, many women did not have the opportunity to ramble in nature viewing vast landscapes, but those who did produced works that are beautifully proportioned and nonrepetitive.

MING DYNASTY (1368–1644): MA SHOU-CHEN AND HSÜEH WU, TWO WOMEN OF THE TOWN

In Chinese painting, as in calligraphy, the emulation and even imitation of past masters is a respected practice. The old is never discarded; it is copied faithfully and combined with the new spirit of the times to produce art that is "in the style of so-and-so" yet distinctly original. So it was with the work of Ma Shou-chen (1592–1628), a painter, poet, and one of the late Ming "Eight Famous Courtesans," noted for her orchids and bamboo in the style of Kuan Tao-sheng. According to her critics, she "developed a special style of painting epidendrums in ink, easy and free, beautiful and quiet, resonant with life."[25] It was for this talent that she received her nickname, Hsiang-lan (River Orchid).

Ma lived on the Ch'in-huai River in Nanking, where she gave banquets and literary gatherings for her friends and composed poetry. The poem inscribed upon *Lotus in Late Summer* voices her disappointment when a friend took a new concubine (Fig. VIII, 13):

I passed my childhood by the
 riverbanks,
 not knowing any sorrows—

But now the storms and rains have
 brought
 the autumn chill to Ch'in-huai.
I dare not turn my head again to
 roads
 I knew along the dykes.
The trees are thin, the sun is low,
 and I
 a woman of the town.

**Written by Ma Shou-chen in The
House by the Blue Stream**[26]

Why are so many courtesans appearing on the lists of women artists? Although most were either born into brothels or sold to them by their families, and their lives were undeniably hard, one wonders if perhaps some talented, independently minded women did not choose to be courtesans. They were relatively free from domestic chores and were given training in literature and the other arts; furthermore, life in the gay quarters offered them mobility and stimulating company.

Famous courtesans could be quite choosy about the company they kept, and they were by no means obligated to extend sexual favors; in fact, their occupation consisted mainly of providing intellectual conversation and social entertainment for their guests. These women were in many cases equals of men in a way that "respectable" women could never be, hence the Confucian proverb: "only the untalented woman is virtuous." Yet, paradoxically, these so-called nonvirtuous women are often those who are remembered in history.

Another one of the "Eight Famous Courtesans" was Hsüeh Wu, or Hsüeh Su-su (c. 1564–1637), who lived most of her life in Nanking, the former capital, where she consorted with notable painters and poets of her time. One of her contemporaries, Hu Ying-lin, wrote of Hsüeh when she was only sixteen or seventeen:

Hsüeh Wu looks amiable and graceful; her conversation is refined and her manner of moving is lovely. Her calligraphy in the regular style is excellent, her paintings of bamboo and orchids even better. Her brush dashes rapidly; all her paintings are full of spirit. They are superior to those of most professional painters in town.[27]

Besides being gifted artistically, Hsüeh was a skilled horsewoman and archer: "While galloping on horseback she shoots two balls

Fig. VIII, 13 MA SHOU-CHEN. *Lotus in Late Summer.* Early 17th c. Poem inscribed by artist (see text).

Fig. VIII, 14 HSÜEH WU. *Wild Orchids.* 1601. Portion of a handscroll over nineteen feet long.

from her crossbow, managing to make the second ball hit the first one in the air."[28] It is said that when performing such feats she never missed one shot out of a hundred. Hu also notes that Hsüeh, with her "heroic spirit" and "love of originality," was particular about her friends, receiving only those with talent and intelligence; though she had several loyal lovers, she never married. She also wove, embroidered, and played the flute and lute. She was known by as many as eight names, liking especially to call herself the "Fifth Boy."

Reproductions of handscrolls by Hsüeh Wu were popular, although much of her work is missing today. The orchid scroll, a section of which is here reproduced, bears none of the faults common to works of comparable scope; it is diverse yet not choppy, flowing but not repetitious. (Fig. VIII, 14) Her greatest work, it "remains the most accomplished work of its kind in the whole Ming period, whether by man or woman painter."[29]

PAINTERS OF THE DIVINE, HUMAN, AND ANIMAL WORLDS: TS'AO MIAO-CH'ING, HSING TZ'U-CHING, CH'IU SHIH, AND WEN SHU

Do not expect to find a multitude of panoramic landscapes in paintings by women. The remainder of our Ming artists worked in their garden studios and expanded these small scenes to fill their scrolls. The two flower paintings by Ts'ao Miao-ch'ing are good examples of nature painting on a smaller scale than the river and mountain vistas of Kuan Tao-sheng and Hsüeh Wu. (Figs. VIII, 15, 16) Ts'ao was a poet, calligrapher, and painter of the mid-fourteenth century. Although, as in the West, many works by women are

listed as anonymous, Ts'ao leaves no doubt as to her name and sex, signing her paintings "Woman Historian, Ts'ao Miao-ch'ing."

Hsing Tz'u-ching painted Kuanyins in gold. (Figs. VIII, 17, 18) Kuan-yin, the Chinese version of Avalokiteśvara, the male Indian Buddha of Compassion, is a favorite of women. As Goddess of Mercy, Kuan-yin listens to the prayers of the world. Hsing's elegantly simple style captures the development of Kuan-yin's image through the centuries, transformed from an austere male figure through various stages of androgyny to the merciful goddess of Ming China. Hsing (c. 1570), from Shantung province, was also a poet and calligrapher. She studied the style of Kuan Tao-sheng and painted landscapes, bamboo, and flowers as well as Buddhist figures.

Ch'iu Shih (c. 1550), "Ms. Ch'iu," daughter of the artist Ch'iu Ying, was more concerned (judging from her extant works) with human scenes than our previous painters. She studied the style of her father and is praised for her "landscapes of delicate beauty," a quality revealed in her *Lady in Garden,* an illustration to a T'ang poem. (Fig. VIII, 19) Chinese descriptions of paintings abound in adjectives translatable only as "refined" or "delicate," a trait that may seem quaint or verbose to the modern Western reader. But as one can see from these examples of Ch'iu's work, her style was indeed refined. The minute crooks in tree branches, the microscopic leaves and the wispiness of the lady's hair are the work of an observant eye and a steady, well-trained hand. Her paintings are filled with women engaged in various activities: playing chess, writing at desks, posing under trees with books, playing mu-

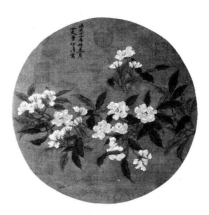

Fig. VIII, 15 TS'AO MIAO-CH'ING. *Branch of Flowers.* 1380.

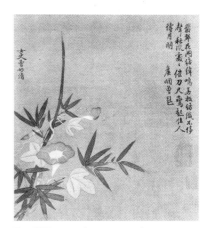

Fig. VIII, 16 TS'AO MIAO-CH'ING. *Morning Glories.* Late 14th c.

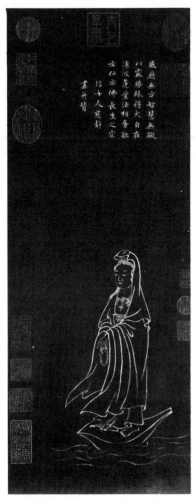

Fig. VIII, 17 HSING TZ'U-CHING. *Kuan-yin.* 16th c. Painted in gold and inscribed with a Buddhist poem by the artist, signed "Woman Devotee, Tz'u-ching."

sic, and threading needles on the seventh day of the seventh moon. The last is in reference to a popular myth concerning the ill-fated lovers, Weaver Girl and Herd Boy, who are destined to dwell at opposite ends of heaven, meeting only once a year—on the seventh of July.

Wen Shu (1595–1634), our last Ming painter, was more preoccupied with the animal world than with people. Her *Butterfly and Flowers* is but one example of her fascination with *ch'ung,* a word that encompasses worms, reptiles, and insects of all kinds. (Fig. VIII, 21) She had an eye for such subjects; the butterfly here is a sensuous creature indeed, and the rock and flowers look quite pale in comparison.

Wen painted in the *hsieh-i* style, a term that is translated as "impressionist outline" and means literally to portray an idea through brushwork. Her subjects included silkworms, fishes, crabs, grasshoppers, and dragonflies as well as extraordinary plants. She is noted for her subtle use of color in capturing the spirit of exotic plants and *ch'ung,* a talent that achieved for her a place on the official list of Ming artists, along with thirty-three other women.

CH'ING DYNASTY (1644–1911): MA CH'ÜAN, CH'EN SHU, AND T'ANG SOU-YÜ—LAST ARTISTS OF THE JADE STUDIO AND THEIR CANONIZER

Ma Ch'üan (1768–1848), the painter of *Butterflies,* was born in Kiangsu province but, after marriage, moved to Peking, the capital during the Manchu dynasty. (Fig. VIII, 22) Both she and her husband were successful artists there, but she is considered the better of the two. Numerous works by her sur-

vive, documenting her skill in painting animals as well as flowers and plants. Like Ch'iu Shih, she painted in the rapid and bold *hsieh-i* style.

Although Ma made excellent use of color, legend has it that she was also fond of monochrome, having studied with her grandfather, a scholar of high rank, who was a connoisseur of calligraphy and a collector of black ink—of which he had several rooms full. His son, Ch'üan's father, was a rather untalented man and not interested in such diversions, so Ch'üan became the protégée of Grandfather Ma. Once, in reply to her inquiry regarding his obsession with ink, the old man remarked, "This is a precious thing. To ordinary people it looks to be all of the same color. I, who have spent much silver upon it, see eight colors."[30] It is said that Ma Ch'üan, unlike other women her age who preferred to wear brightly colored clothes, dressed only in gray and black and that her last request was to be buried in a coffin filled only with ink sticks.

Whereas many women artists had no children or financial problems to keep them from their work and painted primarily for pleasure, Ch'en Shu (1660–1736) was a professional artist. The eldest daughter of a great scholar, she married an extravagant official who was seldom home and, when he was, spent the little money they had entertaining guests. Ch'en pawned her clothes and sold her paintings to support their daughter and sons. Through her persistent efforts to educate them, the children all became successful officials, poets, and painters. She was renowned in her own time as the teacher of many outstanding artists and writers.

Her *Cockatoo,* domestic yet spirited, is but one example of her bird

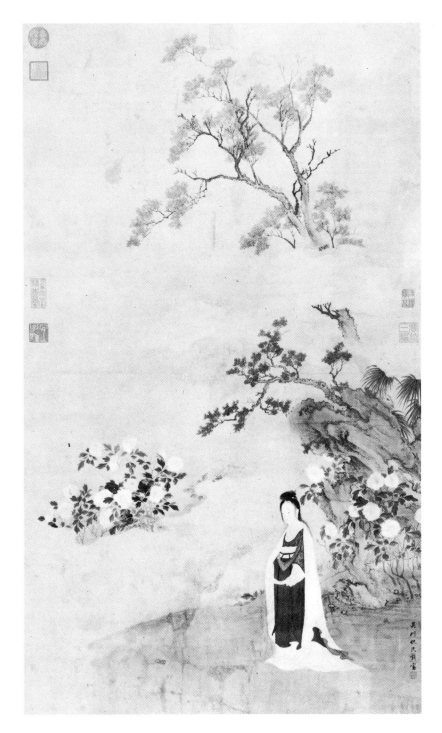

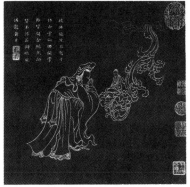

Fig. VIII, 18 HSING TZ'U-CHING. *The thirty-second Manifestation of Kuan-yin.* This version of the goddess facing the Buddha is also painted in gold and inscribed with a poem by the painter.

Fig. VIII, 19 CH'IU SHIH. *Lady in Garden.* 16th c. Signed "Painted for pleasure, Ch'iu Shih."

Fig. VIII, 20 CH'IU SHIH. *White Robed Kuan-yin.* 16th c. Kuan-yin's forms are as many as there are eyes to behold her; Ch'iu Shih, "painter of things fine and delicate," has depicted a goddess serene and watchful, composed and relaxed.

Fig. VIII, 21 WEN SHU. *Butterfly and Flowers.* 1630. Signed "Wen Shu, painter."

Fig. VIII, 22 MA CH'ÜAN. *Butterflies*, c. 1800. Portion of a handscroll over eight feet long. The artist signs herself "Chiang-hsiang, Female Scholar, Ma Ch'üan."

Fig. VIII, 23 CH'EN SHU. *A White Cockatoo.* 1721. The artist signs both works shown here "Old Person of the Southern Studio, Ch'en Shu."

and animal paintings; she also did magpies and buffalo. (Fig. VIII, 23) *The Quiet of the Mountain and the Length of the Day* illustrates what Western art critics like to call a "typically Chinese" approach to painting—that is, a landscape in which human life is minimal. (Fig. VIII, 24) The cliffs and twisted trees are far more imposing than the human dwellings; the figures in the windows and the man in the lower-right-hand corner are barely visible.

The recording of famous artists in dictionaries of painters was customary in China, though in many cases all we have are their names and a few words of praise. A curious discrepancy often occurs between facts in Chinese sources and their representation in foreign works; whereas Western books on Chinese art are almost exclusively devoted to male artists, leading one to suppose that women painters were extremely rare if not nonexistent, Chinese sources are abundant with references to women and often contain reproductions of their work. In fact, at the beginning of the nineteenth century, the art critic T'ang Sou-yü wrote a remarkable book called *Yü-t'ai hua-shih* (Jade Studio Painting History) specifically about women artists and their contributions to the field.

Madame T'ang's book contains information on over 200 artists from the early centuries A.D. to Ch'ing dynasty. She divides the artists into four categories: Palace Ladies, Famous Beauties, Concubines, and Courtesans. The title "Famous Beauties" is somewhat misleading; actually, the women in that section (the largest) are all of those who do not fall under the other headings, such as Wen Shu, Ch'en Shu, and Kuan Tao-sheng. *Yü-ta'i hua-shih,* still untranslated, unfortunately, is a well-documented and valuable text on Chinese painting as well as a tribute to women.

The beginning of the end of life in China as the ladies of the jade studio knew it was already underway in T'ang Sou-yü's time. The nineteenth century, though still entrenched in traditional ideology, was an age of change; foreign imperialist powers expanded their territories in China and both anti-Western and anti-Manchu sentiment grew.

THE LAST GREAT EMPRESS: TZ'U HSI (1835–1908)

"The Manchu house will be overthrown because of a warrior woman of the Yehonala clan"—this was the ancient prophecy that crossed the minds of those present when the emperor was catapulted overboard during a boating trip by his strong-willed concubine Yehonala, later to be known as Tz'u-hsi, the empress dowager of China.[31] It was she who presided over the Ch'ing court for nearly fifty years, struggling to maintain control in one of China's most difficult and challenging periods. Never before had Chung-kuo—the Middle Kingdom—been so brutally forced to recognize that it was not actually the center of the world and that the nations who demanded use of her land were not like the tribute states of the past. The Opium War and the Taiping Rebellion in the mid-nineteenth century and finally the Boxer Rebellion in 1900 were humiliating assaults on the sovereignty of the Ch'ing.

Tz'u-hsi, a controversial figure in the annals of history, has had practically every name in the book thrown at her—ruthless tyrant, impotent puppet, and even murderess. Whatever the validity of such charges, she undoubtedly was a proud, shrewd, and determined

子西佳句拼吟仗怜
合南棧倒老人筆秉
有詩師窎傾巾
冬爱不傳神幽居
深務松林護景嶐
鋪荷景被為想嘗
年勤課發集戚香
樯果濤新
乙己孟夏卅游
□□

山靜如太古日長如小年
餘此身無事法廬前
深讀書�非人境室庵
阿然屐其清謐心
□□老人陳書信

Fig. VIII, 24 CH'EN SHU. *The Quiet of the Mountain and the Length of the Day.* Early 18th c. Inscription by the artist (at right) describing the painting.

Fig. VIII, 25 TZ'U-HSI. *Peonies and Cat Meowing at Pug Dog.* Late 19th c.

woman, working her way up from the ranks of imperial concubines to become the ruler of China. She chastised the emperor for his cowardice before the foreign powers, and, as regent after his death, she made certain that she alone was responsible for crucial decisions on foreign policy and political reform. In a characteristically outspoken and narcissistic moment, she remarked:

Do you know that I have often thought that I am the cleverest woman who ever lived and that others cannot compare with me. Although I have heard much about Queen Victoria and read a part of her life . . . still I don't think her life half as interesting and eventful as mine. Now look at me, I have 400 million people all dependent on my judgment.[32]

Tz'u-hsi liked to compare herself to the English queen whose portrait she kept by her bed. The empress even condescended to write Queen Victoria a letter pleading for help during the Boxer Rebellion, and it gave her great satisfaction that she outlived her British counterpart.

Having spent her childhood at Wuhu on the Yangtze River, Tz'u-hsi was especially attached to the scenic beauty of the south and hated the bleakness of Peking, particularly the Forbidden City itself. She was therefore very fond of the summer palace, and when the beautiful temples, gardens, and hunting parks of the Western Hills were plundered and razed by the French and British in 1860, Tz'u-hsi was furiously vengeful. Her later embezzlement of navy funds to build her solid marble boat at the new summer palace, probably the most notoriously extravagant deed of her life, furnished her enemies with new ammunition to attack her.

With no formal training, Tz'u-hsi

managed to teach herself to read and write, becoming a pedantic authority on history and protocol. She was quite proud of her calligraphy and graciously bestowed samples of it upon her friends. During her days of leisure at the summer palace, the empress loved to paint. Her painting teacher, Lady Miao, said of her:

We were both young when she began. Shortly after she was taken into the palace, she began the study of books, and partly as a diversion, but largely out of her love for art, she took up the brush. She studied the old masters as they have been reproduced by woodcuts in books, and from the paintings that have been preserved in the palace collection, and soon she exhibited rare talent.[33]

Lady Miao had the distinction of being the only Chinese woman allowed by the Manchu elitist Tz'u-hsi to live in the imperial court. This was a rare breach of precedent for the empress. The law barring non-Manchu women from the Forbidden City was introduced by the mother of the first Ch'ing emperor, who had the following words inscribed on a pillar at the entrance to the palace: "If any females with small feet dare to pass this gate, let them be summarily beheaded."[34] Tz'u-hsi, who had always detested bound feet, displayed unusual compassion for Lady Miao by having her best doctors attempt to straighten her painting teacher's feet.

Among Tz'u-hsi's artistic subjects were flowers, cats, and dogs. (Fig. VIII, 25) It was a significant show of forgiveness and friendship when, in her post-Boxer Rebellion days of generosity, the empress gave diplomatic guests Pekingese from her own kennels as gifts. The dogs were, of course, neutered—Tz'u-hsi's change of heart was not so complete that she would tolerate

Fig. VIII, 26 LI FENG-LAN. *Spring Hoeing.* 1970s.

the proliferation of the imperial Pe-kingese in barbarian parts of the world—but for "Old Buddha," as she was affectionately called, it was a great step toward diplomacy.

Tz'u-hsi, for many years, had been removed from the suffering and turbulence of the lives of her 400 million subjects. When the city was captured by foreigners in 1900, the empress had to flee Pe-king. While in exile she saw for the first time with her own eyes how her people lived. When she later re-turned to the palace, humiliated and broken, she began to earnestly initiate the reforms for which pro-gressive thinkers had been clamor-ing. Tz'u-hsi was indeed the last great monarch of China. The Ch'ing dynasty itself was overthrown in 1911, only three years after her death, and momentous reforms, both political and cultural, were to change the traditions that had main-tained China for thousands of years.

THE TWENTIETH CENTURY: THE TREND TOWARD SOCIAL REALISM

By the turn of the century revolution-ary thought was in full bloom, fos-tered by new ideas imported from Russia and the West. Chinese stu-dents who went abroad to study were influenced by Western art and literature as well as political, scien-tific, and philosophical thought.

A variety of painting schools ap-peared, some strictly traditional and others hardly recognizable as Chinese. Such schools often re-flected political philosophy, as did literary groups; "art for art's sake" was no longer accepted automati-cally as a worthy motivation for crea-tivity. Within the ranks of the New Culture movement, the vanguard of revolutionary thought in the twen-ties, ideology ranged from liberal-ism to socialism. All who wanted a new China agreed that the arts and

Fig. VIII, 27 MA YA-LI. *The Brigade's Chicken Farm.* 1970s.

literature had to change, but even among members of sympathetic political factions arguments arose as to what exactly the role of the artist in society should be.

In 1942, at the Communist base area in Yenan, the newly recognized leader of the revolutionaries, Mao Tse-tung, gave a speech on art and literature that was to become a classic.[35] Mao's reminder that art must serve the people and have good content as well as good form is quoted frequently in China today. After liberation in 1949, artists were urged to make reconstruction of China their primary responsibility. The artist must portray real life and real people, which can only be accomplished by working with the masses; likewise, workers and peasants should have access to art materials and courses.

The two modern paintings shown here were done by peasants from Shensi province in north-central China. Li Feng-lan, the painter of *Spring Hoeing* was born in 1935 to a poor peasant family and did not learn to read until after liberation. (Fig. VIII, 26) Li had always been

creative, making such things as paper cuts for window decoration, so she joined a spare-time art class in 1958, where she learned to paint. She does collective farm work and cares for four children and three elderly people but has found time to create over 300 paintings. Li paints the scenes she knows best, the work of her comrades in the fields; she carries her sketch books with her to jot down ideas and does her painting late at night.

Ma Ya-li (b. 1955) is of the new generation, born after liberation. She, too, is a peasant and chooses subjects from the daily life of her people. Women working together, as in Li Feng-lan's *Spring Hoeing,* is the theme of Ma's *The Brigade's Chicken Farm.* (Fig. VIII, 27)

Ma Ya-li's chickens are of a different class and style than Ch'en Shu's elegant cockatoo, and the human activity of Li Feng-lan's agrarian scene is quite a contrast to the remote landscapes of previous centuries. They are painters of a new age, honoring through their hard work the long struggle carried on by their sister artists before them.

Notes

Chapter 1

1. Patricia Meyer Spacks, *The Female Imagination,* p. 143.

2. Kenneth Clark, *The Nude,* p. 458.

3. Elizabeth Janeway, "Images of Women," *Women and the Arts* issue *Arts in Society* II (Spring–Summer 1974):12. This issue was devoted to the proceedings of the Women and the Arts Conference in Wisconsin in September 1973. Henceforth, it will be referred to as *Women and the Arts.* For an interesting discussion of self-portraiture, see Ruth Iskin's "Sexual and Self-Imagery in Art—Male and Female," *Womanspace Journal* (1973):4–10, 14.

4. In the French romantic novel by Bernardin de Saint Pierre, *Paul et Virginie,* the young maiden, who has been re-educated after growing up free on a desert island with Paul, drowns in a shipwreck because, with her newly learned modesty, she refuses to remove her hoopskirts—and so, sinks, a martyr to modesty. She was a heroine for generations of readers.

5. Eleanor Flexner, *Mary Wollstonecraft,* p. 215.

6. Quoted by Nancy Foote, "Who was Sonia Sekula?" *Art in America* 59 (September–October 1971):76.

7. Lise Vogel, "Fine Arts and Feminism: The Awakening Consciousness," *Feminist Studies* 2 (1974):3. In partial answer, Athena Tacha Spear compiled syllabi of various courses being taught, entitled *Women's Studies in Art and Art History.* The second revised edition, dated 1975, can be ordered for $2.50 from Lola B. Gellman, 14 Lakeside Drive, New Rochelle, NY 10801. The Education Division of Dun-Donnelley Publishing Corporation, 666 Fifth Avenue, New York, NY 10019 has prepared a rapid seven-hundred-year summary with slides of women artists with commentary as part of a larger package of materials for grades 9 through 12 entitled: *identity: FEMALE* (1974).

8. Susanne K. Langer, *Philosophy in a New Key;* she has written many other books even more directly on the visual arts. Elizabeth Janeway, in the paper cited above, acknowledges her debt to Langer and says: "She is also the only philosopher of art of whom I know who is read with passion and delight by practising artists. . . ." (p. 14)

9. Simone Weil, *Waiting for God,* p. 112.

10. For example, in music, Sister Nancy Fierro has recently done a record, *Première* (AV 1012), where she performs keyboard works by women composers (Avant Records, 6331 Quebec Drive, Hollywood, CA 90068). She discusses some of the analogous research she, Judith Rosen, and Pauline Oliveros have been doing to recover lost works and history in an interview in Anica Vesel Mander and Anne Kent Rush's book, *Feminism as Therapy.* The film on the life of Antonia Brico, the conductor, is relevant here also (*Antonia* was done by Jill Godmilow and Judy Collins and is distributed by Rocky Mountain Productions, 1775 Broadway, New York, NY 10019).

11. Tillie Olsen, "Silences: When Writers Don't Write," *Harper's,* October 1965; reprinted in Susan Koppelman Cornillon's *Images of Women in Fiction: Feminist Perspectives.*

12. This remark was made in the course of an interview at the end of one of Sir Kenneth's "Romantic Rebellion"

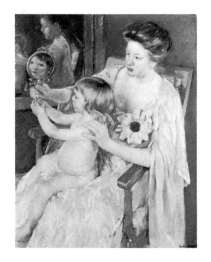

programs on television. For women composers, we refer to note 10 above; there is also Sophie Drinker's book, *Women and Music,* now difficult to find. For women and architecture, see: Doris Cole, *From Tipi to Skyscraper: A History of Women in Architecture.*

13. Vogel, p. 5.

14. Judith Wragg Chase, *Afro-American Art and Craft,* p. 139.

15. Eileen Power, *Medieval English Nunneries,* p. 238. Chase herself recommends as useful Porter's *Modern Negro Art* (New York: Arno Press, 1969) and Cedric Dover's *American Negro Art* (Greenwich, Conn: The New York Graphic Society, 1960). There is Elton C. Fax's *Seventeen Black Artists* (New York: Dodd, Mead & Co., 1971), Ruth Waddy and Samella Lewis, *Black Artists on Art* (Los Angeles: Contemporary Crafts Publishers, 1969), Elsa Honig Fine, *The Afro-American Artists: A Search for Identity* (New York: Holt, Rinehart and Winston, 1973). See also: *Afro-American Artists, a Bio-bibliographical Directory,* compiled and edited by Theresa Dickason Cederholm (Boston: Trustees of the Boston Public Library, 1973) and Ora Williams, *American Black Women in the Arts and Social Sciences: a Bibliographic Survey* (New Jersey: Scarecrow Press, 1973).

16. *Women and the Arts,* p. 14. For example, Mildred Constantine and Jack Lenor Larsen's *Beyond Craft* and Rachel Maines's forthcoming book on the art of needlework. Sue Fuller tells in a catalog of her works that she had to consult with the lace expert at the Metropolitan Museum of Art in order to develop her own wonderfully contemporary modes.

17. The *Women of Photography: An Historical Survey* exhibit at the San Francisco Museum of Art has a catalog that fills in many gaps. See also: Anne Tucker's *Women's Eye;* Ann Hershey's film on Imogen Cunningham called *Never Give Up!* (distributed by the same people who distribute *Antonia.*) On film, a number of good books have come out recently, *Popcorn Venus* by Marjorie Rosen, for one. Another: Molly Haskell, *From Reverence to Rape* (New York: Holt, Rinehart and Winston, 1973).

18. Judy Chicago, *Through the Flower: My Struggle as a Woman Artist,* p. 96.

19. *Art News* 69 (January 1971), especially the article, "Why Have There Been No Great Women Artists?" by Linda Nochlin. The issue has been reprinted in *Art and Sexual Politics,* Elizabeth Baker and Thomas B. Hess, eds., somewhat abridged. Linda Nochlin's thinking has developed much past the misleading title of her early article, as can be seen in the paper she read at the Women and the Art's Conference mentioned above, "How Feminism in the Arts Can Implement Cultural Change," *Arts in Society* II, 1 (Spring–Summer 1974):81–89. This paper has been reprinted in the new journal of the Washington Womens Arts Center, *Womansphere* (September 1975):14–16.

20. These books are also appraised in at least two articles in *The Feminist Art Journal:* Therese Schwartz, "They Built Women a Bad Art History" (Fall 1973), and Carl Baldwin, "The Predestined Delicate Hand" (Winter 1973–74). A book that recapitulates much of the information in these early texts has just recently become available: Hugo Munsterberg, *A History of Women Artists.*

21. These names are not random, of course, and could have been expanded from John Singleton Copley to Yves Tanguy—each of them is connected with a woman artist. Most of these connections will emerge in the narrative of the book, but, by way of illustration, take van Gogh's mother, Anna Cornelia Carbentus, daughter of a bookbinder. One of the Freudian critics does mention her, after first emphasizing that van Gogh's grandfather's great-uncle was a sculptor! She married at thirty-two and shared her husband's work with all her heart; she loved nature and wrote very well; she also showed ability at drawing, "an activity that was customary for girls of her time," as the critic allowed casually. He goes on to diagnose that Vincent's early interest in drawing might well have been "the result of identification with his mother and an attempt at pleasing her and gaining her favor." (Humberto Nagera, *Vincent van Gogh: A Psychological Study).* In fact, his

nephew tells us that van Gogh's very first paintings were actual copies of her works.

22. Chicago, p. 90.

23. This poem is by the poet Rena Rosenwasser; she knows art well also and strives to keep us abreast of the newest of the new. We are very grateful to her.

24. The Women's Caucus for Art's president is Mary Garrard, who put out for the Caucus a useful source book of slides by women available in American museums. Write to her at 7010 Aronow Drive, Falls Church, VA 22042, enclosing $2.25, if you want a copy. For membership in the Caucus, write to Ellouise Schoettler, 9112 Brierly Rd. Chevy Chase, MD 20015.

25. To subscribe to *The Feminist Art Journal,* write editor Cindy Nemser, 41 Montgomery Place, Brooklyn, NY 11215.

26. This phrase from Adrienne Rich's poem "Planetarium," honoring Caroline Herschel, the astronomer, is included in *The Will to Change.* "The Stranger," from *Diving Into the Wreck,* is also applicable to much of our effort here. Rich's poetry and her prose are giving a new key to our evolving philosophies.

Chapter 2

1. The traditional source here is the Elder Pliny's listing of the women artists of Greece and Rome; there is also good new work being done on women of antiquity. Of the many books on women's prehistory, we will mention Helen Diner's *Mothers and Amazons.*

2. John W. Bradley, *A Dictionary of Miniaturists,* II, p. 298.

3. Lina Eckenstein, *Woman under Monasticism,* p. ix. It is worth noting that this comment was written in 1896, and to date this is the best book we have found on this rich subject.

4. Power, *Medieval English Nunneries,* p. ix.

5. Edward Quaile, *Illuminated Manuscripts,* p. 91; see also p. 83.

6. Eckenstein, p. 231.

7. Eckenstein, pp. 236–37. Much of Diemud's work has been scattered and lost, though several volumes remain in the Munich Library.

8. Casanovas et al., *Sancti Beati a Liebana in Apocalypsin codex Gerundensis.* 2 vols. For example, the editors tell us of the Benedictine nun Londegondo, who copied in 912 a compilation of monastic rules for the monastery of Samos (II, p. 71).

9. Pedro de Palol-Salellas and Max Hirmer, *Early Medieval Art in Spain,* p. 56.

10. Joan Morris, *The Lady Was a Bishop,* p. 98.

11. Eckenstein, p. 264.

12. Hildegard von Bingen, *Wisse die Wege (Scivias).*

13. Eckenstein, p. 250.

14. Eckenstein, pp. 254–55.

15. Eckenstein, p. 222.

16. Eckenstein, p. 224.

17. Eckenstein, p. 227.

18. Power, *Medieval English Nunneries,* p. 257.

19. Eckenstein, p. 238.

20. As Evelyne Sullerot points out in her *Woman, Society and Change:* "Thus if one tries to evaluate the contribution of women to the output of the country, it would be much smaller today than in the Middle Ages, when women produced as much or even more than men" (p. 79). We are grateful to our friend and colleague Professor Mary Felstiner for this reference.

21. Marius Vachon, *La Femme dans l'art,* p. 136.

22. Richard Hamaan, ed., *Das Strassburger Münster.*

Chapter 3

1. Many of the primary sources of material on these artists were not available to us and indeed, the whole period cries out for the attention of a specialist. Just such a scholar, Ann Sutherland Harris, has been extraordinarily generous and helpful to us in the best spirit of feminist scholarship. Any mistakes that might have survived her rigorous reading are, of course, our own.

2. Quoted by Eckenstein from the colloquy of the Abbott and the Learned Lady, pp. 217–23.

3. Quoted by Eckenstein from Charitas Pirkheimer's memoirs, p. 474. See

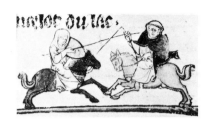

also letters quoted by Georgiana Hill in her *Women in English Life,* I, pp. 80–83. Also the novel by H. J. M. Prescott, *The Man on a Donkey.*

4. Clara Erskine Clement, *Women in the Fine Arts,* p. 142. Professor Harris tells us that there is a life of Caterina Ginnasi by G. B. Passeri, written about 1670 and first published in 1772.

5. E. Miriam Lone, "Some Bookwomen of the Fifteenth Century," *Colophon* (September 1932). We saw one of the books done by these nuns in the rare books collection at Scripps College, Claremont, Calif.

6. Morris, p. 151, but the whole appendix, pp. 150–57, is interesting.

7. Hannelore Sachs, *The Renaissance Woman,* p. 42.

8. Power, p. 412.

9. Sachs, p. 42. In Antwerp, for example, the Plantin sisters administered a large and flourishing lace business. (Eleanor Tufts, *Our Hidden Heritage,* p. 243.)

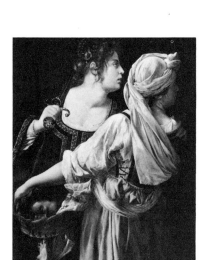

10. Jacob Burckhardt, *The Civilization of the Renaissance in Italy* (New York: New American Library, 1960), p. 281. He also congratulates them on the "manly tone" of their writing "so far removed from the tender twilight of sentiment and all the dilettantism we commonly find in the poetry of women . . ." (p. 280). Georgiana Hill quotes a French historian, Paul Rousselot, as acknowledging that the majority of women, as outsiders, profited little from the Renaissance, I, p. 121.

11. Sachs, p. 15.

12. Giorgio Vasari, *The Lives of the Painters, Sculptors, and Architects,* III.

13. Charles de Tolnay, "Sophonisba Anguissola and her Relations with Michelangelo," *Journal of the Walters Art Gallery* IV (1941):115–19.

14. Eleanor Tufts reports research on just this aspect of Anguissola's career, pp. 23–24.

15. G. Adriani, *Anton van Dyck: Italienisches Skizzenbuch,* pp. 72–73.

16. Elizabeth Ellet, *Women Artists in All Ages and Countries,* p. 300.

17. Laura Ragg, *Women Artists of Bologna,* p. 4.

18. Tufts, pp. 30–39. The best source thus far on Fontana is Romeo Galli's *Lavinia Fontana, pittrice.*

19. Laura Ragg devotes a chapter to Sirani's life and death. The archetype of these promising young mARTyrs is Irene di Spilimberg: "Tasso sung her, Gradenigo praised her, Titian painted her," but she died at 18! (Vachon, p. 341) As Mark Twain has Huck Finn observe, "Dyin' is always more romantic than livin' it out."

20. Eric Newton, *Tintoretto,* p. 62.

21. Ward Bissell, "Artemisia Gentileschi—A New Documented Chronology," *Art Bulletin* I (June 1968):153–68.

22. Professor Causa thinks her influence second only to Caravaggio's, a view quoted by, but also questioned by, Bissell, p. 162.

23. Rudolf and Margot Wittkower, *Born under Saturn,* p. 162.

24. Giulio Carlo Argan, *The Europe of the Capitals,* p. 72.

25. Clement, *Women in the Fine Arts,* p. 86.

26. A little book by J. Parada y Santin entitled *Las Pintoras Españolas* lists over 150 names.

27. This anecdote was told us by Professor Heinz Kusel of California State University, Fresno; he gave as his source *Espasa Calpe Enciclopedia.*

28. Beatrice G. Proske, "Luisa Roldán at Madrid," *Connoisseur,* Parts 1–3, (February 1964):128–32; (March 1964):199–203; (April 1964):269–73.

29. Audrey Flack, quoted by Cindy Nemser, *Art Talk,* p. 312.

30. Quoted in Marjorie Henry Ilsley's *A Daughter of the Renaissance,* p. 216. There is a whole chapter on Marie le Jars de Gournay's feminism, pp. 200–16.

31. See the interesting note on women engravers in Tufts, p. 244.

32. Jacques Wilhelm, "Louise Moillon," *L'Oeil* 21 (September 1956):6. See also Michael Faré, *La Nature Morte en France, Son Histoire et son Evolution du XVIIe au XXe Siècle.*

33. Bradley, III, pp. 219, 222.

34. Quoted by Mary Stott in her review of the show, *Manchester Guardian* (October 30, 1975).

35. Horace Walpole, *Anecdotes of Painting in England,* III, p. 124.

36. Quaile, p. 92.

37. W. J. Weale and Maurice Brock-well, *The van Eycks and Their Art,* pp. xiii–ix. (Wilenski treats her existence as more probable.)

38. Bradley, II, pp. 106, 308.

39. It was suggested that the group of works attributed to the "Monogrammist of Brunswick" are perhaps by Mayken Verhulst or even Catharina van Hemes-sen. Simone Bergman, "La problème Jan van Hemessen, monogrammiste de Brunswick," *Revue Belge d'Archéologie et d'Histoire de l'Art* 13 (1955).

40. R. H. Wilenski, *Flemish Painters,* I, p. 654. Wilenski lists a number of women artists, working in all styles and schools. Such names as: Justina van Dyck, Catharina Pepyn, Gertrude Pe-lichy, Michaelina Wautier, Catharina Pee-ters, Catharina van Knibbergen, Susan-nah van Steenwyck, Gertrude van Veen, Margarethe van Godewyck, Anna Cromenburch, may well reward further study.

41. Tufts, p. xviii.

42. The pioneer study of Judith Leys-ter was done in 1927 by Juliana Harms in *Oud-Holland* (see Biblio.). It unfortu-nately remains untranslated. However, Frima Fox Hofrichter of Rutgers Univer-sity is currently preparing a *catalogue raisonné* of Leyster's work. Her article, "Judith Leyster's *Proposition*—Between Virtue and Vice" in *The Feminist Art Jour-nal* (Fall 1965) discusses at length Leys-ter's domestic genre paintings.

43. Chicago, p. 154. The whole pas-sage is nice.

44. Walther Bernt, *Netherlandish Painters of the Seventeenth Century,* p. 141.

45. R. H. Wilenski, *Dutch Painting,* p. 196. Ann S. Harris tells us that the situa-tion is sometimes reversed with the much respected name of Rachel Ruysch turning up on works by fakers, copyists, or less valuable male artists.

46. "A Surinam Portfolio," *Natural His-tory* (December 1962).

47. The Leonardo quote comes from Michael Levey's *Early Renaissance,* p. 21.

48. Wilenski, *Dutch Painting,* p. 198.

49. M. H. Grant, *Rachel Ruysch.*

Chapter 4

1. Lady Mary Wortley Montagu, writ-ing to her daughter in 1753, as quoted in Hill, I, p. 348.

2. Lady Victoria Manners and Dr. G. C. Williamson, *Angelica Kauffmann, R.A.,* p. 242. This lush edition bears the special imprint of Lady Victoria's person-ality and is well worth looking at. The most recent full-length biography was done in 1972 by the late Dorothy Moul-ton Mayer, and we shall be quoting of-ten from it. Ann S. Harris tells us that there is an excellent unpublished disser-tation on Kauffmann by Peter Walch (Princeton, 1968, available from Univer-sity Microfilms, Ann Arbor); he is cur-rently working on a monograph.

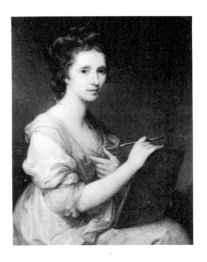

3. Ellen Clayton's *English Female Art-ists* (1886) is difficult to find now. It is here quoted from Hill, II, p. 168.

4. Angelica, when asked if she ever used nude models, always protested that they were draped in sheets from head to feet and that her father was present at all times. Her statement makes it sound more like a gynecology examination than a drawing ·exercise and an exercise not likely to teach one much anatomy.

5. Dorothy Moulton Mayer, *Angelica Kauffmann, R.A.,* p. 11.

6. Mayer, p. 31.

7. Mayer, pp. 47,89. Fuseli and Kauffmann had much in common ac-tually, both Swiss, both disciples of Winckelmann. Fuseli was adored by Mary Wollstonecraft; as the eighteenth century is rich in this sort of cross-refer-ence, some might want to read Eleanor Flexner's *Mary Wollstonecraft.*

8. Another slander was supposedly perpetrated by Nathaniel Hone in a painting of his called *The Conjuror,* in which Kauffmann was pictured naked. Should you wish to read more about this incident, see Mayer, pp. 81–87.

9. Elisabeth Vigée-Lebrun's *Mem-oirs,* quoted by Mayer, p. 158.

10. Mayer, p. 134.

11. John Flaxman, an artist and con-temporary of Kauffmann's, made this statement, quoted in Mayer, p. 35.

12. Quoted in Mayer, p. 28.

13. Thomas Fleming, *The Man from Monticello,* p. 133.

14. Fleming, p. 375.

15. Hill, I, p. 294.

16. Lady Victoria Manners, "Catharine Read: The 'English Rosalba,' " *Connoisseur* 88 (1931):380.

17. Her will, published in her journal along with innumerable footnotes, asked her family to burn all of her private papers. (See Bibliography.)

18. Much of this account comes from quite a long entry in the *Biographie Universelle;* it also tells us that at the time of her death she was working on a *History of Present Times for the Instruction of My Children.*

19. Quoted from a March 1728 letter from the Abbot Conte to Madame De Caylus by Ugo Ruggeri, whose *Dipinti e Disegni di Giulia Lama* is most helpful. (p. 9) The Abbot (who forgives Lama her ugliness of face because of her finesse in conversation) tells us that she, like Carriera, worked in lace and was interested in the invention of a lace making machine. She studied mathematics in her youth.

20. Diderot's *Salons, 1767,* p. 39.

21. Elisabeth Vigée-Lebrun, *Memoirs,* p. 31

22. Vigée-Lebrun, pp. 35–36.

23. Vigée-Lebrun, pp. 68–69.

24. Vigée-Lebrun, p. 63.

25. Vigée-Lebrun debated this decision with her childhood friend, Anne Filleul, who stated, "You were wrong to leave. I will stay, because I believe in the happiness which the Revolution will bring us" (Vigée-Lebrun, p. 18). Anne did not live to see it, however, as she was guillotined during the Terror.

26. She is known to have done over 200 landscapes also, mostly in her exile, though we have not yet found them reproduced.

27. Vigée-Lebrun, p. 86.

28. Roger Portalis, "Adélaïde Labille-Guiard: 1749–1803" (article in four parts) *Gazette des Beaux Arts* (1901–1902). There is now also the welcome *Biographie et catalogue raisonné des oeuvres de Mme. Labille-Guiard* by Anne-Marie Passez.

29. Portalis, third article, p. 102.

30. Portalis, third article, p. 105.

31. The story of her entry into the Academy was rhymed by a friend as follows: "C'est l'equité, non la faveur/qui ouvre avec transport le temple de la gloire." (It is justice, not favor which opens to you the temple of glory.) This is probably a reference to Vigée-Lebrun's use of influence to gain entry. Quoted in Marianne Roland-Michel's *Anne Vallayer-Coster,* p. 272.

32. Charles Sterling, *Still Life Painting,* p. 89.

33. Roland-Michel, p. 45.

34. George Levitine, *The Sculpture of Falconet,* p. 57. This book speculates on Collot's relationship with Falconet and gives illustrations of her work.

35. H. N. Opperman, "Marie-Anne Collot in Russia: Two Portraits," *Burlington* 58 (August 1965):412.

36. Pierre de Nolhac, *Madame Vigée-Lebrun,* pp. 128–29.

37. Charles Sterling, "A Fine 'David' Reattributed," *The Metropolitan Museum of Art Bulletin* 9 (January 1951):132.

38. Sterling, *The Metropolitan Museum of Art Bulletin,* p. 131.

39. François Poulenc, "Feuilles Americaines," *La Table Ronde* 30 (June 1950):72.

40. Sterling, *The Metropolitan Museum of Art Bulletin,* p. 121.

41. A previously unpublished poem by our friend and teacher, the poet Joanna Griffin, entitled "For Our Eyes," 1973–1975.

42. Georges Wildenstein, "Un tableau attribué à David et rendu à Mme. Davin-Mirvault: Le Portrait du Violonist Bruni," *Gazette des Beaux Arts* (February 1962).

43. Andrew Kagan, "A Fogg 'David' Reattributed to Madame Adélaïde Labille-Guiard." *Acquisitions Report 1969–1970,* Fogg Art Museum (1971), p. 38.

44. Margaret Fuller Ossoli, *Woman in the Nineteenth Century,* p. 24.

Chapter 5

1. See the National Portrait Gallery's exhibition catalog edited by Sidney Kaplan, *The Black Presence in the Era of the American Revolution 1770–1800.* Mum Bett's story appears on pp. 216–

17 and the portrait in color is on p. 84. Such exhibitions return to us much of our lost history.

2. If you wish information from De-Renne Coerr about the Index, or can volunteer to help work on it, please write, sending a self-addressed, stamped envelope, to her in care of The Fine Arts Museums of San Francisco, Lincoln Park, San Francisco, CA 94121.

3. Eola Willis, "The First Woman Painter in America," *International Studio* (July 1927):13. (This article was unearthed for us by our friend and researcher extraordinaire, Martha Perry; for this, and many other supportive acts, we wish to thank her here.) Again to show the difficulties of this sort of research, we just mention that in the exhibition catalog *Women Artists of America, 1707–1964* put out by the Newark Museum, William H. Gerdts claims a husband for Henrietta, though adds that he had been "washed overboard on the trip across the Atlantic and, while rescued, he was never able to recover his health" (p. 8).

4. Katharine McCook Knox, *The Sharples: Their Portraits of George Washington and his Contemporaries.* This book does much more than its title describes, by the way.

5. Knox, pp. 12–13.

6. Knox, p. 17. This preoccupation with occupation extended to her children as well, and Ellen comments with relief that her two sons "excel so much in portrait painting as to be nearly independent" (p. 21). And in her diary after the death of her husband, she wrote:

Going to the bank and the attorneys causes me a great deal of agitation and when I had my name to write my hand shook so that it was with difficulty I could do it. Girls as well as boys should be accustomed to transact business of various kinds and to enter public banks and offices which would prevent the distressing sensations which women experience when obliged to do it late in life. (p. 51)

7. Knox, p. 21.

8. Knox, p. 52.

9. Knox, pp. 57–58.

10. William Dunlap, *History of the Rise and Progress of the Arts of Design in the United States,* II, p. 445.

11. Miss Powel, "Miss Jane Stuart 1812–1888," *Bulletin of the Newport Historical Society* (1939).

12. J. H. Morgan, *Gilbert Stuart and his Pupils,* p. 50.

13. Morgan, p. 61.

14. Rachel Maines, "Fancywork: The Archaeology of Lives," *The Feminist Art Journal* (Winter 1974–75), 1, 3. See also: Jean Lipman and Alice Winchester, *The Flowering of American Folk Art, 1776–1886.*

15. Isabel Miller is the pseudonym used by the author of *Patience and Sarah,* originally published with the title *A Place for Us.*

16. Harry T. Peters, *Currier & Ives: Printmakers to the American People,* p. 29. James Ives, on hearing of this accident, is said to have remarked, "That's the best thing he ever did."

17. Pennsylvania Academy of Fine Arts exhibition catalog. *The Pennsylvania Academy and Its Women.* Essay by Christine Jones Huber, p. 10.

18. *The Pennsylvania Academy and Its Women,* p. 10.

19. The Peale Museum in Baltimore put out an exhibition catalog on *Miss Sarah Miriam Peale,* with essays by Wilbur H. Hunter and John Mahey, p. 5. Those interested in women artists will come to love the smaller museums like this one. The staff in such specialized museums have a genuine interest and thorough knowledge of their holdings, and thus can often tell you about their women artists. In the larger museums, women's works are all too often stored away in the basement and are not even recognized as interesting by the harassed staff. Often they are amazed to discover how much work by women they actually have, after we have pored through their files. Again a reason to do the sort of index DeRenne Coerr envisions.

20. *Miss Sarah Miriam Peale,* p. 5.

21. *Miss Sarah Miriam Peale,* pp. 12–13.

22. *Miss Sarah Miriam Peale,* p. 18. Eleanor Tufts treats Peale in *Our Hidden Heritage* for those who want to read further about her.

23. Tufts tells this story in her chapter on Bonheur, p. 148. Generally, however,

we have used the following two biographies: Anna Klumpke, *Rosa Bonheur, sa vie, son oeuvre,* and Theodore Stanton, *Reminiscences of Rosa Bonheur.*

24. Klumpke, p. 311.

25. Klumpke, p. 372; also p. 202. (We should say that our quoting from Klumpke's French is a mixture of translation and paraphrase.) Stanton, p. 114.

26. Klumpke, p. 264.

27. Stanton, p. 13; though Rosa did say, "In matters of art, rewards are much like blisters on wooden legs—they don't affect much" (p. 258).

28. Klumpke, p. 107.

29. Klumpke, p. 190.

30. Klumpke, p. 359.

31. Stanton, p. 42.

32. Klumpke, pp. 250–51.

33. Quoted in Stanton, p. 140.

34. For a different kind of story, see the painting by Emily Mary Osborne in Linda Nochlin, "By a Woman Painted—Artists in the Nineteenth Century," *Ms.,* July 1974, p. 74.

35. The fullest accounts of this group appear in the exhibition catalog, *The White Marmorean Flock, Nineteenth-Century American Women Neoclassic Sculptors,* put out by Vassar College; also Margaret Thorp's *The Literary Sculptors.* James's quote speaks of the appearance of "that strange sisterhood of American 'lady sculptors' who at one time settled upon the seven hills in a white marmorean flock."

36. Harriet Hosmer's *Letters and Memories.*

37. Quoted in *The Pennsylvania Academy and Its Women,* pp. 19–20.

38. For an article that describes in detail the medical problems of conventionally raised Victorian women, see Ann Douglas Wood's, "The Fashionable Diseases," *Journal of Interdisciplinary History* 4 (Summer 1973).

39. Charlotte Cushman's role in encouraging women in the arts is detailed in her biography by Joseph Leach, *Bright Particular Star.*

40. Thorp, p. 86.

41. Hosmer, p. 35.

42. Quoted by Thorp. p. 91.

43. Langston's autobiography *Plantation to Capitol* contains the only first-person account of the episode.

44. Geoffrey Blodgett, "John Mercer Langston and the Case of Edmonia Lewis," *Journal of Negro History* 53 (1968). Dr. Blodgett has meticulously reconstructed the details of Edmonia's trial with an eye to fairness and points out that Langston himself had some doubts about Edmonia's innocence in the case. Tufts has a chapter on Lewis, too.

45. Elizabeth R. Payne, "Anne Whitney," *Massachusetts Review* (Spring 1971). Almost all available material on Anne Whitney is in the Wellesley College Library where it is being developed into a full-scale biography by Payne.

46. Payne, p. 257.

47. The Pennsylvania Academy of Fine Arts catalog provides an excellent source of information on women artists and art training in nineteenth-century America.

48. Quoted in *The Pennsylvania Academy and Its Women,* p. 12.

49. Fortunately, we now all can find out more about who she was because of a recent catalog prepared by Robin Bolton-Smith and William Truettner, *Lilly Martin Spencer, 1822–1902: The Joys of Sentiment;* the newspaper excerpt is quoted on p. 76.

Robin Bolton-Smith has been so helpful to us in our research, as has the whole National Collection of Fine Arts staff. There also are the Archives of American Art, fascinating for researchers (microfilms of it are available).

50. *Lilly Martin Spencer,* p. 50.

51. *Lilly Martin Spencer,* pp. 30–31.

52. *Lilly Martin Spencer,* p. 8.

53. The quotation in the subhead comes from Frederick Sweet's *Miss Mary Cassatt, Impressionist from Pennsylvania,* p. 136. The rest of it reads: "Women do not have to fight for recognition here if they do serious work." The second quotation is taken from Adelyn Dohme Breeskin's introduction to the exhibition catalog, *The Graphic Art of Mary Cassatt,* p. 9.

54. One of the more notable of their disagreements was over the famous Dreyfus case, where Cassatt was militantly pro-Dreyfus and Degas stubbornly opposed. (Sweet, p. 145.)

55. Adelyn Dohme Breeskin, *Mary*

Cassatt: A Catalogue Raisonné, p. 8.

56. Sweet, p. 23.

57. Sweet, p. 124.

58. As John Rewald also suggests in *The History of Impressionism,* p. 409.

59. Sweet, p. 164.

60. Sweet, p. 147.

61. As Adelyn Breeskin describes in her introduction to the exhibition catalog put out by the National Gallery of Art, *Mary Cassatt: 1844–1926,* p. 11.

62. Sweet, p. 150.

63. Sweet, p. viii.

64. Sweet, p. 185.

65. Sweet, p. 131.

66. Quoted in Sweet, p. 41.

67. Paul Valéry, *Degas, Manet, Morisot,* p. 115.

68. Denis Rouart, ed., *The Correspondence of Berthe Morisot,* p. 14.

69. *Correspondence,* p. 21.

70. *Correspondence,* p. 58.

71. *Correspondence,* p. 24.

72. *Correspondence,* p. 71.

73. *Correspondence,* p. 16.

74. *Correspondence,* p. 17.

75. M. L. Bataille and G. Wildenstein, *Berthe Morisot,* p. 15. The N.O.W. women-in-the-arts newsletter is entitled *The Morisot Messenger* in recognition of how many women do not become artists due to the exigencies of their lives.

76. *Correspondence,* pp. 29–30.

77. Philippe Huisman, *Morisot: Enchantment,* p. 20.

78. *Correspondence,* p. 105.

79. *Correspondence,* pp. 38, 43, and elsewhere.

80. *Correspondence,* p. 71.

81. *Correspondence,* p. 41.

82. *Correspondence* p. 42; *see also* p. 83.

83. *Correspondence,* p. 80.

84. Valéry, p. 121.

85. *Correspondence,* p. 187.

86. John Storm, *The Valadon Drama,* p. 89. *See also* Piece #193 in the exhibition catalog, *Suzanne Valadon,* from the Musée National d'Art Moderne. A less charming tale is told of Renoir's reaction to Valadon's developing "genius for drawing," as Degas called it. In 1884 Renoir first saw her work and exclaimed "and you hide this talent!" He then turned away and never again asked to see her work. Suzanne said later that it was Renoir's professional jealousy as much as Degas's encouragement that made her realize she was good. (Storm, p. 72)

87. Storm, p. 52.

88. Storm, p. 106.

89. Storm, p. 165.

90. Storm, p. 202.

91. Storm, pp. 252–53.

Chapter 6

1. Nina Hamnett, *Laughing Torso,* p. 8.

2. Beatrice Glenavy, *Today We Will Only Gossip,* p. 39.

3. Marevna, *Life with the Painters of La Ruche,* p. 43.

4. David Garnett, ed., *Carrington: Letters & Extracts from her Diaries,* p. 61. There will be discussion of Carrington herself further on in this chapter.

5. Holroyd, p. 27.

6. Arts Council of Great Britain, *Gwen John: A Retrospective Exhibition,* p. 7.

7. Robert Melville, "Kinds of Loving," *New Statesman,* February 2, 1968, p. 150.

8. The curator of John's retrospective exhibition quotes from some of the artist's scattered notes about "a search for strange form," p. 9.

9. *Orlando* is about a hero/ine who lives for 400 years right up until the present moment. In the course of this too short life s/he tries out new forms of the novel, of biography, of literary history, of family history, of sex roles and relationships, of just about everything. The "biographer" is a Woolf in sheep's clothing, critical of the status quo and of everything else, as Woolf herself says in her diary entry about her first inkling of the book: "Sapphism is to be suggested. Satire is to be the main note— satire and wildness. The ladies are to have Constantinople in view. Dreams of golden domes. My own lyric vein is to be satirised. Everything mocked. And it is to end with three dots . . . so." (*A Writer's Diary,* p. 105)

10. Djuna Barnes, *The Ladies Almanack: Written and Illustrated by a Lady of Fashion* (in 1928, the same year as the publication of *Orlando*).

11. Meryle Secrest, *Between Me and*

Life: a Biography of Romaine Brooks, p. 312.

12. Secrest, p. 307.

13. National Collection of Fine Arts, *Romaine Brooks "Thief of Souls."* Essay by Adelyn D. Breeskin.

14. Parker Tyler, *Florine Stettheimer: A Life in Art,* p. 83.

15. Linda Nochlin, "What is Female Imagery," *Ms.,* May 1975, p. 82.

16. Tyler, p. 32 and pp. 60–68. Many women artists become involved in stage-set design: Delaunay-Terk, Goncharova, Laurencin, Hepworth, and others. A contemporary practitioner of this art, Ariel Parkinson, says of the relation between her painting and theatre work:

Painting is work. The theatre is play. Paintings are a slow dream for which I alone am responsible. They are uniquely my own creations. . . . My stage work enriches and nourishes my painting. A painter can sometimes get stuck in his own imagination and perhaps become banal. Painting can often become a trap. That's why there are so many Sunday painters . . . an artist often requires the discipline of work that involves other people's sensibilities.

This interesting quote comes from an interview done by Jeanne Miller in the *San Francisco Examiner,* April 21, 1975, p. 24.

17. Tyler, p. 32.

18. Columbia University, *Florine Stettheimer: An Exhibition of Paintings, Watercolors, Drawings.*

19. Tyler, p. 93.

20. Wilhelm Uhde, "Séraphine ou la Peinture Révélée," *Formes* 12 (September 1931); also Wilhelm Uhde, *Fünf Primitive Meister.* The painter Sonia Sekula has a lot in common with Séraphine. In John Cage's *Silence* he tells us the following story:

One spring morning I knocked on Sonia Sekula's door. She lived across the hall. Presently the door was opened just a crack and she said quickly, "I know you're very busy; I won't take a minute of your time."

This was quoted in the article already cited by Nancy Foote, p. 79.

21. The fullest treatment of this wonderful phenomenon in the arts that we have found is Oto Bihalji-Merin's *Masters of Naive Art: A History and Worldwide Survey.*

22. Nigel Nicolson, *Portrait of a Marriage,* pp. 231–32.

23. There are numerous accounts of this painful discrimination in artists' biographies, one of the grimmest told by Lee Krasner of Peggy Guggenheim's visit to the studio she and Jackson Pollock were sharing. "L.K., L.K. I didn't come to look at L.K.'s paintings. Who is L.K.?" Later P.G. suggested to Pollock when he asked for an increase in his gallery stipend, "Tell Lee to go out and get a job" (from an interview in Nemser's *Art Talk,* p. 88).

24. This quotation is from p. 13 of David Garnett's edition of Carrington's letters, already mentioned. For a discussion of the whole issue of Carrington's creativity, see: J. J. Wilson, "So You Mayn't Ever Call Me Anything But Carrington," *The Massachusetts Review* (Winter–Spring 1972). This review has been reprinted in Lee R. Edwards, ed., *Woman: An Issue.*

25. Garnett, pp. 152, 237.

26. Garnett, pp. 173, 170. In a similar outburst, Gwen John wrote: "I should like to go and live somewhere, where I met nobody I know till I am so strong that people and things could not affect me beyond reason." (Holroyd, p. 59)

27. Garnett, p. 369.

28. Anthony d'Offay Gallery. *Vanessa Bell: Paintings and Drawings.* Essay by Richard Morphet, p. 5. Quentin Bell's biography of his aunt, *Virginia Woolf,* includes many details of Vanessa's life also.

29. For the Apollinaire quotation (from his *Essays on Art*) and for the Laurencin source in note 31, we are indebted to Susan Weiss, whose thesis on Laurencin is cited in the bibliography.

30. Nemser, p. 44.

31. Gabrielle Buffet, "Marie Laurencin," *The Arts* 3 (1903).

32. Munich, Städtische Galerie, exhibition catalog, *Gabriele Münter: 1877–1962;* this note by Münter is dated 28 January, 1959.

33. Liselotte Erlanger Glozer, "Gabriele Münter: A Lesser Life?" *Feminist Art Journal,* Winter 1974, p. 11.

34. Ursula Schuh writes of Kandinsky's classroom in *Bauhaus and Bauhaus People,* edited by Eckhardt Neumann, p. 161:

Searchingly I pass closed doors with often quoted imposing names, along the silent corridors to the door: Painting class. Kandinsky. Thank God, *he* has not yet arrived! I find a seat. Benches and tables, like in a classroom. He enters. Immediately everything unreal vanishes in front of these lively, fast-moving, pale blue eyes looking through sharp glasses

35. Munich, Städtische Galerie, *Gabriele Münter,* an undated note by the artist.

36. Munich, Städtische Galerie, *Gabriele Münter,* quoted from *The Times,* 28 September, 1960.

37. S. D. Gallwitz, ed., *Briefe und Tagebuchblätter,* letter to Otto, May 15, 1906, p. 230. All translations used here were done by our friend and colleague, Liselotte Erlanger Glozer, who is preparing a manuscript of the diaries in English in the hopes of publishing it. Alas, there has never been a full translation of this remarkable document into English, though it is much read in Germany. We quote from it, courtesy of the translator, at some length as it is relatively inaccessible. The best English sources on Paula Modersohn-Becker are Peter Selz, *German Expressionist Painting* and Martha Davidson's article, "Paula Modersohn-Becker: Struggle between Life and Art," The *Feminist Art Journal,* Winter 1973–74, p. 1, 3–5. Illustrated books on her in German are listed in the bibliography. There is a Paula Modersohn-Becker Museum in Bremen now, where many of her paintings can be seen.

38. Clara Westhoff remains an enigma. She studied with Rodin in Paris. (Rilke was later his secretary.) Her marriage with Rilke was brief, and after some years of travel, she returned to the village of Fischerhude in 1918, where she lived until her death in 1954.

39. Rilke's relationship with Modersohn-Becker is the subject of H. W. Petzet's *Das Bildnis des Dichters. See also* H. E. Holthusen, *Portrait of Rilke.*

40. Gallwitz, diary entry, Easter, 1902, pp. 169–70.

41. Gallwitz, diary of Otto Modersohn, June 15, 1903, p. 250.

42. Gallwitz, diary entry, October 1902, p. 177.

43. Gallwitz, diary entry, February 20, 1903, p. 197.

44. Hetsch, R. ed., *Paula Modersohn-Becker: Ein Buch der Freundschaft,* letter to Clara, October 1907, p. 49.

45. Gallwitz, diary entry, February 15, 1903, p. 196.

46. Gallwitz, diary entry, February 25, 1903, pp. 198–99.

47. Gallwitz, diary entry, Paris, February 24, 1906, p. 232.

48. Gallwitz, letter to sister, Paris, May, 1906, p. 227.

49. Gallwitz, letter to mother, Paris, May 8, 1906, p. 228.

50. Jacques Damase, *Sonia Delaunay: Rhythms and Colours,* p. 100.

51. Damase, p. 401.

52. So much has been written on Goncharova lately that we are satisfied to refer you to these sources: Gloria Orenstein, "Natalia Goncharova: Profile of the Artist-Futurist Style," *Feminist Art Journal,* Summer 1974; Mary Chamot, *Gontcharova;* Tatiana Loguine, *Gontcharova et Larionov;* there is also a chapter on her in Tufts's book.

53. Leonard Hutton Galleries, *Russian Avant-Garde: 1908–1922* Another good source here is Herta Wescner's *Collage,* where the innovative works of Zatkova, Höch, and Donas are discussed, along with many others.

54. Camilla Gray, *The Russian Experiment in Art: 1863–1922,* p. 192. Even less political artists sought to extend their art into daily life, working in fabric, furniture, metalwork, architecture, etc., during this self-consciously innovative period, and often these innovators were women. The Weimar/Dessau Bauhaus numbered many women among its students. Of particular interest are Gertrud Grunow, one of the few women teachers, Anni Albers, Gunta Stölzl, Marianne Brandt, Alma Buscher, and Ida Kerkovius. In England, Roger Fry's Omega Workshop commissioned numerous women artists, Vanessa Bell, Nina Hamnett, Carrington, etc. In Scandinavia, as early as 1874, the Handar-

betets Vanner had been founded by and for women artists; it is still thriving. This healthy trend to dissolve the divisions between fine arts and useful arts has always been connected with attitudes about women artists.

55. Hans Kollwitz, ed., *The Diary and Letters of Käthe Kollwitz,* p. 23.

56. Quoted in Carl Zigrosser, *Prints and Drawings of Käthe Kollwitz,* p. x.

57. Mina C. and H. Arthur Klein, *Käthe Kollwitz: Life in Art,* p. 82; *Diary,* Sunday, February 21, 1915.

58. *Diary,* p. 78.

59. *Diary,* p. 43.

60. Klein, p. 20.

61. *Diary,* p. 85.

62. Klein, p. 68.

63. Otto Nagel, *Käthe Kollwitz,* p. 90.

64. *Diary,* p. 23.

65. *Diary,* p. 166.

66. Nagel, p. 94.

Chapter 7

1. Barbara Hepworth, *Pictorial Autobiography,* pp. 50, 53. A real family picture album done by Hepworth herself.

2. A. M. Hammacher, *The Sculpture of Barbara Hepworth,* p. 99.

3. Hammacher, p. 98.

4. Hepworth, p. 39.

5. *Art Talk,* p. 14.

6. Hepworth, p. 49.

7. *Art Talk,* p. 15.

8. *Art Talk,* p. 19.

9. Hepworth, p. 19.

10. Hepworth, p. 81.

11. Hepworth, p. 117.

12. *Art Talk,* p. 16.

13. Hepworth, p. 79.

14. *Art Talk,* p. 25.

15. Calvin Tomkins, "Profile: Georgia O'Keeffe," *The New Yorker,* March 4, 1974, p. 64.

16. Lloyd Goodrich and Doris Bry, *Georgia O'Keeffe,* p. 8.

17. Goodrich and Bry, p. 9.

18. Goodrich and Bry, p. 9.

19. Tomkins, p. 46.

20. Goodrich and Bry, p. 16.

21. We found an account of Zelda leaving the hospital against the doctor's orders to go see an O'Keeffe exhibition. She described the "cosmic oysters" and other images, saying: "they are magnificent and excited me so that I felt quite sick afterwards." Zelda's art is well worth including in this book, but we are unable thus far to track down rights and reproductions for her works. (Scott Fitzgerald Smith and Matthew Bruccioli, *The Romantic Egoists,* p. 195.)

22. Goodrich and Bry, p. 18.

23. Goodrich and Bry, p. 23.

24. Tomkins, p. 66.

25. Louise Nevelson, "Nevelson on Nevelson—Perspectives," p. 9.

26. Louis Botto, "Work in Progress/ Louise Nevelson," *Intellectual Digest,* April 1972, p. 8. Much of this interview appears as an introduction to Glimcher's book on Nevelson, cited in note 28.)

27. "Nevelson on Nevelson," p. 10; *Art Talk,* p. 70.

28. Arnold B. Glimcher, *Louise Nevelson,* p. 125.

29. Botto, p. 8.

30. The quotations here are from a recent telephone conversation with the gracious artist. The details of her biography come from Edmund Barry Gaither's essay to the catalog of a recent retrospective exhibit, *Reflective Moments,* sponsored by the Museum of the National Center of Afro-American Artists and the Museum of Fine Arts in Boston.

31. For example and for reference: The Ethnic American Art Slide Library (directors, James Conlon and James Kennedy) at the University of South Alabama, Mobile, ALA 36688, have a large and ever-growing collection, cataloged, from which duplicate slides can be ordered inexpensively. Camille Billops has taped and written biographies, as well as slides, of black American artists at the Archives of Black American Cultural History, 736 Broadway, New York, NY 10003. Dorinda Moreno, at the Concilio Mujeres, 2863 24th St., San Francisco, is compiling a valuable archive on Chicanas, and Professor Jacinto Quirarte, at the University of Texas, San Antonio, has slides of difficult-to-find artists in his region. There are many other such projects and the more the better. We will just mention one bibliographic source (and refer you to our note 15 in chapter I): Ora Williams, *American Black Women in the Arts and Social*

Sciences: a Bibliographic Survey.

32. Benny Andrews wrote a brief article, "New Colors, Old Canvas," for the *Encore* issue devoted to women, June 23, 1975.

33. Gloria Orenstein, "Women of Surrealism," *The Feminist Art Journal,* Spring 1973.

34. Octavio Paz and Roger Callois, *Remedios Varo.*

35. Gloria Orenstein, "Leonora Carrington—Another Reality," *Ms.,* August 1974; her novel *Down Below,* where she describes how she learned to suffer "in extract form," has been reprinted by the Surrealist Group of *Radical America,* 1878 Massachusetts Ave., Cambridge, MA 02140; also Leonora Carrington, *El Mundo Magico de los Mayas.*

36. Marcel Brion, *Leonor Fini et son oeuvre;* Constantin Jelenski, *Leonor Fini;* Xavière Gauthier, *Leonor Fini.*

37. Gauthier, p. 6.

38. Alain Bosquet, *La peinture de Dorothea Tanning.*

39. Bosquet, p. 151.

40. MacKinley Helm, *Modern Mexican Painters,* pp. 170–71.

41. Karen and David Crommie ten years ago made an extraordinary film, *The Life and Death of Frida Kahlo,* with interviews, photographs, and color filming of many of her paintings. It is 16mm., 40 minutes long, and is available through Crommie & Crommie, 1408 Chapin Avenue, Burlingame, CA 94010. It will tell you more about Frida herself than any other source we know. Frida and Diego's relationship is covered in Bertram D. Wolfe's *The Fabulous Life of Diego Rivera;* see also Diego Rivera with Gladys March, *My Art, My Life.*

42. At the Frida Kahlo Museum there is an unpublished (and untranslated) diary that she kept in her last years.

43. The Museo Frida Kahlo at 127 Londres in Coyoacan, Mexico City, publishes a small catalog that gives some idea of her; it is in several languages.

44. Joan Snyder, quoted in the *Ms.* "Forum on the Arts," May 1975, p. 83.

45. Lucy Lippard, "Sexual Politics Art Style," *Art in America* (September–October 1971 [note the early date]), p. 19.

46. Nemser, p. 122.

47. Chicago, p. 99.

48. A.I.R. is in New York, Artemisia in Chicago, Front Range in Boulder, WAC in San Francisco, The Woman's Building in Los Angeles; there should be WEB (West East Bag) in every major city now. There are many more such organizations than we have mentioned here, of course; their proliferation is a good sign.

49. Lippard, p. 19. These insights, by the way, were confirmed by the statistics published by June Wayne's Tamarind Lithography Workshop, *Sex Differentials in Art Exhibition Reviews.*

50. Lippard, p. 20.

51. Grace Glueck, as quoted from a workshop reported in *Women and the Arts,* p. 57.

52. Chicago, pp. 32, 181; also conversations with J.J.'s sister, Melinda.

53. Elizabeth Catlett's lecture, March 31, 1975, in San Francisco, sponsored by the San Francisco Negro Business and Professional Women's Club.

54. See Vogel's article, cited in note 7, chapter I; also Irene Peslikis, "Notes on Art and Society," *Women and Art.* Supplement of *On Art and Society* (1972), p. 18. In a recent article by Cindy Nemser on "Audrey Flack: Photorealist Rebel," *The Feminist Art Journal* (Fall 1975), Flack speaks to many of these issues; we recommend it.

55. Chicago, p. 132.

56. Chicago, p. 176.

57. Wassily Kandinsky, *Concerning the Spiritual in Art,* p.11.

58. Chicago, p. 183.

59. Aside from this show, Mary Beth Edelson held an exhibit called "22 Others," where she did art pieces in response to the fantasies of 22 of her friends. We show a piece from her latest show, "Woman Rising," later in the chapter.

60. Sonia Sekula's letter to Betty Parsons, 1956, quoted by Foote, p. 76.

61. Lloyd Goodrich, *Thomas Eakins: A Retrospective Exhibition,* p. 29.

62. Linda Nochlin, as quoted from a workshop reported in *Women and the Arts,* p. 58.

63. Linda Nochlin, Introduction to *Miriam Schapiro: The Shrine, the Computer, and the Dollhouse* (San Diego: University of California, San Diego,

1975), p. 7. Reprinted with additions from *"Miriam Schapiro: Recent Work,"* *Arts* 48 (November 1973): 38.

64. Nochlin, Introduction to *Miriam Schapiro,* p. 3.

65. Jenny Snider, in an autobiographical lecture on her development as an artist in New York City; this very lively artist has also written her obituary as if she were Picasso.

66. Nochlin, Introduction to *Miriam Schapiro,* p. 3.

67. Virginia Woolf uses this image frequently in her extraordinary "novel" *The Waves,* available in many editions.

68. Woolf, *Orlando,* p. 195. The difficulties of the present moment for critics are discussed at length in Woolf's essay, "How it Strikes a Contemporary," *Common Reader* I, 236–46, from whence we took one of our chapter's subheads, "The Burning Ground of the Present."

Appendix

1. Horizon Magazine, *The Horizon Book of the Arts of China,* p. 297.

2. Tzu Yeh, *A Gold Orchid,* p. 48.

3. Tzu Yeh, p. 103.

4. Horizon, p. 297.

5. Tsien Tsuen-hsuin, *Written on Bamboo and Silk,* p. 115.

6. Horizon, p. 300.

7. Kenneth Rexroth, ed. and trans., *Love and the Turning Year,* p. 105.

8. Judith Burling and Arthur Hart Burling, *Chinese Art,* p. 314, quoting the Ming artist and critic Tung Ch'i-ch'ang.

9. Thomas Francis Carter, *The Invention of Printing in China and Its Spread Westward,* pp. 3, 8. Although its official date of invention is given in dynastic records as A.D. 105, paper is mentioned in Empress Teng's biography as existing in A.D. 102.

10. Tsien, *Written on Bamboo and Silk,* p. 132.

11. Nancy Lee Swann, *Pan Chao,* p. 42. Pan Chao completed the *Han Shu* [History of the (former) Han dynasty], which was begun by her father and brother.

12. Swann, p. 43.

13. Lucy Driscoll, *Chinese Calligraphy,* p. 42.

14. Driscoll, p. 43. *Chin Wei fu-jen pi-chen t'u* [Diagram of the Battle Array of the Brush by Lady Wei of Chin Dynasty] is preserved in Chang Yen-yüan's *Fashu yao-lu* [Catalog of Famous Calligraphy], which is itself in *Ching-tai pi-shu* vol. 6 (n.p., 1922).

15. Driscoll, p. 43.

16. Driscoll, p. 41, citing Chang Yen-yüan, *Li-tai ming-hua chi* [Historical Famous Paintings]. Included in *Ching-tai pui-shu,* vol. 7.

17. Driscoll, p. 45.

18. Driscoll, p. 45.

19. Driscoll, p. 46.

20. Driscoll, p. 46.

21. See Kathryn A. A. Cissell, *The Pi-ch'iu-ni chuan.*

22. Genevieve [B.] Wimsatt, *A Well of Fragrant Waters,* p. 41.

23. See Chiang Chao-shen, "The Identity of Yang Mei-tzu and the Paintings of Ma Yüan," *National Palace Museum Bulletin* (Taipei) 2, no. 2 (1967): 1–14; 2, no. 3 (1967): 9–14.

24. Tseng Yu-ho Ecke, *Chinese Calligraphy,* Pl. 25.

25. Osvald Siren, *Chinese Painting,* vol. V, p. 71.

26. Siren, vol. V, p. 72.

27. Tseng Yu-ho [Ecke], "Hsüeh Wu and Her Orchids in the Collection of the Honolulu Academy of Arts," *Ars Asiatiques* 2, no. 3 (1955): 202, quoting Hu Ying-lin.

28. Tseng, "Hsüeh Wu," p. 202, quoting Hu Ying-lin.

29. Tseng, "Hsüeh Wu," p. 208.

30. Florence Ayscough, *Chinese Women Yesterday and Today,* p. 210.

31. E. Backhouse and J.O.P. Bland, *Annals and Memoirs of the Court of Peking,* p. 472.

32. Maria Warner, *The Dragon Empress,* p. 7.

33. Warner, p. 162, quoting I. T. Headland, *Courtlife in China* (1901), p. 87.

34. Backhouse, *Annals and Memoirs,* p. 475.

35. See Mao Tse-tung, *Talks at the Yenan Forum on Literature and Art.*

Bibliography

A

*Anonymous Was a Woman: A Documentation of the Women's Art Festival, with Letters to Young Women Artists. Valencia, California: Feminist Art Program, California Institute of the Arts, 1974.

Adriani, Gert, ed. Anton van Dyck: Italienisches Skizzenbuch. Vienna: A. Schroll & Co., 1940.

Aeschlimann, Erhard, and Ancona, Paolo. Dictionnaire des miniaturistes. Milan: Ulrico Hoepli, 1949.

*Albers, Anni. On Weaving, Middletown, Conn.: Wesleyan University Press, 1965.

*Andrews, Benny. "Art: New Colors, Old Canvas." Encore, June 23/July 4, 1975, pp. 64–66.

*Arbus, Diane. Diane Arbus: An Aperture Monograph. Millerton, New York: Aperture, Inc., 1972.

Argan, Giulio Carlo. The Europe of the Capitals, 1600–1700. Translated by Anthony Rhodes. Geneva: Skira, 1964.

*Art News 69, January 1971. The whole issue is devoted to women artists.

*Arts Council of Great Britain. Bridget Riley: Paintings and Drawings, 1951–1971. London: The Hayward Gallery, 1971.

Arts Council of Great Britain. David, 1748–1825: Catalog of Exhibition of Paintings and Drawings. Introductory essay by Rene Huyghe. London, 1948.

*Arts Council of Great Britain. Gwen John: A Retrospective Exhibition. Introductory essay by Mary Taubman. London: 1968.

*Arts Council of Great Britain. Opus Anglicanun; English Medieval Embroi-dery. London: Exhibition at The Victoria and Albert Museum, 1963.

*Ashton, Dore, ed. The Mosaics of Jeanne Reynal. New York: George Wittenborn, 1964.

"A Surinam Portfolio." Natural History, December 1962, pp. 28–41.

B

*Baker, Elizabeth, and Hess, Thomas B., eds. Art and Sexual Politics. New York: Viking, 1973.

*Baldwin, Carl. "The Predestined Delicate Hand." Feminist Art Journal, Winter 1973–74.

*Barnes, Djuna. Ladies Almanack: Written and Illustrated by a Lady of Fashion. 1928. Reprint. New York: Harper & Row, 1972.

*Barnes, Mary. Two Accounts of a Journey through Madness. New York: Harcourt Brace Jovanovich, 1972.

*Bataille, M. L., and Wildenstein, Georges. Berthe Morisot—Catalogue des peintures, pastels et aquarelles. Paris: Les Beaux Arts, 1961.

*Baur, John I. H. Loren MacIver, I. Rice Pereira. New York: Whitney Museum of American Art, 1933.

*Beaux, Cecilia. Background with Figures. Boston: Houghton Mifflin Co., 1930.

*Bell, Quentin. Virginia Woolf: A Biography. New York: Harcourt Brace Jovanovich, 1972.

*Bell, Susan G., ed. Women: From the Greeks to the French Revolution. Belmont, Calif.: Wadsworth Publishing Co., 1973.

Bergman, Simone. "La Problème Jan van Hemessen, monogrammiste de Brunswick." Revue Belge d'Archéologie et d'Histoire de l'Art 23 (1955): 133–57.

*An asterisk indicates works that deal primarily with women.

Bergström, Ingvar. *Dutch Still-Life Painting.* Translated by Christina Hedström and Gerald Taylor. New York: Thomas Yoseloff, Inc., 1956.

Bernt, Walther. *The Netherlandish Painters of the Seventeenth Century.* Translated by P. S. Falla. New York: Phaidon, 1970.

Bertrand, Simone. *La Tapisserie de Bayeux.* Paris: Zodiaque, 1966.

Bihalji-Merin, Oto. *Masters of Naive Art: A History and Worldwide Survey.* Translated by Russell M. Stockman. New York: McGraw-Hill, 1970.

*Bissell, R. Ward. "Artemisia Gentileschi—A New Documented Chronology." *Art Bulletin* 1 (June 1968): 153–68.

Black, Mary, and Lipman, Jean. *American Folk Art.* New York: Clarkson N. Potter, Inc., 1966.

*Blodgett, Geoffrey. "John Mercer Langston and the Case of Edmonia Lewis." *Journal of Negro History* 53 (1968).

*Bosquet, Alain. *La peinture de Dorothea Tanning.* Paris: Jean-Jacques Pauvert, 1966.

*Boston. *Reflective Moments: Lois Mailou Jones.* Exhibition Catalog. Essay by Edmund Barry Gaither. Boston: Museum of Fine Arts, 1973.

*Bottari, Stefano. "Fede Galizia." *Arte antica e moderna* 24 (1963): 309–18.

*Botto, Louis. "Work in Progress/Louise Nevelson." *Intellectual Digest* (April 1972): 6–10.

Bradley, John W. *A Dictionary of Miniaturists, Illuminators, Calligraphers, and Copyists.* 1887–1889. Reprint (3 vols). New York: Burt Franklin, n.d.

*Breeskin, Adelyn Dohme. *Mary Cassatt: A Catalogue Raisonné of the Oils, Pastels, Watercolors, and Drawings.* Washington, D. C.: Smithsonian Institution Press, 1970.

*Bregenz, Switzerland, Vorarlberger Landesmuseum. *Angelica Kauffmann und ihre Zeitgenossen.* 1968.

*Brion, Marcel. *Leonor Fini et son oeuvre.* Paris: Jean-Jacques Pauvert, 1955.

*Brooklyn Museum. *Isabel Bishop; prints and drawings, 1925–1964.* Introductory essay by Una E. Johnson. Number 2 in the American Graphic Artists of the Twentieth Century series. New York: Sherwood Publisher, 1964.

*Buffet, Gabrielle. "Marie Laurencin." *The Arts* 3 (1923): 391–96.

C

*California, University of, San Diego. *Miriam Schapiro: The Shrine, the Computer, and the Dollhouse.* Exhibition Catalog. Edited by Moira Roth. San Diego: Mandeville Art Gallery, University of California, 1975.

*Carr, Emily. *Growing Pains: The Autobiography of Emily Carr.* Toronto: Oxford, 1946.

*———. *The Heart of a Peacock.* Toronto: Oxford, 1953.

*Carriera, Rosalba. *Journal de Rosalba Carriera.* Translated by Alfred Sensier into French with notes. Paris: J. Techener, 1865.

*Carrington, Leonora. *Down Below.* Monograph no. 5 of Surrealist Research and Development series. Radical America, 1878 Massachusetts Ave., Cambridge MA 02140, 1972.

*———. *El Mundo Magico de los Mayas.* Mexico: Museo National de Antropologia, 1964.

Casanovas, Jaime Marqués; Dubler, César E.; Neuss, Wilhelm. *Sancti Beati a Liebana in Apocalypsin codex Gerundensis.* Facsimile Edition. Oltun et Lausannae: In Aedibus Urs Graf, 1962.

Cederholm, Theresa Dickason, ed. *Afro-American Artsts: A Bio-bibliographical Directory.* Boston: Trustees of the Boston Public Library, 1973.

*Chamot, Mary. *Gontcharova.* Paris: Bibliothèque des Arts, 1972.

Chase, Judith Wragg. *Afro-American Art and Craft.* New York: Van Nostrand Reinhold, 1971.

*Chicago, Judy. *Through the Flower: My Struggle as a Woman Artist.* Introduction by Anaïs Nin. New York: Doubleday, 1975.

*Clark, Alice. *Working Life of Women in the Seventeenth Century.* London: Cass, 1968.

Clark, Kenneth. *The Nude: A Study in Ideal Form.* New York: Pantheon Books, 1957.

*Clayton, Ellen. *English Female Artists.* London: Tinsley, 1876.

Clement, Clara Erskine, and Hutton, Laurence. *Artists of the Nineteenth Century and Their Works*. Rev. ed. Boston: Houghton Mifflin, 1893.

*Clement, Clara Erskine. *Women in the Fine Arts*. Boston: Houghton Mifflin, 1904.

*Cole, Doris. *From Tipi to Skyscraper: A History of Women in Architecture*. New York: i. press, distributed by George Braziller, 1973.

*Columbia University. *Florine Stettheimer: An Exhibition of Paintings, Watercolors, Drawings*. New York: Columbia University Press, 1973.

Constantine, Mildred, and Larsen, Jack Lenor. *Beyond Craft: The Art Fabric*. New York: Van Nostrand Reinhold, 1972.

*Cornillon, Susan Koppelman, ed. *Images of Women in Fiction: Feminist Perspectives*. Bowling Green, Ohio: Bowling Green University Popular Press, 1972.

*Crommie, Karen, and Crommie, David. *The Life and Death of Frida Kahlo*. 16 mm. film, black and white with color for her paintings. 1408 Chapin Avenue, Burlingame, CA 94010.

D

*Damase, Jacques. *Sonia Delaunay: Rhythms and Colours*. London: Thames and Hudson, 1972.

*Davidson, Martha. "Paula Modersohn-Becker: Struggle between Life and Art." *Feminist Art Journal*, Winter 1973, pp. 1–5.

Delécluze, Étienne Jean. *Louis David, son école et son temps*. Paris: Didier, 1855.

Diderot, Denis. *Salons—1767*. Vol. 3. Edited by Jean Seznec and Jean Adhémar. Oxford: Clarendon Press, 1963.

*Diner, Helen. *Mothers and Amazons*. Garden City, N.Y.: Doubleday, 1973.

Dunlap, William. *History of the Rise and Progress of the Arts of Design in the United States*. 3 vols. 1834. Reprint. New York: Dover Publications, 1969.

E

*Eber, Dorothy, ed. *Pitseolak: Pictures Out of My Life*. Toronto: Oxford University Press, n.d.

*Eckenstein, Lina. *Woman under Monasticism*. Cambridge: University Press, 1896.

*Edwards, Lee R., ed. *Woman: An Issue*. Boston: Little, Brown, 1972.

Egbert, Donald Drew. *Social Radicalism and the Arts: Western Europe*. New York: Alfred A. Knopf, 1970.

Egbert, Virginia Wylie. *The Medieval Artist at Work*. Princeton: Princeton University Press, 1967.

*Eichner, Johannes. *Kandinsky and Gabriele Münter*. Munich: F. Bruckmann, 1957.

Elam, Charles H., ed. *The Peale Family*. Detroit: Wayne State University Press, 1967.

*Ellet, Elizabeth Fries Lummis. *Women Artists in All Ages and Countries*. New York: Harper & Brothers; 1859.

*Elliott, Maud Howe, ed. *Art and Handicraft in the Woman's Building of the World's Columbian Exhibition*. New York: Goupil and Co., 1893.

*Engelhardt, Christian Moritz. *Herrad von Landsperg*. Stuttgart: J. G. Gotta'schen Buchhandlung, 1818.

Espasa Calpe Enciclopedia. Madrid, 1920.

F

Faré, Michael, *La Nature Morte en France, Son Histoire et Son Evolution du XVIIᵉ au XXᵉ Siecle*. Geneva, 1962.

Les Femmes Célèbres. 2 vols. Paris: L. Mazenod, 1960–61.

*Fidière, Octave. *Les Femmes Artistes à L'Academie Royale de Peinture et de Sculpture*. Paris: Charavay frères, 1885.

*Fierro, Sister Nancy. *Première: Keyboard Works by Women Composers*. Hollywood: Avant Records, 1974.

Fleming, Thomas. *The Man from Monticello: An Intimate Life of Thomas Jefferson*. New York: William Morrow and Co., 1969.

*Flexner, Eleanor. *Mary Wollstone-*

craft. New York: Coward, McCann & Geoghegan, Inc., 1972.

*Foote, Nancy. "Who was Sonia Sekula?" *Art in America* 59 (October 1971): 73–80.

*Fuller, Sue. *String Compositions*. St. Louis: The Christian Science Publishing Society, 1965.

G

*Galli, Romeo. *Lavinia Fontana, pittrice*. Imola: P. Galeati, 1940.

*Gallwitz, S. D., ed. *Briefe und Tagebuchblätter von Paula Modersohn-Becker*. Berlin: Kurt Wolff, 1920.

*Garnett, David, ed. *Carrington: Letters & Extracts from her Diaries*. New York: Holt, Rinehart and Winston, 1970.

*Garrard, Mary, ed. *Slides of Works by Women Artists: A Source Book*. Falls Church, Virginia: Women's Caucus for Art, 1974.

*Gauthier, Xavière. *Leonor Fini*. Paris: le musée de poche, 1973.

Gerdts, William H. and Burke, Russell. *American Still-Life Painting*. New York: Praeger, 1971.

Gibbs-Smith, Charles H. *The Bayeux Tapestry*. London: Phaidon, 1973.

Glenavy, Lady Beatrice. *Today We Will Only Gossip*. London: Constable, 1964.

*Glimcher, Arnold B. *Louise Nevelson*. New York: Praeger, 1972.

*Glozer, Liselotte Erlanger. "Gabriele Münter: A Lesser Life?" *Feminist Art Journal,* Winter 1974, pp. 11–13.

*Goncourt, Edmond and Jules. *The Woman of the Eighteenth Century*. Translated by Jacques le Clercq and Ralph Roeder. New York: Minton, Balch, 1927.

Goodrich, Lloyd. *Thomas Eakins: A Retrospective Exhibition*. Washington D.C.: Smithsonian Institution Press, 1961.

*———, and Bry, Doris. *Georgia O'Keeffe*. New York: Praeger, 1970.

*Grant, M. H. *Rachel Ruysch*. Leigh-on-Sea, England: F. Lewis, Ltd., 1956.

Gray, Camilla. *The Russian Experiment in Art, 1863–1922*. New York: Abrams, 1962.

*Solomon R. Guggenheim Museum. *Eva Hesse: A Memorial Exhibition*. Introductory essay by Robert Pincus-Witten. New York, 1972.

*Guhl, Ernst. *Die Frauen in der Kunstgeschichte*. Berlin, 1858.

H

*Hale, Nancy. *Mary Cassatt*. Garden City, N.Y.: Doubleday & Co., 1975.

Hamann, Richard, ed. *Das Strassburger Münster und seine Bildwerke*. 1935.

*Hammacher, A. M. *The Sculpture of Barbara Hepworth*. Translated by James Brockway. New York: Abrams, 1968.

Hamnett, Nina. *Laughing Torso*. New York: Ray Long & Richard R. Smith, Inc., 1932.

*Hanaford, Phebe. *Daughters of America*. Augusta, Maine: True and Co., 1889.

*Harms, Juliane. "Judith Leyster: Ihr Leben und Ihr Werk." *Oud-Holland* XLIV, 1927, 88-96; 113-126; 145-154; 221-241; 275-279.

Held, Julius, and Posner, Donald, eds. *Seventeenth and Eighteenth Century Art*. New York: Abrams, 1971.

Helm, MacKinley. *Modern Mexican Painters*. New York: Harper and Brothers, 1941.

*Hepworth, Barbara. *A Pictorial Autobiography*. New York: Praeger, 1970.

*Hetsch, R., ed. *Paula Modersohn-Becker: Ein Buch der Freundschaft*. Berlin: Rembrandt, 1932.

*Hildebrandt, Hans. *Die Frau als Künstlerin*. Berlin: Rudolf Mosse, 1928.

*Hildegard von Bingen. *Wisse die Wege (Scivias)*. Salzburg: Otto Müller, 1954.

*Hill, Georgiana. *Women in English Life*. 2 vols. London: Richard Bentley & Son, 1896.

*Hill, Vicki Lynn, ed. *Female Artists Past and Present*. 2d rev. ed. Berkeley: Women's History Research Center, 2325 Oak St., Berkeley, Calif., 1974.

Der Hitda-Codex. Facsimile. Berlin: Propylaen, 1968.

*Hoesen, Beth van. *A Collection of Wonderful Things*. San Francisco: Scrimshaw, 1972.

*Hoffman, Malvina. *Heads and Tales*. New York: Bonanza Books, 1936.

*———. *Yesterday Is Tomorrow*. New York: Crown Publishers, 1965.

*Hofrichter, Frima Fox. "Judith Leyster's *Proposition*—Between Virtue and Vice." *The Feminist Art Journal*, Fall 1975, pp. 22-26.

Holroyd, Michael. *Augustus John: A Biography*. New York: Holt, Rinehart and Winston, 1974.

Holthusen, Hans Egon. *Portrait of Rilke*. Translated by W. H. Hargreaves. New York: Herder and Herder, 1971.

*Hosmer, Harriet Goodhue. *Letters and Memories*. Edited by Cornelia Carr. London: John Lane, 1913.

*Huisman, Philippe. *Morisot: Enchantment*. Translated by Diana Imber. New York: International Art Books, 1963.

*Hunt, Persis. "Feminism and Anti-Clericalism under the Commune." *The Massachusetts Review* 12 (Summer 1971): 418–31. Pictures.

*Hunter, Wilbur H., and Mahey, John. *Miss Sarah Miriam Peale 1800–1885*. Baltimore: Peale Museum, 1967.

Leonard Hutton Galleries. *Russian Avant-Garde, 1908–1922*. Exhibition Catalog. New York, 1971.

I

*Ilsley, Marjorie Henry. *A Daughter of the Renaissance: Marie le Jars de Gournay*. The Hague: Mouton & Co., 1963.

*Iskin, Ruth. "Sexual and Self-Imagery in Art—Male and Female," *Womanspace Journal*, 1973, pp. 4–10.

J

*Jacometti, Nesto. *Suzanne Valadon*. Exhibition Catalog. Geneva: Pierre-Cailler, 1947.

*Jelenski, Constantin. *Leonor Fini*. New York: Olympia Press, 1968.

K

*Kagan, Andrew, A. "A Fogg 'David' Reattributed to Madame Adélaïde Labille-Guiard." *Acquisitions Report 1969–1970*. Cambridge: Fogg Art Museum, 1971, pp. 31–40.

Kandinsky, Wassily. *Concerning the Spiritual in Art*. Revised trans. by Michael Sadleir. New York: George Wittenborn, Inc., 1947.

*Karras, Maria. *Woman's Building-Chicago 1893, Woman's Building-Los Angeles 1973*. Los Angeles: Women's Graphic Center, 1973.

*Kearns, Martha. *Käthe Kollwitz: Woman and Artist*. Old Westbury: The Feminist Press, 1976.

*Klein, Mina C., and H. Arthur, *Käthe Kollwitz: Life in Art*. New York: Holt, Rinehart and Winston, 1972.

*Klipstein, August. *Käthe Kollwitz, Verzeichnis des graphischen Werkes*. Bern: Klipstein & Co., 1955.

*Klumpke, Anna Elizabeth. *Memoirs of an Artist*. Boston, 1940.

*———. *Rosa Bonheur, sa vie, son oeuvre*. Paris: E. Flammarion, 1908.

Knox, Katharine McCook. *The Sharples: Their Portraits of George Washington and His Contemporaries*. New Haven: Yale University Press, 1930.

*Kollwitz, Hans, ed. *The Diary and Letters of Kaethe Kollwitz*. Translated by Richard and Clara Winston. Chicago: Henry Regnery Co., 1955.

*Krasilovsky, Alexis Rafael. "Feminism in the Arts: An Interim Bibliography." *Art Forum* (June 1972): 72–75. Reprints available from Laurence McGilvery, Box 852, La Jolla, CA 92037.

*Kysela, S. J., John D. "Mary Cassatt's Mystery Mural and the World's Fair of 1893." *Art Quarterly* 29 (1966): 129–45.

L

*Lahnstein, Peter. *Münter*. Ettal, Germany: Buch-Kunst, 1971.

*Lakeview Center for the Arts and Sciences. *American Women: 20th Century*. Peoria, Illinois, 1972.

Langer, Susanne K. *Philosophy in a New Key*. New York: New American Library, 1942.

Langston, John Mercer. *From the Virginia Plantation to the National Capitol*. Hartford, 1894.

*Leach, Joseph. *Bright Particular Star: The Life and Times of Charlotte Cushman*. New Haven: Yale University Press, 1970.

Lee, Hannah Sawyer. *Familiar Sketches of Sculpture and Sculptors*. 2 vols. Boston: Crosby, Nichols, and Co., 1854.

Leith, James A. *The Idea of Art as Propaganda in France: 1750–1799*. Toronto: University of Toronto Press, 1965.

*Leonhard, Kurt. *Ida Kerkovius: Leben und Werk*. Cologne: M. DuMont, Schauberg, 1961.

Levey, Michael, and Kalnein, Wend Graf. *Art and Architecture of the 18th Century in France*. Baltimore: Penguin Books, Inc. 1972.

Levey, Michael. *Early Renaissance*. Baltimore: Penguin Books, Inc., 1967.

Levitine, George. *The Sculpture of Falconet*. Greenwich, Conn.: New York Graphic Society, 1972.

Lipman, Jean, and Winchester, Alice. *The Flowering of American Folk Art, 1776–1876*. New York: Viking, 1974.

*Lippard, Lucy R. "Sexual Politics Art Style." *Art in America* (September–October, 1971): 19–20.

*Livermore, Mary A., and Willard, Frances Elizabeth. *A Woman of the Century*. Buffalo: C. W. Moulton, 1893.

*Loguine, Tatania. *Gontcharova et Larionov*. Paris: Klincksieck, 1971.

London. National Portrait Gallery. *Catalogue of Seventeenth Century Portraits*. Cambridge, England: Cambridge University Press, 1963.

*Lone, Emma Miriam. "Some Bookwomen of the 15th Century." *The Colophon* 11. New York, 1932.

*Long Beach Museum of Art. *Invisible/Visible*. Introductory essay by Dextra Frankel and Judy Chicago. Long Beach, CA 1972.

*Lunde, Karl. *Isabel Bishop*. New York: Abrams, 1975.

M

Maas, Jeremy. *Victorian Painters*. New York: G. P. Putnam's Sons, 1969.

*Mander, Anica Vesel, and Rush, Anne Kent. *Feminism as Therapy*. New York: Random House (Bookworks), 1974.

*Manners, Lady Victoria. "Catherine Read: The 'English Rosalba.'" *Connoisseur* 88 (1931): 376–86.

*———, and Williamson, Dr. G. C. *Angelica Kauffmann, R. A.: Her Life and her Works*. London: The Bodley Head, 1924.

Marevna. *Life with the Painters of La Ruche*. New York: Macmillan, 1974.

*Marlborough-Gerson Gallery. *Beverly Pepper: Recent Sculpture*. New York, 1969.

*Maulde la Clavière, Marie Alphonse René de. *The Women of the Renaissance: A Study of Feminism*. Translated by George Herbert Ely. New York: G. P. Putnam's Sons, 1901.

*Mayer, Dorothy Moulton. *Angelica Kauffmann, R.A., 1741–1807*. Gerrards Cross: Colin Smythe, 1972.

*Melville, Robert. "Kinds of Loving." *New Statesman*, February 2, 1968, p. 150.

*Merritt, Anna Lea. "A Letter to Artists, Especially Women Artists." *Lippincott's Monthly Magazine* 65 (1900): 463–69.

*Miller, Isabel, pseud. *Patience and Sarah*. New York: McGraw-Hill, 1972.

Moir, Alfred. *The Italian Followers of Caravaggio*. 2 vols. Cambridge: Harvard University Press, 1967.

*Mongan, Elizabeth. *Berthe Morisot: Drawings/Pastels/Watercolors/Paintings*. Exhibition catalog. New York: Shorewood Publishing Co., 1960.

*Moore, Anne Carroll. *The Art of Beatrix Potter*. London: Frederick Warne & Co., 1967.

Morgan, John Hill. *Gilbert Stuart and His Pupils*. New York: New York Historical Society, 1939.

*Morphet, Richard. *Vanessa Bell: Paintings and Drawings*. London: Anthony d'Offay, 1973.

*Morris, Joan. *The Lady was a Bishop: The Hidden History of Women with Clerical Ordination and the Jurisdiction of Bishops*. New York: Macmillan Co., 1973.

*"*Ms*. Forum on the Arts: What is Female Imagery?" *Ms.*, May 1975, p. 62.

*Munich. Städtische Gallerie. *Gabriele Münter*. Munich, 1962.

*Munsterberg, Hugo. *A History of Women Artists*. New York: Clarkson N. Potter, Inc., 1975.

*Musée du Jeu de Paume. *Les Femmes Artistes d'Europe*. Exhibition catalog. Paris, 1937.

*Musée National d'Art Moderne. *Sophie Täuber-Arp*. Exhibition catalog. Paris, 1964.

*———. *Suzanne Valadon*. Exhibition catalog. Paris, 1967.

*Museum of Graphic Art. *The Graphic Art of Mary Cassatt.* Exhibition catalog. Introductory essay by Adelyn D. Breeskin. New York, 1967.

N

*Nagel, Otto. *Käthe Kollwitz.* Greenwich, Conn.: New York Graphic Society, 1971.

*———. *Die Selbstbildnisse der Käthe Kollwitz.* Berlin: Henschelverlag, 1965.

Nagera, Humberto. *Vincent van Gogh; A Psychological Study.* New York: International Universities Press, 1967.

National Art Education Association. *Black Art: A Bibliography.* Washington, D.C., 1970.

*National Collection of Fine Arts. *Lilly Martin Spencer, 1822–1902: The Joys of Sentiment.* Exhibition catalog. Introductory essays by Robin Bolton-Smith and William H. Truettner. Washington, D.C.: Smithsonian Institution Press, 1973.

*———. *Romaine Brooks, "Thief of Souls."* Exhibition catalog. Introductory essay by Adelyn Breeskin. Washington, D.C.: Smithsonian Institution Press, 1971.

*National Gallery of Art. *Mary Cassatt, 1844–1926.* Exhibition catalog. September 27, 1970 to November 8, 1970. Washington, D.C.: Smithsonian Institution Press, 1970.

National Portrait Gallery. *The Black Presence in the Era of the American Revolution, 1770–1800.* Exhibition catalog. Edited by Sidney Kaplan. Washington, D.C.: Smithsonian Institution and the New York Graphic Society, 1973.

*Neilson, Winthrop and Frances. *Seven Women: Great Painters.* Philadelphia: Chilton Books, 1969.

*Nemser, Cindy. *Art Talk: Conversations with 12 Women Artists.* New York: Charles Scribner's Sons, 1975.

*Nemser, Cindy. "Audrey Flack: Photorealist Rebel." *The Feminist Art Journal,* Fall 1975, pp. 5–11.

Neumann, Eckhard, ed. *Bauhaus and Bauhaus People.* New York: Van Nostrand Reinhold, 1970.

*Nevelson, Louise. "Nevelson on Nevelson—Perspectives." *California Living Magazine. San Francisco Chronicle & Examiner,* January 27, 1974.

*Newark Museum. *Women Artists of America, 1707–1964.* Exhibition Catalog. Introductory essay by William H. Gerdts. Newark, N.J., 1965.

Newton, Eric. *Tintoretto.* Westport, Conn.: Greenwood Press, 1952.

*New York Cultural Center. *Women Choose Women.* Exhibition catalog New York: Organized by Women in the Arts, 1973.

Nicolson, Nigel. *Portrait of a Marriage.* New York: Atheneum, 1973.

Nin, Anaïs. *Diaries.* Edited by Gunther Stuhlmann. 5 vols. New York: Harcourt Brace Jovanovich, 1971.

*Nochlin, Linda. "By a Woman Painted—Artists in the Nineteenth Century." *Ms.* July 1974, p. 68.

*———. "Feminism in the Arts and Cultural Change." *Womansphere,* September 1975, pp. 14–16.

*Nolhac, Pierre de. *Madame Vigée le Brun.* Paris: P. Goupil, 1912.

Novotny, Fritz. *Painting and Sculpture in Europe, 1780–1880.* Baltimore: Penguin (Pelican), 1960.

O

*Oakland Museum. *Miné Okubo: An American Experience.* Exhibition catalog. Oakland, CA, 1972.

*Olsen, Tillie. "Silences: When Writers Don't Write." *Harper's,* October 1965, pp. 153–61. Reprinted in Cornillon, *Images of Women in Fiction: Feminist Perspectives.*

*Opperman, H. N. "Marie-Anne Collot in Russia: Two Portraits." *Burlington* 107 (August 1965): 408–12.

*Orenstein, Gloria. "Natalia Goncharova: Profile of the Artist—Futurist Style." *Feminist Art Journal,* Summer 1974, pp. 1–6.

*———. "Women of Surrealism." *Feminist Art Journal,* Spring 1973, pp. 17–21.

*Ossoli, Margaret Fuller. *Woman in the Nineteenth Century.* 1855. Reprinted. New York: Source Book Press, 1970.

P

Palol-Salellas, Pedro de, and Hirmer, Max. *Early Medieval Art in Spain.* Translated by Alisa Joffa. London: Thames and Hudson, 1967.

*Parada y Santin, J. *Las Pintoras Españolas.* Madrid, 1903.

*Paris. *Dorothea Tanning: oeuvre.* Exhibition catalog. Paris: Centre national d'art contemporain, 1974.

*Passez, Anne-Marie. *Biographie et catalogue raisonné des oeuvres de Mme. Labille-Guiard.* Paris: Arts et Métiers Graphiques, 1973.

*Pauli, Gustav. *Paula Modersohn-Becker.* Munich: Kurt Wolff, 1919.

Pavière, S.H. *Floral Art.* Leigh-on-Sea, England: F. Lewis, Ltd., 1965.

*Payne, Elizabeth Rogers. "Anne Whitney: Sculptures; Art and Social Justice." *The Massachusetts Review* (Spring 1971):245–60.

*Paz, Octavio, and Callois, Roger. *Remedios Varo.* Mexico: Ediciones ERA, 1966.

*Pennsylvania Academy of Fine Arts. *The Pennsylvania Academy and Its Women.* Exhibition catalog. Essay by Christine Jones Huber. Philadelphia, 1974.

Pereira, Irene Rice. *The Transformation of Nothing and the Paradox of Space.* New York, 1953.

Peslikis, Irene, "Notes on Arts and Society." *Women and Art Supplement On Art and Society* (1972):18.

Peters, Harry T. *Currier & Ives: Printmakers to the American People.* Garden City, N.Y.: Doubleday, Doran & Co., 1942.

*Pétridès, Paul. *L'Oeuvre complet de Suzanne Valadon.* Paris: Compagnie française des Arts Graphiques, 1971.

*Petzet, Heinrich Wigand. *Das Bildnis des Dichters: Paula Modersohn-Becker und Rainer Maria Rilke.* Frankfurt am Main: Societäts, 1957.

Piercy, Marge. *To Be Of Use.* New York: Doubleday, 1973.

*Pope-Hennessy, Una Birch. *Anna van Schurman: Artist, Scholar, Saint.* New York: Longmans Green & Co., 1909.

*Portalis, Baron Roger. "Adélaïde Labille-Guiard: 1749–1803." *Gazette des Beaux Arts* (1901):101–18; 325–47; (1902):353–67; 477–94.

Poulenc, François. "Feuilles Americaines." *La Table Ronde* 30 (June 1950):66–75.

*Power, Eileen. *Medieval English Nunneries c. 1275–1535.* New York: Biblo and Tannen, 1964.

*————. "The Position of Women." *The Legacy of the Middle Ages.* Edited by G. C. Crump and E. F. Jacob. Oxford: Oxford University Press, 1926, pp. 401–33.

Prampolini, Ida Rodriguez. *Surrealismo y el arte fantastico de Mexico.* Mexico: Universidad Nacional Autonoma de Mexico, 1969.

Prescott, H.J.M. *The Man on a Donkey.* New York: Ballantine Books, 1952.

*Proske, Beatrice Gilman. "Luisa Roldán at Madrid." *Connoisseur,* Part I, February 1964, pp. 128–132; Part II, March 1964, pp. 199–203; Part III, April 1964, pp. 269–273.

Q

Quaile, Edward. *Illuminated Manuscripts.* Liverpool: Henry Young & Sons, 1897.

R

*Ragg, Laura. *Women Artists of Bologna.* London: Methuen & Co., 1907.

Randall, Lillian M. C. *Images in the Margins of Gothic Manuscripts.* Berkeley: University of California, 1966.

Rewald, John. *The History of Impressionism.* New York: The Museum of Modern Art, 1961.

Rich, Adrienne. *The Will to Change.* New York: Norton, 1971.

*Richards, Mary Caroline. *Centering in Pottery, Poetry, and the Person.* Middletown, Conn.: Wesleyan University Press, 1962.

Rilke, Rainer Maria. *Selected Works: Poetry.* Translated by J. B. Leishman. London: The Hogarth Press, 1967.

Rivera, Diego, with March, Gladys. *My Art, My Life.* New York: The Citadel Press, 1960.

*Roland-Michel, Marianne. *Anne Val-*

layer-Coster 1744–1818. Paris: C.I.L., 1970.

*Rosen, Marjorie. *Popcorn Venus*. New York: Coward, McCann & Geoghegan, 1973.

Rosenblum, Robert. *Transformations in Late Eighteenth Century Art*. Princeton: Princeton University Press, 1967.

*Rouart, Denis, ed. *The Correspondence of Berthe Morisot*. Translated by Betty Hubbard. London: Lund Humphries, 1957.

*Ruggeri, Ugo. *Giulia Lama: Dipinti e Designi*. Bergamo, Italy: l'Instituto Italiano d'Arti Grafiche, 1973.

S

*Sachs, Hannelore. *The Renaissance Woman*. Translated by Marianne Herzfeld. New York: McGraw-Hill, 1971.

*Saint-Phalle, Niki de. *hon-en historia*. Stockholm: Moderna Museet, 1967.

*Salomon, Charlotte. *Charlotte: A Diary in Pictures*. Comment by Paul Tillich. New York: Harcourt Brace, 1963.

*San Francisco Museum of Art. *Women of Photography: An Historical Survey*. Exhibition catalog. Introductory essay by Margery Mann. San Francisco, 1975.

*Schapiro, Miriam, ed. *Art: A Woman's Sensibility, 1975*. Valencia, Ca.: Feminist Art Program, 1975.

*Schütte, Marie, and Müller-Christensen, Sigrid. *The Art of Embroidery*. London: Thames and Hudson, 1964.

*Schwartz, Therese. "They Built Women a Bad Art History." *Feminist Art Journal* (Fall 1973).

*Secrest, Meryle. *Between Me and Life: A Biography of Romaine Brooks*. N.Y.: Doubleday. 1974.

*Seiler, Harold. *Paula Modersohn-Becker*. Munich: F. Bruckmann, 1959.

Selz, Peter. *German Expressionist Painting*. Berkeley: University of California Press, 1957.

Smith, Scott Fitzgerald, and Bruccioli, Matthew. *The Romantic Egoists*. New York: Charles Scribner's Sons, 1974.

*Spacks, Patricia Meyer. *The Female Imagination*. New York: Knopf, 1975.

*Sparrow, Walter Shaw. *Women Painters of the World*. London: Hodder & Stoughton, 1905.

*Springfield, Mass. *Three American Purists: Mason/Miles/von Wiegand*. Springfield, Mass.: Museum of Fine Arts, 1975.

*Stanton, Theodore. *Reminiscences of Rosa Bonheur*. London: Andrew Melrose, 1910.

*Stelzer, Otto. *Paula Modersohn-Becker*. Berlin: Rembrandt, 1958.

*Sterling, Charles. "A Fine 'David' Reattributed." *The Metropolitan Museum of Art Bulletin* 9 (January 1951):121–32.

————. *Still Life Painting From Antiquity to the Present Time*. Revised edition. Translated by James Emmons. New York: Universe Books, Inc., 1959.

*Storm, John. *The Valadon Drama*. New York: E. P. Dutton & Co., 1959.

*Straus, Lenore Thomas. *The Tender Stone*. Washington, D.C.: Galaxy, Inc., 1964.

*————. *Stone Dust*. Accokeek, Md.: Sun-Stone, 1969.

*Sullerot, Evelyne. *Woman, Society and Change*. Translated by Margaret Scotford Archer. New York: McGraw-Hill, 1971.

*Sweet, Frederick A. *Miss Mary Cassatt, Impressionist from Pennsylvania*. Norman, Okla.: University of Oklahoma Press, 1966.

T

*Tapié, Michel. *Claire Falkenstein*. Translated by Dorothy Cater. Rome: De Luca Art Monographs, 1958.

Taylor, Henry Osborne. *The Medieval Mind*. Cambridge: Harvard University Press, 1959.

*Thomas, Edith. *The Women Incendiaries*. Translated by James and Starr Atkinson. New York: George Braziller, 1966.

*Thomas, Edith. "Women of the Commune." *The Massachusetts Review* 12 (Summer 1971):409–17.

Thorp, Margaret Farrand. *The Literary Sculptors*. Durham, N.C.: Duke University Press, 1965.

*Tolnay, Charles de. "Sophonisba Anguissola and her Relations with Michelangelo." *Journal of the Walters Art Gallery* 4 (1941):115–19.

*Tomkins, Calvin. "Georgia O'Keeffe: Profile." *New Yorker,* March 4, 1974, pp. 40–66.

Troyer, Gene van. "Interview with Ursula K. LeGuin." *Vertex,* December 1974, p. 34.

*Tucker, Anne. *Women's Eye.* New York: Knopf, 1973.

*Tufts, Eleanor. *Our Hidden Heritage: Five Centuries of Women Artists.* New York: Paddington Press, 1974.

Twenty-Six Contemporary Women Artists (from Abish to Zucker). Exhibit organized by Lucy Lippard. Ridgefield, Conn.: The Aldrich Museum of Contemporary Art, 1971.

*Tyler, Parker. *Florine Stettheimer: A Life in Art.* New York: Farrar, Straus, and Co., 1963.

U

Uhde, Wilhelm. *Fünf Primitive Meister.* Zurich: Atlantis, 1948.

*——. "Séraphine ou la Peinture Révelée." Formes 17 (September 1931):115–17.

*University Art Museum, Berkeley. *Barbara Chase Riboud.* Exhibition catalog. Notes by F. W. Heckmanns. Berkeley, 1973.

V

*Vachon, Marius. *La femme dans l'art.* Paris: J. Rouam, 1893.

Valéry, Paul. *Degas, Manet, Morisot.* Translated by David Paul. New York: Pantheon, 1960.

*Vallier, Dora, ed. *Vieira da Silva.* Vol. 1. Paris: Weber, 1971.

*Vassar College Art Gallery. *The White Marmorean Flock, Nineteenth Century American Women Neoclassical Sculptors.* Exhibition catalog. Introductory essay by William H. Gerdts. Poughkeepsie, NY, 1972.

Verdier, Phillippe. *Catalogue of the Painted Enamels of the Renaissance.* Baltimore: Walters Art Gallery, 1967.

*Vigée-Lebrun, Elisabeth. *Memoirs.* Translated by Lionel Strachey. N.Y.: Doubleday, 1907.

*Vogel, Lise. "Fine Arts and Feminism: The Awakening Consciousness." *Feminist Studies* 2 (1974):3–37.

W

Waddy, Ruth G., and Lewis, Samella S., eds. *Black Artists on Art.* 2 vols. Los Angeles: Contemporary Crafts Publications, 1969.

Walpole, Horace. *Anecdotes of Painting in England, 1760–1795.* 5 vols. New Haven: Yale University Press, 1937.

*Walters Art Gallery. *Old Mistresses, Women Artists of the Past.* Exhibition catalog. Notes by Ann Gabhard and Elizabeth Brown. Baltimore, 1972. See also *The Walters Art Gallery Bulletin* 24 (April 1972).

*Wayne, June; Braeutigam, Rosalie; and Fiske, Betty, eds. *Sex Differentials in Art Exhibition Reviews: A Statistical Study.* Los Angeles: Tamarind Lithography Workshop, 1972.

Weale, W. J., and Brockwell, Maurice W. *The van Eycks and Their Art.* London: John Lane, 1912.

Weil, Simone, *Waiting for God.* Translated by Emma Craufurd. Introduction by Leslie A. Fiedler. New York: Harper & Row, 1951.

*Weiss, Susan. "Marie Laurencin: An Artistic and Feminine Consciousness in Confrontation and Conflict." Honors thesis, Barnard College, 1974.

*Werner, Alfred. "Paula Modersohn-Becker: A Short, Creative Life." *American Artist* 37 (June 1973):16–23.

Wescher, Herta. *Collage.* Translated by Robert E. Wolf. New York: Abrams, 1968.

Wilenski, R. H. *Dutch Painting.* New York: Beechhurst Press, 1955.

——. *Flemish Painters.* 2 vols. New York: Viking, 1960.

*Wilhelm, Jacques. "Louise Moillon." *L'oeil* (September 1956):6–13.

*Williams, Ora. *American Black Women in the Arts and Social Sciences: A Bibliographic Survey.* New Jersey: Scarecrow Press, 1973.

*Willis, Eola. "The First Woman Painter in America." *International Studio* (July 1927):13.

*Wilson, J. J. "So You Mayn't Ever Call Me Anything but Carrington." *The Massachusetts Review* (Winter-Spring, 1972):291–96.

Wingler, Hans M. *The Bauhaus.* Cam-

bridge: The MIT Press, 1969.

Wittkower, Rudolf and Margot. *Born under Saturn.* New York: Random House, 1963.

*"Women Artists." *The Westminster Review* 14 (July and October 1858).

*Wildenstein, Georges. "Un Tableau Attribué à David et Rendu à Mme. Davin-Mirvault: Le Portrait du Violinist Bruni." *Gazette des Beaux Arts* (February 1962):93–98.

Wolfe, Bertram D. *The Fabulous Life of Diego Rivera.* New York: Stein & Day, 1963.

*"Women and the Arts." *Arts in Society* 11 (Spring–Summer 1974).

*Wood, Ann Douglas. " 'The Fashionable Diseases': Women's Complaints and Their Treatment in Nineteenth-Century America." *Journal of Interdisciplinary History* 4 (Summer 1973):25–52.

Woolf, Virginia. *Common Reader I.* New York: Harcourt Brace, 1925.

*————. *A Room of One's Own.* New York: Harcourt Brace, 1929.

*————. *Orlando: a Biography.* New York: New American Library, 1928.

————. *The Voyage Out.* New York: Harcourt Brace, 1920.

————. *The Waves.* London: Hogarth Press, 1931.

————. *A Writer's Diary.* London: Hogarth Press, 1953.

*Worcester Art Museum. *Marisol.* Exhibition catalog. Worcester, Mass., 1971.

Z

*Zigrosser, Carl. *Prints and Drawings of Käthe Kollwitz.* New York: Dover, 1969.

Zorach, Marguerite. Exhibition catalog. Introductory essays by Joshua C. Taylor and Roberta K. Tarbell. Washington, D.C.: Smithsonian Institution Press, 1973.

Appendix

A

*Ayscough, Florence, *Chinese Women Yesterday and Today*. Cambridge. Mass.: Houghton Mifflin Co., 1937.

B

Backhouse, E., and Bland, J. O. P. *Annals and Memoirs of the Court of Peking (from the 16th to the 20th Century)*. New York: Houghton Mifflin Co., 1914.

Burling, Judith, and Burling, Arthur Hart. *Chinese Art*. New York: Bonanza Books, 1953.

C

Carter, Thomas Francis. *The Invention of Printing in China and Its Spread Westward*. New York: The Ronald Press Co., 1955.

Ch'en Chih-mai. *Chinese Calligraphers and Their Art*. Melbourne, Australia: Melbourne University Press, 1966.

*Chiang Chao-shen. "The Identity of Yang Mei-tzu and the Paintings of Ma Yüan." *National Palace Museum Bulletin* (Taipei) 2, no. 2 (1967):1–14; 2, no. 3 (1967):9–14.

Chung-kuo ku-hua chi [Collection of ancient Chinese paintings]. Book One. Hongkong, 1956. Vols. 19 and 20.

Chung-kuo ku-hua chi [Collection of ancient Chinese paintings]. Hongkong, 1966. Vols. 45, 46, 47, 201.

Chung-kuo ming-hua [Famous Chinese paintings]. Shanghai: Yu Cheng Book Co., 1920–23. Vols. 2, 9, 15.

*Cissell, Kathryn Ann Adelsperger. *The Pi-ch'iu-ni chuan: Biographies of Famous Chinese Nuns from 317–516* C.E.

Ann Arbor, Mich.: University Microfilms, Inc., 1972.

D

Driscoll, Lucy, and Toda, Kenji, *Chinese Calligraphy*. Chicago: University of Chicago Press, 1935.

Giles, Herbert G. *A History of Chinese Literature*. Tokyo: Charles E. Tuttle Co., 1973.

H

*Hackney, Louise. "Chinese Women Painters." *International Studio* 87 (1923):74–77.

Horizon Magazine. *The Horizon Book of the Arts of China*. New York: American Heritage Publishing Co., n.d.

Hsin Wen. "Painting for the Revolution." *Chinese Literature* (Peking), December 1973 94–100.

K

Kokka. Vols. 147, 555. Tokyo, 1887–1941.

Ku-kung shu-hua chi [Paintings in the Palace Museum]. Vols. 3, 11, 12, 14, 26, 39. Peking: Palace Museum, 1930–36.

L

Laing, E. J. *Chinese Paintings in Chinese Publications, 1956–1968: An Annotated Bibliography and an Index to the Paintings*. Ann Arbor, Mich.: Center for Chinese Studies, University of Michigan, 1969.

Laufer, Berthold. *T'ang, Sung and Yüan Paintings Belonging to Various Chinese Collectors*. Paris: G. Van Oest and Co., 1924.

*Li Feng-lan. "How I Began to Paint the Countryside." *China Reconstructs* (Peking) 23, no. 1 (1974):21–23.

M

Ma Chiang-hsiang nü-shih hua niao ts'e [(Reproductions of) Paintings of flowers and birds by Ma Chiang-hsiang (Ma Ch'üan), female scholar]. Shanghai: Wen Ming Hsu Chu, n.d.

Mao Tse-tung. *Talks at the Yenan Forum on Literature and Art*. Peking: Foreign Languages Press, 1967.

N

Nan-lou lao-jen hua niao shan-shui ts'e [(Reproductions of) Paintings of birds and landscapes by the old person of the southern studio (Ch'en Shu)]. Shanghai: Yu Cheng Book Co., 1919.

O

Osaka Exchange Exhibition: Paintings From the Abe Collection and Other Masterpieces of Chinese Art. Japan: San Francisco Center of Asian Art and Culture, 1970.

P

"Peasant Paintings from Huhsien." *Chinese Literature* (Peking), December 1973:88–89.

Priest, Allen. *Aspects of Chinese Painting*. New York: Macmillan, 1954.

R

Rexroth, Kenneth, ed. and trans. *Love and the Turning Year: One Hundred More Poems from the Chinese*. New York: New Directions Publishing Corp., 1970.

*———, and Chung, Ling, eds. and trans. *Orchid Boat: Women Poets of China*. New York: McGraw-Hill, 1972.

S

Siren, Osvald. *Chinese Painting, Leading Masters and Principles*. 7 vols. New York: The Ronald Press Co., 1958.

Speiser, Werner; Goepper, Roger; and Fribourg, Jean. *Chinese Art: Painting, Calligraphy, Stone Rubbing, Wood Engraving*. New York: Universe Books, 1964.

Sullivan, Michael. *The Arts of China*. Berkeley: University of California Press, 1973.

Sun Ta-kung, ed. *Chung-kuo hua-chia jen-ming ta tz'u-tien*. [Biographical dictionary of Chinese painters]. Shanghai, 1934.

*Swann, Nancy Lee. *Pan Chao: Foremost Woman Scholar of China, First Century* A.D. New York: Russell and Russell, 1968.

T

*T'ang Sou-yü. *Yü-t'ai hua-shih* [Jade studio painting history]. n.p., n.d.

Tseng Yu-ho Ecke. *Chinese Calligraphy*. Philadelphia: Philadelphia Museum of Art, 1971.

*Tseng Yu-ho [Ecke]. "Hsüeh Wu and Her Orchids in the Collection of the Honolulu Academy of Arts." *Ars Asiatiques* 2, no. 3 (1955):197–208.

Tsien Tsuen-hsuin [Ch'ien Ts'un-hsün]. *Written on Bamboo and Silk: The Beginnings of Chinese Books and Inscriptions*. Chicago: University of Chicago Press, 1962.

*Tzu Yeh. *A Gold Orchid: The Love Poems of Tzu Yeh*. Translated by Lenore Mayhew and William McNaughton. Tokyo: Charles E. Tuttle Co., In., 1972.

W

Wang Fang-chuen. *Chinese Free Hand Flower Painting*. Peking, 1937.

Wang Shih-chien, ed. *Ku-kung ming-hua* [Select Chinese paintings in the National Palace Museum]. Vols. 7, 8. Taipei, 1966.

*Warner, Maria. *The Dragon Empress: The Life and Times of Tz'u-hsi, Empress Dowager of China, 1835–1908*. New York: Macmillan, 1972.

*Wimsatt, Genevieve B. *The Bright Concubine and Lesser Luminaries*. Boston: John W. Luce and Co., 1928.

*Wimsatt, Genevieve [B]. *A Well of Fragrant Waters: A Sketch of the Life and Writing of Hung Tu*. Boston: John W. Luce Co., 1945.

*Wolf, Margery, and Witke, Roxane, eds. *Women in Chinese Society*. Stanford: Stanford University Press, 1975.

Illustrations

Chapter 1

Fig. I, 1: *Marcia* from Boccacio's *De Claris Mulieribus*. 1402. MS. fr. 12420, fol. 101 v. Paris. Bibliothèque National

Fig. I, 2: MARY CASSATT. *Mother and Child*. 1905. Washington, D.C. National Gallery of Art, Chester Dale Collection

Fig. I, 3: MARY CASSATT. *Girl Arranging her Hair*. 1886. Washington, D.C. National Gallery of Art, Chester Dale Collection

Fig. I, 4: SUZANNE VALADON. *Dressing Two Children in the Garden*. 1910. Drypoint. San Francisco Achenbach Foundation for Graphic Arts. California Palace of the Legion of Honor

Fig. I, 5: PAULA MODERSOHN-BECKER. *Nude Study*. Drawing. Bremen. Roselius Collection

Fig. I, 6: PAULA MODERSOHN-BECKER. *Worpswede Peasant Girl*. Drawing. Bremen. Roselius Collection

Fig. 1, 7: PAULA MODERSOHN-BECKER. *Study*. Drawing. Bremen. Roselius Collection

Fig. 1, 8: GERMAINE RICHIER. *The Hurricane*. 1948/49. Paris. Musée National d'art Moderne

Fig. I, 9: MARY CASSATT. *The Loge*. 1882. Washington, D.C. National Gallery of Art, Chester Dale Collection

Fig. I, 10: ISABEL BISHOP. *Noon Hour*. 1936. Springfield, Massachusetts. Springfield Museum of Art

Fig. I, 11: AMRITA SHER-GIL. *Two Girls*. 1939. New Delhi. National Gallery of Modern Art

Fig. I, 12: FRIDA KAHLO. *The Two Fridas*. Mexico City. Museum of Modern Art

Fig. I, 13: REMEDIOS VARO. *Lovers*. Courtesy of Walter Gruen

Fig. I, 14: ERNESTINE MILLS. *Mermaid Overwhelmed by Octopus*. c. 1910. Enamel tondo. 7 in. New York. Collection of Mr. and Mrs. H. W. Janson

Fig. I, 15: LEONOR FINI. *The Useless Toilette*. Courtesy of the artist

Fig. I, 16: DOROTHEA GREENBAUM. *The Drowned Girl*. 1950. Marble. New York. Whitney Museum of American Art

Fig. I, 17: LENORE THOMAS STRAUS. Illustration from *The Tender Stone*. Courtesy of the artist

Chapter 2

Fig. II, 1: *Nun and Monk Tilting*. From MS. *Lancelot del Lac,* Part 3. Picard. Late thirteenth century. New Haven. Yale University Library

Fig. II, 2: GUDA. Self-portrait from *Homeliary*. Frankfurt am Main. Staatsbibliothek

Fig. II, 3: *Maria Ormani*. Self-portrait from folio 89 *Breviarium cum Calendario*. Vienna. Bildarchiv der Osterreichisches Nationalbibliothek

Fig. II, 4: *Claricia*. Self-portrait from a South German *Psalter*. c. 1200. Baltimore. Walters Art Gallery

Fig. II, 5: *Woman Scribe*. From

Flemish *Hours,* MS B.11.22, folio 100, early 14th c. Cambridge. Trinity College Library

Figs. II, 6–9: ENDE. Four illuminations from the *Beatus Apocalypse of Gerona.* 975. Gerona. Cathedral Treasury

Figs. II, 10, 11: Two miniatures from the *Gospel Book* of the Abbess Hitda. c. 1020. Darmstadt. Staatsbibliothek

Fig. II, 12: *The Crucifixion.* From the *Gospel Book* of Abbess Uta. c. 1025. Munich. Staatsbibliothek

Figs. II, 13–16: Four of St. Hildegard von Bingen's visions from the Ruperstberg Codex. The original MS was lost in World War II, and these illustrations are taken from a parchment copy made by the nuns of St. Hildegard's convent in 1927

Figs. II, 17–19: Three line drawings made from the original twelfth century MS. *Hortus Deliciarum* by Herrade von Landsberg, Abbess of Hohenburg. The work itself was destroyed in the Franco-German War of 1870

Fig. II, 20: *Woman Weaving.* From the Queen Isabella *Psalter,* MS. Cod. gall. 16 folio 20x. Munich. Staatsbibliothek

Figs. II, 21–24: Four panels from the over 200-foot-long secular embroidery, the so-called Bayeux Tapestry, made in England. 11th c. Bayeux, France. Musée de la Reine Mathilde

Fig. II, 25: The Syon Cope. c. 1300. London. Victoria and Albert Museum

Fig. II, 26: Rupertsberg Altar Frontal. c. 1230. Brussels. Musée Royaux d'Art et d'Histoire

Fig. II, 27: The Göss Vestments. c. 1275. Vienna. Österreichisches Museum für Angewandte Kunst

Fig. II, 28, 29: Two figures from the south portal of Strasbourg Cathedral, traditionally attributed to Sabina von Steinbach

Chapter 3

Fig. III, 1: PLAUTILLA NELLI. *Last Supper.* Florence. Sta. Maria Novella (photo: Alinari)

Fig. III, 2: BARBARA RAGNONI. *The Nativity.* Siena. Pinacotheca (photo: Alinari)

Fig. III, 3: BARBARA LONGHI. *Madonna and Child.* Baltimore. The Walters Art Gallery.

Fig. III, 4: ORSOLA MADDALENA CACCIA. *A Saint Reading.* Museo Civico Allessandria (photo: Frick Art Reference Library)

Fig. III, 5: LUCIA ANGUISSOLA. *Pietro Maria, Doctor of Cremona.* Madrid. Prado

Fig. III, 6: SOFONISBA ANGUISSOLA. *The Painter Campi Painting Sofonisba Anguissola.* Siena. Pinacotheca.

Fig. III, 7: SOFONISBA ANGUISSOLA. *Three of the Artist's Sisters Playing Chess.* 1555. Poznan. National Museum

Fig. III, 8: SOFONISBA ANGUISSOLA. *Portrait of an Old Woman.* Nivaagaard. Hage Collection.

Fig. III, 9: ANTON VAN DYCK. Portrait of Sofonisba Anguissola from his *Italian Sketch Book.* 1624.

Fig. III, 10: PROPERZIA ROSSI. *Joseph and Potiphar's Wife.* c. 1520. Marble bas-relief. 545 mm x 590 mm. Bologna. Museo di San Petronio

Fig. III, 11: LAVINIA FONTANA. *Portrait of a Noblewoman.* Baltimore. The Walters Art Gallery

Fig. III, 12: LAVINIA FONTANA. *The Samarian Woman at the Well.* Naples. Museo di Capodimonte (photo: Alinari)

Fig. III, 13: ELISABETTA SIRANI. *The Holy Family with an Angel.* Vercelli. Museo Civico Borgogna (photo: Frick Art Reference Library)

Fig. III, 14: ELISABETTA SIRANI. *Mary Magdalen.* 1660. Bologna.

Pinacotheca (photo: Alinari)

Fig. III, 15: ELISABETTA SIRANI. *Salome*. Zagreb. Strossmayer Gallery

Fig. III, 16: ELISABETTA SIRANI. *Judith with the Head of Holofernes*. Baltimore. The Walters Art Gallery

Fig. III, 17: FEDE GALIZIA. *Judith with Head of Holofernes*. 1596. Sarasota. Ringling Museum

Fig. III, 18: ARTEMISIA GENTILESCHI. *Judith*. Florence. Uffizi (photo: Alinari)

Fig. III, 19: ARTEMISIA GENTILESCHI. *Judith*. 1615/20. Florence. Pitti (photo: Alinari)

Fig. III, 20: ARTEMISIA GENTILESCHI. *Esther and Ahasuerus*. New York. Metropolitan Museum of Art

Fig. III, 21: ARTEMISIA GENTILESCHI. *La Pittura*. London. Hampton Court. Copyright reserved

Fig. III, 22: GIOVANNA GARZONI. *A Vase of Flowers*. Florence. Uffizi (photo: Alinari). Watercolor on vellum

Fig. III, 23: JOSEFA DE AYALA. *The Mystical Marriage of St. Catherine*. 1647. Lisbon. Museu Nacional de Arte Antiga

Fig. III, 24: LUISA ROLDÁN. *The Mystical Marriage of St. Catherine*. Late 17th c. Terracotta polychrome. 36.5 cm x 45 cm. New York. Hispanic Society

Fig. III, 25: SUZANNE DE COURT. *The Annunciation*. c. 1600. Enamelwork. Baltimore. The Walters Art Gallery

Fig. III, 26: CLAUDINE STELLA. *Pastoral no. 16*. 17th c. engraving. Boston. Museum of Fine Arts

Fig. III, 27: LOUISE MOILLON. *Still Life with Cherries, Strawberries, and Gooseberries*. 1630. San Francisco. Norton Simon Foundation. California Palace of the Legion of Honor

Fig. III, 28: SOPHIE CHÉRON. *Self-portrait*. 1672. Versailles. Clichés des Musées Nationaux

Fig. III, 29: ESTHER INGLIS. *Self-portrait* from her *Ecclesiastes*. 1599. MS. Add 27927, folio 2. London. The British Library

Fig. III, 30: DAUGHTER OF VERGECIUS. Houseflies from a bestiary written by her father. Burney MSS. 97, folio 15v. 16th c. London. The British Library

Fig. III, 31: MARY BEALE. *Thomas Sydenham, physician*. London. National Portrait Gallery

Fig. III, 32: CLARA PEETERS. *Self-Portrait with Still Life*. Formerly London. Hallsborough Gallery. (Present location unknown)

Fig. III, 33: CLARA PEETERS. *Still Life with Fruits and Nuts*. Oxford. Ashmolean Museum

Fig. III, 34: CLARA PEETERS. *Still Life with Fish*. Amsterdam. Rijksmuseum

Fig. III, 35: CATHARINA VAN HEMESSEN. *Self-portrait*. 1548. Basel. Offentliche Kunstsammlung

Fig. III, 36: CATHARINA VAN HEMESSEN. *Portrait of a Lady*. 1551. London. National Gallery

Fig. III, 37: CATHARINE PEETERS. *Sea Battle*. 1657. Vaduz. Coll. of the Prince of Liechtenstein

Fig. III, 38: MICHAELINA WAUTIER. *St. Joseph Holding a Lily*. Vienna. Kunsthistorisches Museum

Fig. III, 39: CATHERINE YKENS. *St. Theresa and Jesus*. 1659. Madrid. Prado

Fig. III, 40: JUDITH LEYSTER. *The Jolly Toper*. 1629. Amsterdam. Rijksmuseum

Fig. III, 41: JUDITH LEYSTER. *Signature*

Fig. III, 42: JUDITH LEYSTER. *The Gay Cavaliers*. Philadelphia. John G. Johnson Collection

Fig. III, 43: JUDITH LEYSTER. *Boy and Girl with Cat and Eel*. London. National Gallery

Fig. III, 44: JUDITH LEYSTER. *Self-portrait*. c. 1635. Washington, D. C. National Gallery of Art

Fig. III, 45: SIBYLLA MERIAN. Plate

from *Metamorphosis Insectorum Surinamensium*

Fig. III, 46: SIBYLLA MERIAN. *Studies from Nature*. Watercolor. New York. Metropolitan Museum of Art, Fletcher Fund

Fig. III, 47: SIBYLLA MERIAN. Plate from *Metamorphosis Insectorum Surinamensium*

Fig. III, 48: MARIA VAN OOSTERWYCK. *Flowers and Shells*. Dresden. Staatliche Kunstsammlung

Fig. III, 49: GEERTJE PIETERS. *Flowers*. 1675. Cambridge. Fitzwilliam Museum

Fig. III, 50: RACHEL RUYSCH. *Still life*. Oxford. Ashmolean Museum

Fig. III, 51: RACHEL RUYSCH. *Fruits and Insects*. Florence. Pitti Palace (photo: Alinari)

Chapter 4

Fig. IV, 1: ANGELICA KAUFFMANN. *Self-portrait*. London. National Portrait Gallery

Fig. IV, 2: ANGELICA KAUFFMANN. *Portrait of Johann Joachim Winckelmann*. 1764. Zurich. Kunsthaus

Fig. IV, 3: ANGELICA KAUFFMANN. *Telemachus Crowned by the Nymphs of Calypso*. New York. Metropolitan Museum of Art

Fig. IV, 4: ANGELICA KAUFFMANN. *Hebe*. Estate of Dorothy Moulton Mayer. Colin Smythe Ltd.

Fig. IV, 5: ANGELICA KAUFFMANN. *Drawing of a Woman*. Berlin. Kupferstichkabinett

Fig. IV, 6: MARIA COSWAY. *Self-portrait*. Color mezzotint after Maria Cosway by Valentine Green. Washington, D. C. National Gallery of Art

Fig. IV, 7: ROSALBA CARRIERA. *Spring*. Pastel. Dijon. Musée des Beaux Arts

Fig. IV, 8: ROSALBA CARRIERA. *Self-portrait*. Pastel. Venice. Galleria Accademia

Fig. IV, 9: GIULIA LAMA. *Young Man with a Turban*. Dijon. Musée

des Beaux Arts

Fig. IV, 10: ANNA DOROTHEA THERBUSCH. *Self-portrait*. 1779. Berlin. Gemäldegalerie. Staatliche Museum

Fig. IV, 11: FRANÇOISE DUPARC. *The Old Woman*. Marseilles. Musée des Beaux Arts

Fig. IV, 12: FRANÇOISE DUPARC. *Man with a Sack*. Marseilles. Musée des Beaux Arts

Fig. IV, 13: ELISABETH VIGÉE-LEBRUN. *Self-portrait*. Florence. Uffizi

Fig. IV, 14: ELISABETH VIGÉE-LEBRUN. *Mme. Vigée-Lebrun and Her Daughter*. 1789. Paris. Musée du Louvre, Clichés des musées nationaux

Fig. IV, 15: MARIE VICTOIRE LEMOINE. *Mme. Vigée-Lebrun and Her Pupil, Mlle. LeMoine*. New York. Metropolitan Museum of Art. Gift of Mrs. Thorneycroft Ryle

Fig. IV, 16: ELISABETH VIGÉE-LEBRUN. *Marie Antoinette and Her Children*. 1787. Versailles. Clichés des musées nationaux

Fig. IV, 17: ELISABETH VIGÉE-LEBRUN. *Bacchante*. 1785. The Fine Arts Museums of San Francisco, Mildred Anna Williams Collection. California Palace of the Legion of Honor

Fig. IV, 18: ELISABETH VIGÉE-LEBRUN. *Madame Molé-Raymond*. 1786. Paris. Musée du Louvre, Clichés des musées nationaux

Fig. IV, 19: ELISABETH VIGÉE-LEBRUN. *Hubert Robert*. 1788. Paris. Musée du Louvre, Clichés des musées nationaux

Fig. IV, 20: ADÉLAÏDE LABILLE-GUIARD. *Pajou, Sculpting the Bust of M. Lemoine*. 1782. Paris. Musée du Louvre, Cliché des musées nationaux.

Fig. IV, 21: MARIE GABRIELLE CAPET. *Portrait of Houdon Modelling the Head of Voltaire*. Formerly Musée de Caen (photo: Frick Art Reference Library)

Fig. IV, 22: ADÉLAÏDE LABILLE-GUIARD. *André Vincent*. 1795. Paris. Musée du Louvre, Clichés des musées nationaux

Fig. IV, 23: ADÉLAÏDE LABILLE-GUIARD. *Louise Elisabeth de France*. 1788. Paris. Musée du Louvre, Clichés des musées nationaux

Fig. IV, 24: MARGARETA HAVERMAN. *A Vase of Flowers*. 1716. New York. Metropolitan Museum of Art

Fig. IV, 25: ADÉLAÏDE LABILLE-GUIARD. *Portrait of the Artist with Two Pupils, Mlle. Marie Gabrielle Capet and Mlle. Carreaux de Rosemond*. 1785. New York. Metropolitan Museum of Art. Gift of Julia A. Berwind

Fig. IV, 26: ANNE VALLAYER-COSTER. *Attributes of Music*. New York. Metropolitan Museum of Art. Gift of J. Pierpont Morgan

Fig. IV, 27: ANNE VALLAYER-COSTER. *Still Life with Game*. Toledo, Ohio. Museum of Art. Gift of Edward Drummond Libbey

Fig. IV, 28: MARIE-ANNE COLLOT. *Lady Cathcart*. Nancy. Musée des Beaux Arts

Fig. IV, 29: MARIE-ANNE COLLOT. *Falconet*. Nancy. Musée des Beaux Arts

Fig. IV, 30: MARGUERITE GERARD. *The Bad News*. 1804. Paris. Musée du Louvre, Clichés des musées nationaux

Fig. IV, 31: MARIE-GUIHELMINE BENOIST. *Pauline Bonaparte*. Paris. Musée du Louvre, Clichés des musées nationaux

Fig. IV, 32: MARIE-GUIHELMINE BENOIST. *Portrait of a Negress*. 1800. Paris. Musée du Louvre, Clichés des musées nationaux

Fig. IV, 33: CONSTANCE MARIE CHARPENTIER. *Mlle. du Val d'Ognes*. New York. Metropolitan Museum of Art. Bequest of Isaac D. Fletcher

Fig. IV, 34: C. H. FLORE DAVIN-MIRVAULT. *Portrait of Asker Kan*. 1810. Versailles. Clichés des musées nationaux

Fig. IV, 35: ADÉLAÏDE LABILLE-GUIARD. *Portrait of Dublin-Tornelle*. Cambridge, Mass. Fogg Art Museum.

Chapter 5

Fig. V, 1: SUSAN SEDGWICK. *Mum Bett* (Elizabeth Freeman). 1811. Boston. Massachusetts Historical Society

Fig. V, 2: HENRIETTA JOHNSTON. *Portrait of Thomas Moore as a Child*. c. 1725. Richmond. Virginia Museum of Fine Arts

Fig. V, 3: ELLEN SHARPLES. *George Washington*. Bristol, England. City Art Gallery

Fig. V, 4: ELLEN SHARPLES. *A North American Indian*. Watercolor on ivory. Bristol, England. City Art Gallery

Fig. V, 5: ROLINDA SHARPLES. *Rolinda Sharples and Her Mother*. Bristol, England. City Art Gallery

Fig. V, 6: ROLINDA SHARPLES. *The Trial of Colonel Brereton*. 1832–34. Bristol, England. City Art Gallery

Fig. V, 7: JANE STUART. *George Washington*. Washington D. C. National Collection of Fine Arts

Fig. V, 8: JANE STUART. *Portrait of Gilbert Stuart*. Providence, R. I. Brown University

Fig. V, 9: SARAH GOODRICH. *Gilbert Stuart*. New York. Metropolitan Museum of Art

Fig. V, 10: PRUDENCE PUNDERSON. *The First, Second, and Last Scene of Mortality*. c. 1775. Silk thread on satin. Hartford. Connecticut Historical Society

Fig. V, 11: MARY ANN WILLSON. *Marimaid*. Watercolor. Cooperstown. New York State Historical Association

Fig. V, 12–15: MARY ANN WILLSON. Four scenes from the *Parable of the*

Prodigal Son. c. 1820. Washington, D. C. National Gallery of Art, Garbisch Collection

Fig. V, 16: HANNAH COHOON. *The Tree of Life*. 1854. Spirit drawing. Watercolor. Hancock, Mass. Shaker Community, Inc.

Fig. V, 17: EUNICE PINNEY. *Mrs. Clarke the York Magnet*. 1821. Watercolor. Williamsburg, Virginia. Abby Aldrich Rockefeller Folk Art Collection

Fig. V, 18: DEBORAH GOLDSMITH. *The Talcott Family*. 1832. Watercolor. Williamsburg, Virginia. Abby Aldrich Rockefeller Folk Art Collection

Fig. V, 19: BETSY LATHROP. *Venus Drawn by Doves*. c. 1825. Watercolor on silk. Williamsburg, Virginia. Abby Aldrich Rockefeller Folk Art Collection

Fig. V, 20: SUSAN MERRETT. *Fourth of July Picnic at Weymouth Landing*. c. 1845. Watercolor on paper. Art Institute of Chicago. Bequest of Elizabeth R. Vaughan

Fig. V, 21: LEILA T. BAUMAN. *Geese in Flight*. c. 1870. Washington, D. C. National Gallery of Art, Garbisch Collection

Fig. V, 22: FRANCES FLORA BOND PALMER. *The Route to California*. Lithograph. New York. Metropolitan Museum of Art. Gift of George S. Amory.

Fig. V, 23: LEILA T. BAUMAN. *U. S. Mail Boat*. 1860. Washington, D. C. National Gallery of Art, Garbisch Collection

Fig. V, 24: SARAH MIRIAM PEALE. *Notice from the Baltimore American*. July 31, 1829. Baltimore. Peale Museum. Courtesy of Wilbur H. Hunter

Fig. V, 25: SARAH MIRIAM PEALE. *Self-portrait*. c. 1830. Baltimore. Peale Museum

Fig. V, 26: SARAH MIRIAM PEALE. *John Montgomery*. 1830. Baltimore. Peale Museum

Fig. V, 27: SARAH MIRIAM PEALE. *Henry A. Wise*. Richmond, Virginia. Museum of Fine Arts

Fig. V, 28: SARAH MIRIAM PEALE. *Mrs. Denny*. c. 1835. Baltimore. Peale Museum

Fig. V, 29: ROSA BONHEUR. *Sheep*. Bronze. The Fine Arts Museums of San Francisco. Gift of Archer M. Huntington. California Palace of the Legion of Honor

Fig. V, 30: ROSA BONHEUR. *Study of a Pig*. Engraving from Anna Klumpke, *Rosa Bonheur, sa vie, son oeuvre*.

Fig. V, 31: *Rosa Bonheur Smoking*. Photograph from Anna Klumpke, *Rosa Bonheur, sa vie, son oeuvre*.

Fig. V, 32: Authorization for Rosa Bonheur to wear trousers, from Theodore Stanton's *Reminiscences of Rosa Bonheur*.

Fig. V, 33: ANNA KLUMPKE. *Rosa Bonheur*. New York. Metropolitan Museum of Art. Gift of the Artist in memory of Rosa Bonheur

Fig. V, 34: ROSA BONHEUR. *The Horse Fair*. 1853–55. 96 in. x 199 in. New York. Metropolitan Museum of Art. Gift of Cornelius Vanderbilt

Fig. V, 35: ROSA BONHEUR. *Buffalo Bill on Horseback*. 1889. Cody, Wyoming. Buffalo Bill Historical Center

Fig. V, 36: ANNA BILINSKA. *Self-portrait*. 1887. Cracow. National Museum

Fig. V, 37: MARY NEWTON. *Self-portrait*. London. National Portrait Gallery

Fig. V, 38: THERESE SCHWARTZE. *Self-portrait*. Florence. Uffizi

Fig. V, 39: Photograph of Harriet Hosmer at work on her statue of Thomas Benton

Fig. V, 40: HARRIET HOSMER. *Zenobia in Chains*. Hartford, Conn. Wadsworth Atheneum

Fig. V, 41: HARRIET HOSMER. *Bea-

trice Cenci. Marble. St. Louis. Mercantile Library

Fig. V, 42: Photograph of Edmonia Lewis

Fig. V, 43: EDMONIA LEWIS. Hagar. 1875. Marble. Washington, D. C. Museum of African Art

Fig. V, 44: ANNE WHITNEY. Roma. Bronze. Wellesley, Mass. Wellesley College Art Museum

Fig. V, 45: ANNE WHITNEY. Charles Sumner. Bronze. Cambridge, Mass. Harvard Commons

Fig. V, 46: VINNIE REAM HOXIE. Lincoln. Marble. 6 ft. 11 in. Washington, D. C. Capitol Rotunda. Courtesy of the Architect of the Capitol.

Fig. V, 47: ANNA HYATT HUNTINGTON. Joan of Arc. Bronze. San Francisco. The Fine Arts Museums. California Palace of the Legion of Honor

Fig. V, 48: MALVINA HOFFMAN. Mother and Child of the Kalahari Bushman Tribe. 1931. Bronze. Chicago. Field Museum of Natural History

Fig. V, 49: ANNA KLUMPKE. Elizabeth Cady Stanton. Washington, D. C. National Collection of Fine Arts

Fig. V, 50: ADELAIDE JOHNSON. Susan B. Anthony. Marble. New York. Metropolitan Museum of Art

Fig. V, 51: THOMAS EAKINS. Ladies Modeling Class at the Pennsylvania Academy of Fine Arts. c. 1883. Photograph. Philadelphia Museum of Art

Fig. V, 52: LILLY MARTIN SPENCER. The Young Husband: First Marketing. 1856. Collection of Mr. and Mrs. Edward E. Abrahams

Fig. V, 53: LILLY MARTIN SPENCER. We Both Must Fade. 1869. Washington, D. C. National Collection of Fine Arts

Fig. V, 54: Photograph of Lilly Martin Spencer. c. 1900. Washington, D. C. National Collection of Fine Arts

Fig. V, 55: MARY CASSATT. The Boating Party. 1893/94. Washington, D. C. National Gallery of Art, Chester Dale Collection

Fig. V, 56: MARY CASSATT. The Letter. Color print, with dry point, softground, and aquatint. Washington, D. C. National Gallery of Art, Rosenwald Collection

Fig. V, 57: MARY CASSATT. The Bath. 1891. Art Institute of Chicago, Robert A. Waller Fund

Fig. V, 58: BERTHE MORISOT. The Artist's Sister, Mme. Pontillon, Seated on the Grass. 1873. Cleveland Museum of Art. Gift of Hanna Fund.

Fig. V, 59: EVA GONZALES. Reading in the Forest. 1879. Waltham, Mass. Rose Art Museum. Brandeis University. Gift of M. M. Abraham Sonnabend

Fig. V, 60: BERTHE MORISOT. The Mother and Sister of the Artist. Washington, D. C. National Gallery of Art, Chester Dale Collection

Fig. V, 61: BERTHE MORISOT. The Artist's Daughter with a Parakeet. Washington, D. C. National Gallery of Art, Chester Dale Collection

Fig. V, 62: BERTHE MORISOT. The Cradle. 1873. Paris. Musée du Louvre, Clichés des musées nationaux

Fig. V, 63: BERTHE MORISOT. The Cherry Pickers. Collection of Denis Rouart

Fig. V, 64: BERTHE MORISOT. Self-portrait. 1885. Art Institute of Chicago, Joseph and Helen Regenstein Foundation

Fig. V, 65: BERTHE MORISOT. Swan. Drawing. Collection of Denis Rouart

Fig. V, 66: SUZANNE VALADON. Self-portrait. VESINET/Utrillo. Photographie Giraudon

Fig. V, 67: SUZANNE VALADON. Adam and Eve. 1909. Paris. Musée National d'Art Moderne, Clichés des musées nationaux

BECKER. *Self-portrait*. 1906. Basel. Kunstmuseum

Fig. VI, 27: PAULA MODERSOHN-BECKER. *Self-portrait*. 1907. Essen. Folkwang Museum

Fig. VI, 28: SONIA DELAUNAY. *Market at the Minho*. 1915. Paris. Musée National d'Art Moderne, Clichés des musées nationaux

Fig. VI, 29: SONIA DELAUNAY. *Triptych*. 1963. London. The Tate Gallery

Fig. VI, 30: NATALIA GONCHAROVA. *Cats*. 1911–12. New York. Solomon R. Guggenheim Museum

Fig. VI, 31: NATALIA GONCHAROVA. *Dynamo Machine*. 1913. New York. Leonard Hutton Galleries

Fig. VI, 32: NATALIA GONCHAROVA. *Le Coq d'Or*. Design for the ballet produced by the *Ballet Russe*, Paris 1914. Gouache on cardboard. New York. Museum of Modern Art, Lillie P. Bliss Bequest

Fig. VI, 33: LIUBOV POPOVA. *Architectonic Painting*. 1917. New York. Museum of Modern Art, Philip Johnson Fund

Fig. VI, 34: ALEXANDRA EXTER. *Still Life*. 1913. New York. Leonard Hutton Galleries

Fig. VI, 35: OLGA ROZANOVA. *Directional Lines*. 1916. New York. Leonard Hutton Galleries

Fig. VI, 36: MARTHE DONAS. *Still Life, No 29*. 1917. New Haven. Yale University Art Gallery, Collection Société Anonyme

Fig. VI, 37: RUZHENA ZATKOVA. *Struggle of Objects for Supremacy*. 1916. New York. Leonard Hutton Galleries

Fig. VI, 38: RUZHENA ZATKOVA. *The Monster of War*. 1918. New York. Leonard Hutton Galleries

Fig. VI, 39: HANNAH HÖCH. *Cut with the Kitchen Knife through the Last Weimar Beer Belly Cultural Epoch,* 1919. Berlin. National Gallery

Fig. VI, 40: KÄTHE KOLLWITZ. *Self-portrait*. Etching. San Francisco Achenbach Foundation for Graphic Arts. California Palace of the Legion of Honor

Fig. VI, 41: KÄTHE KOLLWITZ. *". . . resting in the peace of His Hands."* Cologne. Rheinisches Bildarchiv

Fig. VI, 42: KÄTHE KOLLWITZ. *Mary and Elizabeth*. Woodcut. San Francisco Achenbach Foundation for Graphic Arts. California Palace of the Legion of Honor

Fig. VI, 43: KÄTHE KOLLWITZ. *Twins*. 1935. Bronze. Staatliche Museen zu Berlin

Fig. VI, 44: KÄTHE KOLLWITZ. *Death Snatching a Child*. Lithograph. San Francisco Achenbach Foundation for Graphic Arts. California Palace of the Legion of Honor

Fig. VI, 45: KÄTHE KOLLWITZ. *Pietà*. 1937. Bronze. 15 in. Staatliche Museen zu Berlin

Fig. VI, 46: KÄTHE KOLLWITZ. *Working Woman*. Washington, D. C. National Gallery of Art, The Rosenwald Collection

Fig. VI, 47: KÄTHE KOLLWITZ. *Karl Liebknecht Memorial*. Woodcut. Washington, D. C. National Gallery of Art, The Rosenwald Collection

Fig. VI, 48: KÄTHE KOLLWITZ. *Never Again War!* Lithograph. Washington, D. C. National Gallery of Art. The Rosenwald Collection

Fig. VI, 49: KÄTHE KOLLWITZ. *Self-portrait with a Pencil*. Charcoal drawing. Washington, D. C. National Gallery of Art, The Rosenwald Collection

Chapter 7

Fig. VII, 1: BARBARA HEPWORTH. *The Dag Hammarskjöld Memorial*. 1964. Bronze. 21 ft. New York. United Nations

Fig. VII, 2: BARBARA HEPWORTH. *Pendour*. 1947. Painted wood. 10 in. x 27 in. x 9 in. Washington, D. C.

Smithsonian Institution, The Hirshhorn Museum and Sculpture Garden

Fig. VII, 3: GEORGIA O'KEEFFE. *Single Lily with Red*. 1928. 18 in. x 16 in. New York. Whitney Museum of American Art

Fig. VII, 4: GEORGIA O'KEEFFE. *Cow's Skull with Calico Roses*. 1931. 36 in. x 24 in. Art Institute of Chicago

Fig. VII, 5: LOUISE NEVELSON. *Sky Cathedral*. 1958. Wood assemblage. 11 ft. x 10 ft. x 18 in. New York. Museum of Modern Art. Gift of Mr. and Mrs. Ben Mildwoff

Fig. VII, 6: LOUISE NEVELSON. *Untitled*. 1957. Painted wood. 25 in. x 20 in. Washington, D. C. Smithsonian Institution, The Hirshhorn Museum and Sculpture Garden

Fig. VII, 7: LOUISE NEVELSON. *Illumination—Dark*. c. 1959. Wood & Bronze reliefs. 125 in. x 108½ in. New York. Whitney Museum of American Art

Fig. VII, 8: AUGUSTA SAVAGE. *Lift Every Voice and Sing*. 1939. Work destroyed. Photo by Carl van Vechten

Fig. VII, 9: LOIS MAILOU JONES. *Meditation (Mob Victim)*. 1944. Collection of the artist

Fig. VII, 10: LOIS MAILOU JONES. *Moon Masque*. 1971. Collection of the artist

Fig. VII, 11: MARY BETH EDELSON. *Some Living American Women Artists*. 1972. Courtesy of the artist

Fig. VII, 12: MARIA ELENA VIEIRA DA SILVA. *Labyrinth*. 1956. 31 in. x 31 in. Washington, D. C. Smithsonian Institution, The Hirshhorn Museum and Sculpture Garden

Fig. VII, 13: I. RICE PEREIRA. *The Celestial Gate Sways on the Ringing Swells*. Washington, D. C. National Collection of Fine Arts

Fig. VII, 14: LOREN MACIVER. *Skylight Moon*. 1958. 50 in. x 39 in. Washington, D. C. Smithsonian Institution, The Hirshhorn Museum and Sculpture Garden

Fig. VII, 15: LEE KRASNER. *The Guardian*. 1960. 53 in. x 58 in. New York. Whitney Museum of American Art

Fig. VII, 16: JOAN MITCHELL. *Lucky Seven*. 1962. 79 in. x 74 in. Washington, D. C. Smithsonian Institution, The Hirshhorn Museum and Sculpture Garden

Fig. VII, 17: GRACE HARTIGAN. *Grand Street Brides*. 1954. 72 in. x 102 in. New York. Whitney Museum of American Art

Fig. VII, 18: JOAN SNYDER. *Soft Pocket Song*. 1973. 79 in. x 108 in. New York. Whitney Museum of American Art. Gift of Albert A. List Family

Fig. VII, 19: LEE BONTECOU. *Untitled*. 1961. New York. Whitney Museum of American Art

Fig. VII, 20: EVA HESSE. *Sans II*. 1968. Fiberglass. 38 in. x 170 in. x 6 in. New York. Whitney Museum of American Art

Fig. VII, 21: NANCY GRAVES. *Variability and Repetition of Similar Forms*. 1971. Ottawa. National Gallery of Canada

Fig. VII, 22: MARY BAUERMEISTER. *Sketch for Tanglewood Press*. 1966. Berkeley. University Art Museum

Fig. VII, 23: CECILE ABISH. *About Face*. 1974. Collection of the artist

Fig. VII, 24: REMEDIOS VARO. *Capillary Movement,* 1960. Courtesy of Walter Gruen

Fig. VII, 25: REMEDIOS VARO. *The Vegetarian Vampires*. Courtesy of Walter Gruen

Fig. VII, 26: REMEDIOS VARO. *The Useless Science or the Alchemist,* 1963. Courtesy of Walter Gruen

Fig. VII, 27: REMEDIOS VARO. *The Phenomenon of Weightlessness,* 1963. Courtesy of Walter Gruen

Fig. VII, 28: LEONOR FINI. *The Lesson on Botany*. 1974. Courtesy of

the Artist

Fig. VII, 29: LEONOR FINI. *Wrapped in Silence*. 1961. Courtesy of the Artist

Fig. VII, 30: MERET OPPENHEIM. *Object (Breakfast in Fur)*. 1936. Fur covered cup, saucer, and spoon. New York. Museum of Modern Art

Fig. VII, 31: KAY SAGE. *No Passing*. 1954. New York. Whitney Museum of American Art

Fig. VII, 32: FRIDA KAHLO. *The Broken Column*. Mexico City. Museo Frida Kahlo, Collection Lola Olmedo.

Fig. VII, 33: FRIDA KAHLO. *Self-Portrait with Cropped Hair*. 1940. New York. Museum of Modern Art. Gift of Edgar Kaufmann, Jr.

Fig. VII, 34: FRIDA KAHLO. *My Miscarriage. (Henry Ford Hospital)*. Mexico City. Museo Frida Kahlo, Collection Lola Olmedo.

Fig. VII, 35: FRIDA KAHLO. *The Birth of Moses*. Private Collection

Fig. VII, 36: FRIDA KAHLO. *Roots*. Mexico City. Museo Frida Kahlo, Collection Lola Olmedo.

Fig. VII, 37: FRANCES GILLESPIE. *Self-portrait*. Courtesy of the artist

Fig. VII, 38: CHARLEY TOOROP. *Self-portrait*. Eindhoven. Stedelijk "Van Abbe" Museum

Fig. VII, 39: AUDREY FLACK. *Self-portrait*. 1974. Collection of the artist

Fig. VII, 40: JUDY CHICAGO. *Female Rejection Drawing*. 1974. Colored pencil on paper. 30 in. x 40 in. Courtesy of the artist

Fig. VII, 41: JUDY CHICAGO. *George Sand*. 1973. Sprayed acrylic. 5 ft. x 5 ft. Courtesy of the artist

Fig. VII, 42: MARY BETH EDELSON. *Blood Mysteries*. 1973. Drawing. 91 in. x 57 in. Courtesy of the artist

Fig. VII, 43: MARY BETH EDELSON. *Blood Mysteries*. Detail. Courtesy of the artist

Fig. VII, 44: MIRIAM SCHAPIRO. *Shrine*. 1962. Magna. 50 in. x 60 in. Courtesy of the artist

Fig. VII, 45: FAITH RINGGOLD. *Bernice Mask*. From the Family of Woman series. 1974. Collection of the artist

Fig. VII, 46: NIKI DE SAINT-PHALLE. *Black Venus*. 1967. Painted polyester. 110 in. x 35 in. x 24 in. New York. Whitney Museum of American Art

Fig. VII, 47: LEONOR FINI. *The Ideal Life*. 1950. Courtesy of the artist

Fig. VII, 48: ELIZABETH CATLETT. *Homage to My Young Black Sisters*. 1969. Cedar. 71 in. x 14 in. Courtesy of the artist and José Verde

Fig. VII, 49: BETYE SAAR. *The Liberation of Aunt Jemima*. 1972. Berkeley. University Art Museum

Fig. VII, 50: MARY BETH EDELSON. *Great Goddess Series*. 1975. Courtesy of the artist

Fig. VII, 51: BARBARA CHASE-RIBOUD. *Confessions for Myself*. 1972. Bronze, painted black, and black wool. 120 in. x 40 in. x.12 in. Berkeley. University Art Museum

Appendix

Fig. VIII, 1: ANON. *Woman Painter at Work*. Ch'ing dynasty. Chicago. Field Museum of Natural History

Fig. VIII, 2: Women tending silkworms. Woodcut. From Cheng Chen-to, *A History of Chinese Woodcuts*. Liang Yu (Fu-hsing) Publishing and Printing Company

Fig. VIII, 3: Women reeling silk filaments. Woodcut. New York Public Library, Spencer Collection

Fig. VIII, 4: Embroidered imperial dragon. Ming dynasty. New York. Metropolitan Museum of Art

Fig. VIII, 5: Woman making ink sticks. Woodcut. Paris. Bibliothèque Nationale

Fig. VIII, 6: KUNG SU-JAN. *Consort Ming Crossing the Frontier.* Early 12th c. Osaka. Osaka Municipal Museum of Fine Art

Fig. VIII, 7: YANG MEI-TZU. *Calligraphy.* c. 1200. Collection of John M. Crawford, Jr.

Fig. VIII, 8: KUAN TAO-SHENG. *Calligraphy.* c. 1300. From Ch'en Chih-mai, *Chinese Calligraphers and Their Art*

Fig. VIII, 9: Kuan Tao-sheng and her husband in the studio. Woodcut. From Ch-en Chih-mai, *Chinese Calligraphers and Their Art*

Fig. VIII, 10: KUAN TAO-SHENG. *The Slender Bamboo of Spring.* c. 1300. Stockholm. Museum of Far Eastern Antiquities

Fig. VIII, 11: KUAN TAO-SHENG. *Kuan-yin With Fish Basket.* 1302. Osaka. Osaka Municipal Museum of Fine Art

Fig. VIII, 12: KUAN TAO-SHENG. *A Bamboo Grove in Mist.* c. 1300. New Haven. Yale University Art Gallery

Fig. VIII, 13: MA SHOU-CHEN. *Lotus in Late Summer.* Early 17th c. Stockholm. Museum of Far Eastern Antiquities

Fig. VIII, 14: HSÜEH WU. *Wild Orchids.* 1601. Honolulu Academy of Arts

Fig. VIII, 15: TS'AO MIAO-CH'ING. *Branch of Flowers.* 1380. Taipei. National Palace Museum

Fig. VIII, 16: TS'AO MIAO-CH'ING. *Morning Glories.* Late 14th c. Taipei. National Palace Museum

Fig. VIII, 17: HSING TZ'U-CHING. *Kuan-yin,* 16th c. Taipei. National Palace Museum

Fig. VIII, 18: HSING TZ'U-CHING. *The Thirty-second Manifestation of Kuan-yin.* Taipei. National Palace Museum

Fig. VIII, 19: CH'IU SHIH. *Lady in Garden.* 16th c. Taipei. National Palace Museum

Fig. VIII, 20: CH'IU SHIH. *White Robed Kuan-yin.* 16th c. Taipei. National Palace Museum

Fig. VIII, 21: WEN SHU. *Butterfly and Flowers.* 1630. Taipei. National Palace Museum

Fig. VIII, 22: MA CH'ÜAN. *Butterflies.* c. 1800. New York. Metropolitan Museum of Art

Fig. VIII, 23: CH'EN SHU. *A White Cockatoo.* 1721. New York. Metropolitan Museum of Art

Fig. VIII, 24: CH'EN SHU. *The Quiet of the Mountain and the Length of the Day.* Early 18th c. Taipei. National Palace Museum

Fig. VIII, 25: TZ'U-HSI. *Peonies and Cat Meowing at Pug Dog.* Late 19th c. Chicago. Field Museum of Natural History

Fig. VIII, 26: LI FENG-LAN. *Spring Hoeing.* 1970s. *Chinese Literature,* Dec. 1973

Fig. VIII, 27: MA YA-LI. *The Brigade's Chicken Farm.* 1970s. *Chinese Literature,* Dec. 1973

Index